ARTS, THEOLOGY, AND THE CHURCH

ARTS, THEOLOGY, AND THE CHURCH

NEW INTERSECTIONS

edited by Kimberly Vrudny and Wilson Yates

THE PILGRIM PRESS
CLEVELAND

TO *John Dillenberger and*

Jane Daggett Dillenberger,

for their visionary contributions

in the field of theology

and the arts

The Pilgrim Press, 700 Prospect Avenue, Cleveland, Ohio 44115-1100
thepilgrimpress.com
© 2005 by Kimberly Vrudny and Wilson Yates

Library of Congress Cataloging-in-Publication Data

Arts, theology, and the church : new intersections / edited by Kimberly J. Vrudny and Wilson Yates.
 p. cm.
 Includes bibliographical references.
 ISBN 0-8298-1651-8 (paperback : alk. paper)
 1. Christianity and the arts. I. Vrudny, Kimberly J., 1969– II. Yates, Wilson.
BR115.A8A78 2005
246—dc22

2005047635

Contents

Preface

The essays included in this volume came out of a National Consultation on Theology and the Arts sponsored by United Theological Seminary of the Twin Cities. Fourteen scholars were asked to work on new ideas to be explored at the first meeting in 2002. Finished papers read at the second meeting in 2003 were critiqued by a group of respondents from Cambridge University, the University of Minnesota, and The Graduate Theological Union, as well as from Art and Christianity Enquiry (ACE), an international group of scholars working in the area of theology and the arts.

Over the past twenty-five years, the exploration of the arts in relationship to theology has become a significant part of the landscape of theological education and the church. It has dealt with profound issues ranging from *theories* regarding the relationship of beauty to holiness and the connection between aesthetic and religious experience, *interpretations* regarding the significance of the arts in revealing the birth and history of Christianity, and *practices* regarding the importance of

the arts in the task of theological reflection in the life of the church and its ministry as well as in spiritual life and worship. Indeed, this three-fold exploration has opened the door to the creation of a new field in theology and the arts that has the promise of extending the ministry of the church and expanding how we do theology.

The writers in this volume of essays treat these three types of issues in an effort to define the relationship between the arts, theology, and the religious life. At the heart of their concern is their effort to explain where we are on this journey of understanding and to suggest the rich store of discovery that is possible within this new field of theology and the arts. The essays focus on a range of visual forms of artistic expression including photography and film, as well as nonvisual forms of expression including story, music, and liturgy. The authors are established scholars who are leading figures in this exploration. They are among those theologians who are writing the script of what is happening in theology and the arts even as the story unfolds. We take great delight in offering you the fruit of their work.

The purpose of the essays is to explore the relationship between the arts, theology, and the church in three different areas of theological and church inquiry. This will involve the examination of issues related to theoretical questions regarding theology and the arts, interpretative issues related to the arts as documents and sources for theology, and issues related to the practice of ministry.

To elaborate, in terms of theory, our concern is to treat issues related to *theoretical questions,* such as why the church should be involved with the arts; what the roles are that the arts play in the religious life; how the arts may reveal the presence of God; what the relationship is between the spiritual and the aesthetic; and what the relationship is between beauty and holiness. Wilson Yates surveys the early history of this new and emerging field from the period of World War II to the present. Frank Burch Brown acknowledges the historical and contemporary struggles confronted when religion and art meet, but argues, too, that one can scarcely be understood without reference to the other—though it has been attempted. Mary Farrell Bednarowski develops an aesthetic of hope in her reading of contemporary American spiritual memoirs even as they create a "lump in the throat," an experience that elicits a

response in both her head and her heart—a phenomenon that she suggests has as much to do with the artistic enterprise as it does the theological. And, finally, Kimberly Vrudny imagines a continuum of beauty stretching between glory and suffering, which is equated with all of existence, to suggest that God is sacramentally present in documentary photography, making it a worthy source for theological inquiry.

In terms of *interpretation of Bible and history,* our concern is to treat issues related to how art can serve theology and the church as document, text, and source in understanding both the history of the Christian faith and contemporary spiritual life. Bruce Birch reflects on his experience of retrieving the ancient Jewish interpretive method of midrash as a means of imaginatively approaching works of art based on texts from the Hebrew Bible, as well as the texts themselves, in order to understand a fuller range of meaning inherent in biblical passages than is typically possible by standard methods. Doug Adams examines depictions of the parables of the prodigal son, the sower, and the leavened bread in order to demonstrate how artists, in addition to exegetes, interpret the parables, often revealing insights into their own sociocultural and religious worldviews. Robin Jensen contemplates the invisible God made visible in a wide range of works both historical and contemporary. And, finally, Deborah Haynes explores the place of art in contemporary culture, religion, and her own artistic work since 2000.

In terms of the *practice* of the church's ministry, our concern is to treat issues related to the practice of the liturgy, including the enactment of the eucharist, the role of the arts in theological education, and the actual use of the arts in worship and prayer. Don Saliers discusses how Christian worship is rooted in the body and how its rituals are utterly dependent upon the arts for their enactment and expression, ultimately advancing an ecumenical agenda for theological aesthetics. Jann Cather Weaver discusses eucharistic images in the films *Priest* and *Daughters of the Dust* in order to suggest that films can revitalize the church's liturgical practice by "thickening" its own ecclesiological understanding. Cindi Beth Johnson describes three models for arts programs in theological seminaries: an exhibitions program, an artist-in-residence program, and a collaborative program with local arts institutions, by reflecting on the experience of developing one such program at United

Theological Seminary of the Twin Cities. And, finally, Sidney Fowler suggests several different methods by which photography can be used to enhance prayer life, understood as paying "loving attention."

Contributors to a volume that has come out of a consultation, such as this one, have many institutions and people to whom we are indebted. Foremost is the Henry Luce Foundation. The consultation, funded by the Foundation, was a project of United Seminary's Religion and Arts Program. United's intention in seeking funds was to gather national scholars who would speak to the question of where we are at this point in our work in the field of theology and the arts. The generosity of Luce in not only funding but also supporting the importance of such a consultation has been crucial in the work that we have produced.

We are indebted, too, to the Program in Religion and the Arts at United Theological Seminary of the Twin Cities and its director, Cindi Beth Johnson, who arranged for this consultation to take place and guided it through its three-day sessions in two subsequent Octobers, 2002 and 2003. Kimberly Vrudny and Wilson Yates were also participants in the consultation's program development.

Our special respondents included Professor Graham Howes of Trinity College, Cambridge; the Reverend Tom Devonshire Jones of ACE, Great Britain; Emeritus Professor John Dillenberger of the Graduate Theological Union, Berkeley; and Professor Gayle Graham Yates of the University of Minnesota American Studies Program. Their critiques became important points of discussion and of revision for our writers.

Renee Flesner, assistant to the Religion and Arts Program at United Seminary, and Gretchen Milloy, assistant to the president, conducted important staff work vital to managing a complex conference.

Finally, we are deeply grateful to Pamela Johnson and The Pilgrim Press for encouraging us in the preparation of this volume.

—*Kimberly Vrudny and Wilson Yates*

List of Illustrations

Ill. 1. Sebastião Salgado, *Drought and Famine,* Mali, 1985, ©
Sebastião Salgado (Amazonas/Contact Press Images).

Ill. 2. Steve McCurry. *Haunted eyes tell of a young Afghan refugee's
fears,* Baluchistan, Pakistan, 1985, © Steve McCurry (Magnum
Photos).

Ill. 3. Shirin Neshat, *Faith*, 1995, RC print and ink, 11 x 14 inches
(27.9 x 35.6 cm), © 1995 Shirin Neshat. Photo taken by Kyong Park,
Courtesy Barbara Gladstone.

Ill. 4. Shirin Neshat, *Bonding*, 1995, 11 x 14 inches (27.9 x 35.6 cm),
© 1995 Shirin Neshat. Photo taken by Kyong Park, Courtesy Barbara
Gladstone.

Ill. 5. Seyed Alavi, *Ode to Rumi; Drawn to Light,* 30' W x 35' H,
Rice paper, beeswax, paper butterflies, Sufi poetry, © 2000 Seyed
Alavi; used with permission.

PART I **The Arts and Theology**

The Theology and Arts Legacy

WILSON YATES

Over the past fifty years, we have seen a growing number of scholars, artists, and church leaders publishing works and developing programs that explore the relationship of the arts to religion, theology, and the church. While these works were written out of particular contexts and often for specialized audiences, they have all contributed to the creation of a body of literature that has produced the foundation for the emerging field of theology and the arts. They have set the stage for exploring anew the relationship between art, theology, and the church. They have given us a legacy on which to build. This essay is about that legacy.

For such a field as theology and the arts to emerge, however, there must be more than scholarly publications. There must be institutional settings where the arts are integrated and supported, including theological schools, religious studies programs, and professional societies; conferences and consultations that flow out of seminaries, churches,

and religious organizations; and publishing houses, journals, and magazines that offer voice to the field. Further, there must be solid foundation support, particularly in a time of development. If there is to be a full field of inquiry within theological education and the church these are the major actors who have to enter stage center and who have to play their proverbial academic and church roles that promote the dialogue between theology and the arts. There must also be a receptive time and audience ready to receive the play's narrative. As I will show, we have seen all of these components converge, making it possible, perhaps for the first time, to speak of theology and the arts as its own discipline.

In this discussion, I want to acknowledge the historical context that has been the setting for this play, for it is necessary that we know something of what was happening in American society, the cultural life of the country, and the church's own awakening to the arts in order better to understand how theology, the arts, and the church have forged this new relationship.

THE 1950s TO THE 1970s

Before World War II, the North American Christian churches, both Protestant and Roman Catholic, gave limited consideration to the arts. With the exception of music and the liturgical arts that informed the life of worship, there was little programmatic attention given to the literary and performing arts, and there was a ready uneasiness with the visual arts, at least within major Christian traditions. This was particularly true in evangelicalism and the reformed traditions of Protestantism and selectively so in Roman Catholicism. What, then, were the influences that led to the church and its theologians' own quiet revolution that led to a new awareness and engagement with the arts? In responding to that question, I want to treat two periods: the 1950s to the 1970s, and then turn to the 1970s to the present.

From the 1950s to the 1970s, there were certain influences that came together to shape the theology and arts dialogue and, more broadly, the overarching interest in the intersections of religion and the arts. Such influences certainly included the role of the theologians, but there were other important sources. I wish to summarize these influ-

ences by highlighting four that were key to this revolution, including the dynamic burst of the arts into American culture after World War II; the programs of several leading seminaries, groups, and conferences within the church that sponsored national arts-related projects; the Christian student movement, which became a major voice in supporting the arts; and *motive* magazine, which gave a sustained voice to theologians, the church, and the student movement as these parties sought to work with the arts.

Societal Responsiveness to the Arts

The first influence was the larger society's own growing responsiveness to the arts. By the mid-twentieth century, a new era for the arts in American society began to take shape, marked most dramatically by the stream of artists who came to North America right before and during World War II. New York City was their port of entry, though most urban areas were beneficiaries. These painters, musicians, architects, poets, playwrights, actors, and filmmakers joined the community of artists already present—a community that included the figures who had shaped the renaissance in American drama, literature, and dance—to cultivate new and amazingly fertile ground for artistic growth.[1] After the war, American society experienced enormous development in the arts. New York City became the art world's capital, and arts institutions across the country began to thrive in unprecedented ways. New interests from the public, new funds from both private and public sources, and new energy from artists, arts institutions, and the larger community all converged to create a context in which the arts could flourish more fully than they ever had before. The growth and development of museum holdings, arts publications, galleries, concert halls, repertory theaters, arts education programs, and the burgeoning newer art forms of film, photography, and, later, video, were all indicators of the new vitality of the arts. It was a bold and exciting period during which North America artistically entered a new age and then came of age. The arts were seen, at last, as a major force of culture by a society that had too often left their nurture and enjoyment to special groups within the community. This period, which defined a new role and importance for the arts in society, is significant in understanding the church's own response to the

arts, for it defined a vibrant and exciting cultural context for the church's involvement.

Theological Currents in Seminaries

The second influence was the seminary, where theological currents were awakening interest in the arts in both theology and the church. Theologians engaged in serious dialogue and interaction with artists and their works in new and groundbreaking ways. It is in this arena that the "theology and arts" dialogues took form. Major theologians, such as Paul Tillich, Amos Wilder, Jacques Maritain, Nicholas Berdyaev, Roger Hazelton, and Walter Ong, S.J., gave shape and focus to the dialogue. Tillich, who was the most influential of these figures, offered through his theological writings a particularly inviting framework for the analysis of the arts. A generation of his students, including James Luther Adams, Nathan Scott, Tom Driver, Jane Daggett Dillenberger, and John Dillenberger, were to make substantial contributions to the study of religion and the arts and, at points, to revise and elaborate his basic approach.[2]

Several theological schools in the 1950s did significant work in the arts. Union Theological Seminary in New York, the Divinity School of the University of Chicago, and Boston University School of Theology were three such centers, and nearly all major seminaries offered courses that dealt with one or more art forms, with such schools as Drew Theological School and Christian Theological Seminary offering important opportunities for arts-related work.

Work flowed out of the 1950s into the 1960s. The religious drama work of Harold Ehrensperger had begun at Boston University and was further developed by Ruth Winfield Love. Robert Seaver at Union Seminary in New York developed a major program in religious drama; and E. Martin Browne, president of the Religious Drama Society in Great Britain, taught at Union. Eugene Jaberg created a summer religious drama program at United Theological Seminary of the Twin Cities, and the School of Sacred Music at Union served as a center for the study of religious music. This school later moved to Yale University, where it would expand its work with the arts. The new program in Christianity and the Arts at the Graduate Theological Union in

Berkeley, California, took shape under the leadership of Jane Daggett Dillenberger and John Dillenberger and would be developed under the leadership of Doug Adams of Pacific School of Religion. Writings continued to flow from such figures as Jane Daggett Dillenberger, Stanley Romaine Hopper, Nathan Scott, Tom Driver, Giles Gunn, John W. Dixon Jr., Walter Ong, S.J., Roger Ortmeyer, and Robert Steele. New church architecture came into its own, including such major works as Marcel Breuer's design of St. John's Abbey Church in Collegeville, Minnesota, and Eliel and Eiro Saarinen's design for First Christian Church in Columbus, Indiana—and there were more.[3]

While these theologians varied in their own particular theological approaches to the arts, they tended to accent the importance of the arts in rather specific ways. Foremost, the arts were considered to be a source of religious and moral questions emerging out of the culture. One could "read the religious situation" by reading, listening to, and seeing what artists were doing. The arts could also reveal to us the character of Christian life in its different historical moments. Thus, Tillich could find in medieval art a theonomous expression of religious life, in Rembrandt an autonomous expression of the individual's relationship to God, and in many contemporary artists the expression of both a social and personal heteronomous situation. The arts could play prophetic roles as the bearers of what Tillich called the Divine NO and the Divine YES as the bearers of a word against idolatry and injustice and the possibilities of transformation.[4]

For many, including Tillich, the focus rested on the power of modern art to reveal insights into the human situation. James Luther Adams called such art "art of the fall." Adams, as well as others, however, could also speak of the "art of creation" and the "art of redemption and transformation." Thus, works of art with a broader focus could point to the mystery of creation, as Roger Hazelton suggested, and to the beauty of creation that Adams wrote about. Furthermore, art could play a crucial sacramental role as a means of grace, a means through which we could not only glimpse some image of wholeness but also experience such wholeness itself. Thus, Adams spoke of the "redemptive ecstatic joy" that art could provide, of the power of art to transform our lives.[5] Other theologians explored various theological themes.

Again, Roger Hazelton in his important work, *A Theological Approach to Art,* cast his treatment in terms of art as disclosure, as embodiment, as vocation, and as celebration, considering, as did Adams, the possibilities of art to speak to the fullness of the religious life.[6] Harold Ehrensperger in *Religious Drama: Ends and Means* sounded a Tolstoian note that art's purpose is to inspire us to love more fully by holding out for theater the goal of helping us experience the truth, the transformative possibilities of life, and encounter with beauty.[7] Tom Driver, perhaps the most significant of the theologians treating drama, saw, too, the capacity of drama to inspire, though he explored more fully the boundaries of life with which theater confronted us.[8] Amos Wilder, the New Testament theologian, set forth his own theory of theopoetics and the power of the poetic to enable us to break through to new levels of religious meaning and divine encounter.[9] Tillich's student, Nathan Scott Jr., paralleled Wilder in the analysis of the novel and poetry and, under his pen, William Faulkner, Robert Penn Warren, T. S. Eliot, W. H. Auden, Elizabeth Bishop, and Flannery O'Conner all became a canon of writers whom Scott saw speaking profoundly to the human condition and our relationship to God.[10] Overall, however, theological interests primarily focused in the 1940s and 1950s and into the 1960s on the power of art to reveal the darker side of human existence and the limits of human finitude.

The Christian Student Movement

The third influence was that of the Christian Student Movement. The student movement had very active denominational organizations (often called foundations) on university and college campuses, as well as support from national denominational offices and links to the National Council of Churches and the World Council of Churches and most all of them had special interest and work in the arts.[11] The interest within the Christian Student Movement was most powerfully expressed through the movement's creation of arts-related projects, its contribution to the liturgical renewal movement and, through the Methodist Student Movement (MSM), the creation of the ecumenical publication *motive* magazine. (I shall treat *motive* as a separate influence because of its importance in the creation and shepherding of the theology and arts conversation.)

To appreciate something of the nature of the arts-related projects, I want to highlight certain of these events. There were religious drama groups such as "The Bishop's Company" that toured the country performing the works of such dramatists as Dorothy Sayers, Christopher Fry, T. S. Eliot, W. H. Auden, Arthur Miller, and Tennessee Williams. There were art trips abroad, such as those led by Joe Brown and Ruth Winfield Love, who were national leaders in the Methodist campus ministry. National conferences were held, including the 1959 convocation for Methodist youth and students where 6,000 participants gathered at Purdue University to hear Dave Brubeck's religious jazz and Odetta's music and see the Martha Graham dance troupe create a dance drama about the history of black people in America, followed by Ted Gill, who lectured on theology and the arts. An earlier but similar MSM conference had been held at the University of Kansas in 1955 and later at the University of Illinois in 1962. There were arts seminars such as the 1960 MSM seminar in New York City, where thirty participants, under the leadership of B. J. Stiles, the editor of *motive* magazine, and Gayle Graham (Yates), the national MSM president, and the sponsorship of *motive* assembled to explore the connections between theology and the arts. They came to listen to Alfred Barr of the Museum of Modern Art, to visit Jacques Lipchitz at his studio, to hear Amos Wilder lecture on theology and art, and to experience a discussion of Edward Albee's *The Zoo Story* and *The American Dream* by a panel made up of Tom Driver, Uta Hagen, and Alan Schneider.[12]

Separate from these events, but related to the student movement, were a number of significant institutional efforts. Major churches, such as Judson Memorial in New York City and Germantown Methodist in Philadelphia, provided significant ministries through the arts and to artists that became national models for the student movement. Television programs drawing on the student movement were launched: the NBC *Look Up and Live* religious drama series, sponsored by the National Council of Churches, was one of the most significant. And there was the influential Society for the Arts, Religion and Contemporary Culture, which was formed in 1962 to provide opportunities for artists, theologians, and lay people to gather for discussion and promotion of the arts and artists within theology and the church.[13]

The liturgical renewal movement, which was nurtured by the student movement, was also pivotal in the creation and nurture of the arts and theology dialogue. In the Roman Catholic Church, the Liturgical Renewal Society, founded in 1928, had a much earlier start in the American context than did the Protestant effort. It soon developed its very important and influential journal, *Liturgical Renewal,* and the Society, through its journal, gave important attention to the liturgical arts, which paved the way for later Protestant work.[14] In the Protestant clime, the liturgical renewal movement was, in many respects, a child of the student movement, with the campus serving as a primary context for its experimentation and development. In turn, *motive* played a significant role in the renewal effort and the importance of the arts to that effort with Roger Ortmayer, *motive's* second editor, playing a crucial role in *motive's* contribution with his focus on the performing arts. Theologically, the liturgical movement in Protestantism had such a strong focus on the "the word" as the center of worship that the visual arts often failed to receive their due, but *motive* helped redress that imbalance with its own focus on the importance of the visual image in the life of worship. Whatever the particular influences, however, the renewal movement gave further credence generally to the treatment of the theology and arts dialogue and provided the movement an enthusiastic base of workers.

It is not difficult to appreciate why the liturgical movement encouraged the arts, for it was concerned with the one context in the church's life where the arts are essential. One need only think of Sunday morning to understand their presence and importance. Worshipers enter a work of architectural form and move into liturgical space that is aesthetically defined space; the rudiments of dance occur with the choreographed movement of the body—walking, sitting, kneeling, bowing, standing—that the ritual practices require; the liturgy itself is a drama in which the religious story unfolds with all its participants playing dramatic roles; the liturgical drama depends on a range of forms, including music, both instrumental and vocal; poetry and story are read from scripture; the eyes are met by the fabric art in vestments and paraments, the art of pottery, silver, and woodcarvings, and still more visual images in stained glass, paintings, sculpture, and architectural detail. Given this interdependence of worship and the arts, we might assume that all

would recognize the significance of the arts in worship, but that was not the case. Protestantism's uneasiness, particularly with the visual image, set a tone of caution, and the liturgical renewal movement had to make its case for the liturgical arts. But it did so in very good fashion due, in part, to the significance of *motive* magazine.

motive Magazine

The fourth major influence affecting the early development of the theology and arts dialogue was *motive* magazine, and it was, arguably, the most important publication in the sustained growth of the church's and theology's conversation with the arts. It was published by the Department of Higher Education of the Methodist Church, but it served as an ecumenical publication and was used by most all of the mainline student movement groups, including Roman Catholic student ministries.[15] While it flowed out of the student movement, it had an influence that rippled through the whole church and into theological schools. In certain respects, it brought together different participants in the theology and arts conversation, increasing the number of parties around the table. Its contributions were several: it published articles by the very theologians who were central to the dialogue, pulled in figures from the university and college world, served as a major voice of the Protestant efforts for liturgical renewal, served as a voice for the progressive wings of the church and those in the church engaged with the arts, and, foremost, it was the training ground for students who would become the next generation of theologians and church leaders that enlarged the theology and arts conversation in both the seminaries and the churches. *motive* was not a journal of the arts alone, for it covered political and social issues and particularly those of war and peace. It was launched in 1941 under a pacifist editor, Harold Ehrensperger, and it became a significant context for analyzing social justice issues in America. The arts, however, became pivotal in the public's judgment of where *motive* made its greatest contributions in the secular and church arenas. Because *motive* mirrored, participated in, and promoted the dialogue between theology and the arts and between artists and theologians, the following discussion will be more extensive than our earlier treatment of events and organizations, for it offers us a microcosm of the legacy we are seeking to define.

motive developed its approach to the arts under each of its four editors, Harold Ehrensperger (1941–50), Roger Ortmeyer (1950–58), Jamieson Jones (1958–61), and B. J. Stiles (1961–69). While there were changes in its perspective from one period and editor to the next, it maintained a strong transformationist stance. The church was called to transform culture and the arts had their role to play in that transformation. Within this perspective, *motive* treated art that invited an exploration of such central theological themes as creation and the power of imagination, alienation and the character of human evil, and reconciliation and the search for wholeness; it treated what we might identify in James Luther Adams's terms, "art of creation," "art of the fall," and "art of redemption."[16] The transformationist stance was one that reflected the student movement's own theological focus and much of the theology dominant in seminaries and divinity schools. Under Ehrensperger, film, literature, drama, and music and later video and television were reviewed with a focus on works that treated issues of social import. The visual arts during this period were much less a part of the magazine's focus, though that changed when Gregor Goethels became art editor.

The fact that religious ideas and meanings were a part of poetry, novels, music, drama, and the visual arts that, otherwise, were not specifically religious in subject matter and iconography set a major course for *motive's* treatment of the arts that would remain true throughout its life. Ehrensperger framed his judgment of what constitutes works that have religious significance in theologically idealistic terms. He insisted, not unlike Tolstoy, whom he greatly admired, that art must inspire, must elevate the human spirit, must call us to a higher state of religious life. Indeed, as Tolstoy had insisted in his work *What is Art?*[17], the criterion for judging a work of art was whether it enhanced the moral life by making us more able to love the neighbor. In his influential work *Religious Drama: Ends and Means,* he insisted that art is religious art "when it shows meaning and purpose in life that grows from the revelation of the highest values conceivable."[18] This happens through tragedy or comedy, through historical plays or plays about contemporary life, but for drama to be religious it must reveal something of what life ought to be or what we ought to do to the end that our own spiritual life will be enhanced.

Ehrensperger, reflecting his own liberal Protestant perspective, held to a rather high view of human nature with a strong sense of human possibility. This was consonant with much church theology of the time that shared a liberal theological perspective. The arts were seen as a vital force for such human transformation.

The theme of transformation continued under Roger Ortmayer, but there were certain basic shifts under his editorship. Theologically, Ortmayer reflected a more existentialist and neo-orthodox stance. Given his Tillichian appreciation for discerning the culture's religious questions, his overall concern was for *motive* to provide for its readers a format for theological reflection on culture. In turn, he held to a high view of the church and its role in society even as he viewed the society as increasingly secular. The focus on religious and moral transformation remained, but the focus was understood in light of a more realistic view of human nature, a more paradoxical and ambiguous social situation, and a call for Christians to take with ultimate importance responsibility for proclaiming the Word of God. The fragmented character of society and the world, the depth of human alienation and brokenness, the press for conformity and patriotism, and the fears engendered by the cold war on the world stage and McCarthyism on the domestic stage—all were realities that *motive* took with utmost seriousness whether treated through the sobering power of Robert Hodgell's expressionism or the sharp-edged humor of Jim Crane's cartoons. Thus personal angst, social injustice, and the responsibility of the church received their due as Ortmayer's theology of paradox and responsibility defined the magazine's tone. In turn, the treatment of the arts focused more, though not exclusively, on "art of the fall" rather than on art of vision and spiritual growth.

Margaret Rigg joined the staff in 1955 as the arts editor. She made a good balance to Ortmayer, whose primary interest was drama. She expanded the treatment of the visual arts, presenting the works of particular artists. At times, she included well-established figures such as Peter Blume, Käthe Kollwitz, or Ben Shahn; at other times, she selected artists who received national recognition for the first time.

For both Ortmayer and Rigg, there was a keen appreciation for the power of the arts to raise religious questions. If society were becoming

12

more secular and the church's responsibility to speak to the culture more demanding, the arts were seen as a medium that revealed the religious questions people were asking and to which the church was being called to understand and respond. In this process, *motive's* art dealt extensively with crucifixion themes and human suffering and probed such subjects as angst, meaninglessness, guilt, and alienation. Certainly, the treatment reflected a highly Tillichian view of the human condition where the most powerful religious questions were identified as those of human suffering and brokenness, and other theologians who were treating similar themes, such as Tom Driver, Roger Hazelton, Nathan Scott, Robert Steele, and Stanley Romaine Hopper, were all writers in *motive.*

Jamieson Jones, the third editor, continued *motive's* focus on the social questions of the time. The magazine's treatment of the arts during this period reflected deeply the work of Rigg, who continued as art editor. With Jones, she was able to introduce in a limited way the use of color in the treatment of the visual arts and particularly so on the covers. If she and Ortmayer developed *motive's* identification with the visual arts in the mind of its public, then with Jones she developed a more aesthetically rich treatment of the arts that further deepened the publication's arts identification. The May 1959 issue, "Christianity and the Arts: Painting, Sculpture and Architecture," provides a good index of the role the arts played during *motive's* life. Opening with a quote from Harold Ehrensperger, "The communication of truth is the religious function of art," it makes a strong case for the importance, indeed, the necessity of the arts for the community of faith. The cover is graced by Rigg's work on the descent of the Holy Spirit into a troubled and cacophonous world.

The fourth editor, B. J. Stiles, launched the most complex, controversial, and fruitful period in the life of the publication, which were the years from 1961 to 1969. During this period, *motive* became a voice with which to be reckoned in the church, and a journal with a readership beyond the context of the university, campus ministry, and the church. In a real sense, *motive* joined league with a religious press that included *Christianity and Crisis, The Christian Century, The National Catholic Reporter,* and other intellectually important journals that were providing significant cultural analysis for their readers.

Against the background of the 1960s when crisis and change marked the culture, *motive* maintained its transformationist stance and particularly so with the arts. Stiles and Rigg gave the fullest treatment that had been given to the arts, and the artworks presented in the magazine reflected all three emphases, which I have referred to as "art of creation," "art of the fall," and "art of redemption." Furthermore they gave greater attention to the sweep of major art forms, with the regular inclusion of works on the visual arts, literary arts, dramatic arts, film, music, liturgical arts, and, to a lesser extent, dance.

The visual arts, however, were most extensively treated of all the arts. As features, as illustration, as subjects of analysis, as works of meditation, *motive* introduced to a primarily Protestant student body the power and significance of the visual arts to Christianity. From features on Byzantine art to avant-garde art, from international art to the folk art of Appalachia, *motive* worked with most forms, though it treated primarily "high" art and only in more limited fashion "popular" art. (This approach, one might add, was equally true in theological treatment of the arts in seminary and in the arts projects of the denominations.) Most significantly, it presented major features on such artists as Peter Blume, Edward Munch, Sr. Corita Kent, Leonard Baskin, Fritz Eichenberg, Jim McLean, Isutomu Yoshida, Orozco, Jacob Lawrence, Watanabe Sadeo, Robert Hodgell, Red Grooms, Mimi Gross, Ben Mahmoud, Ben Shawn, and Margaret Rigg. Three of the most dramatic covers were a full-color reproduction of Jacob Lawrence's *American Revolution 1963,* Sr. Corita Kent's recreation of a Camus statement on justice, and Rigg's *Resurrection.*

This more extended treatment of *motive* magazine as a major influence in the conversation provides important insights into the type of theological and relational contact with artists that was current during the period of 1950s through the early 1970s, and it highlights one of the major influences on the theology and arts dialogue that was taking shape during this period. In certain historical respects, *motive* was a central actor in the unfolding relationship of religion and the arts and, more particularly, theology and the arts.

～

THE 1970s TO THE PRESENT

If the influences of the 1950s into the 1970s created the first modern chapter in the history of the theological world's interest in the arts, there unfolds in the late 1970s down to the present another chapter that saw the rise of new institutional interests including, particularly, the development of programs in seminaries, the importance of foundations in supporting this work, and an increasing flow of scholarly writings, including the publication of new journals and magazines.

In this period a number of indicators of growing engagement with the arts became obvious. In seminaries, new religion and the arts programs began to emerge. Course offerings that focused on the arts began to increase in number even as the breadth of art forms treated expanded, with more faculty members including the arts as a part of their teaching; a new group of theologians emerged whose scholarly work appeared in the form of research papers, essays, and books and, it should be added, with a particular focus on the visual arts; a greater interest was given to the arts in national professional societies; foundation funds became more available for work with the arts; efforts at liturgical reform and renewal continued to emphasize the arts—particularly architecture and the liturgical arts; new arts such as the media arts and popular arts, along with folk and craft arts, began to receive more serious attention; and a range of religion and arts conferences and consultations took place (including the national consultation for which this essay was written, and from which this book came).

In the earlier decades, the interest in the visual arts was present, but the most dominant art forms were those of music, literature, and drama. In the 1970s, however, the visual arts were to receive their due by both Protestant and Roman Catholic scholars and institutions, and, while the writings on theology and art as a growing dialogue took place primarily in Roman Catholic and Protestant settings, the Orthodox tradition, with its much greater theological and spiritual integration of the visual arts and icon tradition of beauty and image, also entered the conversation in a fresh way, though less programmatically.[19] The Graduate Theological Union, with the Pacific School of Religion as its leading arts-related seminary, extended its work with the arts during the 1960s and 1970s and, during the early 1970s, when seminary work generally tended to slow,

it provided the most extensive graduate work available in this field. It has continued to do so under the leadership of Doug Adams. The presence and work of Jane Daggett Dillenberger and John Dillenberger at Pacific School of Religion gave further prominence to that program. The second institution during this period that contributed new and significant programming was Yale's religion and arts program developed by John Cook, with support from the Henry Luce Foundation, and the Yale Institute of Sacred Music and the Related Arts. These were the central seminary settings for the arts during this period.

There is an important chapter in theological education's treatment of the arts that emerges in the late 1970s and develops in the 1980s that speaks to the question of how significant the interest in the arts was for seminary curricula or, in different terms, how deep and rich the soil had become for theological writings, arts-related events, and special religion and arts programs. In 1984, the Lilly Endowment sponsored a conference at Candler School of Theology in Atlanta that was *led* by James L. Waits, Dean of Candler, who was an important voice in moving theological education to institutionalize its work with the arts and later was a major force behind the creation in 2003 of the Society for the Arts in Religious and Theological Studies. The conference featured two studies. The first was by John Dillenberger. His work would later be published as *A Theology of Artistic Sensibilities: The Visual Arts and the Church* (see note 2). The book became a major text for analyzing the role of the arts in the church and theological thought and called for the development of the church's artistic sensibilities. The second work presented at the conference was one that I wrote and that was later published under the title *The Arts in Theological Education.*[20] The study was an effort to discover what was happening in the curricula of seminaries. The research examined the work of eighty-nine seminaries out of 134 surveyed and reflected what was happening in the 1980s. There are four major conclusions that the research yielded that are of special significance in considering what theological education was doing during this period of the field's development and what type of foundation stones it was laying for the next chapter in the theology and arts undertaking. Most importantly, the study suggests what was happening inside the seminaries relative to the acceptance and integration of the arts in theological education.

The first conclusion of the Arts in Theological Education study was that there was a significant inclusion of the arts in theological education, which pointed to the beginning of a process of integration within the larger, theological curricula. The study proposed that "integration" of the arts within theological coursework:

> exists when the treatment of the arts is considered a necessary part of the tasks of constructing theology, interpreting faith and culture, and preparing persons for the practice of ministry—in effect, when the arts inform the theological curriculum in such an inclusive and necessary way that they become an essential part of theological education.[21]

That process of integration appears to have continued through the 1990s and into the present, if the overall response of theological schools to the arts through faculty writings, religion and arts programs, consultations, and random reviews of catalogue listings is an indicator.

A second conclusion was that there existed a range of art forms that were treated in scholarly work and in course offerings across theological education, with music and literature most common and the visual arts and drama next in importance. The study noted that drama had begun to lose the prominence it had enjoyed in the 1950s and 1960s. Other art forms such as liturgical dance, the fabric arts, photography, architecture, film, and the craft arts were becoming more important. Since that study, we have seen the visual arts, architecture, film, and video become more dominant in theological schools and theologians' writings as a review of catalogues and religion and arts publications suggests.[22]

Thirdly, the study gave us data regarding why and how the arts had been integrated. Drawing on statements from deans, presidents, and lead professors working with the arts, the study found that there were four primary reasons for including and integrating the arts in theological study. The arts could serve as a means for: understanding culture, communicating the Christian faith, enabling students' preparation for ministry, and shaping theological education as a whole. Eight more specific reasons for integration were extrapolated from these four rationales:

1. The arts are important to theology as sources in identifying and understanding the religious questions of human existence.

2. The arts are important as sources for understanding the spiritual character of a particular culture.

3. The arts are important as sources of prophetic judgment and protest against human injustice and idolatry.

4. The arts are important as documents and sources for understanding the nature of historical and contemporary faith.

5. The arts inform the process of creating theology.

6. The arts provide forms integral to liturgy and worship.

7. The arts provide essential means for communicating the meaning of the Christian faith to the church and to the world.

8. The arts can play essential roles in the professional and spiritual growth of students by helping them to develop their intuitive mode of knowing.

These reasons wind their own way through theological writings, conferences, and programs down to the present. There are different accents in recent writings and I would add here two that are subsumed under the above rationales but have emerged on their own as quite important to the current conversation:

9. The arts can serve as structures through which people encounter the presence of God. That is to say, the arts can serve as a means of grace.[23]

10. The arts pose to theology the need to explore certain fundamental questions that come out of theology's encounter with the arts, including those regarding the relationships between aesthetics and theology, aesthetic experience and religious experience, and beauty and holiness.[24]

The fourth major conclusion drawn from the study was that the foci of theological interest could be located under three rubrics. These are important when we look at arts-related activity in theological schools, for they serve as tools for helping identify where individual schools locate their work. Moreover, these foci form the general outline

for this book. Under each category, four essays are included that explore in depth one dimension within each rubric. These foci can be summarized in the following manner:[25]

Theoretical Focus. The arts are treated in light of their theoretical relationships to religion and theology with a particular concern for rules of interpretation, definitional questions, methodological issues, and/or specific links between the arts and theology. This focus leads us to raise questions about the relationship between the construction of theology and the making of art, and about the connection between aesthetic beauty and holiness.

Analytical Focus. The arts are treated as sources and documents in the historical and contemporary analysis of faith and culture. This focus explores how the art object of whatever medium can be insightful in the interpretation and understanding of religious faith, rituals, organization, and action.

Practical Focus. The arts are treated in terms of their roles in the practice of ministry and worship. This focus explores the role the artist can play in the church, and the role the church can play through a ministry to artists and the arts.

In the study, a primary set of schools that had or were developing programs in the arts were identified, including a number that had been a part of the history of this movement and others rather new to work in the field. I have noted the importance of Pacific School of Religion at the Graduate Theological Union and Yale Divinity School, but Christian Theological Seminary, Drew School of Theology, United Theological Seminary in the Twin Cities, and Union Theological Seminary in New York were also a part of that history and important in the continuing work of the field. In the 1990s, the number of schools increased with Wesley Theological Seminary, Andover Newton Theological School, Fuller Theological Seminary, and, more recently, St. John's University School of Theology in Collegeville, Minnesota, developing major programs.[26]

There was also a new body of scholarship that emerged. In addition to the works on theological aesthetics, which Frank Burch Brown notes

in his article in this volume, I want to note some major works, but this list is by no means exhaustive for the writings have been extensive. Doug Adams' work on sculpture, the body, dance, artistic form, and transcendence has been significant in furthering approaches to theological reflection on art. Adams' studies titled *The Art of Living: Aesthetic Values and the Quality of Life*[27] and *Transcendence with the Human Body in Art: George Segal, Stephen De Staebler, Jasper Johns, and Christo*[28] are two of his most significant works in this field, with a new work on sculpture forthcoming. James Luther Adams and Wilson Yates, in their collection of essays *The Grotesque in Art and Literature: Theological Reflections,* provide models for theologically interpreting the grotesque in the arts and the importance of the grotesque in religion and culture.[29] Earlier studies that focused on approaches to the analysis of art from a theological perspective included H. R. Rookmaaker's *Modern Art and the Death of a Culture;*[30] George Heyer's *Signs of Our Time;*[31] Jeremy Begbie's *Voicing Creation's Praise: Towards a Theology of the Arts*[32] and *Theology, Music, and Time;*[33] and William Dyrness' recent study *Visual Faith: Art, Theology, and Worship in Dialogue.*[34] These are important contributions to the task of interpretation. Also in the field of theology and music is the work of Brian Wren, *Praying Twice,* which sets forth a theological approach to the arts generally and music particularly,[35] and Don Saliers's study, *Worship as Theology: Foretaste of Glory Divine,* which is a broad introduction to the experience of worship and the arts.[36] *The Art of God Incarnate,* by Aidan Nichols, O.P., offers a study of theological approaches to understanding art and experience in relation to incarnation.[37] It is important to note Jane Dillenberger's study *Style and Content in Christian Art,* which was a groundbreaking work for those in theology seeking to understand how to approach the analysis of art.[38] Works that followed, including *Secular Art with Sacred Themes* and *The Hand and the Spirit,* which she wrote with Joshua Taylor, offer models for such analysis down through her study *The Religious Life of Andy Warhol*—a classic of interpretative method.[39] She drew on a significant art historical text, as have other theologians, which is a primary text in interpretation: Erwin Panofsky's *Meaning in the Visual Arts.*[40] Joshua Taylor's study *Learning to Look: A Handbook for the Visual Arts,* has also become a primary work in the interpretation of the visual image.[41]

Margaret Miles' significant work *Image as Insight* provided a theoretical framework for theological reflection that particularly drew on modern cultural criticism and history.[42] Alejandro R. García-Rivera's recent study, *A Wounded Innocence: Sketches for a Theology of Art,* offers an approach to theological interpretation in which he calls for the arts to be a major subject for theology.[43] Gregor Goethals published *The TV Ritual: Worship at the Video Altar,* which offered a theologian's approach to popular culture via television;[44] and David Morgan's work *Visual Piety: A History and Theory of Popular Religious Images* provided insight into the impact of popular religious images on faith.[45]

A number of writers focused on the importance of art, theology, and ethics, including an earlier work *Art and Morality* by R. W. Beardsmore,[46] Edward Farley's study *Faith and Beauty: A Theological Aesthetic,* which uses morality as a key rubric in his study though he is setting forth more broadly a religious aesthetic;[47] and Duane K. Friesen's *Artists, Citizens, Philosophers: Seeking the Peace of the City.*[48]

In the study of church history, Robin Jensen's important study, *Understanding Early Christian Art,* explores in the development of the early church and its theology the role of art in both reflecting and creating that theology.[49] Nathan Scott's study *Visions of Presence in Modern American Poetry* continued his work in theology and literature, offering a critique of cultural criticism in theological interpretation.[50]

There are many other studies that are entrances into theological conversation and method in approaching the arts. I want to highlight three. Deborah Haynes offers us an excellent study in *The Vocation of the Artist* and, in her new study, she offers us an autobiographical work that reflects on the spiritual dimensions of the artist's work in *Art Lessons: Meditations on the Creative Life.*[51] Karen Stone, in a recent work, *Image and Spirit,* offers a theological approach to the interpretation of the arts.[52] A number of writers have focused on imagination, aesthetics, and beauty, including Richard Viladesau in his important study *Theological Aesthetics: God in Imagination, Beauty, and Art,* and Frank Burch Brown in his works *Good Taste, Bad Taste, and Christian Taste: Aesthetics in Religious Life,* and *Religious Aesthetics: A Theological Making and Meaning.* Again, I refer to his essay in this volume to expand upon the bibliography in this subdiscipline.[53]

A second major source of scholarly and journalistic writings was that of new magazines and journals publishing in the field of religion and art. In 1988, *ARTS: The Arts in Religious and Theological Studies* began publication first as a sixteen-page newsletter and forum for brief essays and then, through its own evolution, it became a forty-eight page publication that served a small but influential group of subscribers and became the publication of the core group of theologians working in the field. Edited by Kimberly Vrudny and Wilson Yates, *ARTS* publishes articles under the general categories of theology and the arts "in the studio," "in the classroom," "in the study," and "in the sanctuary," along with book reviews and editorial commentaries.

In addition there were other significant publications including *Cross Currents, Faith and Form* and, later, *Christianity and the Arts, Christians and the Visual Arts* (CIVA publications), *Image, Journal of Religion and the Arts,* the Asian publication from Japan *Image, Christ and Art in Asia,* and the distinguished British publication *Art and Christianity Enquiry Bulletin,* edited by Tom Devonshire Jones. Each of these publications carved out its own special niche. *Christianity and the Arts* focused on the church and the arts, *Faith and Form* on church architecture, *Image* on literature and the visual arts, and *Image, Christ and Art in Asia* placed its emphasis on Asian Christian artists and their work.[54] There are also important studies that led to journal editions and books that deserve mention, for they are crucial documents in defining the field's work over these last few years. They include the Association of Theological Schools' journal *Theological Education: Sacred Imagination: The Arts and Theological Education,*[55] guest edited by Wilson Yates, which included work by Frank Burch Brown, Gordon Kaufman, Edward Farley, John W. Cook, Max Stackhouse, William Dyrness, Margaret Miles, Richard Hayes, Paul Westermeyer, and others. *Reluctant Partners: Art and Religion in Dialogue,* edited by Ena Giurescu Heller, included essays by Doug Adams, Robert L. Nelson, Ena Giurescu Heller, Marcus Burke, and Lindsay M. Koval, with an excellent bibliography by Koval.[56]

Outside financial support during this period was important. Various schools and publications received grants and gifts from donors to make possible both publications and religion and arts programs. In the 1980s,

the Lilly Endowment provided important grants, the Association of Theological Schools provided implementation grants, and individual donors supporting schools such as the Pacific School of Religion with its Center for the Arts, Religion, and Education (C.A.R.E.), proved greatly important for developing work with the arts in seminary settings. A large donor gift recently received by Fuller Theological Seminary will enable that school to develop its curriculum and programming in theology and the arts. A very recent Carpenter Foundation grant will enable *ARTS: The Arts in Religious and Theological Studies* to expand its readership. But the Henry Luce Foundation has proven to be the most important funding source, with its own efforts to create theological school centers for work with the arts. Schools directly impacted by these funds have included Andover Newton Theological School, the Graduate Theological Union, St. John's University School of Theology, United Theological Seminary of the Twin Cities, Union Theological Seminary, Vanderbilt Divinity School, and Wesley Theological Seminary. Other important grants were given by Luce to the American Bible Society, as well as to the Minneapolis Institute of Arts and United Theological Seminary of the Twin Cities to enable community-based, interfaith dialogue and work projects. John Cook, the president of the foundation, initiated this program. Michael Gilligan, the current president, continues it. In addition to funding institutions, Luce has funded book-length volumes, consultations, and programs in an effort to support development of the field. Perhaps Luce more than any other influence in theological education has supported a group of theological schools to test what is possible in this field by offering support for doing so and to help bring us to the next stage of work in this field.

Important during this period has been a range of consultations and conferences. One of the first was a consultation called to respond to two books that attempted to understand aspects of Christianity's relationship to the arts. The books were John Dillenberger's *A Theology of Aesthetic Sensibilities* and Wilson Yates' *The Arts in Theological Education*. There followed a number of events, including the four Yale Consultations on the arts led by John Cook, which treated music, literature, and the visual arts in separate conferences. (Papers from these consultations were published in *Theological Education,* referred to

above.) There were meetings of the international organization ACE: Art and Christianity Enquiry, which included a number of the theologians who were important to the developments in the United States. One of these conferences was held in Berkeley at the Pacific School of Religion and included a larger symposium that attracted over two hundred in attendance. A consultation was held at Wesley Theological Seminary on the arts in theological education and a later conference inaugurated their program in religion and the arts. Three consultations were held under the auspices of the American Bible Society that explored the interactions of disciplines and institutions in the work of religion and the arts. Finally, two national consultations and a session of ACE's international meeting created and hosted by United Theological Seminary of the Twin Cities led to the writing of the essays published in this book.

A final development that has affected the field has been the role of professional societies. Four such societies from the 1970s to the present have included the treatment of the arts in their sessions: the American Academy of Religion/the Society of Biblical Literature, the North American Academy of Liturgy, the College Art Association, and CIVA (Christians in the Visual Arts), which is a professional society of artists who hold a yearly conference on the artist and faith. Other organizations such as denominational organizations in worship and the arts are also important groups concerned with enhancing this field.

In 2003, a new society was created: SARTS, The Society for the Arts in Religious and Theological Studies. It meets immediately before the American Academy of Religion on a yearly basis and will be served by *ARTS: The Arts in Religious and Theological Studies,* which will function as a journal for use by the Society as well as the journal for the field as a whole. This is an important step, for it is the first effort to institutionalize an academic society whose sole purpose is to serve this field of inquiry. Developed by a committee that met over eight years, it has the promise of becoming a significant organization in the cause of this effort. It is with the creation of this society that history reaches into the present.

The history of the theology and arts engagement in the church and theological education is a rich one that this essay has only mined in a very cursory fashion. It is a complex history that developed along sev-

eral tracks at the same time. There were theologians and theological writings; arts events undertaken by the church, the Christian student movement, and seminaries; religion and arts programs created by a group of schools scattered across the country; publications that focused on the dialogue between theology and the arts; consultations and conferences that treated the subject; and the development of professional societies including the new Society for the Arts in Religious and Theological Studies. They were and are interwoven pieces of a fabric that holds together this new field of theology and the arts, offering coherence among its many pieces. There were important influences that launched the effort through such catalysts as the culture's own recognition of the arts, theologians and their interest in the cultural and theological significance of the arts, the church and the student movement's interest in the arts, financial and institutional support for this work, and important publications that provided a forum for the field. These influences gave rise to the scholarly and institutional work that has unfolded, and they continue to leave their impact. The legacy of the arts, theology, and the church has served the field well as it sits poised to impact the twenty-first century.

⁓

NOTES

1. The period of World War II into the 1950s is richly documented in art history as a major turning point in America for the arts. The most obvious new school of art to arise was abstract expressionism, with the work of de Kooning, Rothko, Pollock, Motherwell, Newman, and others. This was also the period of American artists like Georgia O'Keefe and Red Grooms, who were representational. In turn, the artistic dynamism had been fueled in part by the amazing energy of the Harlem Renaissance that flowed into the 1930s and with figures such as Romare Bearden and Jacob Lawrence into the 1940s and 1950s. This was also the time of Martha Graham and Merce Cunningham in dance, the great playwrights such as Arthur Miller, Lillian Hellman, and Tennessee Williams in drama, and novelists including the Southern Renaissance writers such as William Faulkner, John Crow Ransome, Allen Tate, Robert Penn Warren, Eudora Welty, and Margaret Walker. The period was truly the golden age of the arts as the arts came of age.

2. For Paul Tillich, see Paul Tillich, *On Art and Architecture,* ed. John Dillenberger and Jane Daggett Dillenberger (New York: Crossroad, 1989). Amos

Wilder's leading work on the arts of this period was *Theopoetic: Theology and the Religious Imagination* (Philadelphia: Fortress Press, 1976). See also Jacque Maritain, *Creative Intuition in Art and Poetry* (New York: Pantheon Books, 1953); Nicholas Berdyaev, *The Meaning of the Creative Act* (New York: Harper, 1955); Nathan A. Scott, *The New Orpheus: Essays Toward a Christian Poetic* (New York: Sheed and Ward, 1964) and *Center of the Spirit: Studies in the Modern Novel* (Baltimore: Johns Hopkins, 1968); *Roger Hazelton, A Theological Approach to Art* (Nashville: Abingdon Press, 1967); Walter Ong, S.J., *Evolution, Myth, and Poetic Vision* (New York: Macmillan, 1968); and James Luther Adams, *The Prophethood of All Believers,* ed. George Beach (Boston: Beacon Press, 1986) and *On Being Human Religiously,* ed. Max L. Stackhouse (Boston: Beacon Press, 1976). Both of James Luther Adams' volumes include essays by Adams on the arts. See also Wilson Yates, "Homage to JLA: A Theologian and His Love of the Arts," *ARTS: The Arts in Religious and Theological Studies* 6/3 (Summer 1994): 1–3, and James Luther Adams and Wilson Yates, eds., "Preface" and "An Introduction to the Grotesque," *The Grotesque in Art and Literature: Theological Reflections* (Grand Rapids: Wm. B. Eerdmans, 1997), xi–xv; 1–68. For a study of Tillich, Maritain, and Berdyaev, see David Harned, *Theology and the Arts* (Philadelphia: Westminster Press, 1966). Jane Daggett Dillenberger made significant contributions to the development of this field in the 1960s. Her books reflected the interdisciplinary mind of one who could work in art history, in which she was trained, and theology. See note 39. John Dillenberger, a major church historian and theologian, turned to theology and the arts with major essays and books, including *Images and Relics: Theological Perceptions and Visual Images in Sixteenth-Century Europe* (New York: Oxford University Press, 1999); *The Visual Arts and Christianity in America* (Chico, Calif.: Scholar's Press, 1984); and *A Theology of Artistic Sensibilities: The Visual Arts and the Church* (New York: Crossroad, 1986). No two figures span this fifty-year period more than they do, nor have others had greater impact on this field.

3. See Wilson Yates, "Chapter 1: How Extensively the Arts Are Treated: A Profile," *The Arts in Theological Education* (Atlanta: Scholars Press, 1987), 1–41, for a discussion of these art-related events that were important to the emergence of dialogue in theology and the arts.

4. Paul Tillich, *The Protestant Era,* edited with an introduction by James Luther Adams (Chicago: University of Chicago Press, 1948).

5. Yates, "Homage to JLA," 1–3.

6. Hazelton, *A Theological Approach to Art.*

7. Harold Ehrensperger, *Religious Drama: Ends and Means* (New York: Abingdon Press, 1962).

8. Tom Driver taught at Union Seminary in New York and wrote extensively in the area of drama for such publications as *motive* magazine and *The Christian Century,* as well as for *The Reporter Magazine,* where he was the drama critic.

9. Wilder, *Theopoetic.*

10. Nathan A. Scott was a prolific writer on theology, literature, and poetry at the University of Chicago Divinity School. His 1964 study *The New Orpheus: Essays Toward a Christian Poetic* was followed by a series of books that dealt with major novelists, playwrights, and poets. Scott was, in many respects, the father of the theology and literature area of study. See *Rehearsals of Decomposure* (New York: Columbia University Press, 1952).

11. *The Journal of Ecumenical Study* 32/4 (Fall 1995) devoted an entire issue to "Student Christian Ministries and Issues," which documents the work of the Christian Student Movement and the events that played into its relationship to liturgical reform, politics, war, peace, race, and the arts.

12. Wilson Yates, "*motive* magazine, the Student Movement, and the Arts" in *The Journal of Ecumenical Studies,* 32/4 (Fall 1995). The discussion of *motive* magazine in this current chapter draws on the findings of the journal article, which is an extended discussion of *motive's* contribution to the student movement. See also Frank L. Dent, "*motive* magazine: Advocating the Arts in the Life of the Church" in *ARTS: The Arts in Religious and Theological Studies,* 1/3 (Summer 1989), and B. J. Stiles, "Motive Editorial, May 1969," ibid.

13. Betty H. Meyer, *The ARC Story: A Narrative Account of the Society for the Arts, Religion, and Contemporary Culture* (New York: ARC, 2003).

14. See Susan White's excellent study of the influence of liturgical renewal on Christian liturgical reform in Susan White, *Art, Architecture, and Liturgical Reform: the Liturgical Arts Society (1928–1972)* (New York: Pueblo Publishers, 1990).

15. *motive* magazine, 1941–1967, was a monthly publication published by the Department of Higher Education of the Methodist Church, Nashville.

16. Yates, "Homage to JLA," 1–3.

17. Tolstoy, *What is Art?: And Essays on Art* (London, New York: Oxford University Press, 1932).

18. Ehrensperger, *Religious Drama.*

19. Eastern Orthodoxy has since its beginning had a profound spirituality that integrated and depended on the visual image as icon for its devotion and experience of God. It has had what the western church has not had: a carefully worked-out theology of the icon and of beauty. For contemporary works that spell out the Orthodox understanding of the relationship between faith and art and theology and art, see Leonid Oesspensky and Vladimir Lossky, *The Meaning of the Icon* (New York: St. Vladimir Press, 1983); John Baggley, *Doors of Perception* (New York: St. Vladimir Press, 1988); and Genesadios Limouris, *Icons: Windows of Eternity* (Geneva: World Council of Churches Publication 147, 1990).

20. Yates, *The Arts in Theological Education.* This empirical study explored the state of the arts in theological education and the relationship of the arts to theological study with models for interpreting the arts theologically.

21. Ibid., 6.

22. Ibid., 6–7.

23. Articles in the journal *ARTS: The Arts in Religious and Theological Studies* have treated the visual arts, architecture, drama, dance, and music for the last fifteen years in terms of their power as means for encountering God.

24. See Frank Burch Brown, *Religious Aesthetics: A Theological Study of Making and Meaning* (Princeton, N.J.: Princeton University Press, 1989); and James Alfred Martin Jr., *Beauty and Holiness: The Dialogue Between Aesthetics and Religion* (Princeton, N.J.: Princeton University Press, 1990) for two studies that explore this rationale. See also Frank Burch Brown, *Good Taste, Bad Taste, and Christian Taste: Aesthetics in Religious Life* (New York: Oxford University Press, 2000).

25. Yates, *The Arts in Theological Education,* 152–54.

26. See the journal *ARTS: The Arts in Religious and Theological Studies* for articles written about newer programs at Wesley Theological Seminary and Andover Newton Theological School. Forthcoming issues of *ARTS* will have articles on Fuller Theological Seminary and St. John's University School of Theology.

27. Doug Adams, *The Art of Living: Aesthetic Values and the Quality of Life* (Bellingham, Wash.: Western Washington University Press, 1980).

28. Doug Adams, *Transcendence with the Human Body in Art: George Segal, Stephen De Staebler, Jasper Johns, and Christo* (New York: Crossroad, 1991).

29. James Luther Adams and Wilson Yates, eds., *The Grotesque in Art and Literature: Theological Reflections* (Grand Rapids: Wm. B. Eerdmans, 1997).

30. H. R. Rookmaaker, *Modern Art and the Death of a Culture* (Downer's Grove, Ill.: Inter-Varsity Press, 1970).

31. George Heyer, *Signs of Our Time* (Grand Rapids: Wm. B. Eerdmans, 1980).

32. Jeremy Begbie, *Voicing Creation's Praise: Towards a Theology of the Arts* (Edinburgh, Scotland: T & T Clark, 1991).

33. Jeremy Begbie, *Theology, Music, and Time* (New York: Cambridge University Press, 2000).

34. William Dyrness, *Visual Faith: Art, Theology, and Worship in Dialogue* (Grand Rapids, Mich.: Baker Academic, 2001).

35. Brian Wren, *Praying Twice: The Music and Words of Congregational Song* (Louisville: Westminster John Knox Press, 2000).

36. Don Saliers, *Worship as Theology: Foretaste of Glory Divine* (Nashville: Abingdon Press, 1994).

37. Aidan Nichols, O.P., *The Art of God Incarnate: Theology and Image in Christian Tradition* (New York: Paulist Press, 1980).

38. Jane Dillenberger, *Style and Content in Christian Art* (New York: Crossroad, 1965, 1986).

39. Jane Dillenberger, *The Religious Life of Andy Warhol* (New York: Continuum, 1998). See also *Secular Art with Sacred Themes* (Nashville: Abingdon Press, 1969); and, with Joshua Taylor, *The Hand and the Spirit: Religious Art in America, 1700–1900* (Berkeley: University Art Museum, 1972).

40. Erwin Panofsky, *Meaning in the Visual Arts: Papers in and on Art History* (Garden City, N.Y.: Doubleday, 1955).

41. Joshua Taylor, *Learning to Look: A Handbook for the Visual Arts* (Chicago: University of Chicago Press, 1957, 1981).

42. Margaret R. Miles, *Image as Insight: Visual Understanding in Western Christianity and Secular Culture* (Boston: Beacon Press, 1985).

43. Alejandro R. García-Rivera, *A Wounded Innocence: Sketches for a Theology of Art* (Collegeville, Minn.: Liturgical Press, 2003).

44. Gregor Goethals, *The TV Ritual: Worship at the Video Altar* (Boston: Beacon Press, 1981).

45. David Morgan, *Visual Piety: A History and Theory of Popular Religious Images* (Berkeley: University of California Press, 1998).

46. R. W. Beardsmore, *Art and Morality* (London: Macmillan, 1971).

47. Edward Farley, *Faith and Beauty: A Theological Aesthetic* (Burlington, Vt.: Ashgate, 2001).

48. Duane K. Friesen, *Artists, Citizens, Philosophers: Seeking the Peace of the City: An Anabaptist Theology of Culture* (Scottsdale, Pa.: Herald Press, 2000).

49. Robin Jensen, *Understanding Early Christian Art* (London, New York: Routledge, 2000).

50. Nathan A. Scott, *Visions of Presence in Modern American Poetry* (Baltimore: Johns Hopkins University Press, 1993).

51. Deborah Haynes, *The Vocation of the Artist* (Cambridge, New York: Cambridge University Press, 1997) and *Art Lessons: Meditations on the Creative Life* (Boulder, Colo.: Westview Press, 2003).

52. Karen Stone, *Image and Spirit: Finding Meaning in Visual Art* (Minneapolis: Augsburg Books, 2003).

53. Burch Brown, *Religious Aesthetics* and *Good Taste, Bad Taste, and Christian Taste.*

54. Major publications that have been developed since this 1987 study have included *ARTS: The Arts in Religious and Theological Studies, Image, Religion and the Arts, Christianity and the Arts,* and theology and the arts literature has increased markedly. See my comments below and Frank Burch Brown's essay in this volume.

55. See *Theological Education: Sacred Imagination: The Arts and Theological Education* XXXI/1 (Autumn 1994), guest edited by Wilson Yates.

56. Ena Giurescu Heller, ed., *Reluctant Partners: Art and Religion in Dialogue* (New York: The Gallery of the American Bible Society, 2004).

How Important Are the Arts, Theologically?

FRANK BURCH BROWN

ARTS: THE QUESTION

My title refers to art's importance to theology, but I am really interested in more than theology. As a shorthand way of designating that larger interest, I have decided to use the acronym ARTS. In the periodical *ARTS*—as also in the new Society for the Arts in Religious and Theological Studies called SARTS—the letters A-R-T-S stand for "Arts in Religious and Theological Studies." In the present context, "A" will continue to stand for "Arts." The letters "R-T-S," however, will now stand for "Religion," "Theology," and "Spirituality"—the cluster of phenomena that, for the sake of simplicity, I will also sometimes refer to as "religion." By the acronym "ARTS," therefore, I will be referring to the overall connection between the arts and religion/theology/spirituality.

What I am calling the ARTS question comes in two parts. The first part has to do with *how* these things get together: arts (on one side) and religion/theology/spirituality (on the other). The second part of the question has to do with what *importance* to ascribe to that togetherness when it occurs.

As someone who works in the often-daunting field of religious and theological aesthetics, I am acutely aware that such abstract questions have a limited appeal to most of the world. I want to suggest at the outset, however, that the ARTS question (in either of its forms) is not just theoretical. It comes up, for instance, whenever a school administrator wonders why a member of the faculty wants to offer a whole course, a whole curriculum, or a whole degree, in some area of religion and the arts. If we cannot explain how art gets together with religion, and why that is important for religion as well as for art, then we are in trouble. Again, the ARTS question is at work in worshiping communities whenever they splinter or incinerate themselves over matters of musical style, one side accusing the other of religious infidelity while facing, itself, the accusation of bad taste or even irreverence. If we cannot figure out how music in general, or a certain kind of music in particular, is important to worship and liturgy, we are again in trouble.

It is also the case that the ARTS question comes up in various guises among practicing artists. One cannot read Robert Wuthnow's recent sociological study *Creative Spirituality: The Way of the Artist*[1] or Deborah Haynes's *The Vocation of the Artist*[2] without realizing that, even in our supposedly secular, postmodern time, many approaches to artistry are spiritually and theologically active. But what that activity entails, and how much it matters—all this is usually far from obvious even to the artist. And in a time when some of us hope to see artists and religious communities mutually engaged and better supported, we will not bring that about without some better understanding of how genuinely creative artistry can possibly fit with the good of communities and the aims of worship as currently practiced. Likewise, theologians and liturgists often need a better understanding of how worship itself can be artful, and needs to be.

⌢

"A" AND "RTS" TOGETHER

I want to start with the first part of the ARTS question—the question of how art gets together with religion, and vice versa. It may seem obvious that the arts and aesthetic imagination draw in meaningful ways on the realm of religion, theology, and spirituality, broadly considered, and that religion itself has important artistic and aesthetic dimensions. But that is often easier to see in terms of history than in terms of present activity. And even when we are thinking historically, the sheer abundance of religious art and music can easily cause us to forget that every religious community, historically speaking, has forbidden or discouraged certain (sometimes most) kinds of art and artistry even while encouraging others. For centuries, Calvinist Christians, for instance, restricted their hymnody to the unaccompanied singing of metrical psalms. It was not long ago that the Catholic Church still held the official position that the piano is an inherently secular instrument inadmissible in worship settings. Those standards have obviously changed. But no religious community can afford to accept uncritically every sort of artistic or musical offering. A group's religious identity, after all, is shaped by that to which it says "no," and not only by that to which it says "yes." Often the rejection of certain kinds of art and music symbolizes a larger sense of the character of true devotion, as in the usual exclusion of music from Islamic prayer services. The chanting of the Qur'an is intended to be beautiful but not, strictly speaking, musical.

At the same time, it must be said that, when it comes to scholarship regarding religion, there appears to be a growing sense today that art and artistry can and do form a significant part of what the study of religion (and the practice, too) needs to entail. While the Romantics and Victorians certainly attended in various ways to what one might call the aesthetics of religion, and the religion of aesthetics, relatively little of this carried over to the serious study and teaching of religion. In the modern academy, this sense of inner connection and overlap between art and religion has often been remarkably attenuated. It is little short of astonishing to recall that as recently as 1989 the distinguished philosopher of religion John Hick could write a four-hundred-page book, *An Interpretation of Religion: Human Responses to the Transcendent,* and in that book could devote exactly one page to art (including ritual art)

and to what he called "aesthetic meaning."[3] Never once in discussing Hinduism did Hick refer to temples or music or dance, or even to images and the act of *darsan*—the act of seeing and being seen by the deity as imaged. Never once in discussing Buddhism did he mention stupas or the sculptural groups of hundreds—sometimes thousands—of Buddhas and Bodhisattvas so important in the Mahayana and Vajrayana traditions. To be sure, Hick was writing philosophy of religion. But his whole idea of the nature and character of religion was built on a model that gave extremely short shrift to a whole realm of imaginative religious experience and material/sensory activity. Similarly, it is amazing, in retrospect, to realize that for a very long time, and perhaps even now, one could be a specialist in the history of Christianity and give little attention to Christian visual and material culture, to church architecture and church music—as though these were essentially extrinsic or peripheral to the forms and formations of faith. And how often, in churches and other religious institutions, has the occasional discussion of hymnody or of the music of Bach or Handel turned into reflection mainly on the texts that the composers set to music, not on how the music interprets the texts or takes on a religious meaning of its own?

The unwarranted privileging of intellectual and textual materials has not disappeared, by any means—as Vasudha Narayanan points out in her 2002 presidential address to the American Academy of Religion.[4] Yet it seems clear that the majority of our colleagues and students today are prepared, often even eager, to recognize that the arts have something vital to do with religion—not merely as pleasant ornamentation or warm-up exercises—and that the realm of religion/theology/spirituality has many and varied connections with what we have come to call the arts and aesthetic imagination. Biblical scholars, for instance, are not afraid these days to develop genuinely literary theories and approaches to scripture, recognizing that the Bible really is literary to a significant extent, and that its being literary is one of its primary ways of being religious. The literary medium is part of the scriptural message. That thought was already put forth in the nineteenth century, and can be traced all the way back to Augustine, if not before, but it appears to have been taken seriously only in the late twentieth century.

If I am right in conjecturing that we do not have to struggle quite so hard these days to make this basic ARTS argument among artists, religious folks, or theologians, then we have experienced a significant change. It does not mean, however, that our colleagues are necessarily prepared in their own work to engage the artistic aspects of religion. Even now, few have been trained to do that, even when they are so inclined. Neither does it mean that in practice we have fulfilled the promise that was glimpsed some time ago in Wilson Yates's well-known study of the potentially integral role of the arts in theological education.[5] Nor can we say that we have fully entered the promised land that was spied over a decade ago in the many seminars on theology and the arts sponsored under the leadership of John Cook and the Yale Institute of Sacred Music.

But the change is real. And it has been in part a change in our very understanding of what we understand arts, and religion itself, to be about. During the heyday of modernism, there is no doubt that formalism and aesthetic purism left little room for what I am calling the ARTS principle. To be sure, even secular intellectuals acknowledged that art could get carried away into religion, and vice versa. Art could be *used* by religion, it was said. Indeed, a lot of Romantic poetry and art was seen to be "spilt religion." Moreover, ever since the rise of Romanticism, people such as the critic Clive Bell were happy to *substitute* art for religion. Aesthetic modernists, moreover, sometimes sounded surprisingly like Romantic theologians and religious thinkers such as Friedrich Schleiermacher and Rudolf Otto, who pointed out *parallels* or *analogies* between aesthetic and religious experience: between beauty and holiness or between the holy and the sublime.[6] Besides that, for much of the modern era, many artists, writers, and musicians continued to produce work that the discerning and theologically minded critic could discover to be somehow religious or at least spiritual, an expression of mystical sentiment or of ultimate concern. Such art and its critical analysis has always, in fact, been pivotal to the modern study of religion and the arts.

Nevertheless, the predominant assumption in *modern* (as opposed to *postmodern*) aesthetics and criticism was that, if one wanted to get at what was truly artistic and aesthetic about a work of art or music or

literature, one needed to bracket, or at least render inert, the actively re-
ligious stuff—much in the way museums once thought they needed to
ignore or bracket out the ritual uses of tribal masks when displaying
them for artistic admiration. In the end one might be left with a hint of
religious or mystical feeling; but that feeling was now safely aestheti-
cized. It was typically kept distant from religious commitments or ac-
tual worship, or indeed from any serious engagement with religious
ideas or rituals themselves. To point this out is not to deny that the el-
evation and isolation of aesthetics and art had value. For one thing, it
had the great merit of stifling the perennial temptation to reduce art to
morality or religion or social engineering. But eventually it meant that
both aesthetics and the arts were in danger of dying from lack of cul-
tural, moral, and spiritual oxygen.

Happily, as I say, we have set aside much of that modernist ten-
dency to isolate art artificially and aesthetically. In the 1970s and early
1980s, just about the time that books and articles were coming forth to
pronounce the death of aesthetics, and possibly even the death of art
(once again!), one could witness the beginnings of a recovery of the re-
alization that, after all, a spiritually and socially deprived art is not nec-
essarily *more* satisfying, aesthetically, and is often *less* satisfying.

Thus one can witness today, in the sphere of so-called classical
music for instance, a whole audience and industry attentive in some
fashion to music's religious, theological, and spiritual aspects. We can
again hear a large body of "serious" music in which the "A" is con-
necting again with the "RTS." It is not just for the early music or
baroque crowd, either. The earlier, modernist musical scene was un-
comfortable trying to accommodate (and often refused to discuss) the
ritualistic religiosity of Igor Stravinsky's *Symphony of Psalms* and the
Catholic (albeit eccentric) mysticism of Olivier Messiaen's *Quartet for
the End of Time,* and perhaps even the urgent pacifism of Benjamin
Britten's *War Requiem.* By contrast, we now have a great quantity (if
not always great quality) of explicitly spiritual or indeed sometimes
downright theological music. One thinks of compositions from Arvo
Pärt, John Tavener, Sophia Gubaidulina, James MacMillan, Christopher
Rouse, John Harbison, the late Arnold Schnittke, John Adams—to
name just a few. In response to a September 11 commemorative com-

mission from the New York Philharmonic, for example, John Adams composed a thirty-minute work entitled *On the Transmigration of Souls,* which was awarded a Pulitzer Prize. Like many of his works, it evokes at its very core some sense of transcendence, however evasive and elusive. Then there is Osvaldo Golijov's *St. Mark Passion,* from the year 2000, which has received high acclaim for convincingly blending South American, Cuban, Jewish, and Western European traditions in a powerful rendering of the passion narrative from the Gospel of Mark. Nor has popular music lacked for religious themes, from Jewel's spiritual album to James Taylor's *Hourglass* to Bruce Springsteen's *The Rising*—not to mention the huge and increasing commercial success of contemporary Christian music.

In visual arts, we appear to be paying more attention these days to what is sometimes called material Christianity, and to the vernacular and mass-produced religious arts studied so perceptively by scholars such as David Morgan and Colleen McDannell.[7] Quite obviously a change has happened in the visual art world and in what Nicholas Wolterstorff calls the "institution of high art." The intentional religious or spiritual mining and marketing of art by museums appears to have become a major enterprise. One thinks not only of earlier exhibits such as *The Spiritual in Art: Abstract Painting 1890–1985,* at the Los Angeles County Museum of Art, but also of the exceedingly popular millennium show *Seeing Salvation* at the National Gallery in London. Again, with the issues of ecospirituality so alive today, it cannot be merely an antiquarian or narrowly aesthetic interest that, in 2002, motivates a museum such as the Minneapolis Institute of Art to mount an exhibit called *American Sublime.* Many of those nineteenth-century landscape painters, we see, had no doubt that nature was somehow revelatory of the divine—nature constituting a second book of scripture, as it were. They thought that, by painting nature, and viewing nature as painted, one could have access to nature's sacred character, thereby interpreting it devotedly and devoutly. That notion is getting a new lease on life in "green theologies" of our time. Indeed, for a subsequent generation, the photography of Ansel Adams and Eliot Porter has appealed in a somewhat tougher way to some of the same interests or sentiments. And speaking of sentiments, one notes, albeit with some hesitation, that

the "great mall artist" Thomas Kinkade depicts nature rapturously glorified, and sometimes awfully prettified.

What I have been suggesting, then, is that, during the peak of modernism, when aesthetic formalism and artistic purism reigned, it was often a major task for religiously or theologically minded critics and historians just to show that the arts could have a notable religious dimension precisely as art, not as something incidental to their value as art. Making that case was long a major concern of scholarship associated with members of the American Academy of Religion and its Arts, Literature and Religion section—scholarship often relying on Paul Tillich or Martin Heidegger as a resource. During the middle to late decades of the twentieth century, it was a major accomplishment just to bring art and religion back into the same conversation, and it often meant looking for hidden connections. It is not surprising that such work tended to focus on discerning religious meaning or ultimate concern in apparently secular art, and on matters of form and style as mediators of religious significance. This was a way of putting the "A" back into contact with the "RTS." Theologically, it often meant correlating artistic cultural questions with theological answers, in a Tillichian fashion. More recently, it entailed interrogating theology itself from an artistic or critical perspective, as in the deconstructive work of Mark C. Taylor and Jacques Derrida. In any case, in the last decades of the twentieth century, a major shift occurred in approaches to art and to the aesthetic dimensions of religion itself, making it easier than in the heyday of modernism to see how it is in the interests of both "A" and "RTS" that we discern their connectedness even as we see tensions or ruptures.

Positing a genuine and integral ARTS connection generates, however, further stages in the line of questioning, one of which is this: When things come together to create ARTS—art seen in relation to religion, theology, spirituality—what does that add up to? What does ARTS spell, or has it merely cast a spell? In other words: just how important is the allegedly integral connection of religion, theology, spirituality to art itself, or of art to theology? More skeptically put, is there even enough coherence to the very notions "art" and "religion" to warrant pursuing such questions in this form? In the remaining sections of this paper, I will sketch a response from the perspective of religious and theological aesthetics.

ARTS—A RELIGIOUS AESTHETICS PERSPECTIVE

In the past few decades or so, one of the notable developments when it comes to ARTS has been the rise—or revival—of religious and theological aesthetics. That was never much of a prospect in an era of aesthetic formalism and purism, although there were hints of theological aesthetics in books devoted to one kind of art or another—for example, Nathan A. Scott Jr.'s edited volume called *The New Orpheus: Essays Toward a Christian Poetic,* which came out in 1964.[8] But even Scott could be found struggling, at that point, with what was called the New Criticism and its emphasis on the autonomy and self-referentiality of works of art and literature. As that way of thinking about art eroded, so did the number of books in religious or theological aesthetics.

There had already been various, isolated studies in the theological interpretation of the arts generally, even in an era of modernist aesthetics. In the mid-twentieth century, for instance, there was Roger Hazelton's modest but suggestive little book *A Theological Approach to Art,* published in 1967.[9] But the foremost study in religious aesthetics available in English had doubtless been Gerardus van der Leeuw's *Sacred and Profane Beauty: The Holy in Art,* first published in translation in 1963.[10] It stood pretty much as *sui generis.* By the 1970s, things began to change. In 1972, William Dean published a book called *Coming To: A Theology of Beauty,* which was written from a process theology perspective.[11] In 1978, John Dixon published *Art and the Theological Imagination.*[12] Then, in 1980, the philosopher Nicholas Wolterstorff published his influential *Art in Action: Toward a Christian Aesthetic.*[13] A similarly Calvinist Christian perspective, though more narrowly circumscribed, appeared at the same time in Calvin Seerveld's *Rainbows for the Fallen World: Aesthetic Life and Artistic Task.*[14] Likewise in that same year, Samuel Laeuchli presented us with a provocative, highly unorthodox book called *Religion and Art in Conflict*[15] and Aiden Nichols produced an illuminating study entitled *The Art of God Incarnate,* which brought Eastern Orthodox ideas into a Western Christian and Roman Catholic context.[16] Not long after, John Dillenberger gave us *A Theology of Artistic Sensibilities* (1986),[17] which focused on visual arts but made a larger appeal for a theology of "wider sensibilities." And just a few years after that, Jeremy Begbie published *Voicing*

Creation's Praise: Towards a Theology of the Arts (1991), attentive to Calvinist aesthetics in particular.[18] That was roughly the same time at which I published *Religious Aesthetics: A Theological Study of Making and Meaning* (1989, 1990), which endeavored to provide a philosophical theological grounding for the field of religious aesthetics.[19]

By then we were all becoming more aware of, even if somewhat baffled by, the multivolume theological aesthetics of the Swiss Roman Catholic Hans Urs von Balthasar, called *Herrlichkeit, or The Glory of the Lord,* which was slowly being translated into English.[20] Partly under that influence, Patrick Sherry wrote *Spirit and Beauty: An Introduction to Theological Aesthetics* in 1992.[21] On the more philosophical side, James Alfred Martin Jr., offered his survey *Beauty and Holiness: The Dialogue Between Aesthetics and Religion* (1990).[22] Shortly thereafter, in a more popular vein, came Richard Harries' *Art and the Beauty of God* (1993).[23] Then, in 1999, Richard Viladesau published a comprehensive study entitled *Theological Aesthetics: God in Imagination, Beauty, and Art.*[24] The same year saw the appearance of Alejandro García-Rivera's *The Community of the Beautiful: A Theological Aesthetics,* written from a multicultural, Pan-American perspective.[25] In the year 2000, I published a theological study in aesthetics with a large component of practical theology to go along with the theory. It was called, somewhat mischievously, *Good Taste, Bad Taste, and Christian Taste: Aesthetics in Religious Life.*[26] The next year Edward Farley gave us a brief but deeply thoughtful study entitled *Faith and Beauty: A Theological Aesthetic* (2001).[27] That was accompanied by John de Gruchy's book from the same year, *Christianity, Art and Transformation: Theological Aesthetics in the Struggle for Justice,* which, along with recent work by such theologians as Dorothée Solle, secured the link between aesthetics and ethics, and specifically a link to theologies of liberation.[28] Aesthetics has also emerged as a major concern of the movement called Radical Orthodoxy, as evident in lectures from John Milbank, Graham Ward, and Edith Wyschogrod published as *Theological Perspectives on God and Beauty.*[29]

Nor is that all. We might mention two short books recently published by John Navone: *Toward a Theology of Beauty*[30] and *Enjoying God's Beauty.*[31] In a very different vein, William Dyrness has recently

gone far toward opening up and re-forming Calvinist and evangelical theology in an artistic and aesthetic mode.[32] One detects considerable affinity between that study and Anthony Monti's *A Natural Theology of the Arts.*[33] One could also expand the list to include books in liturgical theology that have a strongly aesthetic emphasis, including Albert Rouet's *Liturgy and the Arts*[34] and Don Saliers's *Worship as Theology: Foretaste of Glory Divine.*[35]

We could go on. Any point at which these citations would cease would be rather arbitrary. Even without my attempting to describe such studies as these in any detail, my main point should be evident by now: the alleged death of aesthetics in the mid- to late-twentieth century actually resulted in the dissemination and growth of many varieties of aesthetics, and in a genuine burgeoning of the whole field of religious and theological aesthetics, which shows no signs of letting up in the early years of the twenty-first century. Nothing of the sort would have occurred without some freshly awakened sense of the ARTS connection, to which aesthetics has been making its own contribution.

THE IMPORTANCE OF ARTS

How, then, does this growth in theological aesthetics illumine the second part of the ARTS question I have been posing—namely, the question of the relative *importance* of the connections that exist between art and religion/theology/spirituality: between "A" and "RTS"? We may find that aspects of the answer are a bit sobering.

In the first place, it is striking that a large number of these studies in religious aesthetics leave the arts on the outer periphery of the discussion. Aesthetics, as Richard Viladesau points out, concerns three spheres: imagination, beauty, and art. Even if we include sublimity on that short list—or perhaps also take in the grotesque, in deference to the book on that topic edited by James Luther Adams and Wilson Yates[36]—it is clear that one could talk a long time about aesthetics (that is, about religious imagination, beauty, sublimity, and so forth) and still not be talking about art as we have come to think of it. That is particularly true if one is convinced (with many theologians in the past) that the highest beauty is invisible and that the highest music is intellectual and thus inaudible. In that case, with so much of the Christian tradition from

Augustine on, one might want to ascend as soon as possible from a concern for artistry, which appeals so to the senses and which so encourages unbridled and often playful imagination—and from the arts go quickly upward toward abstract truth or mystic bliss. Art would then be seen as elementary, and artistry viewed as a spiritual path mainly for beginners. Such assumptions have pervaded much earlier theology, and the bias persists to this day, cropping up even in the writings of Thomas Merton—although in his case encouraged by Buddhist modes of meditation that want to ascend eventually beyond sense and image.

That fact helps explain the relative neglect of art in earlier Christian discussions of beauty. With enough effort, as in the case of Abbot Suger's admiration for his beloved Gothic abbey church of St. Denis, one could usually justify the need for bright and beautiful forms, especially for the laity. But those things would not inspire theologians more generally. Even Thomas Aquinas, who treats beauty as a divine attribute and (at least implicitly) as one of the transcendentals—along with truth, goodness, and unity—does not dwell on the need for cathedrals.

But a certain distrust of the senses and of the delights of artistic imagination certainly does not explain why a modern Catholic theologian such as Hans Urs von Balthasar, in seven volumes of theological aesthetics, chooses to discuss only three artists at any length: Dante, St. John of the Cross, and Gerard Manley Hopkins, or why he discusses art itself only intermittently, in volumes 2 and 5. Nor does it explain why Patrick Sherry in *Spirit and Beauty* talks mostly about the Holy Spirit and the beauty of God, making almost no reference to nature or to art. It does not account for why, still more recently, Alejandro García-Rivera treats the arts only illustratively in *The Community of the Beautiful*, even while taking an affirmative view of embodiment and imagination.[37] And we are left somewhat puzzled as to why Edward Farley, in his new book on theological aesthetics, studiously attends to beauty without straying far off into the arts. Like Jonathan Edwards, whom he takes as a beacon of light in the realm of theological aesthetics, Farley is much absorbed by the ethical dimension of beauty, the beauty of morality itself, and he celebrates faith's aesthetic sensibilities, even to the point of insisting on an aesthetic dimension of redemptive existence.[38] But he declines here to give much attention to the things we call art. Why is that?

The possible explanations are complex and probably rather different in each case, but worth exploring in brief. The least exciting explanation is perhaps the most far-reaching. It seems virtually undeniable that we are dealing partly with the effect of scholarly disciplines, intellectual traditions, and habits of mind. As long as what is typically called theology is something taught and written by the people we commonly call theologians—that is, by people with systematic, analytical minds trained primarily in verbal intellectual arts (the liberal arts of the medieval curriculum, you might say)—then it makes sense that the bulk of that theology will be about ideas, arguments, and thought processes. That automatically distances such ways of thinking from the aesthetic arts, which may indeed constitute modes of intelligence but which do not use that intelligence mainly in conceptual exposition, argument, or analysis.

Insofar as art in the aesthetic sense is always embedded in a medium, such that its message cannot fully be abstracted from that medium, it will always, in some measure, resist complete assimilation to what we commonly call theology. Robert Frost once said that poetry is what gets lost in translation. I would say—and I do not mean this critically at all—that what is poetic about faith is what gets lost in formal theology. That overstates the matter, of course. Poetry itself can be thoughtful, and contribute to more abstract thought. I fully agree with those who see a back and forth dialogue between symbol and thought, between arts and ideas. But the basic point still stands.

The problem is not unique to Christian thought. It is found the world over. Whenever an intellectual tradition acts as the primary interpreter of religious meaning for a community—whether the Indian philosophers of Advaita Vedanta or Buddhist monks translating and pondering the sacred sutras—the people whose task it is to teach and interpret the tradition verbally will almost inevitably privilege words even if and when they regard words as ultimately inadequate or futile. Words may be inadequate, they will admit; but images and sounds usually appear to them to be even more so. Moreover, even when open to the arts, such people will rarely treat them as any of their own business. Most academic theologians will devote relatively little of their time to reading the sorts of books on art and aesthetics that I have catalogued

in some detail—not because they think those books are bad but because such books deal with artistic and aesthetic matters that seem to them, after all, somewhat tangential to issues and arguments that have always been thought of as properly theological.

Accordingly, if we ask how important the arts are likely to be to theology, and if we address our question to intellectuals who make their living by discursive thought and verbal analysis, the answer is likely to be: important in touching the heart and soul, in moving the will, and perhaps in making the truths of the faith memorable; but they are not so very important for academic teaching and reflection. When it comes to reckoning with art and aesthetics, academic theologians for the most part seem to have something better to do.

I offer a second thesis, related to the first. Whatever impression one might have from certain theological efforts to help faith in its search for understanding, most of us would probably agree that it is normal and common for faith and spirituality actually to be fed and transformed aesthetically, and for the love of art to be fed and possibly transformed religiously and morally. But the ways in which art matters to faith, and vice versa, cannot be put entirely satisfactorily into words. Consequently, we can never explain in words the full extent to which either faith or theology has at some level been influenced by art, or art by verbal theology.

Accordingly, the dialogue between theology and art is often indirect and sometimes unconscious. For that reason, many Christian thinkers sympathetic with the arts nonetheless decide, with Nicholas Wolterstorff, that the best way to do academic philosophy or theology is not by interweaving it with artistry, which would only confuse things, but by doing what the philosopher and theologian does best.[39] On this interpretation, even if the law of prayer shapes the law of faith, and even if prayer takes artful forms, the reflective work of theology should be conducted in conversations with other theologians and philosophers.[40]

And perhaps that is as it should be, at least part of the time. But such an approach to theology or religious reflection easily forgets what should not be forgotten: that if the arts have their own ways of thinking and probing and reflecting as well as feeling, then theology that is conducted as a conversation between theologians, so to speak, will miss a lot—a lot that is theologically important.

The problem can be stated simply. If theology seeks to understand and reflect critically on faith, and if much that is vital to faith is poetic and imaginative, then a theology incapable of appreciating and interpreting what is poetic and imaginative about faith will have no way of finishing its job. Indeed, if poetic and symbolic language mediates what is true or trustworthy in ways that theological words can never fully grasp, then there is a sense in which theology *never can be* finished with the artistic and symbolic world. The conversation between theology and art, while fruitful, must in a real way be unending. And that is a good thing, potentially, because it makes for an open-ended process in which theology can be reflected in art, and in which art can be reflected in theology, and each be transformed by the other. It is doubly unfortunate, therefore, that in so many contexts the theological conversation with the arts (and vice versa) never even begins!

This is hardly a minor matter. As is well known, a great many philosophers and theologians from Immanuel Kant through Martin Heidegger, Hans-Georg Gadamer, and Paul Ricoeur have argued persuasively that, although the symbol gives rise to thought, artistic or symbolic truth and understanding cannot be translated without reminder into philosophical or theological concepts. Now, one can never make a completely convincing case for that claim while using the language of philosophy or academic theology. But that does not render the claim false; it is exactly what one would expect if there are limitations to the extent to which the symbolic and conceptual modes of thought are mutually intelligible.

Although one can always doubt that special artistic insight exists in relation to matters of faith, it seems evident that human beings will continue to turn to music, art, literature, film—and indeed to artful ritual and liturgy—for expressing and interpreting some of the highest and deepest things of life and religion. This is not just because art makes us feel better, though it can do that. And it is not just because art can add immeasurably to our capacity for both joy and lamentation. It is also because art, by and large, helps us know and hope and envision better. It creates an intimate awareness of the particulars of life, a larger and more refined sense of who we are individually and corporately, and often some new sense of the larger whole to which we are related. To

the extent that artistry interprets life both faithfully and engagingly, and does so in ways not interchangeable with intellectual theology, it can be thought of as experiential theology traveling *incognito*. Robert Wuthnow, in fact, provides considerable sociological support for such a view in his recent book *All in Sync: How Music and Art are Revitalizing American Religion.*[41]

We should not gloss over the fact, however, that "the arts" in the narrowly aesthetic sense have played a relatively minor role in most lives over the course of history. The art that has most widely influenced churchgoers in most strata of society has been the art of the liturgy or, in a related way, the art of preaching. And neither liturgy nor preaching is designed in such a way as to focus on the aesthetic form or medium, or to stand alone in the way a work of "fine art" can do. They are artful (or should be), but are not an "art form" in the usual sense. Outside church, moreover, most human beings have not had the financial resources or free time available to devote themselves to making and appreciating fully formed artworks—certainly not of the sort destined to be called artistic "classics." It is literally true, therefore, that art in the most fully developed and independent sense has played a relatively minor part in most lives up to now. In that respect art deserves its peripheral status in many forms of theology, which is one reason we can reluctantly appreciate David Tracy's point when he declares that religious classics are rarely artistic classics, and artistic classics rarely religious ones.[42] The kind of art that has functioned most often in religiously important ways has generally been something short of "classic" from a sheerly artistic perspective. It has been simpler, more direct, less difficult, not so exclusively aesthetic in its appeal. Like the liturgy itself, such art depends on the whole context of memory, tradition, ritual, and sentiment to work on God's behalf.

But with that point I want to turn things in a different direction. For one thing, I think it is only fair to say that even the works of theology that David Tracy regards as indubitable religious classics rarely function as such for most people. Very few churchgoers read Augustine or Thomas Aquinas, and most of their ministers show little evidence of having done so themselves. So when we ask about whether a work is a religious classic, we must also ask: For whom? And when we do that,

we are bound to conclude that, for the vast majority of us, the "classics" that have shaped our lives and faith most persistently have seldom been works of theology, per se. In many cases, they have been artistic, even when they have not been great art.

Beyond that, we need to recognize the way in which our lives tend to be shaped, in the modern world, by arts and media outside religious communities. Here I would simply remind us that pivotal religious/theological/spiritual moments and meanings are indeed mediated for many human beings artistically, and at a very high level. These artistic mediations of religion, whether Beethoven's gargantuan and liturgically inappropriate *Missa Solemnis* or a painting by Barnett Newman, or in sometimes uncomfortable guises such as the popular film *The Matrix I*, do not all fit with creeds otherwise declared and accepted. They may challenge or undermine various moral and religious assumptions. But all of us are aware that some of these arts that we experience religiously outside the formal realm of religion are far more disciplined, developed, moving, powerful, or possibly sophisticated than anything typically offered by churches and other religious communities themselves. In that sense, and for that reason, it is sometimes art rather than theology, per se, that has the higher calling, and it is art that cultivates the higher mode of spiritual awareness and prophetic insight.

Should we leap from our high claim regarding the religious potential of various arts, both elite and vernacular, to the conclusion that all art is religious? At virtually every conference on art and religion, someone seems determined to make such a claim in some form or other. But here we would do well to control ourselves. I think that all art is religious only, or at least mainly, in the sense that all life is religious, or in the sense in which for a Mahayana Buddhist the changing world of samsara can be seen finally as nirvana. Perhaps beauty, truth, and goodness all finally derive from and return to God. Everything that is beautiful may hint at something "more" in which it participates. But to think of all art as beautiful in that way, and of all beauty as religious in that way, is more than a little eschatological. In the meantime, not all true statements are religious, and not all art—not even all good art—is religious. Art sometimes becomes religiously valuable precisely because of its resistance to, and distance from, orthodox theological claims—

the Grand Inquisitor story in *The Brothers Karamazov,* for example. At the same time, genuinely religious aesthetics puts art itself in its place by recognizing that aesthetics is far more than art alone, and that the arts which matter most in religious life often matter not because of their excellence in isolation but because of their connection with other things, including religious practices.

Be that as it may, there is a final reason for taking the theological importance of art more seriously than theologians are traditionally prone to do. It is the flip side of the observation that, for most people in most societies throughout history, access to highly developed arts as such has been limited. That situation is changing. It may very well be that the time we live in right now offers certain possibilities for artistic religious realization that really are quite new under the sun. Due to revolutions in electronic media and digital communication and rapid transportation, never before have so many people *at least potentially* been able to gain access to so much art of every sort—whether film or video or music or dance or drama. Even museums and works of architecture are accessible as never before, due to modern transportation and media. Moreover, with advances in technology, the tools for making even relatively complex art are potentially becoming more accessible to larger numbers of people. Granted that the impersonality and artificiality of much modern technology can also be inhibiting, aesthetically, it nonetheless appears that we have more opportunity now than ever to realize the potential of the arts and religion to be mutually enlarged, intensified, and transformed. For that reason, among others, I am eager to see what happens next—artistically, theologically, and spiritually. Even in a time that poses significant threats to the quality of artistic and religious life, we can harbor and cultivate hope for a new era in ARTS.

~

NOTES

1. Robert Wuthnow, *Creative Spirituality: The Way of the Artist* (Berkeley: University of California Press, 2001).

2. Deborah J. Haynes, *The Vocation of the Artist* (New York: Cambridge University Press, 1997).

3. John Hick, *An Interpretation of Religion: Human Responses to the Transcendent* (New Haven, Conn.: Yale University Press, 1989), 151–52.

4. Vasudha Narayanan, "Embodied Cosmologies: Sights of Piety, Sites of Power," *Journal of the American Academy of Religion* 71.3 (2002): 495–520.

5. Wilson Yates, *The Arts in Theological Education* (Atlanta: Scholars Press, 1987).

6. For a sense of the range of those parallels see, for instance, James Alfred Martin Jr., *Beauty and Holiness: The Dialogue between Aesthetics and Religion* (Princeton: Princeton University Press, 1990); and Earle J. Coleman, *Creativity and Spirituality: Bonds between Art and Religion* (Albany: State University Press of New York, 1998).

7. See, for instance, David Morgan, *Visual Piety: A History and Theory of Popular Religious Images* (Berkeley: University of California Press, 1998); and Colleen McDannell, *Material Christianity: Religion and Popular Culture in America* (New Haven: Yale University Press, 1995).

8. Nathan A. Scott Jr., *The New Orpheus: Essays Toward a Christian Poetic* (New York: Sheed and Ward, 1964).

9. Roger Hazelton, *A Theological Approach to Art* (Nashville: Abingdon Press, 1967).

10. Gerardus van der Leeuw, *Sacred and Profane Beauty: The Holy in Art,* trans. David E. Green (New York: Holt, Rinehart and Winston, 1963).

11. William Dean, *Coming To: A Theology of Beauty* (Philadelphia: Westminster, 1972).

12. John W. Dixon Jr., *Art and the Theological Imagination* (New York: Crossroad-Seabury, 1978).

13. Nicholas Wolterstorff, *Art in Action: Toward a Christian Aesthetic* (Grand Rapids: Wm. B. Eerdmans, 1980).

14. Calvin Seerveld, *Rainbows for the Fallen World: Aesthetic Life and Artistic Task* (Downsview, Ont.: Toronto Tuppence Press, 1980).

15. Samuel Laeuchli, *Religion and Art in Conflict* (Philadelphia: Fortress Press, 1980).

16. Aiden Nichols, *The Art of God Incarnate: Theology and Image in Christian Tradition* (London: Darton, Longman & Todd, 1980).

17. John Dillenberger, *A Theology of Artistic Sensibilities: The Visual Arts and the Church* (New York: Crossroad, 1986).

18. Jeremy S. Begbie, *Voicing Creation's Praise: Towards a Theology of the Arts* (Edinburgh: T & T Clark, 1991).

19. Frank Burch Brown, *Religious Aesthetics: A Theological Study of Making and Meaning* (Princeton, N.J., and London: Princeton University Press and Macmillan Press, 1989, 1990).

20. Hans Urs von Balthasar, *The Glory of the Lord: A Theological Aesthetics,* 7 vols., various translators (San Francisco: Ignatius, 1982–89).

21. Patrick Sherry, *Spirit and Beauty: An Introduction to Theological Aesthetics* (Oxford: Oxford–Clarendon, 1992; 2nd ed., London: SCM Press, 2002).

22. See Martin, *Beauty and Holiness.*

23. Richard Harries, *Art and the Beauty of God: A Christian Understanding* (London: Mowbray, 1993).

24. Richard Viladesau, *Theological Aesthetics: God in Imagination, Beauty, and Art* (New York: Oxford University Press, 1999).

25. Alejandro García-Rivera, *The Community of the Beautiful: A Theological Aesthetics* (Collegeville, Minn.: Liturgical Press–Michael Glazier, 1999).

26. Frank Burch Brown, *Good Taste, Bad Taste, and Christian Taste: Aesthetics in Religious Life* (New York: Oxford University Press, 2000).

27. Edward Farley, *Faith and Beauty: A Theological Aesthetic* (Aldershot, England, and Burlington, Vt.: Ashgate, 2001).

28. John W. de Gruchy, *Christianity, Art, and Transformation: Theological Aesthetics in the Struggle for Justice* (Cambridge: Cambridge University Press, 2001).

29. John Milbank, Graham Ward, and Edith Wyschogrod, *Theological Perspectives on God and Beauty* (Harrisburg, Pa.: Trinity Press International, 2003). Wyschogrod is not normally associated with Radical Orthodoxy, it should be noted, whereas Milbank and Ward are leaders in the movement.

30. John Navone, *Toward a Theology of Beauty* (Collegeville, Minn.: Liturgical Press, 1996).

31. John Navone, *Enjoying God's Beauty* (Collegeville, Minn.: Liturgical Press, 1999).

32. See, for instance, William A. Dyrness, *Visual Faith: Art, Theology, and Worship in Dialogue* (Grand Rapids: Baker Books, 2001).

33. Anthony Monti, *A Natural Theology of the Arts: Imprint of the Spirit* (Aldershot, England, and Burlington, Vt.: Ashgate, 2003).

34. Albert Rouet, *Liturgy and the Arts* (Collegeville, Minn.: Liturgical Press, 1997).

35. Don E. Saliers, *Worship as Theology: Foretaste of Glory Divine* (Nashville: Abingdon Press, 1994).

36. James Luther Adams and Wilson Yates, eds., *The Grotesque in Art and Literature* (Grand Rapids: Wm. B. Eerdmans, 1997).

37. He has since helped fill out the picture with his poetically composed book *A Wounded Innocence: Sketches for a Theology of Art* (Collegeville, Minn.: Liturgical Press, 2003).

38. Farley, *Faith and Beauty,* 97.

39. Nick Wolterstorff made this observation in 1997 at an informal dialogue at Ridley Hall, Cambridge, among consultants to the project called "Theology Through the Arts."

40. That opinion was expressed to me by my University of Chicago professor Langdon Gilkey in conversation some thirty years ago. Gilkey (like Tillich) had an extremely high regard for symbol. But the theologian, he seemed to say, is better off not mixing modes. For a certain kind of theology, he is probably right—but not for Meister Eckhart, or Hildegard of Bingen. And we may live in a time

in which theology itself needs more often to become poetic, and in which poetry could afford on occasion to become more theological (and not merely spiritual).

41. Robert Wuthnow, *All in Sync: How Music and Art are Revitalizing American Religion* (Berkeley: University of California Press, 2003).

42. David Tracy, *The Analogical Imagination: Christian Theology and the Culture of Pluralism* (New York: Crossroad, 1981), 134, 163, 172, 174, 176–77, 200–201, 380.

"Lump in the Throat" Stories

Narrative Art, Religious Imagination, and an Aesthetic of Hope

MARY FARRELL BEDNAROWSKI

I n an essay about the "creative spirituality" of the French paleontologist and theologian Teilhard de Chardin, Donald P. Gray reflects on the early confusion about how to categorize Teilhard's *The Phenomenon of Man,* his treatise on cosmic evolution and the emergence of life.[1] "It was difficult," Gray says, "to know precisely how the book was to be read and, hence, how it was to be interpreted and understood."[2] *The Phenomenon of Man* has elements of science, philosophy, and theology, but to choose (one) among disciplines in order to categorize Teilhard as a scientist, a philosopher, or a theologian does not get us to "the heart of the matter," as Gray puts it. He argues, rather, that, "Essentially [Teilhard] is a storyteller and a masterful one

at that. This is the source of his attraction. He has a strange but spell-binding story to tell, one that awakens wonder and bewilderment."³ It is in the power of his role as storyteller, Gray implies, that Teilhard is at his most creative and compelling because, in his new story of the origins and continuous unfolding of the universe and all that is in it, he cuts back and forth across the boundaries of disciplines in ways that create something new. It is my sense, further, that Gray is making a strong connection between Teilhard's spiritual creativity, as he calls it, and his power to convey the need to do something other with traditional categories than to stay within them.

Fifty years after Teilhard's death, like Teilhard himself and his now numerous interpreters, we are still learning how to tell and make sense of new kinds of stories, stories that go back and forth across disciplinary borders. We are discovering, as well, that in order to keep our religious traditions, and religion itself, vital in a plural culture we have to learn how to tell and receive stories that travel back and forth across many other kinds of boundaries: between and among very different kinds of religious traditions; across the chasm of polarized stances on various social and ethical issues; between those who inhabit the realm of religion and those who see themselves as dwelling in the lands of spirituality and secularity; among theologies that range from—and sometimes mix together—the premodern, the modern, and the postmodern; across the continuum from one part of our own lives to another; from within the boundaries of religious communities to the wider cultural arena. In addition, we are telling and hearing stories about religion and religious experience at a moment in history when we cannot *not* know certain things about religion.

We have come to understand and acknowledge as good news rather than bad that human beings construct religious meaning systems, that, as Gordon Kaufman has said so often, theology is imaginative construction. In making sense of this insight, we have come to experience that this "fact" does not have to diminish the reality of what we experience religiously or the possibility that there are spiritual realities that transcend what we can ever know. We are learning, instead, to interpret that reality in new ways. We are telling and listening to stories about the permeability and flexibility of religious boundaries, or, said a

little differently, we are discovering that wherever vitality and depth live within religious traditions, they are not sustained by putting guards at the boundaries. The religious ideas and symbols of our traditions, as it turns out, have powerful ways of crossing boundaries and, in the process, becoming deepened and renewed rather than disappearing over the horizon. They come back to us in revitalized but recognizable forms. All these things we have learned from stories.

The stories I am particularly interested in for this essay are those that are, at some level, autobiographical. I find them in spiritual memoirs and in theologies whose authors are self-revelatory well beyond the disclosure of social location. Typically, these are stories embedded in writings offered to a broader public than the members of a particular religious community. Many of them can be found in best sellers. They are writings that have made it possible over the last two decades or so for religion and religions to enter cultural conversations in new ways: not as efforts of persuasion or conversion to the writers' points of view, but as invitations to appreciate the extent to which multiple manifestations of the religious imagination are part of the human search for depth and meaning.

My approach is to offer a dual framework for reflecting on the religious and aesthetic significance of the stories that follow. First, by offering examples of what I have come to call "lump in the throat" stories, I elaborate on the phenomenon of the emergence of this genre in American culture. And second, by working out not a theology but a religious aesthetic of hope, I construct an interdisciplinary approach to reading these stories, a method that comes out of my own border travels between religious studies and theology—travels that have inclined me toward interpretive stances that take theology and theological creativity very seriously but that also move within a variety of religious traditions.

I have for several years worked with the idea that there are special kinds of stories that I like to describe as "lump in the throat" stories. These are stories about religious experiences that elicit an emotional and an intellectual response in the teller or the listener. When their meanings are explored, we discover that the affective responses we have to these stories are not "merely" emotional as they are sometimes cari-

catured as being, but rather are experiences of deep feeling that have intellectual, affective, and aesthetic content. They stir up both head and heart at the same time, and in so doing offer a counter-story to historical patterns in American religious history that suggest we must choose one kind of religious experience or the other: head or heart experiences, but not both. These stories embody creative acts of the religious/theological/spiritual imagination that carry our histories and our futures. They offer multiple intimations of the vitality of religion as an endlessly wide and deep arena of human creativity. My goal with these stories is not so much to guarantee that each one will produce a lump in the throat of every reader, as it is to offer a variety of illustrations of how head and heart work together, often in boundary-crossing ways.

I also believe that these stories, whatever else they are and do, are stories that generate hope. My own broad definition of hope has come out of my research on healing as a major theme in women's theologies.[4] As I have come to understand it, to be healed is to have hope. And to be hopeful is to know that whatever our circumstances, there is always something more to be said or to be understood or to be experienced or to be accomplished. Traditionally theologies of hope are tied to the belief systems and symbols of particular religious communities. To emphasize an aesthetic of hope rather than a theology of hope is not to suggest that implicit and explicit theologies of hope are absent from these stories. It is, rather, that I am looking for a broader category of inquiry. I want to explore their appeal from a different interpretive angle related to the "artfulness" of the stories, to suggest ways to appreciate the quality of hope in these lump-in-the-throat stories, wherever hope lies, whatever forms it takes in the project of keeping religious traditions vital. Hope, as I see it in these stories, is about possibility, vitality, openness. At the same time it is grounded in, depends upon, finds expression in the language and symbols of religious traditions.

The possibility of constructing an aesthetic of hope is a part of my ongoing interest in sorting out how these lump-in-the-throat stories help us to come up with fruitful ways of thinking about the relationships among religion, theology, and the arts, in this case the literary arts: how they illuminate each other, play off each other, play with each other, without diluting or distorting their distinctive contributions to

the project of being human in the world. That concern has been cat-
alyzed in new ways by *New York Times Book Review* columnist Judith
Shulevitz. For the most part, Shulevitz does not consider the genre of
spiritual memoir appealing because of its very lack of artfulness. In a
column entitled "They Trust in God, Sort of," she counters a claim by
New Yorker critic Anthony Lane that sex is the hardest thing to write
about. "Read through the offerings of most religious publishers,"
Shulevitz argues, "and you'll suffer greater affliction."[5] Writing about
religious experience with "artful restraint," says Shulevitz, is nearly im-
possible to do without sounding "mawkish" and without uttering
"oracular pronouncements" from some perch high above the rest of us
struggling on the ground.[6] I consider her overall assessment of spiritual
memoirs much too sweeping, even though she makes some points it
would be hard to refute. I have certainly read too much of the oracular
stuff myself. But it has been productive for me to think about why my
own response to spiritual memoirs and similar kinds of writings has
been, in general, more positive and why the phenomenon of spiritual
self-revelation is so compelling at this moment in American religious
and cultural history.

The questions I have are straightforward. Why are people telling
these stories and why are they telling them or writing them "in public"?
Why are other people buying these stories or listening to them on pub-
lic radio, for example? How did Kathleen Norris's *Dakota* and then
Cloister Walk and then *Amazing Grace* get to be best sellers? Why did
Minnesota Public Radio's "First Person: Speaking of Faith" show re-
cently get a grant for $500,000 to produce weekly programs when not
long ago host Krista Tippett, who is also the originator of the program,
could hardly get twenty-five cents to get it going in the first place? What
do people want from these stories? What do people get from either the
telling or the listening? In light of Judith Shulevitz's objection that she
has not come across many stories about religious experience that are
"artful" rather than "mawkish" or self-serving, can we point to some
characteristics of particularly good lump-in-the-throat stories that
make them hearable across the divisions that are part of a plural cul-
ture and that in their best forms demonstrate what I have come to think
of as an aesthetics of both hope and invitation? Can we find stories that

exhibit both aesthetic appeal and theological creativity in a variety of different ways?

I argue that stories that are both theologically compelling and aesthetically appealing can be found in abundance these days. I am convinced that the best ones have a compelling quality that crosses various boundaries because they offer examples of the possibility for hope defined as "renewal of life." Whether we belong to the person's tradition or not—and, often, it is "not"—or to any religious tradition at all, we encounter in these stories living testimonies that people can make something "deep," something "more," something new from the stories of their lives. When these stories are artfully told, there is implicit in them a double invitation that has both religious and aesthetic dimensions. Both are related to hope: the invitation to "appreciate" what we are hearing, to receive it with empathy, to take it in and be moved by its dynamism and then to ponder not only the story itself, but what we might want and need to make new in our own lives and communities.

The marks of an aesthetic of hope, as I see it, lie in the way it both fosters and demands a sense of possibility, openness to new interpretations of our traditions and those of others, appreciation that there is always "more." An aesthetic of hope responds to the repertoire in these stories of intellectual/experiential moves that are transferable across religious boundaries and are usable, likewise, for those who consider themselves spiritual rather than religious.[7] An aesthetic of hope recognizes new forms of religious persuasion. Whatever the specific theological, ethical, or religious content of the story itself, an aesthetic of hope urges the listener to recognize that the spiritual outcome is fitting for the storyteller. There is satisfaction engendered in the listener on behalf of the teller, a rejoicing at a story of spiritual authenticity and transformation that is moving to us even if it is a story about a tradition different from our own, even if the story is about someone who ultimately rejects the tradition we hold dear. An aesthetic of hope leaves open the possibility of multiple responses to implicitly and explicitly theological questions like "Hope in what?" "Hope for what?"

The stories that follow are stories that I find emotionally moving, intellectually stimulating, hope-engendering, and aesthetically pleasing. They send rays from my throat to my brain and to my heart. They offer

invitations rather than judgments or cautionary tales or meant-to-be-unassailable conclusions. They are stories that emerge from the worldviews of Judaism, Christianity, both Protestantism and Catholicism, Mormonism, Buddhism, Hinduism, and what is often referred to as secular humanism. They are stories about coming to see one's own tradition in new ways; about constructing models of God adequate to experiences of tragedy; about extending the meanings of traditional religious doctrine to the experiences of ordinary life; about seeing the religious meaning of ecological "irreligion"; about conversion to a radically different tradition from the community of one's birth; and about coming to see the deepest meaning of one's own tradition through its encounter with the deepest wisdom of another. I experience them all as lump-in-the-throat stories and, taken together, they help me know more about some of the many kinds of religious vitality out of which an aesthetic of hope can teach us to take heart.

I begin with two stories by Jewish feminist theologian Rachel Adler. The first involves a change of heart and understanding about the most essential gift a religious tradition can offer its members. In 1993 Adler published an article in *Tikkun*, a Jewish journal of politics, religion, and culture about an article she had published twenty years earlier about how Jewish women might come to see menstrual purity laws in a more positive light and as integrated within the broader category of purity regulations. By 1993, she had changed her mind and had come to see the purity laws as having a negative effect on Jewish women's self-understanding. There continues, in fact, to be intense discussion about this issue among Jewish women. The earlier article turned out to be quite famous, and Adler was still getting praise for it, praise she no longer wanted but now did not know what to do about. As she understands it now, her mistake lay in denying the reality of her own experience and setting aside her doubts that "God's Torah could be in error."[8] As she pondered the dilemma of how to make it clear how and why she had changed her mind, she made a statement that I continue to think is profound and filled with hopeful possibility, because it changed not her loyalty to her tradition, but the terms of her trust in it: "Sacred need not mean inerrant; it is enough for the sacred to be inexhaustible."[9]

Adler has demonstrated her confidence in that insight in a newer publication, *Engendering Judaism.* She begins chapter 1 with the words, "I am going to tell you a story." This chapter, entitled "The Female Rapist and Other Inversions," contains, in fact, many stories, but the one I want to tell is Adler's own about reading highly misogynistic midrashim—stories that not only exclude women but "de-face" them. One of these stories in the orthodox Jewish tradition is that of a female rapist who pounces on a rabbi—a story which Adler finds "hilarious." Her overall project, as she describes it, is "not judgment but restoration," and she proposes to "restore these texts as sources of a trajectory toward holiness by reframing them as comedies."[10] She wonders whether this is a perverse perception on her part, no doubt well aware that outrage might be considered the more likely response. She speculates about whether she can fashion a feminist hermeneutic in response to texts like these. She is reassured when she reads her analysis to a group of scholars, and they, too, "rocked with laughter." She extends the story by recounting the response of a classically trained male scholar who said wistfully (Adler's word), "You know, I was taught these stories from childhood and, although I have long understood that they were misogynistic, I never found them funny before. Now, how will I ever read them again without laughing?"[11] Adler speaks again: "Then I understood at last: I told him, 'That is a gift to you from feminist Torah.'"[12] In other words, yes—Adler discovered that she could fashion a feminist hermeneutic from texts like these—the possibilities are inexhaustible and one of them is to laugh at what is laughable.

Religion and literature scholar Robert Detweiler tells us that there are three things he cares about in the literature and religion enterprise: the curatorial, which speaks to the double concern for not losing a significant text, whether in "the canon" or not, and also not losing the history of its interpretation; the hermeneutical, by which he means interpretation and its complexities and, also, as I understand him, the intertwining of how we interpret with what we believe; and the existential, which has to do with the choices we make.[13] These concerns, as I see them, are intellectual, aesthetic, and ethical in nature, all at the same time, and in this story by Rachel Adler, we see all three working together. Keeping these concerns in mind aids us in shaping further the outlines of an aesthetic of hope.

The painter Meinrad Craighead, a former contemplative nun who now lives in New Mexico, has another very powerful way to talk about the inexhaustibility of a tradition. In *The Litany of the Great River,* she tells us that as an artist nothing has affected her more powerfully from the religious practice of her childhood than the processional recitation of litanies. The memory of how "the rhythmical flow and the precise syllables of the sacred language got inside our bodies" evoked for her a connection many years later in an art history class with "the principle of indefinite extension."[14] This is an idea that has moved her over the years to recognize how her prayer life and her art have been aesthetically and theologically "indefinitely extended" by the memory of the litanies. *The Litany of the Great River* is, in fact, a book of paintings that accompanies a new litany Craighead has written honoring the natural beauty of the Rio Grande Valley—with phrases like "Heart of the Fire," "Holy Mountain," "Guardian of the Place."[15]

I encounter numerous examples of the principle of "indefinite extension," the possibility for pushing at the boundaries of what particular religious ideas or symbols or rituals can mean in order not only to extend their meanings outward but to give them greater depth—more possibilities to move people by saying, in effect, "what if we look at it this way or that way and see what happens," or, "how far can we extend the meaning of a particular doctrine or symbol—communion, for example—before it is no longer recognizable by its community of origin?" These are questions we ask not cynically, but with the genuine desire to plumb the depth and breadth of our traditions. It strikes me that another word for this process is "play," a term that can sound frivolous at first, dangerous, and even, somehow, sinful, when applied to theology. That phrase, though—"theological play"—is coming to have new and powerful meanings for us. We are beginning to understand the aesthetic and intellectual possibilities, in fact the hope-producing qualities of "play." Artists have been better at playing with symbols than theologians, seeing it as their aesthetic obligation rather than a temptation to be avoided.

Perhaps because "communion" is a meal both fathomless in its mystery and "ordinary" in its elements, it has become a likely subject for experiencing the inexhaustibility of the Christian tradition and for

the project of indefinite extension. The possibilities become evident in the writings of two well-known contemporary writers, Terry Tempest Williams, a Mormon, and Andre Dubus, a Roman Catholic. Both Williams and Dubus know how to extend the meaning of "sacrament" outward into their everyday lives and into their art and renew and deepen its distinctive meaning in their particular traditions. To do so, they need to acknowledge, even if implicitly, the power of the historical, more doctrinally oriented meanings of sacrament as it formed each of them spiritually.

In *Leap*, a spiritual memoir by nature writer Terry Tempest Williams, we encounter many stories that seem to me to be examples of "indefinite extension." One is about an old woman she sees every morning in Madrid who wears a turquoise sweater and black skirt, stockings, and shoes. She is "breaking bread" for the pigeons—at least fifty pigeons circling her. Williams says, "She finishes her sacrament for the birds and always leaves with a couple of loaves under her arms."[16] Williams watches her walk away and a Mormon communion hymn comes into her mind: "I think of all the years," she says, that

> I have taken the formal sacrament in my church and the beautiful hymns sung with solemnity prior to the blessing given on the bread and water; the communal silence that permeated the chapel as silver trays were passed; the silence I loved and how I was taught to use this time each week to honor the broken body of Christ and his spilled blood.[17]

She is not finished with this meditation or with this memory. She extends it further:

> And then I remember standing on the edge of Great Salt Lake as a young girl, watching hundreds and thousands of birds fly over me, feeling the wind of wings, the songs of a world in motion.
> Yes.
> Yes, I would take and participate.
> Yes, I would break bread for the birds and say a prayer for safe travel, each one a cross against the sky.[18]

Another communion story, one of several, in fact, appears in *Meditations from a Movable Chair,* a book of essays by Andre Dubus, the short story writer who died in 1999. The movie *In the Bedroom* is based on one of his stories. Dubus was a Roman Catholic who grew up in a very traditional family in Louisiana and lived much of his adult life in Massachusetts. He lost one leg and much of the use of the other in a car accident in 1986. Dubus was hit after he got out of his own car to help somebody else. He was candid in his writings about the physical, psychological, and spiritual pain that was never-ending for him from that time on. In the essay, "Sacraments," he is playing with, indefinitely extending, the meaning of "sacrament." He describes making sandwiches for his young daughters to bring to them when he picks them up after school. He is divorced from their mother and does not live with them.

> On Tuesdays when I make lunches for my girls, I focus on this: the sandwiches are sacraments. Not the miracle of transubstantiation, but certainly parallel with it, moving in the same direction. If I could give my children my body to eat, again and again without losing it, my body like the loaves and fishes going into mouths and stomachs, I would do it. And each motion is a sacrament, this holding of plastic bags, of knives, of bread, of cutting board, this pushing of the chair, this spreading of mustard on bread, this trimming of liverwurst, of ham. All sacraments, as putting the lunches into a zippered book bag is, and going down my six ramps to my car is.[19]

Not every story that fosters an aesthetic of hope is the story of a person who stays within the tradition into which they were born or even participates in a religious tradition at all. Nonetheless, the storyteller is someone who knows how to use recognizably religious language in creative ways. William Kittredge's *Taking Care: Thoughts on Storytelling and Belief,* published, interestingly, in the "Credo" series of Milkweed Editions, is not on the surface about religious beliefs; it seems to be about exactly the opposite. It is a book about ecology and about taking care of the land. But many of the things Kittredge has to say are highly instructive for those of us who are drawn to lump-in-the-throat

stories about what people commit their lives to and how they articulate their commitment. "There are things I believe," says Kittredge: "Everything is part of everything. . . . Generosity . . . is the prime moral and political virtue. . . . And compassion."[20] He calls himself "irreligious as a stone" and confesses that he does not feel any more "profound or coherent" in his thinking than he did when he was eleven—at which time he told himself, "there's plenty of time, you'll think of something."[21] "But no such luck," he says, and now he's in his sixth decade. "Irreligious as a stone" he may be, but Kittredge does very creative, very artful, things with religious language. For example, he writes a great deal about "paradise." I see his creative theological work as part of a wider body of work in American religion, feminist theologies, in particular, as that of bringing "paradise" down to earth. For him the task is "how to think up a just and sustaining community for ourselves on this transmogrified planet."[22] He tells us that there is no single story that names paradise and that there never will be. He sounds to me like both a theologian and a storyteller when he says, "Our stories have to be constantly reworked, reseen. Energies and processes are what is actual, complexity is actual. We inhabit thickets of responsibility, and wonder how good we can be."[23]

Often it is an individual tragedy rather than a pressing cultural issue that moves a person to find new ways to tell in religious terms the story of coming to know what it takes to want to keep on living. Thomas Crider, a freelance writer, has written a book called *Give Sorrow Words,* about how he has learned to survive the death of his twenty-one-year-old daughter—his only child—in an apartment fire. Crider describes himself as a person who had no faith to fall back on. He found statements made to him about God's love and God's plan and life after death not only incomprehensible but infuriating. None of the books he read on bereavement helped him. They were all, he said, "written either from a conventionally religious stance or from a New Age one."[24] What he did was turn to different kinds of books, "books that led me into a soothing stream of stories, ideas, poems, and emotions that flows through time from the minds and hearts of people of all cultures and ages. The music of this stream sang tenderly to me and rocked me in its embrace. It still does."[25] By the end of that first terri-

ble year after his daughter's death he can say this: "What about this word God so repugnant to me when I thought it meant 'God the Father'? I now see it as a word of a thousand meanings. It's a word I don't reject in anger any more. I can accept it in my own way as referring to the unnameable mystery that lies behind invisible reality."[26] And he can say many other things, as well, about the new and multiple meanings he is able to give to other religious concepts and traditional prayers that he had once rejected as both empty and destructive. I do not think Tom Crider's story is a rare one in American culture nor do I think it is lacking in evidence of both theological creativity and aesthetic appeal. I do not think it is a story, either, about "finding religion" in the traditional sense; nor do I have the inclination to turn it into that. It is, on the other hand, yet another story of the endless depths of traditional religious language and its capacity to yield, over and over again, stories of its inexhaustible power.

Some of the most interesting stories I have come across are stories about conversions from one religious tradition to another. This, of course, is not a rare thing in a religiously plural culture, but I am especially interested in the kinds of stories that are shared with "artful restraint," as Judith Shulevitz would say, in that they do not suggest that the hearer should "go and do likewise." They do not imply or state that the decision the storyteller has made and told us about is the only decision a right-thinking person can make. They are persuasive in different ways, because they remind us of the original meaning of "conversion" cited by John D. Barbour in his book *Versions of Deconversion: Autobiography and the Loss of Faith* that it is the term once used to describe how the material of a work of art is transformed by the artist.[27] These are stories about how the realities of people's lives lead them to embrace another religious tradition: the combination of intellectual insight, powerfully affective response, and artful storytelling that undergirds both lump-in the-throat stories and an aesthetic of hope. I am not going to tell traditional Christian conversion stories, because most of us, I suspect, have access to those stories. Instead, I am going to recount how an African American man, a well-known author and black activist whose father was a Methodist minister in the South and whose first book was *Look Out, Whitey, Black Power's Gon' Get Your Mama!*, be-

came a Jew. And about how a woman who grew up in the Wisconsin Synod Lutheran Church in rural Wisconsin became a Buddhist.

In *Lovesong: Becoming a Jew,* Julius Lester juxtaposes his experience of outsider status in American culture as an African American with his outsider status, at least at first, as a black man among Jews. He tells us, as well, that he knows that if he becomes a Jew he will take on yet another kind of outsiderness in American culture. It is a complicated story.

Throughout *Lovesong,* Julius Lester interweaves his experiences of blackness with the insights and incidents that lead him toward Judaism and that help him explain to himself what he has experienced as a nearly lifelong yearning for Judaism. Two of the most powerful incidents in the book offer counterpoint situations—one in which Lester feels acutely that he is not a Jew with another in which he knows that he is a Jew. Together—and Lester, I am certain, means the reader to pull them together across the intervening pages—they point to one of the major themes of the book and the backbone of its narrative: Lester's split identity and its eventual healing. In the first instance, Lester is asked by a Jewish colleague to attend Kol Nidre services with him at his synagogue. This is at a time when Lester is having a great deal of trouble with black colleagues over a course he is teaching on blacks and Jews. He says of the service, "I am afraid to go, afraid I will be betraying my people again. But something in me needs to go, needs to be with—how odd. I almost said, needs to be with other Jews."[28] He is moved by the service: "I sit in the rear of the synagogue and when the cantor begins singing Kol Nidre, I think of my great-grandfather. . . . Tears fill my eyes as the cantor's voice breaks with emotion, and something in me does not feel alien sitting here on this eve of the Day of Atonement."[29] But Lester cannot sustain the feeling: "Suddenly I see myself as if I am looking down from the balcony. I am the only dark face here. I look alien. The yarmulke perched flimsily on my head looks silly. I want to run out. I do not belong here."[30]

Two years later Lester is lying in bed and, although not asleep, he has a vision of himself wearing a yarmulke and dancing down the middle of a brick street. "The joy of the vision," he says, "permeates my body and I smile. I want to laugh aloud, to get out of bed and dance. I

want to shout: I am a Jew! I am a Jew dancing the joy of God!"[31] He wants to tell his wife but he is afraid of what she will say. Two weeks later he tells her, "I think I'm going to convert to Judaism." "I'm not surprised," she says.[32]

Rita Gross, a well-known scholar and teacher of Buddhism, who taught for many years at the University of Wisconsin–Eau Claire, has written a number of scholarly essays that also are self-disclosing, testimonies to her conviction that scholarship and personal revelation about religious transformation are not methodologically opposed to each other. One of the essays in *Soaring and Settling: Buddhist Perspectives on Contemporary Social and Religious Issues* I find especially helpful for a project like this one is titled, "Why Me? Reflections of a Wisconsin Farm Girl Who Became a Buddhist Theologian When She Grew Up."[33] Gross grew up in a log cabin on a poor farm near Rhinelander, Wisconsin. She did not see a flush toilet until she was seven, she tells us. There were no books or newspapers in her home and education was not encouraged. It is difficult to imagine how she became one of the first Buddhist feminist theologians, and, although this essay does not mention it, she also spent some years as a Jew. "Why Me?" is framed aesthetically by the theme of distances: between her childhood milking cows by hand and studying Sanskrit in the Swift Hall Library of the Divinity School at the University of Chicago; between the hayfields of her home and the meditation caves of Tibet. This is also an essay about bringing things together: what Gross calls the reunification of her history-of-religions head with her theological heart and her past with her present. She still owns the log cabin she grew up in and she has returned to it in recent years along a "trail indiscernible to most eyes" to complete a meditation practice that requires total isolation. In another work, *Buddhism After Patriarchy*, Gross tells us that she feels she probably has a karmic predisposition to Buddhism but she acknowledges, as well, that she never would have known enough to convert herself to Buddhism if she had not had academic training in that religion.

The moment of conversion, if there ever is such a "moment," came in September of 1973, as she was walking across the parking lot to her class at the University of Wisconsin-Eau Claire. She knew she was in a place that most likely would not appreciate her gifts and interests, much like the place she had come from where she had struggled as a woman

in a male-dominated academic department. She was grieving for the young man with whom she was in love who had a terminal brain tumor. She tells us that it was "the kind of unbearably beautiful fall day that makes living so far north so pleasurable, [and she was] thinking about how to teach the Four Noble Truths, which I did not think I understood very well, in my upcoming Buddhism class. . . . Something suddenly snapped in my mind and I said to myself in wonder, 'The Four Noble Truths are True!'"[34] This moment moved her to seek out Buddhist meditation disciplines and, she is convinced, set her life "onto a course that previously I had never deemed possible."[35]

These last three stories are about yet another set of encounters with varying kinds of "otherness": a different religious tradition, a new landscape, and a devastating physical illness. All of them illustrate an artful bringing together of past and present, evident in the capacity of the storytellers to keep vital the traditional language, symbols, and most moving claims of their traditions and to do so in ways that are open to new interpretations and experiences.

Sara Grant, who died in 2000, was raised a Roman Catholic in Scotland "in the traditional Christian mode," she tells us in *Toward an Alternative Theology: Confessions of a Non-Dualist Christian.* She was given a great deal of practical religious advice by her mother and she and her brother loved hearing the first three chapters of Genesis read to them, "based on the at least apparently dualistic vision of the Bible."[36] By the time she was three, she knew the chapters "practically by heart," and she knew from common sense experience that the world is made up of "pairs of opposites." She became a nun, studied classics at Oxford, moved to India to teach in a Catholic school, and spent many years of her life living in an interreligious community. She was the director of an ecumenical Christian ashram in Poona.

Even as a child, Grant tells us, she became gradually "aware of a sense of somehow living in two dimensions of consciousness, that of the visible world of everyday life and that of another, mysterious world, least inadequately described as the sense of a presence which was also an absence." What baffled her more, she recalled, was that "no one else seemed to be bothered by this awareness of two dimensions of being and the need to reconcile them."[37]

Grant lived out most of her lifelong search for this reconciliation—she called the first chapter of her autobiography "The Questing Beast"—in India, where she met Hindus, studied Hindu scholars and scriptures, and taught Hindu students. She remained a Christian but came to know how much Christianity and Hinduism had to teach each other about the nondualist nature of reality—God in everything and everything in God. She began to understand her role as a teacher of Hindu students as one of helping them to be better Hindus, to learn their own scriptures, and in doing so she became a "better" Christian, a nondualist Christian. *Toward an Alternative Theology* is not exactly a spiritual memoir; it is a collection of three essays that she delivered at Cambridge and Bristol Universities in England in 1989. The essays are filled with autobiographical references, though, to Grant's theological seeking and to her growing intellectual and experiential understanding of Hinduism's potential for understanding, particularly the nondualist nature of Jesus. She tells numerous lump-in-the throat stories about the powerful effects of experimental eucharistic liturgies on people of very different religious backgrounds. Throughout, Grant conveys her conviction that, however grateful we must be for the church's initiatives in social justice, she thinks it is "too easily forgotten, if indeed it is realized at all, that catering to people's deep inner hunger is also a part of justice."[38] It was this deep inner hunger that was satisfied by her encounter with Hinduism.

In a very different kind of encounter and reconciliation, Carolyn Servid brings together in *Of Landscape and Longing* the coastal village of her childhood in western India, "the first place I came to love," with the Alaskan landscape where she has spent most of her adult life. This is also the story of Servid's gradual reconciling of her childhood faith with the more expansive understanding she comes to have of a spirituality grounded in nature and place. Like Grant's, the Christian faith Servid was taught as a child was a traditional one, more, as she experienced it, about "authority" than about love. Miss Burke, her teacher at boarding school, became the focus for this early faith. It was only in the grey stone chapel of the school that the hymns she sang gave her comfort rather than guilt and fear.

Years later as a young adult she was in Alaska for the first time, overwhelmed by the magnificence of the landscape. She felt that

"Creation itself was demanding witness": "Our rattling Volkswagen rolled on down the road and a sweet tenor voice on the tape deck sang with his guitar. . . . I tried to stretch myself around the swell of my heart. I tried to imagine a music to fit the landscape and thought of Beethoven's Ninth Symphony or Keith Jarrett's Koln Concert. But the melodies that came to me were from the hymns that had filled the sanctuary in that chapel of grey stone. 'Miss Burke, Miss Burke,' I thought, 'If you want to see God, if you want to witness the Holy Spirit, come and look, come and witness this.'"[39]

In the conclusion of the book, Servid describes lying in bed after the end of one of the annual symposia she and her husband sponsor to "synthesize word and idea, story and concept, poem and conviction." Her parents are visiting for the symposium and she can hear her missionary father praying downstairs in the way she remembers from childhood—for each of his children, one by one, and for many other people besides—"all given to the capacious and caring hand of God, all bestowed with love." She can also hear the song of the hermit thrush outside her window, a bird that has been a messenger for her in the past, and the song "a heavenly accompaniment to my father's prayer. I lay still and closed my eyes, grateful for those holy blessings."[40]

And the final story. In 1989 Robert Detweiler published one of his several books on religion and literature, *Breaking the Fall: Religious Readings of Contemporary Fiction.*[41] It was very well received, and I do not have to belabor the multiple and deep meanings one can derive from a title like *Breaking the Fall.* In 1995, Detweiler suffered a terrible stroke and, during the months of his recovery, he worked on a new preface to the next edition. For him the title of his book had taken on new life in powerful, existential ways. The major interpretive concept of the first edition was Gelassenheit, a German word that Detweiler defined as a "mystical abandonment in which one can live one's life, one's fate, in a spirit of abandon, of absolute dependence, letting it flow."[42] "How can I now write about Gelassenheit," he asks, "for my fate after my fall was precisely to be given the 'fall' of which I punned."[43] In the new preface, Detweiler tells us some of the things he has learned about Gelassenheit through his stroke and about revelation and story, love and prayer, the language of the body and the language of love. He says

he has learned "the critical moments of trust as I fall in order to progress toward blessed motion."[44] He has deepened his conviction that "story is redemptive by nature, hoping against hope that one will yet be saved by and through the telling."[45] He has discovered, he says, "in the last analysis, that the language of the body, the language of pain, and the language of love are the same."[46]

These stories have tumbled out one after the other. They have been all over the map geographically, theologically, aesthetically. An aesthetic of hope must be capacious enough to be open to all of them—to their depths and nuances and border-crossings and uses of the religious imagination. Why do people tell these stories? Why do we listen to them or tell them ourselves? To put it very simply, I think we do so because we know at a profound level that they are good for us—they give us new life. They are friends to us, as rhetorician and literature professor Wayne Booth has put it. "Good" stories are good in many ways. They help us to see not only truth and possibility but the beauty as well in the stories of other religious traditions, in the spiritual journeys of very different kinds of people, and in our own journeys, journeys that may well have lost the intensity of their earlier meaning in our lives. They make us hopeful that more is possible—more of justice and love and beauty—than we have yet been able to imagine. They help us to see, in fact, that we need to do more imagining and re-imagining of our traditions both alone and with each other. We know only too relentlessly—we cannot un-know it—that the world is a dangerous place, full of violence and greed and self-interest. There is no story I have told that does not suggest this reality at some level. But we need to know, just as fiercely, that there are other things about the world as well and that hope and religious vitality can take many forms. I would go so far as to say that we have a moral obligation to find hope in these many different forms, to seek out stories that are hopeful and to "enjoy" them, to be encouraged and changed by them, renewed by them. If "enjoyment"—our own as well as enjoying the enjoyment of others—is, as Frank Burch Brown points out, a form of love,[47] it is also, I am convinced, a form of hope.

⌣

NOTES

1. This essay is a revision of Mary Farrell Bednarowski, "Lump in the Throat: Stories, Narrative Art, and the Theological Imagination," in *New Conversations: Imagination, Creativity, and Change,* Proclamation, Identity and Communication Ministry, United Church of Christ (Winter 2004), 28–41.

2. Donald P. Gray, "A New Creation Story: 'The Creative Spirituality of Teilhard de Chardin,'" in *Teilhard in the 21st Century,* ed. Arthur Fabel and Donald St. John (Maryknoll, N.Y.: Orbis Books), 26.

3. Ibid.

4. Mary Farrell Bednarowski, *The Religious Imagination of American Women* (Bloomington and Indianapolis: Indiana University Press, 1999). See especially chapter 6, "Healing and Women's Theological Creativity: Strategies of Resistance, Acceptance, and Hope."

5. Judith Shulevitz, "In God They Trust, Sort of," *The New York Times Book Review* (Sunday, August 25, 2002): 27.

6. Ibid.

7. However ubiquitous this distinction, however trite and annoying it can feel to those of us who live out our personal and professional lives within religious institutions, it is pointing to something experienced as both powerful and true by millions of people at this moment in history and about which they tell stories. As such, it must be taken seriously.

8. Rachel Adler, "In Your Blood, Live: Revisions of a Theology of Purity," *Tikkun* 8:1 (January/February 1993): 38–41. A longer version of this story can be found in Bednarowski, *Religious Imagination,* 39–41.

9. Adler, "In Your Blood."

10. Rachel Adler, *Engendering Judaism: An Inclusive Theology and Ethics* (Philadelphia and Jerusalem: Jewish Publication Society, 1998), 2.

11. Ibid., 16.

12. Ibid.

13. Robert Detweiler, "Vexing the Text: The Politics of Literary-Religious Interpretation," *Christianity and Literature* 41:1 (1991): 65.

14. Meinrad Craighead, *The Litany of the Great River* (Mahwah, N.J.: Paulist Press, 1991), 9–10.

15. Ibid.

16. Terry Tempest Williams, *Leap* (New York: Pantheon Books, 2000), 13–14. In the spiritual memoir, Williams offers the story of her encounter in the Prado Museum in Madrid with a triptych, *Garden of Earthly Delights* by Hieronymus Bosch. As a child, Williams frequently saw two parts of the triptych, "Heaven" and "Hell," in a reproduction that hung over the bed she slept in when she stayed with her grandparents. She was astonished to discover that the original painting had three panels, and the one she had not seen as a child was the one that depicted earth as paradise.

17. Ibid.

18. Ibid.

19. Andre Dubus, *Meditations from a Movable Chair* (New York: Vintage Books, 1998), 89–90.

20. William Kittredge, *Taking Care: Thoughts on Storytelling and Belief* (Minneapolis: Milkweed Editions, 1999), 79.

21. Ibid.

22. Ibid.

23. Ibid.

24. Tom Crider, *Give Sorrow Words: A Father's Passage Through Grief* (Chapel Hill, NC: Algonquin Books, 1996), 159.

25. Ibid.

26. Ibid.

27. John D. Barbour, *Versions of Deconversion: Autobiography and the Loss of Faith* (Charlottesville and London: University Press of Virginia, 1994), 1.

28. Julius Lester, *Lovesong: Becoming a Jew* (New York: Arcade Publishing, 1988), 134.

29. Ibid., 136.

30. Ibid.

31. Ibid., 160.

32. Ibid.

33. Rita M. Gross, "Why Me? Reflections of a Wisconsin Farm Girl Who Became a Buddhist Theologian When She Grew Up," in *Soaring and Settling: Buddhist Perspectives on Contemporary Social and Religious Issues* (New York: Continuum, 1998), 19–33.

34. Ibid., 25.

35. Ibid.

36. Sara Grant, R.S.C.J., *Toward an Alternative Theology: Confessions of a Non-Dualist Christian,* introduction by Bradley J. Malkovsky (Notre Dame: University of Notre Dame Press, 2002), 7.

37. Ibid.

38. Ibid.

39. Carolyn Servid, *Of Landscape and Longing: Finding a Home at the Water's Edge* (Minneapolis: Milkweed Editions, 2000), 39.

40. Ibid., 186.

41. Robert Detweiler, *Breaking the Fall: Religious Readings of Contemporary Fiction* (Louisville: Westminster John Knox Press, 1995), vii–x.

42. Ibid., viii.

43. Ibid.

44. Ibid., vii.

45. Ibid., ix.

46. Ibid., x.

47. Frank Burch Brown, *Good Taste, Bad Taste, and Christian Taste: Aesthetics in Religious Life* (New York: Oxford University Press, 2000).

4

Spirit Standing Still

Documenting Beauty in Photography

KIMBERLY VRUDNY

No matter how slow the film,
Spirit always stands still long enough
for the photographer It has chosen.
—MINOR WHITE

In his attempt to articulate the power of images to elicit an aesthetic response in the viewer, art historian James Elkins posted inquiries in newspapers and journals, asking people to share with him their experiences of crying in front of paintings. Over four hundred people responded, many of them making reference to some sort of a mysterious presence in the images that moved them. In *Pictures and Tears,* the book that recorded his analysis of these responses, Elkins published some of the letters he received, including a deceptively simple letter

signed by one Robin Parks, who alluded to the possibility that God was the power present within an image:

> Hello.
>
> I cried in a museum in front of a Gauguin painting—because somehow he had managed to paint a transparent pink dress. I could almost see the dress wafting in the hot breeze.
>
> I cried at the Louvre in front of Victory. She had no arms, but she was so tall.
>
> I cried (so hard I had to leave) at a little concert where a young man played solo cello Bach suites. It was in a weird little Methodist church and there were only about fifteen of us in the audience, the cellist alone on the stage. It was midday. I cried because (I guess) I was overcome with love. It was impossible for me to shake the sensation (mental, physical) that J. S. Bach was in the room with me, and I loved him.
>
> These three instances (and the others I am now recollecting) I think have something to do with loneliness . . . a kind of craving for the company of beauty. Others, I suppose, might say God.
>
> But this feels too simple a response.[1]

Robin Parks' response is anything but simple, for it drives to the heart of the discussion about this mysterious presence cited by so many of Elkins' respondents as the power present within images to evoke an emotional response. Parks writes about a "craving for the company of beauty" in association with love, and with God. Philosophers and theologians have through the centuries seen in beauty and in love a bridge between what is human and what is divine. In these concepts are the roots of a sacramental encounter—an encounter with the holy through the mediation of physical materials. So when Robin Parks was moved to tears in front of a Gauguin painting, while looking at Victory, and upon hearing the Bach suites, these theologians give us reason to suspect that perhaps she was in fact in the company of Divine Beauty, one of the names by which Christ is known. Perhaps Christ was the mysterious presence encountered in these images. For the briefest of moments, perhaps it was he who abated her loneliness for the company of beauty. Perhaps she cried because she communed with God.

In recent years, I have been drawn to documentary photography and its profound ability to capture something of this mysterious presence. I have collected on my office walls laser copies of six documentary photographs, broadly defined, which have moved me to tears. They are pictures that make me aware of my vulnerability and the precious nature of human life; they help me to imagine a kinder, gentler, more loving universe and call me to accountability in its creation; they raise in me questions of an existential nature even while they assure me of God's presence. In living with these images, I have struggled to understand the mysterious presence I sense within them. Ultimately, this search for meaning led me to theological aesthetics, the discipline charged with articulating connections between God and the perception of Beauty. By reading classical and contemporary approaches to the question of the relationships between the beautiful and the sacred, I began to develop a sketch of my own theological aesthetic—an intellectual construction of how aesthetics inform the theological imagination. Although this essay might be read as a general introduction to the theological aesthetics of the six theologians discussed in the pages that follow, it is meant to be an articulation of my own understanding of beauty as a theological category, an understanding heavily influenced by the writings of Augustine, Paul Tillich, Karl Barth, Hans Urs von Balthasar, John of Damascus, and Immanuel Kant, as well as by the photographs of Sebastião Salgado, Steve McCurry, Shirin Neshat, Seyed Alavi, and Joanna Pinneo.

The words and images of these theologians and artists have given shape to my sense of beauty's identity with existence itself: with God, and with the perceptible presence of Being in the midst of the full range of human life. In this essay, I am conceptualizing existence as a continuum that stretches between two poles: being in glory and being in suffering. Because the entire continuum is identified with existence itself—with God, who is called Divine Beauty—I call it the "continuum of beauty." Beauty, therefore, is defined as identical with existence itself, with a God who has been revealed both in glory and in suffering. When God chooses to make that which is sacred known in human existence, there is no diminishment or enlargement of existence at either end of the continuum, for the entire spectrum is imbued with perfect holiness. This was the first-century experience of Christ, whose suffering did not

diminish his being, nor did glory intensify his existence. The heights of Christ's glory as well as the depths of his suffering, and all the ranges in between, assure us that God is present in all of existence. Existence itself, therefore, is experienced as beautiful. Because of the perceivable presence of God still on the continuum of existence, so, too, can humankind experience beauty in all moments of its shared and earthly existence, whether in glory or in suffering. In such an experience, there is a stripping away of everything superficial. In the absence of all distractions is the sacred presence of God. A life of faith that grows in maturity acquires a sense and taste for the building up of true existence, of enhancing human acknowledgment of true beauty in the world, by becoming more skilled, by God's grace, at distinguishing between what is worthy and what is unworthy of our sustained creative efforts.

In imagining this continuum of beauty, I am indebted to writers in the Christian tradition. Augustine's conception of the soul's existence and orientation as deriving from God in proportion to the Divine Beauty from which it comes enables me to envision a continuum of human existence understood corporately. Rather than focusing on my own individual position on the continuum of beauty, I suggest that humankind will either rise to greater glory or sink to greater suffering as an entire species, based on its response to grace. Looking outward demonstrates a mature response, whereas self-absorption marks an immature response. Therefore, we are dependent upon one another's responses to grace for our common, earthly redemption. Recognizing, then, the vulnerable and precarious nature of this human existence, dependent as we are on both God and one another, we are situated beneath glory but above nothingness by proportion to the truth, goodness, and beauty given us by God, and by the maturity of our response to that gracious determination. The dynamic between those who mature in faith as demonstrated by turning outward and those who remain self-absorbed determines the position of all of humankind on the continuum of beauty between glory and suffering. I draw on the theology of courage as articulated by Paul Tillich to affirm that it takes great courage to be—to actualize true existence, or true beauty, by aligning oneself with the forces of Truth, Beauty, and Goodness over and against conditions of brutality, violence, and unspeakable horror. But until

greater numbers of the population surrender their own self-interests to grace and become more mature in living faithfully, the entire species will suffer. Barth's theological aesthetics reminds us that the human population is not left to its own broken devices as it is charged with the task of enacting beauty in the world; rather, Beauty was God's gift to humankind in Christ, whose presence within us enslaves us to greater service of those with whom we come into contact. We become Beauty to one another once we are embraced by God. This is a phenomenon experienced in faith. Likewise, Balthasar discusses the transformation of the human heart that occurs as a result of the human surrender to this gracious encounter with Divine Beauty. Once transformed by interaction with Beauty, and strengthened by ongoing access to Beauty in the Word and in all things sacramental—things numerous, indeed, John of Damascus assures us—the population is imbued with courage. They are able to confront injustice, ultimately driving the human creation to the virtuous *telos* Kant envisions in his work: a world so marked by an awareness of the Beautiful that rebellion in its midst would be unthinkable. This earthly redemption, surely never to be realized, is nevertheless always to be hoped for and striven after.[2]

THE HOLY LOVER
Augustinian Theology and Beauty in Sebastião Salgado

In a 1985 image from his *Famine in the Sahel* series, documentary photographer Sebastião Salgado captures on film a mother feeding her twins in a nutritional center in Mali (ill. 1). She remains faceless, her identity kept mysteriously beyond the scope of the camera lens. Most of her body is hidden, too, beneath the graceful folds of drapery that join in a visual union with the blankets warming her frail babies. The fabric is clasped in the right hand of one of her infants, his other hand supporting the shriveled breast upon which he feeds. The other infant babe lifts his arm to tug on the breast itself, exposing a ribcage that pokes through skin stretched thinly over his tiny frame. It is difficult to look at this image for any length of time. Indeed, our immediate impulse might be to look away—its content too painful to absorb. Salgado himself admits the paradox of such a response. "The human situations you see that are very difficult are part of life," he writes, "and they must be shown."[3]

Born in 1944, Sebastião Salgado earned a master's degree in economics before fleeing his native Brazil in 1968 when a military dictatorship was established. Settling then in Paris, he worked towards a doctorate in economics at the University of Paris until 1971, when he was hired by the International Coffee Organization to assist in diversifying coffee plantations in Africa. Taking with him his wife's camera, Salgado soon "found that he could depict [the people to whom he was drawn] more vividly in photographs than in economic reports."[4] Thus he ended his career as an economist, and started one as a freelance photojournalist or, more accurately, a documentary photographer, covering first the drought and ensuing famine in the Sahel region of Africa—a tragedy which would recur, and to which he would return to photograph again in the 1980s.[5]

The theology of Augustine of Hippo (354–430 C.E.) is useful in helping us contemplate the power present in the encounter with Salgado's image, for Augustine understands beauty, too, in terms of a continuum. In his *De Musica* (389 C.E.), Augustine borrows language from the field of music in order to describe his theological construction. Originally, Augustine believes, there was perfect harmony, a certain equality, between the Creator and the creature but, ever since the time humankind sinned against the Creator, disharmony has reigned. Rhythm is the term employed by Augustine to describe the degree of correspondence between the Creator and the creature in the fallen world. The world is filled with things comprised of some combination of the true, good, and beautiful, and that which lacks the true, good, and beautiful. The higher proportionality something shares with the truly Beautiful, the more rhythm it is said to have. Such a high proportionality is the result of divine providence, for Augustine's system is highly deterministic. The more one is in sync with the rhythm established by God, which itself comes as gift from the Creator, the more truth, goodness, and beauty a person is enabled to perceive and enact in the world.

For Augustine, it is only by the grace of God that humankind is able to perceive truth, goodness, and beauty with accuracy at all, for, just as these transcendental qualities of being belong preeminently to the identity of the Father, so do they construct the identity of the Son—

the only dimension of the Godhead perceivable to humankind by sense. While the human soul was oriented away from God and all things holy after the fall, Christ came in order to repair the orientation, according to Augustine, and to return its preference for the Trinitarian God. "The whole quality of the soul's existence . . . is from God, and therefore, while it remains within its own order of being, it is enlivened . . . in mental activity and in self-consciousness . . . by God's presence."[6]

Like Augustine, I understand being, or existence itself, to be understood as a polar construction, which I am calling the "continuum of Beauty." The Trinitarian God comprises the entire continuum and is identified here as Beauty—the entirety of existence stretching between "Being in Glory" (marked by an absence of suffering) and "Being in Suffering" (marked by a privation of glory). In my own understanding, humankind, as a collective unit, intersects this continuum between glory and suffering, currently lower rather than higher.

Unlike Augustine, I understand the entire continuum of human existence to be pervaded by God's actual presence extending from physical and spiritual glory to physical and spiritual suffering—from fullness of Being (the Trinity) to a lacking of being in glory. Augustine denied this possibility. Like Plato, Augustine's thought is pervaded by the sense that the true, good, and beautiful, experienced by humans in the world but belonging preeminently to the essence of the Trinitarian God, are only *imitations* of what is most truly real: the Form. Truth, Goodness, and Beauty belong preeminently to God as God's very own identity. All that is earthly is merely a poor imitation of the godly, according to Augustine—and is sometimes despicable, indeed.[7] Therefore, I believe deception, evil, and deformity, the contraries of truth, goodness, and beauty, are present in the world as lesser participations in, rather than only lesser imitations of, the divine source from which they derive. Nonbeing, or nothingness, that which is fully deceptive, evil, and deformed, has nothing left of divinity, or true Being, in it. As such, they cannot be said to exist.

In the human realm, glory and suffering are experienced communally. The quality of existence for all of humankind is directly impacted by the degree to which we allow one another to participate in glory, or to languish in suffering. When one needlessly suffers, we all are pre-

vented from experiencing fuller glory. When justice is demonstrated, we all taste glory, and begin to crave it more and more. By responding to grace maturely in the justice and love shown our neighbors, we are enabled to advance in an upward fashion on the continuum of Beauty, occupying now a higher degree of glory while challenged, still, by the presence of injustice and suffering.

Given this construction, we are able to return to Salgado's image of the breastfeeding mother at the nutritional center for children in Douentza and reflect on it in relation to this continuum of human existence. If we were to categorize this image from Salgado's *Famine in the Sahel* series using Augustinian concepts, specifically beauty and its contrary, deformity, I suspect that most would tend to see deformity here. The babies are starving. Because she, too, is starving, the mother's breasts are no longer producing the milk that ought to be in endless supply for her infant babes. Her dingy cloak and the dry dirt in the background combine to provide the viewer with a heightened sense of the desperate conditions in which this mother lives with her infants. All of this is dramatized by the use of black and white film. Yet, Salgado's image is certainly beautiful in the formal, classical sense. That is to say, it is artistically rendered, with attention to line, shape, color, and texture. The composition has a fine interplay between positive and negative space. Light and dark are distributed in a way that is pleasing to the eye. This image is almost sculptural in its execution. The crevices in the mother's shawl are deep enough that the viewer is almost able to feel them as the plane of the photographic surface disappears. So, while Salgado's photos are aesthetically excellent, their content raises serious questions about classical definitions of beauty, deformity, and the fine gradations between these two poles.

It is my proposal that the starving mother and hungry infants are beautiful in the very sense that they have being. However, because they are prevented from partaking in the good things of the earth, they suffer. It is not they who are deformed—but the circumstances that make them starve, and the participants in a system that perpetuates their hunger. The root of our desire to look away is not, I propose, their deformity, but an instantaneous recognition of our own as a human collective. The deformity is located in a worldwide culture that allows

these circumstances to exist despite the abundance of food inequitably distributed among the world's population. This is the power of the image—it carries within itself the power to capture the communal aspect of our earthly existence, the degree to which we depend upon one another for our own well-being. It captures a conception of the continuum of Beauty by stripping away everything superficial, and by revealing Existence itself. It reveals what is holy and sacred in existence. It reveals God.

Individually, we all exist as occupants of the continuum of Beauty in varying and shifting degrees between glory and suffering as our own circumstances change, sometimes dramatically in an instant, in response to disasters, both natural and human-made. But our individual placement on the continuum impacts the position of all humankind between glory and suffering. The presence of Being in the image insists that we recognize our position on the continuum of human existence, and our responsibility in alleviating suffering wherever possible, for we recognize, too, our own vulnerability, our own dependence on God, fate, governments, and individuals who, like us, occupy this continuum of existence. In this way, we can consider this image beautiful without objectifying the dignity of the subject, and without glorifying suffering, for we acknowledge a commonality with one another that comes from being in the world for any length of time. This is the power of the mysterious presence of Salgado's image—the power of Being in the image both to indict wrongdoing, and to empower compassion according to the ability of the viewer to respond accordingly.

THE BELOVED, BROKEN IMAGO DEI
Tillichian Anthropology and Beauty in Steve McCurry

As a National Public Radio reporter noted, "Photographer Steve McCurry's love of Afghanistan produced perhaps the most well-known anonymous face of our time—the piercing stare of a young woman peering from a bedraggled cloak. She was an Afghan refugee, and Steve McCurry took her picture for the cover of *National Geographic* magazine" (ill. 2).[8] For seventeen years, her name remained unknown to McCurry, and to all who had seen her photo. McCurry resolved to find her again after learning that the destruction he witnessed from the roof

of his Greenwich Village studio in New York City on September 11, 2001, was related to Osama bin Laden and the Taliban in Afghanistan, and after learning that the refugee camp where he photographed that haunting image was about to be destroyed to create a housing project. Showing her photo to village elders in the Pakistani camp, McCurry and his team were given several false leads before showing the photo to a man who insisted that the girl had lived next to him about ten years earlier. He told McCurry that he knew where the girl's brother was, and the brother led McCurry to Sharbat Gula, confirmed by FBI forensic examiners and their use of iris recognition technology to be the woman in the 1985 photograph.

McCurry's portrait of Sharbat Gula expresses something of what it is to be human, for this woman has confronted something we all fear, and which too many have experienced personally. She has seen war and its bloody consequences. Both of her parents were killed in Soviet bombings. To escape the terror, her grandmother escorted her, with her brothers, to Pakistan, begging along the way for blankets to keep them warm. Whether she is haunted by being orphaned, exiled, starved, or still more that remains known only to her, the girl's eyes indicate that she is tormented by what she has experienced. And we who peer into those eyes recognize something of vulnerability—of human dependence on God and on one another. She remains a powerful symbol, inspiring compassion and compelling investigation into the causes of senseless brutality in order that they might be abolished. Finally, though, she remains a woman who lives with the horrors of all that she has seen. McCurry himself endorses such an interpretation. "For me, photography is a way of looking at people, of gaining insight into the human condition. . . . I want to learn something about the person, about life."[9]

Born in Philadelphia in 1950, McCurry attended the College of Arts and Architecture at the Pennsylvania State University. After he graduated with degrees in cinematography and history, he worked for two years at a newspaper, then left for a freelance career in India—a place that would become his passion. He says it was in India that he learned an important lesson in photography, a lesson that impacts this exploration of spirit standing still: "If you wait," he writes, "people would forget your camera and the soul would drift up into view."[10]

Soul drifted into view in the renowned photographs McCurry captured in Afghanistan. Among the first to document the conflict between Afghanistan and Russia, McCurry was able to capture these images by crossing the Pakistan border dressed in native clothes. His photographs survived only because he sewed the film into the lining of his jacket. Describing his first experience of taking the now famous photograph of the Afghan refugee, McCurry notes, "I went into a refugee camp, and I was kind of wandering through, and I saw this one particular girl who had this really kind of haunted look in her eye. So I got permission to photograph her."[11] He goes on, "Her look kind of summed up the horror, because her village had been bombed and her relatives had been killed, and she'd had to make this two-week trek through the mountains to the refugee camp."[12] In response to a question about why he believes the portrait has captivated viewers around the world, McCurry discusses the girl's "hopeless beauty."

> I think it's that hopeless beauty conveyed in her look. She's a very beautiful girl, but it's clear that she's poor; her face is dirty; her shawl is ripped; yet she has a sort of dignity and perhaps confidence and fortitude. In her eyes, I suppose you could sense that there's something troubling her, something not quite right. Perhaps she's seen more than she should have at such a young age. So she's very pretty, but she has flaws such as her scar and the dirt on her face. It's a mix, which gives it a sort of realness. It's not posed or contrived. It's just a young girl.[13]

According to Paul Tillich (1886–1965), who offers us a way to view this portrait in theological terms, it takes great courage to be in the world. The Afghan refugee attests to this truth. Great are the number of things that can harm us. Those we love can, and do, die—sometimes prematurely, sometimes senselessly. And great are the number of things that can draw us away from God. For Tillich, these things are idolatrous, indeed, for they pull us away from that with which we should be "ultimately concerned." They throw our entire being off balance, making us contribute more to the absence of being than to the construction of being itself. "Ultimate reality underlies every reality, and it characterizes the whole appearing world as non-ultimate, pre-

liminary, transitory, and finite. . . . We search for an ultimate reality, for something lasting in the flux of transitoriness and finitude."[14]

Tillich understands there to be a correlation between fullness of being and nonbeing. Jesus of Nazareth demonstrates a life lived in all its fullness. He was concerned ultimately with the Father, and lived thereby with a focus on the dignity of those men and women with whom he came into contact, especially those on the margins, neglected as they were by the Empire and by the religious establishment. He was willing to take nonbeing upon himself at the crucifixion in order that these despised ones might become more fully actualized, like Christ. According to Tillich, actualization is accomplished by focusing attention on things ultimate, thereby avoiding a disastrous cycle of poorly attributed concerns, which Tillich calls idolatrous faith.

After witnessing the type of violence Sharbat Gula has seen, Tillich's theology suggests she has a number of choices. She can live in fear, refusing to take chances because of the risks involved, and because of the chances of seeing repeated those scenes that torment her. Tillich might interpret such a response as a tendency toward nonbeing, for she would live with little courage. She could make her ultimate concern her family, her camp, her nation, or her revenge, risking destabilization when death comes to her loved ones, her camp is destroyed, her nation betrays her, or the cycle of vengeance is elevated. Or, Tillich suggests, she can center herself in the ground of being which, for a Muslim, would be expressed in her faith in Allah. Such a center would allow her to express righteous anger when necessary, enabling her to serve family, community, and nation. Such a faith structure would permit her to be in the world, a witness to atrocity and a symbol of resistance.

Tillich's theology is appropriate to consider here for its treatment of the existential nature of human existence—its messiness, its brutality, its unpredictability. Because the portrait of young Sharbat Gula reminds us of our dependent nature, it is a portrayal of the *imago Dei*—broken, but beloved. Tillich concludes his classic treatment of the human person in relation to God: "The courage to be is rooted in the God who appears when God has disappeared in the anxiety of doubt."[15] Despite the insecurities we face, and in spite of the location we find ourselves on the continuum of Beauty, we endure. We persevere,

trusting that the Holy, the sacred ultimate concern upon which we rest our faith, is worthy of love. Most importantly, however, we have the courage to go forward because we trust that we are God's beloved—the ones upon whom God pours love, in spite of the conflicts in which we entangle ourselves, or perhaps even because of them, for in them we recognize our dependence all the more.

FAITH AND THE EMBRACE OF THE HOLY
Barthian Soteriology and Beauty in Shirin Neshat

A woman's hands are marked by calligraphic designs, mostly interlocking, geometric, teardrop shapes and flowers, surrounding the artfully scripted Arabic words "My Beloved is God," and "I am sacrificed for God." These hands embrace an infant's cupped and unmarked hands. Artist Shirin Neshat calls the image, simply, *Faith* (ill. 3).

Born in Qazvin, Iran, in 1957, Shirin Neshat was studying art in the United States when, in 1979, the revolution in Iran established the Islamic theocracy of Ruhollah Khomeini and the Ayatollahs. Until Khomeini's death in 1989, Neshat was prevented from returning home to join, or even to visit, her family. In 1990, after Khomeini died, she was able to return to her homeland. She was greatly disturbed by the new lifestyle imposed on Iranians in general and, in particular, the lifestyle imposed on women. "As she herself stated in an interview in 1997, the changes in her country represented for her one of the most upsetting experiences of her life and convinced her to return often."[16] Thereafter, she dedicated her work to a reflection on the threshold between East and West, which in some ways can be interpreted in an autobiographical way, for she "appears tormented in one and excluded from the other."[17] The tragedy is that she perceives both West and East to torment and exclude her, sometimes simultaneously. Of her film, *Soliloquy* (1999), which directly treats these matters, Neshat has said,

> architecture is the core of the narrative since it represents two opposite cultures: the East and the West, the traditional and the modern, the communal and the individual. It's about imaging the emotional state of a woman standing at the threshold of two opposite worlds. . . . By the end we find that the woman never quite feels at peace in either space.[18]

In her work, Neshat explores themes of isolation and alienation, espe-
cially as those themes interact with gender, generally, and with radical
Islam, more specifically.

In her *Women of Allah* series (1993), from which the image dis-
cussed here is taken, Neshat imagines herself posing for various com-
positions, and then asks a photographer to shoot the image as Neshat
imagines it. Once the film is developed, Neshat writes on the print with
black ink, designing the patterns of image and text that sometimes com-
pletely cover whatever human flesh is unveiled. Although she has been
criticized for her use of the traditional chador, or veil, in her work, and
thereby for underscoring stereotypes of Islamic, Iranian women,
Neshat's images are multivalent, resisting simple interpretative frame-
works. Her use of veils, texts, guns, and bodies is endlessly complex, at
the same instant breathtaking and disturbing.

In *Faith*, Neshat captures the essence of her Muslim tradition—
that Allah is a God who has reached out to humankind through the sa-
cred words of the Qur'an. For her, this image suggests, faith is not
about adherence to a set number of laws or doctrines; it is not about an
intellectual understanding of revelations to a prophet; it is not about the
superiority of one piety over and against another. Instead, faith is a spir-
itual reality in which God breaks the barriers between the divine and
human realms and embraces humankind, all of us still children by con-
trast to the wisdom of the truly sacred who is always finally veiled be-
yond human comprehension and perception, yet periodically and mo-
mentarily unveiled. For Muslims like Neshat, this occurred when
Muhammed received the revelations preserved in the Qur'an. For
Christians, this occurred when Jesus lived among us. Neshat's image
suggests that, in either religion, faith is ultimately about God's loving
kindness—not ours. Faith, given as a gift by God's gracious activity, is
God's embrace of humanity. It is God's willingness to be made known
to humankind. It is an embrace that holds us, carrying us through the
myriad of crises we face as human persons living a transitory existence.
And it is an embrace that accepts us, finally, when that sometimes long
and tormented journey is finished. In the image by artist Shirin Neshat,
and captured on film by photographer Kyong Park, God embraces the
chosen in love, and promises never to let go.[19]

It is Neshat's image of faith as the Holy One embracing humankind that Karl Barth (1886–1968) likewise expresses for the Christian community in his essays on *Wolfgang Amadeus Mozart* (1955–56).[20] Using Mozart's music as an extended metaphor, Barth discusses how it is that God goes about human salvation. At the core of his understanding are the utter helplessness of the human person and the majestic reliability of God. Just as Mozart was unworthy of the musical genius bestowed upon him by God, so, too, are Christians unworthy of the salvation bestowed upon them by Christ. Salvation remains outside of human control, for it is a divine accomplishment on the cross, extended to humankind by God's providence. Just as the gift of music was given to Mozart and denied to others, a reality brilliantly portrayed through Salieri's character in the critically acclaimed movie *Amadeus*, so, too, does Barth understand faith to be a gift extended to some and denied to others. Barth understands the bestowal of the gift to depend only on God's will, not on the worthiness of the recipient, for, in Calvinist thought, all are equally unworthy of such a remarkable gift. Mozart provides Barth with a compelling case in point, for by all accounts, Mozart was a rude, crass, and immature person. Mozart is, indeed, an apt metaphor for Barth's interpretation of the divine drama, for he is the quintessential example of the undeserving recipient of divine favor. For Barth, the example of Mozart is irrefutable, which only serves to extend likewise to his metaphor, making his understanding of human salvation also undeniable. Just as God gave Mozart the gift of music in spite of his unworthiness, so does God give salvation to humans despite the fact that they do not deserve it.

In response to such a gift, Barth believes there is only one possible response: just as faith is a gift, so too is it a surrender to that gift. We could here imagine the child's hands, in Neshat's image, wiggling and squirming, trying to break free from the grip that holds them firmly, but not too tightly. Because Mozart never resisted the gift, Barth reflects, "It is this sovereign submission at all stages of his artistic career which may be taken as a distinct feature of what was unique and special in the man."[21] Yet, unexpectedly and paradoxically, in this submission is found true freedom. Only in a surrender to God is freedom of the will to be experienced. All else is bound to the compulsions that oppose the godly.

The embrace of the Holy frees the person from bondage. No longer must we consider ourselves slaves to doing good things in order to win God's favor. The only good work that was capable of accomplishing such a feat was Christ's death on the cross and resurrection from the dead. Once embraced by God, however, we are transformed, and do good works as a response of joy and gratitude. Although we remain human and falter, we nevertheless continue to experience the transformation that seals us as among those made righteous by Christ.

Shirin Neshat depicts this dimension of the bonded nature of faith in a second image (ill. 4). The woman's thumbs sink into the center of the infant's cupped hands and unfurl them, opening the palms outward. In this image, entitled *Bonding*, Neshat captures this apparent dichotomy between freedom and servanthood, showing its inherent beauty. Once embraced, we are empowered to look beyond self-serving interests, whether individual or national, to care for the soul of the community. Neshat's images affirm that it is God's nature to love. Therefore, as the Beloved of God, humankind is embraced by God's loving kindness. Sharing the condition of vulnerability, we trust in those promises asserted by religions of the text, Judaism, Christianity, and Islam, that God's promises are true and everlasting, and we are turned outward, to care, as did Christ, as did Muhammad, as did all of the prophets, for the needs of the whole community.

LOVE AND HOLY TRANSFORMATION
Balthasarian Pneumatology and Beauty in Seyed Alavi

Light, tinted by overlapping sheets of rice paper that are dripping with hardened beeswax, filters into the room through windows extending from floor to ceiling, flooding the space with a golden hue (ill. 5). Three thousand paper butterflies, cut out of pages of Sufi poetry and likewise dipped in beeswax, cover the windows at random intervals. From below, they appear to be flying upward, ascending to divine, ecstatic heights, the writings on their wings desiring union with their divine source. The butterflies yearn to carry the texts on their wings beyond the windows, to the very source of light that lures them home.

Ode to Rumi; Drawn to Light, an installation by Iranian-born, California-based artist Seyed Alavi, was ideal for the Fullerton Art

Museum, for Alavi found meaning in the architectural setting—the corner of one of the rooms in the museum. "'[T]aking up a corner' in Sufism means bringing and gathering all of one's (dispersed) forces, and focusing them onto a single point. In Sufism, this point, and the corner that is referred to, is one's heart, in the sense that the heart is also the 'cornerstone' of one's existence."[22] Therefore, in his installation, Alavi intended to provide a place in the corner of the museum space where visitors could focus on the renewal of the heart. Books featuring Sufi poetry were provided for reading on a low table at the foot of the windows. Several of the books, when opened, had a hole cut into them in the same shape as the butterflies on the window. This heightened the sense that the words were returning to their divine source on the backs of the butterflies, now flying to the window.

> In Sufism, the image of the butterfly or moth, with its circling dance around the flame of a candle, is a powerful metaphor for love and reunion. The butterfly by its nature seeks light and strives to be united with it. According to Sufism it is the moth's love which draws him to be united with the candle flame. However, the ultimate union takes place only when the moth completely surrenders itself to the flame.[23]

The butterflies are blocked from reaching the divine source of the inspiration they carry, however, by the windows themselves, creating an obstacle of glass, rice paper, and beeswax. For Alavi, this creates another interpretive dimension for, in order to have reunion with the light, one must get beyond Sufism and all other human constructs in order to be consumed by the Light. "For one to see the light, one would need to clean the stains off the glass and to even go beyond the window, if one yearns to experience what the light truly is."[24]

Alavi's installation, preserved now only in the photographs that document its existence, was the construction of a sacred space—a place where those who entered into its midst were invited to commune with the infinite. In the Sufi writings and in the symbolism of the butterfly seeking union with the Light, the visitor to this space saw an intellectual treatment of inspiration, and could participate in its attractive force. *Ode to Rumi: Drawn to Light* captures the artist's interest in

Islamic mysticism, for it expresses something of the innate human yearning for an experience of the Holy. Moreover, the installation communicates assurance of the infinite's gracious response to that desire, as certain as the light filtering through the window each day.[25]

Moreover, Alavi's installation is based upon the idea that revelation is a real event. Likewise, in Christian theology, Hans Urs von Balthasar (1905–88) wrote his systematic theology entitled *The Glory of the Lord* (1967) defending the reality of divine revelation, the truth that something is offered to humankind by God so that humans can see it, understand it, and live by it. That something which is offered to humankind is understood by Balthasar to be love or *eros*, which simultaneously draws God out of the depths and transports humankind to greater vision.[26] God inspires by a revelation that descends from the genius—who is God—in the person of the Holy Spirit, and the imagination simultaneously is lifted in response to the Holy Spirit from humankind's intimate depths to receive the inspiration. This passing over by the Holy Spirit in inspiration leads humankind to *eros*, in which knowledge of the divine is possible, thereby completing the construction of a bridge between what Balthasar calls natural and supernatural beauty.[27]

The Holy Spirit reveals Christ to be this *eros*, the form or archetype through whom God chooses to reveal the divine mysteries in the historical, temporal realm. In the form of Christ, an essentially inaccessible, unapproachable God enters the realm of visibility, first in the incarnation, and second in the eucharistic bread and wine through which the divine form bursts forth and reveals its ontological rootedness, not by proportion to the divine essence, but by its very own possession of the divine essence.[28] That which is essentially formless takes on form precisely for the purpose of being encountered, of being experienced.[29] The form becomes visible in the masterpiece of divine revelation and presents itself as the revelation of the inner depths of God.[30]

Faith is the human response to the possibility of an encounter with *eros*, with God incarnate. Absolutely dependent on God's antecedent revelation—God's willingness to initiate humankind into the knowledge of things eternal—God's gift of faith allows the recipient to access knowledge of the divine. According to Balthasar, the eyes of the mind are struck by a new light, enabling the human mind to know to be real

that which is divine. When we truly surrender to God's grace, when we offer ourselves to God, we are opened to the receptivity of Christ's impression. God impresses the Christ-form on us, and constant contemplation transforms us into the image of Christ.[31] The attainment of Christian form is, for Balthasar, the *telos* of human existence and is achieved when an interior being is made love-worthy in radiant beauty.[32] Christian form is true form when the Spirit is manifest within one's very being and shines forth with radiant light. When such form is achieved, Balthasar believes the Christian form is the most beautiful thing in the human realm, for it exists in imitation of that which is Beauty personified—Jesus the Christ.

Alavi's installation demonstrates the nature of this reciprocal encounter with the holy. Divine light filters through the windows, reaching all who enter. Those with an openness to its reception are imbued with a sense of the sacred. While I understand this receptivity to the light itself to be a gift from God, the focus is not on the one who receives the light, but is on the Light itself. The light pours over onto the recipients, bathing them in golden hues. The satisfaction of desire for union with God, experienced by one's sense of rapture in the presence of this Light, is what makes known one's own immersion into the depths of the Holy. In Christian terms, divine Beauty, or Christ, expresses himself in glory, and makes himself known. Recipients are imprinted with the beauty of Christ, an impression visible to others. All of this is the work of the Spirit, transforming recipients into beings who participate in a greater way in true Being itself: the True, the Good, and the Beautiful, in perfect proportion.

GRACE AND THE SACRAMENTAL PRESENCE OF THE HOLY
Damascene Christology and Beauty in Sebastião Salgado

The room in which she sits with her young child is bathed in a warm, bright light (ill. 6). Others, busy tending to the needs in the ward, scurry around her. Finding a place of relative solitude, just beyond the sun's sharpest glow, she embraces her child, drawing the young lips to her breast. Her eyes gaze into the distance. Beneath a scarf tied at the base of her neck, her striking facial expression reveals a mind filled with thoughts others can only imagine. Perhaps she dreams about a life in

another place, where food comes easily and plentifully, where children play gleefully and without exhaustion, and where strength to face tomorrow is taken for granted. Perhaps she remembers a happier time. Perhaps she longs for a companion, maybe someone she loved and lost, maybe someone with whom to share the burden. Alone instead, she feeds her child in a children's ward in the Korem refugee camp. The photograph is haunting, its composition iconic in quality.

Salgado, who took the photograph at the height of Ethiopia's 1984 famine, reflects on the passion one must have in order to take pictures like these. Unlike photojournalists, who very often are flown into a region to snap a few pictures and who are whisked away on helicopters from those events and people they cover, documentary photographers like Salgado live among those they photograph. He gains the trust of the individuals he captures on film—and he tells their stories without stripping them of their dignity, precisely because he has lived among them, and because their stories have become a part of his own. About his photography, Salgado reflects:

> You must have a big ideological affinity with the subject you will be shooting, because if you don't you cannot remain sincere and empathetic for long. You must strongly identify with the subject. . . . Now they are a part of you and a part of your work. The people that you are photographing are a part of the universe in which you are living in the deepest way.[33]

Salgado realizes some people question his right to take photos like these. He remains adamant that his work serves a higher purpose, and insists that the artistic quality of his images is not won at the cost of the message it delivers. "I never go to do a good picture. What is a good picture? No. I go to stay inside my story, to try to understand what's going on, to be close to the people I photograph . . ."[34] And, most significantly, he refuses to understand the beauty of his images in a narrowly formal sense. Rather, he affirms his right—his obligation—to take these photos.

> I have never put myself in a situation where I have a moral question about whether or not to photograph, such as, "Do I

have a right to photograph when the death is there in front of me, the suffering is there in front of me?" I never ask myself these questions, because I asked myself the more important questions before I arrived there. Do we have the right to the division of resources that we have in the world? Do I have the right to have the house that I have, to live where I live? Do I have the right to eat when others don't eat? These are the basic questions.[35]

And in this morally alert observation, he uncovers a kind of beauty that relates to theology, for in it his viewers are drawn into a conversation about sin, redemption, and grace. They are presented with a modern vision of suffering that reminds the Christian of the meaning of Christ's death on the cross—and its attending questions. In giving us these images, Salgado emphasizes that he seeks to capture a different kind of beauty—a more philosophically grounded conception of beauty than the merely "pretty" definition of beauty that has found wide usage in the culture today. He recognizes the iconic quality of some of his images, and is content to confront the viewer with their power.

In his *Apology Against Those Who Attack the Divine Images* (ca. 730), John of Damascus (ca. 655–ca. 750) presents a thorough treatment of the power of iconic images to make the holy accessible to humankind.[36] In these apologies, John constructs a system where formal substance is distinguished from material substance. Formal substance is spiritual; it refers to the absolute essence of the Trinitarian God. In John's understanding, material substances, perceivable to humankind by sense, can have something of a semicorporeal continuity with the formal substance from which these realities originate. Because God knows that humans cannot experience an unmitigated revelation of the divine, God makes it possible for humans to experience the divine by mediation of certain images, including preeminently the incarnation itself.[37]

Material things aid human comprehension, lifting the human mind to spiritual contemplation. "Just as we physically listen to perceptible words in order to understand spiritual things, so also by using bodily sight we reach spiritual contemplation."[38] John provides an impressive list of examples drawn from scripture and the tradition in which

Christians become aware of their dependence on the material to mediate the holy.[39] The icon, however, becomes the focus of John's discussion. Central to his argument is the idea that the icon is a shadow of the divine, just as a shadow is an extension of the person who casts it.

He begins by asking, "What is an image?" and answers, "An image is a likeness, or a model, or a figure of something, showing in itself what it depicts."[40] While John admits there are important differences between the image and the thing depicted, "[a]ll images reveal and make perceptible those things which are hidden."[41] In a real way, John argues, the image makes the one who is represented present to all who see it. In the case of icons, Christ himself is present, projecting his presence onto the board that carries his image, and enlivening it with his power. John derives his argument from Acts 5:12–15,

> Now many signs and wonders were done among the people through the apostles. . . . Yet more than ever believers were added to the Lord, great numbers of both men and women, so that they even carried out the sick into the streets, and laid them on cots and mats, in order that Peter's shadow might fall on some of them as he came by. . . . [A]nd they were all cured.

Like a shadow, a representation carries the essence of the person who casts it, so that "[T]he icon of Christ is part of Him, and you must give it what is due."[42]

Most importantly, in relation to our discussion of Salgado's images, however, is John's inclusion, in his category of material objects worthy of our adoration, of others besides the incarnated Christ who merit our devotion. "The fifth kind of relative worship," writes John, "is our veneration *of each other,* since we are God's inheritance, and were made according to His image, and so we are subject to each other, thus fulfilling the law of love."[43] Because the Ethiopian woman is made in the image of God and therefore belongs to God among the Beloved, she makes not only her own identity present to us, but also the presence of God. In her hopes, dreams and aspirations, we find our own. In her disappointments, our own hearts break—as does the heart of God. For, if we are subject to each other, we are responsible to one another, responsible for ensuring that all of humankind's basic

needs are met. If her needs go unattended, then so do ours. And if she is neglected, then so is Christ.

HOPE AND TASTE FOR THINGS UNSEEN
Kantian Eschatology and Beauty in Joanna Pinneo

Joanna Pinneo began her work on the Palestinian story just after a sixteen-year relationship, eight in marriage, ended in divorce. Admitting it was the time to "push the envelope," she traveled to Jordan, taking photographs that won international acclaim for the story they told of life as it looked for Palestinians after the conclusion of the 1991 war in the Persian Gulf.[44] In an image Pinneo calls *Paper Dreams,* a ten-year-old Palestinian girl stands in front of a chalkboard, the day's lesson still legible (ill. 7). Only the slightest amount of hair is visible beneath her headdress. Though only ten, her eyes betray a loss of innocence. Having knowledge of refugee camps, poverty, humiliation, perhaps violent death of loved ones, she holds the day's assignment. She has drawn Jerusalem. Though she has never seen it, she has transferred to paper her vision of what Jerusalem looks like—how it would look, if she could live there.

The girl in Pinneo's photograph reminds us that we are accountable —that humans have the power to enact justice, or to advance injustice. To what, or to whom, however, will we be held accountable, ultimately and existentially? Immanuel Kant (1724–1804) argued that, because his world found explanations for the existence of the universe outside of the creative acts of a loving God, it was the responsibility of the human community to appoint in God's place an authoritative principle. Appointing beauty to this sovereign position, nurturing a taste for virtue, which Kant understood to be beautiful, became the prevalent theme of Kant's *Critique of Judgment* (1790). The *Critique* is his philosophical statement about the importance of the development of aesthetic taste, that is, of a well-informed taste, to discern what is beautiful. Subjective as such a judgment would necessarily be, taste contains the potential to defend the principle's appointment to a position of authority. Because he understood the divide between what is divine and what is human to be so radical as to be completely severed, Kant believed nothing could be known of God. Aesthetics filled for him the void left

vacant by the utter separation of God from human perception. Peace and harmony could be achieved, he hoped, by striving after that which humans judged by taste to be true, good, and beautiful.

Kant begins this *Critique* with a discussion of precisely how the ontological realm can be understood as inaccessible. He subdivides philosophy into a theoretical, natural science and a practical, moral science.[45] He defines the former as resting empirically on natural concepts that exist *a priori* in nature, while the latter rests on supersensual precepts that, when experienced *a posteriori,* are legislative through the application of laws. Neither division of philosophy is able to furnish knowledge of an ontological nature, for an ontological essence is supersensible and made inaccessible by its boundlessness. In the absence of an ontologically verifiable existence, humankind is never held accountable for its actions—it has lost deference to an absolute authority. So that social peace and harmony might be maintained, Kant suggests that a single possibility exists that unites again the theoretical and practical—the possibility of a capacity for judgment. Judgment, Kant proposes, occupies a middle term between theoretical and practical philosophy, mediates between the two, and ultimately arrives at a unity between them. It creates the possibility for a just society in the absence of an authoritative religious structure.

Such authority relies upon a concept Kant calls purposiveness. Purposiveness is the experience of pleasure that is unwittingly produced upon discovery that two or more empirical laws of nature may be combined under one principle that comprehends them both.[46] This experience may also be termed aesthetic. Thus, purposiveness and the aesthetic judgment are equivalent in nature. As distinct from logic, or that faculty which serves to determine an object's essential nature, the aesthetic critique contributes absolutely nothing to the knowledge of an object itself, for it is merely subjective.[47] That is to say, the aesthetic critique decides its reference in relation to the subject, not to the object. Pleasure is subdivided into real purposiveness, which is bound to an object's form, and formal purposiveness, which is bound to the mere subjective apprehension of an object. Taste occupies the middle position between the two, and responds with pleasure when an object's form is apprehended to be well-suited to its purpose. Purposive

well-suitedness is Kant's definition of beauty. Those who disagree are said to have bad taste.

In response to the larger dilemma facing him about what ought to occupy the gaping void left by the inaccessibility of God, Kant explored the purpose of authority. Belief in God compelled people to behave well, he thought. They feared eternal agony for wickedness and hoped for eternal ecstasy for righteousness. In the void left by the inaccessibility of God, Kant believed a subjectively appointed criterion needed to be determined that would elicit the same sort of allegiance. In his earlier work, *Observations on the Feeling of the Beautiful and Sublime* (1764), Kant considered two potential contenders: the sublime and the beautiful. Ultimately, he found the sublime to be better suited to the purpose of inspiring virtue:

> [W]hen universal affection toward the human species has become a principle within you to which you always subordinate your actions, then love toward the needy one still remains; but now, from a higher standpoint, it has been placed in its true relation to your total duty. Universal affection is a ground of your interest in his plight, but also of the justice by whose rule you must now forbear this action. Now as soon as this feeling has arisen to its proper universality, it has become sublime . . .[48]

The sublime is most well-suited to its purpose of establishing authority in a universe cut off from the divine because it elicits true and genuine virtue. He does not proclaim virtue itself as most well-suited to establish authority, for "[O]ne cannot call that state of mind virtuous which is a source of such actions as might be grounded in virtue itself but whose actual cause accords with true virtue only accidentally and which may often . . . conflict with the general rules of virtue."[49] Rather, that which is sublime grounds virtuous action. "True virtue can be grafted only upon principles such that the more general they are, the more sublime and noble it becomes."[50] Kant expects others to judge likewise. All who disagree will be said simply to have poor taste. "Only when one subordinates his own inclination to one so expanded can our charitable impulses be used proportionately and bring about the noble bearing that is the beauty of virtue."[51] Finally, Kant envisions a world

transformed by its new sublime authority. "Thus the different groups unite into a picture of splendid expression, where amidst great multiplicity unity shines forth, and the whole of moral nature exhibits beauty and dignity."[52]

Kant's construction of a teleological system based on the sublime, or a sense and taste for what is virtuous, is noteworthy in relation to Pinneo's photograph of the Palestinian girl and her dreams. Like her, Kant dared to imagine an eschaton achieved by human efforts, guided by a sense and taste for things just. He dreamed of a world society working with an awareness of the cares and concerns of all of its citizens, guided by a well-honed judgment. Although ultimately his work helped to relegate theological work apparently obsolete, his own philosophy was not unrelated to theology. Rather, his work took the Judeo-Christian commandment to "Love thy neighbor" to its philosophical depths, charting a path to a teleological destiny—a moral society.

The Palestinian girl, unaware of her affinity with Kant, dreams similarly. She imagines a New Jerusalem, truly a city of peace. In her vision, no one is fighting. There is just one man, waving two books, perhaps the Qur'an and a prayer book, overhead. Just behind him is the Dome of the Rock, prevalent on the page. Perhaps this is where she hoped she could one day praise Allah within a restored community for Allah's wondrous deeds, for allowing her to go back to the land where her family lived once, before all the wars of the twentieth century, before all the terror, before all seemed lost. In her drawing, a city beckons in the distance, a bundle of buildings of varying heights. Perhaps she would live in one of the apartments, above a bustling shop that fills the neighborhood with promise of good things. But it is only a dream. Even so, it is an image of hope in the midst of despair. The Palestinian ten-year-old and Immanuel Kant beg the question, is the New Jerusalem something we might create? Given the present circumstances, the question becomes even more pressing. Can we afford to wait? Beauty always carries with itself this urgency. Where there is brokenness, where tears are falling, there is an invitation—an invitation of Primal Beauty to surrender to its never satisfied desire for justice in the face of human suffering.

～

CONCLUSION

The unrelenting message in the seven photographs with which I have been living is one that seeks justice in the face of human suffering. Sebastião Salgado's images of breastfeeding mothers reveal something of the continuum of Beauty in the paradox they illustrate between plenty and want. Being in glory is reserved in a perfect way for God, but we are given a glimpse of it from time to time, witnessed in a high degree of truth, goodness, and beauty present in things and deeds in our own world. In our daily lives, though we are aware of the pole of glory, we are more often cognizant of the opposite pole of existence: being in suffering. Salgado's images stir a compassionate response, making viewers desire alleviation of suffering and permanent physical redemption. Steve McCurry's image of an Afghan refugee captures the sense of vulnerability of being, given the reality of all that can harm us. The polarity between glory and suffering, of which we become aware by looking at these images, loses its tension by the very power it possesses—the power of beauty, of Being itself, defined here in a Trinitarian way. This gracious Being embraces humankind in all its brokenness, in the many ways humans are vulnerable, and reconciles the poles. The God of Glory humiliates God's own self by taking on human flesh and, through crucifixion and resurrection, accomplishes spiritual redemption. We continue to await physical redemption, hoping for a time when sorrow, pain, and death torture no longer. Faith, in this telling, is not intellectual assent, but is rather trust that the divine Being embraces human life, and protects it. Shirin Neshat's images of *Faith* and of *Bonding* express something of this mystical embrace of the Holy. Imbued now with Spirit, the world is equipped with the power to transform. Seyed Alavi's image excites ecstasy with the possibilities latent in this power. Sometimes this power is twisted and corrupted, creating greater vulnerability and suffering rather than greater compassion and glory. But the power is there, too, as Joanna Pinneo's image attests, for imagining a New Jerusalem, a society marked by peace and loving kindness. The power is there, too, we trust, guiding us in its creation.

The underlying assertion here is that lives lived with an awareness of Beauty (called Christ by some), which unites the Holy One, the divine Lover, to God's Beloved—humankind made in the *imago Dei*—and

who share, in turn, this Beauty with one another, are lives that experience the depths of what it is to be human. They are lives that have encountered and reflect in our world that which is truly sacred, for beauty is precisely that: the sacred nature of existence when it is stripped of everything superficial. Robin Parks, the woman who responded in such a profound way to James Elkins's request for experiences of tears in front of paintings, perhaps did not realize the complexity of her response. In her deceptively simple letter, she captures the essence of what the theologians discussed here wrote about Beauty. When she wrote of how she was overwhelmed by love, when she described her loneliness—her "craving for the company of beauty"—and when she named the mysterious presence behind her encounter by the name of God, she put together philosophical and theological principles that defend the sacramental nature of the images described here. In her experience of Gauguin, of Victory, and of Bach, Parks describes an iconic encounter with the holy—an encounter that is equally befitting Salgado's images of famine, McCurry's image of vulnerability, Neshat's images of the relationship between freedom and bondage, Alavi's image of spiritual desire, and Pinneo's image of hope in the face of injustice. If the power of these images is, indeed, the presence of God, as Robin Parks suspected, then they truly are beautiful, for, in the words of photographer Minor White, these images truly capture Spirit standing still.

⌒

NOTES

1. James Elkins, *Pictures and Tears: A History of People Who Have Cried in Front of Paintings* (New York: Routledge, 2001), 248.

2. The reflections here are intended to be read in terms of viewer response theory: the insights shared here are my own responses to the works and may or may not reflect the intentions of the photographers who have shared their images with the world. In brief sketches, I describe the images as I see them, and I discuss their power as I have experienced it as a female Lutheran theologian. In so doing, I take as a model *Reading for Life,* a book by Margaret R. Miles, in which she explores an informal list of those books that teach "everything one must know to lead a rich human life." (See Margaret R. Miles, *Reading for Life: Beauty, Pluralism, and Responsibility* [New York: Continuum, 1997], 22.) The premise of her book is this: "Too long ago to remember where or when, I read that everything one must know to lead a rich human life could be learned by an attentive reading of the

right eight or ten books. Ever since then, I have kept an informal list of what I thought those books might be. In this book, I explore my current list." Though I am skeptical of the grandeur of the claim, I do resonate with the spirit behind it and so in this essay I borrow her "hook," and reapply it. If everything one must know to lead a rich human life can be learned by an attentive reading of eight or ten books, then perhaps a good deal of what needs to be learned can also be acquired by an attentive looking at a number of carefully selected images. I'm offering my current list of seven. I recognize that Miles develops, too, in her book a method for approaching texts with generosity and criticism. While such a method transfers, likewise, to analysis of images, in this essay I am proposing not a method, but a system based on beauty as identical with existence.

3. Ken Light, *Witness in Our Time: Working Lives of Documentary Photographers*, introduction by Kerry Tremain (Washington: Smithsonian Institution Press, 2000), 111.

4. Sebastião Salgado, *Sebastião Salgado: An Uncertain Grace*, with essays by Eduardo Galeano and Fred Ritchin (New York: Aperture Foundation, 1990), 146.

5. Ibid.

6. Augustine, *De Musica*, trans. W. F. Jackson Knight (London: Orthological Institute), 114.

7. This differs from the theology of Thomas Aquinas, who drew on the thought of Aristotle. Thomas believed we *participate* in universal Truth, Goodness, and Beauty when we recognize truth, goodness, and beauty in the things (both seen and unseen) of the world.

8. www.npr.org/news/specials/americatransformed/reaction/010924 .mccurry.html, retrieved online August 17, 2003. The photograph was featured on the June 1985 cover of *National Geographic,* illustrating Debra Denker's article, "Along Afghanistan's War-torn Frontier." The text of the article is available online, www.nationalgeographic.com/ngm/100best/storyA_story.html#top.

9. Rob Sheppard, "Uncovering Secrets of a Location," *Outdoor Photographer* (January/February 1999); www.outdoorphotographer.com/content/pastissues /1999/jan/secrets.html; retrieved online August 17, 2003.

10. www.stevemccurry.com/bio/bio.html. Retrieved online August 18, 2003.

11. Ibid.

12. Ibid.

13. Steve McCurry, "Seeing Ourselves in Others: The Human Condition in a Photograph," *Topic Magazine,* www.topicmag.com/extras/mccurry.html, retrieved July 22, 2003.

14. Paul Tillich, "Art and Ultimate Reality," *On Art and Architecture,* ed. John Dillenberger (New York: Crossroad, 1989), 140.

15. Paul Tillich, *The Courage to Be* (New Haven: Yale University Press, 1952, 1980, 2000), 190.

16. Elene Carotti and Harlow Tighe, eds., *Shirin Neshat* (Milan: Edizioni Charta, 2002), 179.

17. Ibid., 120.

18. Sara Tedesco, ed., *Shirin Neshat* (Milan: Edizioni Charta, 2001), 64.

19. For a counter interpretation of this image as a vaginal hold of a fetus, see Hamid Dabashi, "Bordercrossings: Shirin Neshat's Body of Evidence," trans. Silvia Maglioni and Graeme Thomson, in *Shirin Neshat*, ed. Elena Carotti and Harlow Tighe (Milan: Edizioni Charta, 2002), 37–38.

20. Karl Barth, *Wolfgang Amadeus Mozart*, trans. Clarence K. Pott (Grand Rapids: Wm. B. Eerdmans, 1986).

21. Ibid., 49.

22. www.netwiz.net/~here2day/dtl.html, retrieved online July 21, 2003.

23. Ibid.

24. Ibid.

25. For a longer treatment of the artist's own sense of his body of work, see Seyed Alavi, "The Garden of Secrets and Visual Poetry: The Art of Seyed Alavi," *ARTS: The Arts in Religious and Theological Studies*, 8/2 (1996): 15–20.

26. Hans Urs von Balthasar, *The Glory of the Lord: A Theological Aesthetics*, trans. Erasmo Leiva-Merikakis, I (San Francisco: Ignatius Press, 1967), 221–22.

27. Ibid., 34–35; 250–52.

28. Ibid., 301–4.

29. Ibid., 303–4.

30. Ibid., 171–73.

31. Ibid., 222–23; 242–45.

32. Ibid., 28.

33. Light, *Witness in Our Time*, 113.

34. Ibid.

35. Ibid., 111.

36. John of Damascus, *On the Divine Images*, trans. David Anderson (Crestwood, N.Y.: St. Vladimir's Seminary Press, 1980). References will be indicated by apology (I, II, or III), paragraph number, and page.

37. Ibid., III.12.72.

38. Ibid.

39. Among the material "things" where the holy has rested, according to John, are: the incarnation, Theotokos, baptism, Eucharist, the saints, Mt. Sinai, Nazareth, the manger in Bethlehem, Golgotha, the wood of the cross, the nails, the sponge, the reed, the lance, the robe, the tunic, the sheet, the swaddling clothes, the tomb, the sepulcher stone, Mt. Zion, Mt. of Olives, the pool of Bethsaida, the garden, the Bible, Aaron's rod, the jar of manna, the altar, Joseph's staff, the tabernacle, the cherubim, the priests, the bishops, and, of course, the Pope. See Ibid., III.33–39.84–88.

40. Ibid., III.16.73.

41. Ibid., III.17.74.

42. Ibid., III.11.72.

43. Ibid., III.37.87 (emphasis added).

44. Cathy Newman, *Women Photographers at National Geographic* (Washington, D.C.: National Geographic Society, 2000), 185.

45. Immanuel Kant, *Critique of Judgement,* trans. J. H. Bernard (New York: Hafner Press, Macmillan, 1951), 7–15.

46. Ibid., 23–35.

47. Ibid., 29–31.

48. Immanuel Kant, *Observations on the Feeling of the Beautiful and Sublime,* trans. John T. Goldthwait (Berkeley: University of California Press, 1960), 58.

49. Ibid.

50. Ibid., 60.

51. Ibid.

52. Ibid., 75.

PART II **The Arts and Interpretation**

5

The Arts, Midrash, and Biblical Teaching

BRUCE C. BIRCH

One of the fundamental concerns of biblical teaching in theological education is to impress upon students that biblical texts do not come to us directly from the witness of the biblical communities where they originate. Biblical texts have been handed on to us through a long history of interpretation, and they are read and interpreted only in the context of communities of readers both past and present. Awareness of this rich but complex process is one of the goals of biblical teaching.

There is great energy and ferment in biblical studies at the present time, and this provides exciting possibilities for biblical teaching. The historical-critical method is still important, but its emphases and associated methodologies are no longer dominant as was the case for much of the last half of the twentieth century. A broader range of literary critical methods has brought fresh insights into the function and impact of the text in its present final form. Theologically this has been paralleled

by a new emphasis on the canonical shape of the text and its message. There is a greater emphasis on the context in which we read, and this has brought new attention to the diversity of voices with which a text can speak depending on the context in which we listen to and converse with the text. Methodologies from the social sciences have informed our understanding of the social settings from which texts emerge. All of this is reflected in an unparalleled range of published resources available for biblical teaching, as well as a wealth of online resources to support this teaching.

This new richness and diversity in biblical study makes biblical teaching both challenging and rewarding. By and large theological schools have addressed this situation well. Newer methods and perspectives have been embraced as a welcome aid to a broadening of student perspectives. The hope has been that an increasingly multifaceted understanding of biblical texts will be a valuable aid in use of the Bible for the diverse challenges of ministry in our complex world. Any examination of introductory course syllabi will illustrate the changes that have taken place. Lengthy discussions of the documentary hypothesis and the synoptic problem have been replaced or given shorter mention to make room for a fuller encounter with the text in its present form and the various communities that have read and interpreted the text. My own introductory Hebrew Bible course, along with a comprehensive text, includes readings from *The Women's Bible Commentary, Stony the Road We Trod, Voices From the Margins,* Renita Weems, Cheryl Exum, Arthur Waskow, and Gustavo Gutierrez. We also read articles on the history of biblical interpretation and look at representative treatment of key texts by central figures from the history of the church.

Since the earliest centuries of the church there has been a parallel history of artistic interaction with the biblical text. This has taken place across the spectrum of artistic media: painting, sculpture, music, drama, poetry, literature, dance, and film. These artistic treatments of biblical subjects have had a great cultural impact and have deeply influenced public perceptions and understandings of the Bible.

For example, a close-up of the extended fingers of God and Adam in the central panel of Michelangelo's Sistine Chapel frescos would be enough for most people to identify the subject as God's creation of the

first human creature. Many people, asked to tell the story of Israel's Exodus from Egypt, will briefly summarize the plot of Cecil B. DeMille's epic film *The Ten Commandments*. Almost every religious person has a painting associated with his or her visual image of Jesus since childhood. Unfortunately, all of these artistic influences range from enduring classics to pure schlock. The morning after NBC showed its miniseries *Noah's Ark,* I received about a dozen verbal or e-mail inquiries wanting to know what I thought of a film about Noah's ark that opens in Sodom where Noah's best friend is Lot.

Unfortunately, seldom does this history of artistic interpretation become a part of required biblical study in theological schools. Most of those serving in the ministries of the church have received no help in critically evaluating these artistic influences and resources. Pastors and church leaders remain largely unequipped to understand and draw upon this history of artistic interpretation and its lively continuation in our present. There is a growing cadre of those interested in and teaching about theology and the arts, but this remains mostly an elective subject for those already interested in such things. Seldom does artistic interpretation find a place in the core curriculum of theological schools and the foundational courses in that curriculum.

This is doubly unfortunate because accessibility to these artistic resources is greater than ever before. Computer technology makes an unbelievable range of materials available in online databases, and theological libraries are increasingly equipped with assistance in accessing these materials from a wide variety of media. Increasingly sophisticated software programs offer the possibility of pedagogy that draws on an entire range of resources not traditionally a part of classroom teaching, and this pedagogy could more easily incorporate artistic resources. But this is primarily happening in a handful of largely elective courses, and faculty who are beginning to use computer technology to a greater degree are still not prepared to draw on artistic resources in their teaching.

In this text, I want to reflect on learnings from a serious effort to take artistic resources and methodologies into account in teaching Hebrew Bible in a theological school. My hope is to encourage others into such ventures and to discuss what have seemed to me to be the challenges, gains, and pitfalls of what has been an admittedly experi-

mental enterprise. My efforts have included large introductory courses, small seminars on biblical subjects, and two intentionally cross-disciplinary courses involving the arts.

My context is Wesley Theological Seminary, a school sponsored by the United Methodist Church but with a broadly ecumenical faculty and student body. It is large enough (over 650 students in degree programs) to offer a broad range of curricula, and its location in Washington, D.C., gives it an unusually diverse student body in every category that measures diversity. I have been particularly helped in my enterprise by the development of a program in the arts and religion at Wesley that has resulted in the establishment of the Henry Luce III Center for the Arts and Religion with its unique resources and programs. This center was conceived and developed over the years by Catherine Kapikian, who still serves as its director. Wesley has an art studio, the Dadian Gallery, resident visiting artists, and faculty members teaching in the visual arts, music, drama, poetry, literature, and dance. I am aware that this does not make us the typical theological school with respect to the arts, but although this has been a wonderful resource for me, I have tried to concentrate on teaching that models what students could also do in using the arts for ministry. It would not be a help to students to teach in a way that relied on visiting experts from our arts faculty or resources that were inaccessible to local churches. Nevertheless, it has given me ongoing resources for consultation and advice, and one of my courses, The Old Testament and the Arts, is intentionally team taught with Deborah Sokolove, the curator of the Dadian Gallery, and an accomplished artist herself.

THE ARTS AS MIDRASH

After a number of years, I have come to believe that a key to my most successful efforts at biblical teaching that incorporates the arts is the recovery of the ancient Jewish interpretive method of midrash.[1] The word midrash is a Hebrew noun derived from a verb meaning "to seek out" or "to inquire." It is used to describe both a methodology and a genre of literature in which biblical texts are imaginatively interpreted in ways that extend the meaning of the text and often make the text more accessible to contemporary experience. Collections of midrashic inter-

pretation by the rabbis of the Roman period were collected and edited between the fifth and eleventh centuries C.E. into books of imaginative comment on the biblical text for each book of the Torah and for many other books of the Hebrew Bible. The New Testament shows evidence of the use of midrash in its treatment of texts from the Hebrew Bible.

The term midrash encompasses a number of specific techniques for imaginative interpretation, but all are characterized by a profound respect for the text itself and a remarkable freedom to extend and elaborate on the text. Narrative traditions can be retold, extended, or elaborated upon. What the text does not say can become as significant as what is said. Such silences in the text become invitations to the imagination. Texts that do not tell a story but give us laws, propositions, or teachings can be dissected, argued against, connected to other texts, elaborated upon, or analyzed and explained. Again, such texts are both respected and imaginatively interpreted with great freedom. The collections of early rabbinic midrashim are sometimes expositional and provide consecutive comment on the verses of a biblical book, or they are homiletical and gather midrashic comments on various texts around a theme or a purpose (e.g., texts to be read on a certain holy day).

Students in theological schools are most likely to encounter midrash as an element in understanding the Jewish background to the New Testament and the ways in which various New Testament writers handle texts from the Hebrew Bible. Students in Hebrew Bible courses might also be introduced to midrash in an effort to demonstrate ongoing Jewish efforts to interpret and interact with the texts of the Hebrew Bible. Almost never is it suggested to students that they might consider midrash as a helpful category for understanding some aspects of the history of biblical interpretation down to the present or that they might legitimately employ the methods of midrash in their own interpretive work.

I have come to believe that the category of midrash, used more widely in biblical teaching, can help free our narrow range of interpretive methods (and how we teach them) and open new, imaginative possibilities that can enliven and extend our usual exegesis of texts. More specifically, for the purposes of this essay, midrash provides the ideal category for understanding artistic interactions with biblical texts. Through midrash, students can understand artists to be both profound respecters

of the power and integrity of biblical texts, while at the same time extending and entering into imaginative encounter with those texts. Without understanding midrash, students tend to judge artistic treatments of biblical texts on the basis of how well they merely illustrate the literal words of the text. Openness to a more imaginative, artistic midrash on the text sends students back to the text with new awareness of the range of potential meanings in those texts, and this in turn opens new possibilities for addressing those texts in lives and ministries. Even a brief exposure to examples of rabbinic midrash suggests to students a greater freedom to interact with the text that does not require them to surrender a deep respect for the text itself and its authority. This freedom, in turn, allows consideration of the arts as midrash whether encountering the enduring work of artists who have engaged the biblical text or referring to the student's own effort at interpretive interaction with biblical texts in an artistic medium.

THE ARTS AND BIBLICAL TEACHING

It will be more concretely helpful for me to turn at this point to share some learnings and examples from my own experience as a teacher of Hebrew Bible for thirty-five years. I have used artistic treatments of biblical texts in my teaching for all of these years, but it has been in the last fifteen years that this has become more critically focused and pedagogically developed. I regularly teach the large introductory survey course as well as a range of electives in Hebrew Bible. Courses in Genesis, Exodus, 1 and 2 Samuel, Job, Amos/Hosea, Isaiah 40–55, and Old Testament Theology as Biography have been especially productive in exploring this topic. I teach two explicitly cross-disciplinary courses: The Old Testament and the Arts (with Deborah Sokolove), and The Hebrew Bible Goes to the Movies.

I offer these learnings and examples not so much as settled conclusions as a sharing of experience to encourage the increased use of the arts in biblical teaching. My comments will all be related to my area of teaching responsibility in Hebrew Bible.

Broadening the Range of Interpretive Voices

The use of artistic interpretation of texts and traditions from the Hebrew Bible has the effect of broadening the range of interpretive voices avail-

able to the student. Most students, if they have thought about it at all, believe that biblical texts are primarily interpreted in commentaries, didactic essays, and sermons. These are the kinds of materials they are most likely to encounter in courses that touch upon the history of biblical interpretation. And these are still the primary modes of current biblical interpretation to which students are exposed.

Exposure to artistic treatments of key biblical texts and themes dramatically extends the interpretive framework. This can have the effect of bringing into sharp focus interpretive alternatives that would require considerable heavy reading to expose in commentary and sermon. For example, Genesis 22 is a centrally important text to both Jews and Christians in the early centuries of the common era. But its importance to these divergent communities is understood in very different ways. For Jews it is the binding of Isaac, the *Akedah*, with a stress on Isaac as a willing sacrifice, whose death was not required in the end. For Christians, Isaac was early on identified typologically with Christ and God's sacrifice of his own son. Christians customarily refer to Genesis 22 as the sacrifice of Isaac. Understanding various dimensions of this important theological divergence and interaction between Christians and Jews could require a good deal of reading in difficult ancient texts. But early Jewish and Christian artistic treatments of the *Akedah* quickly make differences in interpretive trajectories apparent to students. Scholars and teachers drawing on these artistic traditions can quickly guide students to a broadened understanding of the theological possibilities in the text, and the use of images to make this visible enables a much quicker grasp of those possibilities.[2]

Such artistic expansions of interpretive perspectives serve to underline one of the points most valued in current biblical teaching, namely, that *biblical texts are multivalent in meaning*. This is, of course, not a point for students to grasp in the history of interpretation but a point to be understood and used in their own current interpretation and teaching. Artistic resources can both help them to understand this point and can become resources for helping their congregations to understand it. I have often used clippings from three films on the Moses/Exodus story to make this point. The three are Cecil B. DeMille's *Ten Commandments* (1956), Turner Broadcasting's *Moses*

(1996), and DreamWorks' animated feature, *Prince of Egypt* (1999). Ostensibly, each of these films is drawing upon and interacting with the same biblical material (Exod. 1–15) in a serious filmmaking effort. All three films received some deserved critical acclaim in their time. But when students view these films, they see three portraits of Moses that could not be more dramatically different from one another. Charlton Heston is Moses as larger-than-life hero; Ben Kingsley is the stuttering, reluctant, and yet prayerful and obedient servant of God; and the animated Moses is Rameses' former carousing buddy now reluctantly growing up and taking another path. The way the character of Moses is portrayed leads to very different portraits of the Pharaoh and God, as well. Texts can be read and understood in more than one way. Such artistic resources both make the point and become resources for helping others to a fuller understanding of how the Bible functions in our faith in rich and divergent ways.

Creating Openings for Transformation

My experience in using the arts in teaching Hebrew Bible is that the arts can create openings for transformative impact that would not necessarily have been possible in more traditional forms of exegesis and biblical teaching. I return to Genesis 22, the *Akedah*, again to illustrate this. My experience is that, in spite of its central importance in the history of tradition, this is a text many students are reluctant to encounter. They find it problematic and distance themselves from it. "I could never be a parent who would do this." "How could God ask this of Abraham and Isaac?" "Isn't this just a reflection of ancient practices that have nothing to do with us?"

I begin to work with this reluctance by inviting students to midrash. The biblical account is minimal. There are so many invitations to the imagination. What of Sarah? Did Isaac know? What could Abraham and Isaac have said to each other? Why didn't Isaac run? What happened afterwards because Isaac doesn't seem to return with Abraham? I don't stay with this long because the discussion still often seems to be at arm's length.

It is artistic midrash that changes this. When students view key paintings, the universal human drama of the story of the binding of

Isaac begins to break down the emotional distancing. Rembrandt's *The Angel Prevents the Sacrifice of Isaac* and Marc Chagall's *Sacrifice of Isaac* are particularly effective. Chagall includes in the upper right corner of his painting scenes from the holocaust tragedies of World War II and a Christ figure bearing a cross. This is not just an ancient story.

John Huston's film *The Bible: In the Beginning* (1966) includes an episode on the binding of Isaac starring George C. Scott as a very effective and agonized Abraham. His interactions with the boy Isaac add human emotional depth to the spare biblical story. Huston becomes a practitioner of midrash when he sends Abraham and Isaac on their journey to Moriah through the ruins of Sodom. In a landscape reminiscent of the aftermath of a nuclear blast, serious theological questions are raised in the conversation between father and son. God demands obedience and judges the disobedient, says Abraham. But Isaac asks, "Were the children disobedient, too?" Abraham struggles with memories of his unsuccessful effort to bargain with God and deflect God's judgment from Sodom. Later, bound upon the wood, Isaac asks, "Is there nothing God cannot ask of you?" and Abraham mournfully answers, "Nothing." The interaction between father and son during the binding and after the deliverance is wrenching and engaging at the same time.

I immediately ask students to listen to the "Offeratorium" section of Benjamin Britten's *War Requiem,* composed for the dedication of the rebuilt Coventry Cathedral as a memorial to war dead and a commitment to peace. In this section, Britten sets to music the poem of Wilfred Owen on the Abraham and Isaac story. Owen was a young poet killed in the trenches in World War I France whose posthumously published poems are celebrated laments over the tragedy of war. In this poem, given musical setting, the angel cries out to Abraham, "Sacrifice the ram of pride instead!" and the terrible line that follows is, "But the old man would not, and slew his son, and half the seed of Europe one by one." As the innocent voices of a boys' chorus begin to sing, the line reverberates in interrupting insistence "half the seed of Europe, one by one."

On the heels of listening to Britten and Owen, the class views George Segal's sculpture "Abraham and Isaac (in memory of May 4, 1970)," commissioned to memorialize the students killed by the

National Guard at Kent State University during the height of Vietnam War protests in this country. Abraham is in a National Guard uniform with Isaac, a student, kneeling before him. It was not accepted by Kent State and stands today on the campus of Princeton University.

Class discussion following these artistic experiences is no longer distanced. The spare text of Genesis is imaginatively expanded in ways that engage us and make clear to us that this story has many times been our story through the generations. The students have been opened to the transformative impact of the text and begin to understand why the church and the synagogue have returned so often to reflect on this text and its deeply important and troubling themes. The student discussion becomes imaginative and engaged, and I do not believe this could happen nearly so well without the impact of artistic imagination.

This is a dynamic not unique to Genesis 22. In virtually every course I teach, there are key texts with rich histories of artistic interpretation to enhance and supplement the witness of commentary, essay, and sermon.

Demonstrating the Importance of Social Context

Artistic treatments of biblical texts and stories can *demonstrate the importance of social context* on biblical interpretation. This is a major interest in biblical teaching today. Most scholars/teachers are eager for their students to learn that all interpretation is socially conditioned and to develop the ability to critique interpreters and their contexts (historic and modern) as well as texts. The arts can be an invaluable asset in helping students to see this point.

Viewing a series of paintings based on the story of David and Bathsheba reveals a rich and complex social history of gender roles, attitudes toward sexuality, the role of bathing in various cultural settings, and issues of power and abuse. Basing a class discussion on the 2 Samuel 11 text alone would take a much longer time to evoke the same range of interpretive issues than would be the case when those issues and the social agendas that inform them are visually available to students in ways they quickly recognize. I can easily expose a class to ten paintings with distinctive points of view on the text. I could not ask them to read ten commentaries.[3]

By showing students the personal filmed prologue that Cecil B. DeMille gave himself as a preface to the viewing of *Ten Commandments,* students gain a profound appreciation for the way in which ideology can shape interpretive choices. DeMille solemnly tells us that we are about to see the story of the birth of freedom and God's opposition to tyranny. The background for DeMille's concern was the Cold War in 1956. He not only saw the Exodus story as a parable of this clash of ideologies, but saw it as a justification for the use of nuclear deterrence and its threat to innocent lives. Did not God take the innocent lives of Egypt's firstborn for the sake of freedom? The film closes with Moses intoning to Joshua the words from Leviticus inscribed on the Liberty Bell, "Proclaim liberty throughout the land and to all its inhabitants thereto." The film was marketed in 1956 with a picture of Charlton Heston superimposed on the Liberty Bell. Minus the prologue and the poster, this film and its 1950s Cold War freight continues to be shown on network television annually.[4]

Using such examples, students can be challenged to new critical awareness in their use of biblical interpretive material. What do we learn of the interpreter as well as of the text? Likewise, they can be made more sensitive to their own social location and the way it influences their own preaching and teaching.

Accessing Complexities through Art

The arts can often *provide access to difficult or complex biblical texts and theological concepts.* The tendency of clergy and laity alike is simply to avoid portions of the scripture that are known to be challenging for one reason or another. The arts can often help make such texts more approachable and the meaning from those texts more accessible.

One example will suffice. In the spring semester of 2003, I was scheduled to teach a seminar on the Book of Job. Job is notoriously difficult. Most laypersons know only the simple story of the prologue, and pastors rarely offer Job as the subject of Bible study because its poetic text is both difficult and interpretively troublesome. Yet, the subject of innocent human suffering and how we understand our relationship to God in the midst of that is one of the most deeply universal human questions. In my seminar we would, of course, study our way carefully

through the text using some of the more insightful commentaries, but this would not be a process that could be replicated in ministry to help make the rich but challenging Book of Job accessible.

Fredericka Berger, lecturer in church drama at Wesley, was offering her course in chancel drama during the same semester. We had talked about how many playwrights had tackled the subject of Job, and the richness of that dramatic literature. We decided that Job would be the subject of her course and the focus of the dramatic performance she directs each spring in connection with this course. Of the approximately twenty students in each class, eight students registered in both courses. Fredericka Berger sat in on the Job seminar. We added three plays to the seminar syllabus, and I took a small role in the performance. The three plays were Archibald MacLeish, *J. B.,* Robert Frost, *Masque of Reason,* and Neil Simon, *God's Favorite.* The result was a semester-long dialogue on the meanings to be found in the Book of Job and the ways in which audiences might be engaged and challenged by those meanings. The culmination was a performance in Wesley's Oxnam Chapel in April to a filled house. It was our good fortune that Judith Rock, noted dancer, choreographer, and theologian from New York, was our spring visiting artist and lecturer for two weeks shortly before the performance. She choreographed movements to enhance the performance, and these added some astonishing moments to the piece, especially a dance piece used to express the silence of Job's comforters. The script was drawn from the plays we studied, the text of Job using the Stephen Mitchell translation, a Peanuts cartoon strip, and some effective editing and bridging by Fredericka Berger. The performance was powerful and deeply engaging. It drew its audience into encounter with deep and important theological issues but did so in a way that was not intimidating—simply profoundly human. The dining hall was filled with an overflow crowd for a panel discussion after the performance, and the cast spent the afternoon discussing and debriefing with the Job seminar. The Book of Job, which many thought they could not even read, became the focus of a theological conversation that engaged the campus for days afterward. I have taught the Book of Job for years, but never with greater certainty that its many levels of challenge and insight had been engaged fully by students in the class and the community as a whole.

This is one example, but it is illustrative of the access the arts can give to deep and complex theological issues. Students from last year have told me they have now used those Job plays to good effect. Theological issues in the abstract can intimidate and remain impenetrable, whereas the arts open discussion to a greater degree than is possible in abstract, theological discourse: consider Elia Kazan's film *East of Eden* for issues of free will and human sin in the Cain and Abel story; Mendelssohn's oratorio *Elijah* for discussion of idolatry; Madeleine L'Engle's novel *Certain Women* for issues of providence and personality in the David story; Breughel's painting *Tower of Babel* to discuss human hubris and technology.

Interpreting Texts through the Creative Process

An emphasis important to the contribution of the arts to biblical teaching is the opportunity for students to become artistic interpreters themselves. They can experience for themselves a powerful new mode of *entering into conversations with biblical texts by creating an artistic work* in a chosen medium. Except for the large introductory course, such an artistic project is a requirement for every course I teach, and it is common in many other courses at Wesley. It has been an important feature in Wesley's arts program that students view the arts not simply as products to be experienced and used in some way, but as processes of creative engagement in which they, too, can become involved with important benefits for personal growth and ministry.

I believe that it is especially productive in biblical teaching to engage students in this creative enterprise. Meanings from the text emerge in this creative encounter in ways and with impact that are often surprising, revealing, and deeply engaging. I believe it is this same phenomenon that Jo Milgrom has discovered and described in her important book *Handmade Midrash: Workshops in Visual Theology.*[5]

My own efforts have encouraged students to choose any artistic medium they wish and to create a project that interacts with a biblical text or theme appropriate to the course. It is important that this requirement be for all students in the course. This is not merely an opportunity for students with already developed artistic talent to have an alternative to other course requirements. It is a fundamental part of the

course experience based in the notion that such creative encounter with biblical texts produces a level of openness to and engagement with the text that transcends the traditional, more discursive modes of study. Obviously, evaluation of such projects cannot be based on a student's level of developed artistic skill. The range of skill in artistic expression will be wide. The arts faculty at Wesley developed a set of guidelines for evaluating artistic projects.[6] Students may seek advice from any of the arts faculty or visiting artists on the campus. The end of each course includes a sharing of projects: a combined exhibit, performance, reading, and discussion that often attracts attendance by students outside the enrollment of the course.

The results have been richly rewarding. The level of artistic skill varies greatly but the level of creative engagement with biblical texts has been deep and profound. I encourage students to let the artistic work speak for itself, but to talk with the class about their experience of the process and their learnings from that process.

Some examples:

A Zimbabwean student in the Job seminar composed a three-part song using traditional musical idioms of his own background and recruiting two friends to sing it with him in a haunting lament.

A rough-hewn rural student pastor from central Pennsylvania reported that he came to Wesley complaining about having to do "artsy" stuff, but found himself drawn into arts courses and practicums. While taking my course, he was in a practicum with a visiting stained glass artist, and at home his church was struggling with environmental pollution that was aided by state policies and practices they could not get reexamined. He announced he would do a project on Amos 5:24, "but let justice roll down like waters, and righteousness like an ever-flowing stream." He came up with a design that was something of a protest poster in glass. Our stained glass artist told him that glass could not always be made to do what you wanted to do. You had to work with its properties. He tried anyway, but with no success. He said the turning point was when he realized that he was "oppressing the glass." He was trying to make it accept his own agenda. When he worked with the properties of the glass with respect, something else emerged—a remarkable combination of symbols and design, drawn from Amos but

taking a fluid, flowing shape. He reported that this made him think of Amos's image of justice and righteousness related to water. Water flows around obstacles rather than insisting on moving every obstacle. He decided this had implications for how the community worked at justice issues in its own backyard. A new committee and a new strategy emerged that was successful in moving around obstacles rather than insisting on overpowering them.

In the Old Testament and the Arts course I teach with Deborah Sokolove, a woman approached us in despair over her project. She was a talented pianist, but not a composer, she insisted. Apart from that, she could not think about working in another artistic medium. She said she did do a lot of cooking and thought she could cook biblical foods, but she somehow did not think that was what we had in mind. We agreed with her. She struggled for several weeks and then reported that she had asked the quilting circle at the small town congregation where she served as an intern to teach her quilting and she would design a quilt based on the creation story of Genesis 1. Her journal reports a remarkable process. As a small group of women taught her quilting, they began to ask her about the creation account she hoped to engage. They began to do Bible study over the quilt, and she brought in commentaries. One week, she played Haydn's *Creation* to inspire them. She was taking a church history course and her reading from Augustine was on creation and Genesis 1 and 2, so she read Augustine to them and they discussed it. She pieced together a design that moved from chaos to order and in the group they began to talk about the chaos they had experienced and the struggle back to find order in their lives. Was that God, the Creator, at work? They asked the pastor if they could present the quilt in a congregational worship service, and they wrote the liturgy, chose creation hymns, and hung the quilt as a worship backdrop. The student preached on Genesis 1. Reporting on this process to the class, she concluded by saying she was not an artist, and this was her first effort at quilting or design, but the learning in the process was wonderful. She unrolled the quilt and hung it before us, and the room fell silent. It was a stunning and inspired piece—a testimony to God's creation in many ways.

Stories could be multiplied: the fabric artist who began a series on Exodus that has now been exhibited widely; a Catholic priest from one of

our Washington Theological Consortium schools who composed a cycle of poems in the voices of Sarah, Abraham, and Isaac; the dancer who began a cycle of choreographed pieces on Old Testament women with a piece on Eve performed for the Old Testament introductory course; a play composed in the voice of Job's wife and her experience; a painting of Leviathan by a woman struggling with a life-threatening disease; a poetic lament for Tamar by a rape victim; a sculpture of Isaac and Ishmael locked in an embrace from one angle and in combat from another; a cycle of rock-jazz pieces played and sung on the theme of Job as outlaw; portraits of Job's friends done as a collage of cut and pasted words.

Including Artistic Witnesses in Interpretation

The introductory two-semester survey of Hebrew Bible is the greatest challenge for the use of the arts, but this course sets the tone for the curriculum in Hebrew Bible. I have been especially concerned that students be introduced to the Bible in ways that make clear that texts have been handed on to us through a chorus of interpretive voices that include the witness of artists. Our knowledge and perception of biblical texts has been shaped by artistic as well as theological and homiletical interpreters. I wanted to *introduce the Hebrew Bible with artistic witnesses in the mix.*

I have tried different experiments, but this fall is my most comprehensive. I am beginning each class with an artistic testimony to the portion of the Hebrew Bible up for the day. It may be an image or several images (painting, sculpture) or a piece of music or a reading (poetry, drama, prose), or a film clip, and on a couple of occasions a longer multimedia presentation.

There are two dangers. The first is that the arts can be reduced to mere illustration. They make the course more attractive or jazzy. I try to avoid this by incorporating the artistic treatment into the lecture at some point to suggest how it provides for me a creative entry into a text or theme. The second danger is letting the artistic pieces divert the focus of the course. Introducing the entire Hebrew Bible, even in two semesters, is a race against time. I cannot be drawn off into biographies of artists, reactions to a particular work, discussions of artistic technique, or any of dozens of fruitful lines of inquiry into the art forms as wor-

thy of study in their own right. I give minimal information on each piece, but my goal is simply to create a consciousness in students that there is a rich fund of interpretive material on the Bible to be found in the arts. What I share briefly in this class is but an illustrative sampling of that richness.

Outside of class, students often speak to me of these pieces and their own reactions to them. This, of course, is to be desired, and there need be no limitations on such personal conversations. If they express a wish to discuss and study these artistic expressions more fully as a part of their theological journey, I encourage them and direct them to other courses where more time can be taken for that enterprise. When that happens, I feel the sampling exposure in the introductory course is doing its job. It seems especially appropriate for those of us engaged in biblical teaching since artistic engagement with the Bible is so broad and rich. This would also be true for church history, but I realize that strategies for using the arts would be somewhat different for other areas of the theological curriculum.

CONCLUSION

I am convinced that biblical teaching and preaching in the life of the church has a deeply aesthetic dimension. This is at odds with the tendency of the historical critical method to think of biblical exegesis as a scientific and analytical enterprise. During the long recent period when the historical critical method dominated biblical teaching in theological schools, students were not encouraged to think of encounter with biblical texts as an exercise in creativity and imagination. Teaching as a visiting professor in another theological school, I was a bit puzzled at the resistance of my students to an assignment asking them to write a one-page reflection each week on how their own story had been intersected by the biblical story in the readings for that week. Several weeks into the course, a student timidly approached to tell me that, in this school, students were not allowed to raise such questions in the Bible department. They were learning to analyze texts; everything else came in the homiletics department.

The goal of our biblical teaching ought to be to kindle imagination and creativity in encounter with biblical texts that are themselves not

documentary historical data, but imaginative witnesses to the surprising grace of God and the fascinating variety of our human experience with that God. The interpretive method of midrash can help free students for imaginative engagement with the text while holding fast to the notion that the text and its integrity deserve respect and authority. The arts can then enrich the depth and breadth of this imaginative encounter with the biblical text. We must teach in ways that not only allow room for the arts to have vision and voice, but that give our students tools and experience in drawing upon the arts and becoming artists themselves. Who knows? They might even be tempted to think of the sermon as an imaginative art form.

≈

NOTES

1. There are many excellent treatments of midrash for those who wish to explore it more fully. Jacob Neusner, *Invitation to Midrash* (New York, Harper & Row, 1973), is a widely used standard. An excellent shorter treatment can be found in Barry Holz, ed., *Back to the Sources* (New York: Summit Books, 1984), where Holz's own chapter on midrash ends with an extensive guide to further reading. Gary G. Parton, "Midrash," *The Anchor Bible Dictionary*, 3.818–22, is also an excellent short treatment that makes clear the complexity of a precise definition of midrash. Two outstanding examples of the application of midrash to artistic interaction with biblical texts can be found in Jo Milgrom, *Handmade Midrash: Workshops in Visual Theology* (Philadelphia, New York, Jerusalem: Jewish Publication Society, 1992), and in David Curzon, ed., *Modern Poems on the Bible: An Anthology* (Philadelphia, Jerusalem: Jewish Publication Society, 1994).

2. Robin M. Jensen, "The Binding or Sacrifice of Isaac: How Jews and Christians See Differently," *Bible Review* (October 1993): 42–51, is an excellent example of such a teaching use of artistic images, and makes an excellent reading to accompany use of those images in class. Her more technical treatment of this subject and some of the current interpretive debates regarding it can be found in "The Offering of Isaac in Jewish and Christian Tradition: Image and Text," *Biblical Interpretation* 2.1 (1994): 85–110. A comprehensive resource on this subject can also be found in Jo Milgrom, *The Binding of Isaac: The Akedah—A Primary Symbol in Jewish Thought and Art* (Berkeley: Bibal Press, 1988).

3. These days, there are often secondary sources available to assist students in learning from artistic resources on particular texts. On David and Bathsheba, I have found Cheryl Exum, "Bathsheba: Plotted, Painted, and Shot," and David Gunn, "Bathsheba Goes Bathing in Hollywood," both in *Semeia: Biblical Glitz*

and Hollywood Glamour (1996): 47–74; 75–102, to be very effective for use with students.

4. See articles by Alice Bach, "'Throw Them to the Lions, Sire': Transforming Biblical Narratives into Hollywood Spectaculars," and Ilana Pardes, "Moses Goes Down to Hollywood: Miracles and Special Effects," in *Semeia: Biblical Glitz and Hollywood Glamour* (1996): 1–14; 15–32.

5. Jo Milgrom, *Handmade Midrash: Workshops in Visual Theology* (Philadelphia, New York, Jerusalem: Jewish Publication Society, 1992).

6. The following set of evaluating arts projects (dance, drama, music, literary, and visual) were produced in the context of theological coursework and approved by the Faculty Committee on Theology and the Arts, November 7, 1995, at Wesley Theological Seminary.

> As the Seminary pursues its goal of integrating the arts across the entire curriculum, questions have arisen regarding the way to evaluate arts projects done in fulfillment of assignments in courses which do not have the arts as their focus. Faculty, with little or no background in the arts or those with some expertise in one area but not in others, are generally in no position to make artistic judgments on such projects. Likewise, students who have widely varying levels of experience and education in artistic fields will have equally varying abilities both to envision and to produce works of art which have worth outside the educational contexts which evoke them.
>
> Therefore, it is the recommendation of the Faculty Committee on Theology and the Arts that those students who wish a response to their productions *as art* should be referred to the appropriate Arts Faculty or Center for the Arts and Religion staff person, who will engage in dialogue with the student regarding the work in question. Such consultations will in no way influence a student's grade in the course for which the work was produced. Those students wishing a deeper, ongoing engagement regarding their artwork should be encouraged to enroll in an Arts Practicum or other suitable course with the appropriate Arts Faculty member.
>
> The Committee further recommends that, for the purposes of grading, any artistic judgment should be mediated by considering the project in terms of the student's engagement with the process and with the subject matter of the course.
>
> There are a variety of ways that such engagement may be evidenced. For instance, a student might be encouraged to document the process (using sketches, photography, logbook or journal, and/or other appropriate means), and comment in writing or in a presentation to the class on how the process itself arose in response to, and deepened the student's learning in regard to, the assignment. In this way, the student's competence as an artist need not be the

issue evaluated by the instructor. Rather, the art-making process it-self (like the written assignments more common in theological edu-cation) can become a vehicle for new understandings, which can then be articulated and discussed, and thus made the springboard for new explorations.

A more specific way to evidence such engagement is through the use of standardized questions which the student will answer as part of the assignment, in addition to the art project itself; and a similar set of questions for faculty at the time of evaluation. To as-sist faculty with evaluating arts projects produced in their classes, the attached questionnaires for use by students and faculty are pro-vided. Faculty are encouraged to adapt the questions to the partic-ulars of their courses. It is recommended that faculty encourage stu-dents to keep the questions in mind as they plan and produce their projects.

The committee further provided guidelines for "Student Self-Evaluation of Arts Projects (Dance, Drama, Music, Literary, Visual) Produced in the Context of Theological Coursework," as follows: Answer the following questions as part of the preparation for your project: 1) With what group of people do you intend to use this work? How do you hope this piece of creative work will address them? What emotional or moral influence do you hope it will have on these persons? 2) Describe the process engaged in to produce the artwork. How does the process relate to the class assignment or content? 3) Explain the choices and decisions that led to the final form presented for evaluation. If you cannot, why not? 4) Indicate clearly how the artwork comes out of the coursework and is related to it. What is the connection between the artwork itself and the learning that it is supposed to represent?

Finally, the committee provided guidelines for "Faculty Evaluation of Arts Projects (Dance, Drama, Music, Literary, Visual) Produced in the Context of Theological Coursework," as follows: Consider the following questions: 1) Since students are preparing for a ministry which includes proclamation of the Word, it is appropriate to ask them to think about how they hope a piece of creative work will address those to whom this work is intended to communicate. Has the student articulated for what group of persons this work is envisioned, and what emotional/moral influence the work is intended to have on these persons? 2) Has the student clearly described the process, and how the process relates to the class assignment and content? 3) Has the student explained the choices and decisions that led to the final form presented for evaluation? 4) Has the student created an intellectual "bridge" between the artwork itself and the learning that it suppos-edly represents, making it clear to the professor and/or classmates that it comes out of the coursework and is related to it?

~ 6 ~

Changing Patterns and Interpretations of Parables in Art

DOUG ADAMS

W hile miracles of Jesus appear frequently in the first thousand years of church art, his parables appear primarily in the last thousand years. For example, the parable of the prodigal son, the most popular parable in American art of the last two centuries as well as in European art since the Reformation and Counter Reformation periods, is first seen in an eleventh-century Bible and a twelfth-century capital.[1] While the miracles abound in art during earlier periods when there was emphasis on Jesus' divinity or power, the parables are more frequently seen in later art when Jesus' humanity or suffering is emphasized. The second most popular parable in art of the last few hundred years, the parable of the good Samaritan, does appear infrequently in the first thousand years and as early as the sixth century Byzantine Rossano Gospels, but in that source, the parable becomes a miracle story with the haloed Christ

identifying with the victim in dying and rising to portray the soteriology of Christ's divinity. That same aspect of Christ's divinity or saving power is emphasized in the other two parables that appear with greatest frequency in early church art: the parable of the lost sheep, which may be seen in the Good Shepherd, and the parable of the wise and foolish virgins. Aspects of the great banquet parables may be discerned in some church art related to eucharist or agape or the miracle at Cana, but such art is not primarily about the parables.

This essay explores the changing patterns and interpretations of parables in art and is part of a new book I am writing, *Changing Perceptions of Jesus' Parables through Art History: Polyvalency in Paint*. That book will be concerned with how different artists interpret the same parable differently—a polyvalency (i.e., multiple interpretations) through art. It also reflects a larger interest I have in exploring why a particular biblical character or story or parable becomes prominent in the arts of one period but may be less prominent or absent in the arts of another period. For example, changing patterns in the selection of biblical texts and images chosen and developed by leading Puritan preachers in sermons reveal changing American identity and theology in the seventeenth and eighteenth centuries. While their preaching in old England had stressed New Testament criticism of religious and secular authorities, the earliest generations of New England Puritans, who saw themselves as the New Israel in a promised land after exodus from England, emphasized portions of the Old Testament: the first generation, including such figures as John Cotton and Richard Mather, concentrated on the Pentateuch and former prophets; the second and third generations, those of Increase and Cotton Mather, shifted to the Wisdom literature; and only in the next generation, with Jonathan Edwards, is there a shift to the Gospels. Corresponding shifts may be noted in the conceptions of covenant, with differing emphases placed on a covenant with the people, a covenant with a remnant, a covenant with the individual, or an absence of a societal covenant. Parallel shifts may be discerned in the imagery of music and visual art. So it is that awareness of these shifts in imagery and identity aids not only the theologian and church historian, but also the art historian.[2]

Similarly, I have explored changing patterns of biblical stories in dance, such as the parable of the prodigal son. In the early 1930s, themes such as Job, the prodigal son, and the wise and foolish virgins appeared in dance—themes befitting a period of depression. Based on Blake's paintings of Job and premiered in 1931, dances by Ted Shawn (*Job, a Masque for Dancing*) and by Ninette de Valois (*Job* with Vaughn Williams' music) were staged in the United States and Europe respectively; and Martha Graham's *Lamentation* dates from the early 1930s. The theme of the prodigal son, which had been done by the Paris Opera Ballet as early as 1812, reappeared in the twentieth century with Balanchine's 1929 *Prodigal Son* for the Diaghilev Ballets Russes (revived and reworked in 1931 in Copenhagen), Kurt Jooss' *Le Fils Prodigue* in 1931, and David Lichine's *Prodigal Son* in 1938 (a reworking of the Balanchine choreography). Again in the 1960s and 1970s, during the civil rights, student rights, and antiwar movements, there were numerous revivals of the prodigal son, including Balanchine's work and Barry Moreland's *Prodigal Son* in ragtime. Seven leading choreographers shared their views of how they would handle the prodigal son theme in Selma Jeanne Cohen's book, *The Modern Dance: Seven Statements of Belief.*[3] The treatment of the parable of the wise and foolish virgins was inspired by different idioms, from the folk art/folk songs of Jean Borlin's *Les Vierges Folles* for the Ballet Suedois (Swedish Ballet) in the 1920s, to the more classical styles of Ninette de Valois' *Wise and Foolish Virgins* for the Vic Wells Ballet in 1933, to the baroque, curved-line paintings of Frederick Aston's *The Wise Virgins* in 1940.[4]

REASONS FOR CHANGE

With respect to some changing patterns of parables in art, the actions of church councils reveal reasons for the changes. The pre-Christian image of the Good Shepherd may be associated in early church art with Christ as the shepherd who saves sheep in Jesus' saying from John 10:1–16 and in his parable of a lost sheep from Luke 15:3–7 and Matthew 18:12–13. The image, however, is rarely used after the Quinisext Council (or Council of Trullo) in 692 C.E., which prohibited associating Christ as or with lambs not only to avoid animal worship

and other pagan associations but also to avoid demeaning Christ's divinity, as shepherds were increasingly understood to be immoral characters.[5] Being a shepherd was on the list of unacceptable occupations for some first-century Jewish communities, so for Jesus to cast a shepherd as a critical figure in a parable was akin to casting a Samaritan or a woman as central as he did in other parables.[6] The image of Jesus as the Good Shepherd returns in later medieval art as parables generally become more frequently rendered in art and as Jesus' humanity and suffering with the poor are stressed by Franciscan preaching. Similarly the suffering Christ on the cross (*Christus patiens*) is emphasized by the Franciscan-influenced artists beginning in the late twelfth century to reveal Jesus' humanity and affinity with the poor. Whereas the triumphant Christ on the cross (*Christus triumphans*) had been the style of representing crucifixion from its first appearance in the early fifth century until the mid-eighth century, a suffering Christ was first introduced into art in the eighth century to counter the Monophysite overemphasis of Christ's divinity and denial of his humanity.[7]

The actions of the Council of Trent reveal why the parable of the prodigal son increased in prominence during the Reformation and Counter Reformation and why some artists opened one window of interpretation and other artists opened a different window of interpretation. While Protestant artists such as Rembrandt van Rijn (1606–69) rendered that parable in art so as to magnify the grace of God and to assert that God's action of forgiveness came before our action of repentance, Catholic artists such as Bartolome Estaban Murillo (1617–82) followed the injunctions of the Council of Trent (1545–63) to bolster the sacrament of penance by emphasizing the prodigal son as repentant before he was forgiven by the father.[8]

Using intertextuality, a literary and biblical method of comparing how one story is told in terms of previously known stories, one can discern the meanings in *The Return of the Prodigal Son* by Rembrandt (ill. 8). In that painting, the artist appropriated established iconography of Jacob stealing Isaac's blessing, which Rembrandt had often rendered and which was very familiar in Flemish tapestries before and during his time. In Rembrandt's 1652 drawing of *Isaac Blessing Jacob,* for example, Jacob steals the blessing from Isaac that properly belongs to Esau,

and in the upper left background, Rebecca presides over the event. Likewise, in Rembrandt's painting of the *Prodigal Son,* the female in the upper-left corner presides over the father's embrace of the returned prodigal. By emphasizing that the prodigal is not repentant but comes home because he is hungry and remembers that his father's servants have bread enough to spare, and is deceitful and undeserving like Jacob at the very moment when his father embraced him, Rembrandt asserts the Reformation theology of the priority of God's forgiveness before we repent, or even if we never repent. The focus in Rembrandt's painting is on the father, who frontally faces us, while we see the back of the son and only a small part of the right side of his face. The focus is quite different in Murillo's *Return of the Prodigal Son* (1667–70) where the kneeling son is in dramatic full profile and is clearly the center of attention in the work (ill. 9). The father is not positioned frontally but is turned toward the son, who appears very repentant with his hands clasped in prayer. A dog touches the son's knee, which further emphasizes the son's repentance as the dog is often the symbol of faith. Similarly, Kellogg and Company, one of the largest producers of lithographs for the Roman Catholic market in nineteenth-century America, produced the 1846–47 lithograph *The Return of the Prodigal* with the son kneeling in profile and appearing very repentant. The initiative is with the son and not the father, who does not even touch the son—but a Victorian father might not run and embrace and kiss his son. With some Hispanic references, John August Swanson in 1984 created *The Prodigal Son,* in which the father is rushing toward the son, but is not yet embracing him. The son does not move forward but stands like a boxer with his weight on both feet and with his arms raised in front of him, not widely open to embrace the father but somewhat defensively positioned as if he expected the father might strike him. In Chinese artist He Qi's 1992 painting *The Return of the Prodigal Son,* the father is seated in a fine chair and the son kneels before him with his head and neck stretched back in contrition. In Chinese culture, one would expect the father to remain seated in authority and await the son to come to him. Despite the myriad number of ways the parable has been depicted in art, the father rushing to greet the son as Jesus tells it in the parable is surprising, and reveals the father to be taking the initiative.[9]

COMPLICATIONS

Before considering comparisons of artists' changing perceptions of other Jesus parables, we need to be aware of a complication in finding artworks dealing with parables: most art historians create an index according to artists or media, but not by subject. *The Dictionary of Art,* the state of the art tool for art history, has no references to parables in the index. Another usually good source, the *Index of Christian Art at Princeton University,* is of limited value for studies of parables in art because it goes comprehensively only to 1400 (although it has been extended to 1600 with references to art at the Morgan Library and at Princeton University). As noted earlier, most parables were not depicted in the first thousand years, but mainly after 1600. Another complicating factor of finding art works dealing with parables is that while many art works carry titles, those titles do not necessarily parallel the titles of biblical parables. Another problem is that many artists did not give fixed titles to their works. Many curators or collectors tended to invent titles for the works as they came into major private or public museum collections. Also, while some museums title the works to reveal their biblical connections, other museums obscure those connections. A major Rembrandt painting dating from circa 1635–39 is entitled, by a number of Rembrandt scholars, *The Prodigal Son Squanders His Inheritance* or *Rembrandt (Self-Portrait) and Saskia in the Parable of the Prodigal Son* (ill. 10); but the museum in Dresden where the work hangs calls it only *Self Portrait with the Artist's Wife.* All three titles are true, but the biblical allusions are lost if one sees only the latter title.

With *The Dictionary of Art* now online, one may search for subjects like parables through titles; but the foregoing problems may result in one missing many important works related to any given parable. Because art works are more like films than snapshots and so include many biblical stories in one painting rather than referring to only one scriptural text, titles of paintings rarely reveal the full scope of the parables in art. For example, three El Greco paintings entitled *Christ Healing the Blind Man* relate the story of Jesus healing a blind man as told in John 9:1–34 but also include in the middle of the background the figures of the father embracing the son from the parable of the prodigal in Luke 15:20.[10]

FINDING CLUES

By including references to a parable in a work of art on another subject, such as a miracle, an artist may provide clues to interpretation of an art work. For example, in the El Greco works referred to above, the inclusion of the reference to the father embracing the prodigal son in the background calls attention to the importance of embracing or touching in Jesus' healing of the blind man in the foreground. Such embracing contrasts sharply with the lack of touching among both the Pharisees to our right and the disciples to our left. Jesus' left hand embraces and lifts the blind man's left arm as Jesus' right hand touches the man's right eye. Behind the blind man are five of Jesus' disciples, but only the nearest one bends over closely to see what Jesus is doing while the other four are preoccupied in conversation and do not look at the healing. From the other side of El Greco's *Christ Healing the Blind Man,* a large group of Pharisees react negatively to the healing. Two of them look at what is happening and others close their eyes or turn their eyes from the scene, and some point fingers or make gestures that indicate disapproval or an argument about the healing as they did in John 9:1–34. In the middle of the painting, behind and between the group of disciples and the group of Pharisees, are two figures who embrace each other. Art historian Jose Alvarez Lopera identified these two as the father and the returning prodigal son from Jesus' parable in Luke 15:20 where the father embraces the son. In El Greco's work, the father's left hand embraces the son's face and his right hand embraces the son's left side. The son's left hand embraces the father's chin. The embrace of the father and son resonates with Christ's embrace of the blind man. Both of these scenes contrast with the lack of embrace among the disciples to one side and the Pharisees to the other side. While the Pharisees are crowded together, there is no sense of intimacy among them. The same could be said of the group of four disciples. In the central foreground is a dog standing in what some have identified as the pool referred to in John 9, but there is no water in the pool. The dog stands cowering in front of a bag and a jug with its eyes on the Pharisees, whose animation could be ominous. The dog is sometimes a symbol of faithfulness, but in this case the dog as faithfulness seems to be afraid that it might be attacked by the Pharisees, who are criticizing

the healing or who are more interested in diagnosing the causes of sickness than in embracing a cure.

El Greco created three versions of this painting in the 1570s. The one I have been describing is now in the Straatliche Kunstsammlungen Gemaeldegalerie in Dresden, Germany, and was the first. The second is in Parma, Italy. The third is at the Metropolitan Museum of Art in New York. In the second and third paintings, El Greco added a second blind man, a reference to Matthew 9:27–31 where two blind men are healed, and portrayed him already healed. That man stands behind Jesus and the kneeling blind man, turns his back to them, and looks up in the opposite direction from them. In the second and third paintings, the father and prodigal son are painted farther in the background, and are smaller than they appeared in the first. In the third painting, a man escorts a woman in the foreground. They loom large as they face in the direction of Jesus and the kneeling blind man.

In each of the paintings, we are faced with many people who do not see the healing or who turn away from it. Those persons, whether in the group of disciples or in the group of Pharisees, do not touch each other even though they are very close to each other. By contrast, Jesus and the three kneeling figures, the blind man in the foreground and the father and prodigal son in the background, embrace or are embraced. There is a prayerful relationship between Jesus and the blind man and between the father and the prodigal son.

Looking at the painting, we may ask: to which figures are we drawn? With whom would we wish to be associated? Most of us likely would answer that we would prefer to be with those who are kindly embracing each other. Where in our own lives do we embrace and heal and see each other; and where in our own lives do we criticize and argue without embracing and without seeing? In El Greco's art work, embracing comes before healing and seeing. Do we insist on healing and seeing before embracing?

Comparing three art works on the parable of the Sower reveals changing emphases in the last half of the nineteenth century. In Francois Millet's *The Sower* (1850; ill. 11), the action of the man sowing seed is central; but in John Everett Millais' woodcut *The Sower* (1864; ill. 12), there is less focus on the man and more attention on the negative fate

of the seeds. In the 1888 *Sower* (the Rijksmuseum, Kroeller-Mueller), Vincent van Gogh follows Millais in deemphasizing the sower but shifts our attention to the abundant field of wheat that the sun brings forth (ill. 13). The sower never looks back as he scatters seeds in van Gogh's work. While that painting was based on Millet's 1850 work, van Gogh places the figure far to our right in his painting. We are aware that there is much behind him to which he pays no attention. Millet's painting is a close-up of the sower, who fills the canvas and emphasizes the human being's importance, whereas van Gogh's work makes the man appear small and not that important. The van Gogh placement of the sower is somewhat similar to Millais' woodcut. Millais noted that such placement focused the viewer's attention on the negative fate of the seed and not on the sower: "I have made it landscape for variety; and to show the stony ground, briars, nettles, and fowls of the air feeding upon the stray seed. The Sower who is supposed to have sown the side of the field is subordinate."[11]

While the sower is subordinate in the works by both van Gogh and Millais, the focus in van Gogh's art is less on the fate of seeds being devoured by birds or being lost among the stones in the foreground and is more on the abundance of wheat filling the background. Such a shift of focus is affected by his painting the rocks and birds in the foreground in darker colors of purples, blues, and black while painting the wheat in bright gold so our attention is drawn to the background. Behind the thriving wheat field is a large bright yellow sun that fills the sky with yellow flecked by red. That sun does not appear to be the ominous sun that scorched the seed in Jesus' parable but rather a nourishing sun that animates the growing wheat. That sun may be interpreted as Jesus Christ, the son of God, as van Gogh associated that color with Christ.[12]

The van Gogh painting helps us perceive more of the parable than either the work of Millet or Mallais. In Mark 4:3–8, a surprise results from the contrast between the awful fate of the seeds in verses four through seven and the unexpected abundance of the seeds in verse eight. Millet focuses mainly on the sower, with the birds at the left as a hint of the destruction that awaits some seeds but with no indication of abundance; and Mallais focuses mainly on the seeds that are being destroyed by the birds and thorns. The massive growth of seeds is evident

only in the van Gogh work. While Vincent van Gogh gives more than two-thirds of the painting to seeds that were devoured by birds or that were scorched by the sun or that were choked by thorns, just as the parable gives four of six verses to those unproductive seeds, his vibrant color and abundant growth of the wheat in the background draw our attention away from the foreground of destruction.

The growing violence of the words used in verses four through seven would lead us to expect even worse things to come. Birds "devour" the seeds, then the sun "scorches" seedlings, and then thorns "choke" young plants. When such accelerating violence has affected our expectations for the worse, then we might burst out laughing with surprise and relief when the next seeds bring forth thirty-, sixty-, and a hundredfold. As a yield of sevenfold would be considered good in that period, we see how mind-boggling Jesus' parable would be to a first-century listener.

What destructive forces in our own day preoccupy our thoughts and lead us to expect the worst so we fail to see the best in others and in our world? Why might we become so caught up in the details in the foreground destruction that we fail to see the abundance in the background? What problems in our past prevent us from seeing present and future possibilities? The sower does not look back to see which seeds die and which ones grow. The sower may remind us of Paul's lines from Philippians 3:13b–14: "forgetting what lies behind and straining forward to what lies ahead, I press on toward the goal for the prize of the heavenly call of God in Jesus Christ." One could contrast that image to the biblical story of Lot's wife who "looked back, and she became a pillar of salt" (Gen. 19:26) or to the Greek story of Orpheus, who looked back and lost Eurydice.

Millais renders visually another parable, which strikes us as mundane when we first see the art or read the parable but which mystifies the mind if we look more closely. The following discussion shows how a biblical parable may be illumined by consideration of only one art work. A woman kneading the bread dough appears to be an ordinary scene in Millais' 1864 engraving *The Leaven* (ill. 14). Similarly, at first glance, we see nothing unusual in Jesus' parable in Matthew 13:33. "The kingdom of heaven is like yeast that a woman took and mixed in

with three measures of flour until all of it was leavened." When we look closer at both the art and the parable, we see some extraordinary features that stretch how we envision the kingdom of God or heaven.

When we learn that three measures of flour equal fifty to sixty pounds, we understand that there will be a huge quantity of bread for many more folk than some people expect to see included in heaven. Millais' engraving does not suggest such a massive amount of bread but is inclusive in other ways. When we remember that a Jewish symbol for God's coming to lead us to the promised land is the unleavened bread of the Passover seder service, we are reminded that leaven had come to be a symbol of the immoral life, whereas unleavened bread was symbolic of moral purity. For Jesus to say that the kingdom of God is like leaven is similar to saying that the kingdom of heaven is like the immoral life. Will he clean it up? No. Jesus has the woman take the leaven, immorality, and put it into the huge quantity of pure flour until the whole thing is leavened, that is, until the whole thing is immoral. To feature a woman further emphasizes the point of the parable. In first-century Judaism, women did not count toward the number necessary for worship, which required ten men. Women were usually not allowed to be present during worship, and were sometimes only permitted in a balcony or behind a screen. So the kingdom of heaven is like the yeast taken by a person who does not count and is put in a huge quantity of pure flour until the whole thing becomes immoral. We may see why the disciples were baffled by parables.

As in other parables, such as one we call the Good Samaritan, Jesus in this parable of the leavened bread puts together two things, leaven and heaven, which his followers considered to be evil and good. Equally troubling to them would be the central character in this kingdom of heaven parable: a woman. This parable is similar to the parable of the Good Samaritan. Many Jews considered Samaritans to be bad because Samaritans generations before cooperated with invaders, betrayed the faithful Jews who were exiled, and received Jewish lands. Therefore, some of Jesus' Jewish followers would not envision a Samaritan doing good.

Because unleavened bread was a highly charged political symbol of Exodus from slavery to freedom, we could translate Jesus' parable into political terms to see its impact for our day. Think of the most liberal per-

son whom you know and imagine saying to that person, "The kingdom of heaven is like putting Jesse Helms in the White House." To the most conservative person whom you know, imagine saying "The kingdom of heaven is like putting Jesse Jackson in the White House." To capture the full dynamics of Jesus' parable, you would say to both liberals and conservatives, "the kingdom of heaven is like putting Jesse Helms and Jesse Jackson together in the White House." People would laugh, for that image strikes the categories of our minds as nonsensical—but such is the kingdom of heaven that Jesus' parable helps us glimpse.

The engraving by Millais helps us see extraordinary features in this parable as we look more closely. The older woman and the girl are the only two people in the scene. Many painters featured important people in their works, such as national leaders or the wealthy or highly educated or moral exemplars like clergy, but Millais features two poor females who hardly counted in their own nineteenth-century culture, any more than women did at the time of Jesus. At the very center of the engraving is a billowing piece of fabric around the woman's waist—a feature like the billowing loincloth around the middle of Jesus on the cross in many art works. The woman's hands could be kneading the bread or blessing the bread, and the latter action is one that is like so many art works of Jesus' hands on bread. We may see the table as a communion table at which a woman not only is present but also presides. At the time of this engraving, the priest at the altar stood with his back to the congregation in celebrating the mass as this woman in Millais' engraving stands with her back to the viewer; but in most churches only men officiated. The girl, too, holds a loaf in her hand and could be thought of as a server of the communion or an altar girl at a time when there were only altar boys. Millais' seemingly ordinary engraving offers a challenging viewpoint in that mid–nineteenth-century context and extends the implications of the parable so women are not only present in worship, but also preside and are seen as a full part of the body of Christ.

CONCLUSION

This essay has revealed some of the perceptions that result from exploring a Jesus parable by looking closely at works of art. Each parable has many doors and windows of interpretation, which artists open to

us. Changing perceptions of Jesus' parables develop as we look through those different doors and windows. When I was visiting a parables course being taught by New Testament scholar James Breech, the students persisted in trying to find themselves in each parable. While Professor Breech welcomed some of the students' self-identification with the parables, he cautioned them to allow the parables to be windows as well as mirrors by saying "Some of these parables are not about you but are about other people. There are other people in the world." The parables, and art based on the parables, help us gain perspective on our time and our place even as they help us see the meanings found in them at other times and in other places.

⌒

NOTES

1. The reference to the prodigal son appearing in an eleventh-century Bible is noted in "Prodigal Son," *The Dictionary of Art,* ed. Linda and Peter Murray (New York: Oxford University Press, 2001), 448. The capital is at St. Nectaire, Puy-de-Dome, France.

2. For those patterns, see Doug Adams, "Changing Biblical Imagery and Artistic Identity in Seventeenth and Eighteenth Century Sermons and Arts" in *Meeting House to Camp Meeting: Toward a History of American Free Church Worship from 1620 to 1835* (San Jose: Resource Publications, 1981), 113–27.

3. Selma Jeanne Cohen, *The Modern Dance: Seven Statements of Belief* (Middletown, Conn.: Wesleyan University Press, 1966).

4. For all of the foregoing developments, see Doug Adams, "Changing Biblical Imagery and Artistic Identity in Twentieth-Century Dance," *Dance as Religious Studies* (New York: Crossroad, 1990), 3–14.

5. Robin Margaret Jensen provides a judicious assessment of the arguments as to whether early Christians saw Jesus in the Good Shepherd art in *Understanding Early Christian Art* (London and New York: Routledge, 2000), 37–41. Jane Daggett Dillenberger traces the Egyptian, Greek, and Roman roots of the Good Shepherd image in *Secular Art with Sacred Themes* (Nashville: Abingdon, 1969), 77–87.

6. See further discussion of these matters in Doug Adams, *The Prostitute in the Family Tree: Discovering Humor and Irony in the Bible* (Louisville: Westminster John Knox Press, 1997).

7. For the history of those developments, see Doug Adams' entries on "Crucifix" in *The Dictionary of Art* 8 (London and New York: Grove, 1996): 210–16.

8. See *Canons and Decrees of the Council of Trent,* trans. Henry John Schroeder (St. Louis: B. Herder, 1941). I explore this difference in a chapter entitled "Changing Perceptions of Jesus' Parables through Art History: Polvalency in Paint," in *Reluctant Partners: Art and Religion in Dialogue,* ed. Ena Heller (New York: Art Gallery of the American Bible Society, 2004).

9. Jerry Evenrud has assembled an extensive collection of the prodigal son in art, as seen at the Steensland Art Museum of St. Olaf College in Minnesota.

10. Jose Alvarez Lopera, *El Greco: Identity and Transformation* (Milan: Skira, 1997), 104. I discuss many other examples of how individual paintings bring together several biblical texts and sometimes the whole sweep of the biblical story in *Eyes to See Wholeness: Visual Arts Informing Biblical and Theological Studies in Education and Worship through the Church Year* (Prescott, Ariz.: Educational Ministries Press, 1995).

11. Abigail Willis, *The Parables of Jesus and Their Place in Christian Art* (New York: Penguin Putnam, 1998), 25.

12. Grose Evans, *Van Gogh* (New York: McGraw-Hill, 1968), 46.

The Portrait of God in Christian Visual Art

ROBIN M. JENSEN

The first hymn in the UCC *New Century Hymnal* addresses God in the terms of the ancient mystical *via negativa*—as "immortal, invisible, only wise, in light inaccessible, hid from our eyes." Although the opening lines of this well-known hymn are adapted from the words of 1 Timothy, "To the King of the ages, immortal, invisible, the only God" (1 Tim 1.17a), the concluding stanzas are attributed to Walter C. Smith, the late nineteenth-century Scottish author of the hymn text. The fourth verse declares: "So perfect your glory, so brilliant your light, your angels adore you, all veiling their sight; all praise we now render as your angels do; in awe at the splendor of light hiding you."[1]

This text asserts a commonly avowed tenet of Christian teaching—that the First Person of the Holy Trinity is invisible to mortal and possibly even to angelic eyes. It could mean (and often does to Christians) that God is invisible in the same way that pure air is—that God is

everywhere and also "clear." God may be *heard*—preferably speaking a language we can understand—or a presence that may be palpably *felt*, but God has no actual physical being—a face or body—that we can *see*, no matter how hard we try, since God is limitless and incomprehensible and, as Jesus says in the Gospel of John, "God is spirit" (John 4.24) and no one has ever seen God (John 1.18).

On the other hand, we might say that God is visible to the "inner eye" or the illumined soul, an idea that extends the ordinary meaning of the idea of "seeing" to include intellectual apprehension. And the above-cited hymn text, like the biblical passage on which it is based, does not actually deny that God has some kind of "appearance." Rather it claims that God *does* have a form, even if mortals cannot or should not try to behold it. God's divine being is "hidden" from view by "light" or "splendor." To be safe, humans had better follow the example of the angels and not attempt to sneak a peek or at least to await patiently the time that such a manifestation will happen in the age to come when God shall be revealed to us and we will "see him as he is" (1 John 3.2). To attempt some kind of prior glimpse of God's "face" is to court death. We recall that God denied Moses such a look for his own good, "for no one will see me and live" (Exod. 33.20).

In the meantime, certain blessed individuals may receive actual intimations of this beatific vision or see angelic beings, bright lights, or other mystical apparitions. In general, however, liberal, postenlightenment Protestants tend to be skeptical of those who claim to have experienced such divine theophanies and, in a Kantian sense, tend to prefer the intellect as the more reliable and rational medium for comprehending the divine. Such a view is ancient, however, and is well articulated in the writings of Augustine of Hippo, among other early Christian thinkers. Augustine, for instance, insisted that for Christians to think of God as being visible or in any way "bodily" verges on the naïve or superstitious beliefs of children, the uneducated, or ancient pagans. The future sight of God as promised by the text of 1 John will not be a seeing with bodily eyes of a corporeal divine form, but rather a spiritual gaze at an incorporeal being.[2] People attribute sanctity to stones or imagine that God might look like them—creating God in their own image rather than respecting the limits and natural fallibility of the human imagination.

For this reason, representation of God having human appearance, whether in textual narrative or in visual art, may strike us as childish, primitive, or perverse. To attempt such fabrication is to tell a lie. Nevertheless, we western Christians are quite accustomed to such representations, many of them blatantly anthropomorphic. The visual art of the High Middle Ages and Renaissance is an especially good source for such images. Perhaps the most famous, Michelangelo's fresco of God creating Adam, adorns the vault of the Sistine Chapel, and is an image certainly derived from an already established and widespread tradition. However, this representation appears in nearly every late medieval, renaissance, or baroque painting of the annunciation or the coronation of the virgin Mary, and often in portrayals of the nativity, baptism, or passion of Jesus as well (ill. 15). These images still appear everywhere in churches today—sometimes as part of a didactic trinitarian composition that includes the figures of the Son and Holy Spirit (ill. 16; ill. 17).

Most of these visual images, like the one in the Sistine Chapel, depict God as a wise old man with white hair and a long white beard. Such a representation has a possible textual basis in the enigmatic "Ancient One" mentioned in Daniel 7:9, although we rarely see the rest of that prophetic vision actually depicted in art (e.g., the flaming throne or the stream of fire extending from the Ancient One's presence). Ezekiel had a vision of "something like a human form" sitting on the appearance of a throne, but offered no description of the being he saw other than to say that it was the "appearance of the likeness of the glory of the Lord" (Ezek 1:28). Other scriptural texts mention God's back, bosom, hands, loins, and feet, but offer no descriptions of God's face. Apart from these theophanies described in the Bible, we have no certain basis for explaining why western artists began portraying God as a wise old man from the seventh century onwards, not to mention why they began to portray God at all. One obvious possibility is that referring to God as "Father" in Trinitarian formulae had its visual counterpart in portraying the First Person as the older, mature, parent of the incarnate Christ, who was ever since the Byzantine iconoclastic period during the eighth century a constant subject of both eastern and western iconography. If the question of textual basis is problematic, the question of artistic prototype is mysterious. Who or what was the model for those first artistic

representations? And, finally, we might ask an even more pressing theological question. On what basis, insight, divine self-revelation, or simple audacity are such images made? Who *dares*? Christ had a face; therefore, many famous theologians have defended images of him. But tradition, as well as text, usually argues that Christians should stop short of actual physical representations of God, both verbal and visual.

EARLY CHRISTIAN TEACHING ON THE INVISIBLE GOD

Most Christians simply assume that they inherited this belief in God's inherent invisibility from Jews who, they asserted, taught that while God might be heard, God could not be *seen*. Like early Christian teachers, they take for granted that while certain adherents to *other* religions might believe that their gods could be represented in carved or painted likenesses, faithful and enlightened Christians, following the Jews, understood that this was at least foolish, and probably dangerous. Asserting that God might have a particular, recognizable appearance was idolatrous and blasphemous, as well as naïve.

Justin Martyr, a Christian apologist who lived at the end of the first century, regarded statues of the traditional gods as tools of the demons. According to him, these deceiving spirits trapped gullible humans into worshiping such images, though they were clearly lifeless. By contrast, the deity that Christians worship, he proclaimed, had no form that could be imitated or represented. The form and glory of the Christian God are ineffable. Ordinary statues were merely the work of human hands, and inferior even to the artisans who fabricated them. Justin, however, really did not expect much objection from his intellectually sophisticated but "pagan" audience, and assured them that they shared such sentiments:

> For why need we tell you, who *already know*, into what forms
> the craftsmen, carving and cutting, casting and hammering,
> fashion the materials? And often out of vessels of dishonor, by
> merely changing the form, and making an image of the requisite shape, they make what they call a god?[3]

Whether Justin would have tolerated representations of the Divine Being by some purely abstracted or symbolic form—a Trinity triangle

or three intersecting circles, for example—is an unanswerable question. Such figures might serve a useful didactic function, even if acknowledged to be essentially inadequate. Alternatively, he might have accepted poetic metaphors and nature images (e.g., rock, wind, eagle) as having limited value, following Paul, who asserted that although we cannot see God directly ("his eternal power and divine nature, invisible though they are"), we may comprehend God through the works of God's creation and understand God's nature by a limited analogy to those things we can see in the world (Rom. 1:19–20). Justin seems to have been fond of symbols, as he particularly notes that the cross was figured in a ship's mast, plow, or mechanics' tools.[4]

The early second-century African apologist and teacher Tertullian used the above-mentioned Pauline text to support his claim that the object of Christian worship is One God, who is beyond all our conceptions, entirely incomprehensible, and known only to Itself. Like Paul, however, Tertullian claimed that while invisible to the human eye, God is yet "spiritually visible" because God's works can be seen everywhere in nature and the working out of history. God is "at once known and unknown." For this reason, humans are held accountable for recognizing God, since they have no excuse for ignorance.[5] At the same time, Tertullian rails against idolaters who would make images of gods out of wood or stone, citing Psalm 115:3–8, claiming that the Christian God is in the heavens, "doing what he pleases," while pagan idols of silver and gold are blind, deaf, and dumb, unable to feel, move, or speak. Oddly, the text itself, by contrasting a God who speaks and hears and walks with "lifeless" idols, shapes an imaginative, but rather anthropomorphic, image in the reader's mind.

Several other New Testament writings also support the contention that God is invisible in addition to John 1:18. For example, 1 John 4:12 says that "no one has ever seen God; if we love one another, God lives in us, and his love is perfected in us." This line echoes the important qualification in John 1, which adds that: "it is God the Only Son who is close to the Father's heart, who has made him known." Later in John's Gospel, Jesus perhaps elaborates on this, telling the disciples that they have never heard God's voice or seen God's form (John 5:37) and that no one "has seen the Father except the one who is from God; he

has seen the Father" (John 6:46). At the same time, that same Gospel has Jesus assert that the one who "sees me sees him who sent me" (John 12:45) and that "whoever has seen me has seen the Father" (John 14:9). Thus, seeing Jesus is a *way* of seeing God, although a mediated way. Paul similarly writes that Christ: "is the image of the *invisible* God" (Col. 1:5, cf. 2 Cor. 4:4–6). Jesus as the Incarnate One unavoidably had a visible appearance and bodily presence. This appearance and presence revealed God's essential being in some sense, but not necessarily in its physical appearance.

Origen of Alexandria, Tertullian's contemporary in Egypt, also took up the question of whether God had a body or could be visible in any sense, but made a distinction between the divine self-revelation in the incarnation and the eternally invisible God. In his treatise *On First Principles,* Origen agrees that the Son reveals the Father, but emphasizes that the purpose of such revelation was to make God *known* and understood to the *mind.* Citing the words of Jesus from John 14:9, "whoever has seen me has seen the Father," Origen asserts that the visible savior shows forth the essential being of the invisible and transcendent God, and—surprisingly, given his general repudiation of pagan idols—uses the analogy of a giant statue to illustrate his point. He invites his audience to imagine a statue so immense that it fills the world, and thus cannot actually be seen by any mortal creature. However, in order that we should be able to see and understand this statue, a model is made of a smaller, comprehensible size. The incarnation of the divine into an insignificant human body is like this, he says, able to reveal something otherwise not so much invisible as unfathomable.[6] Origen compensates for the materiality of this analogy, however, by claiming that the semblance of Jesus Christ to God was not so much a physical one as one based upon showing forth the works of the Father through the works of the Son, as when Jesus says "Very truly I tell you, the Son can do nothing on his own, but only what he sees the Father doing; for whatever the Father does, the Son does likewise" (John 5:19).[7] In this way, Origen avoids saying that God has any recognizable bodily or physical appearance.

Two hundred or so years later, in the early fifth century, Augustine of Hippo similarly addressed the matter of the visibility or invisibility

of God. A certain Paulina had written to ask whether God could be seen with our bodily eyes. In his lengthy and detailed response, Augustine says that humans can see God, not as we can see the sun or earthly objects, but rather with the "gaze of the mind" as we see ourselves inwardly. Citing Matthew 5:8 ("Blessed are the pure in heart for they will see God"), Augustine distinguishes between seeing and believing (as well as between present and future sight), since we believe much of what we cannot see (from details about our family history to Christ's virginal conception). He then tries to reconcile scripture texts that claim that certain persons have seen God (e.g., Gen. 32:30—Jacob at Peniel; Exod 33:11—Moses speaking to God "face to face"; and Isa. 6.1—the vision of Isaiah) over against those that say that such direct sight is impossible (e.g. John 1:18; 1 John 4:12).

The above-cited texts from Genesis and Exodus undoubtedly raised some potential contradictions. "When Abram was ninety-nine years old, the Lord appeared to Abram and said to him, 'I am God Almighty, walk before me, and be blameless'" (Gen. 17:1). And even though Moses is denied a direct look at God's face, he is at least accorded a look at his back (Exod. 33:23). Earlier in the book, Moses, Aaron, Nadab, Abihu, and seventy of Israel's elders "saw the God of Israel . . . they beheld God" (Exod. 24:9–11). Thus, it was hard to say that God had no "appearance," even if hidden in glory or however difficult to withstand. With regard to these scriptures, Augustine argued that such accounts of divine manifestation or theophanies prior to the incarnation were actual appearances of God. However, the patriarchs only saw God as God willed to appear and in a certain form that God chose. But this changing form did not mean that God was mutable in any way, since it did not reveal God's true nature. Thus, no one had seen the fullness of the divinity with bodily eyes, but particular individuals might have seen God in the form that God fashioned for the purpose of self-disclosure, in the same way that humans disclosed their own invisible natures through spoken words or visible gestures:

> For God produces them [visions] in order to appear by means of them as he wills, to whom he wills, and when he wills, while his substance remains immutably hidden in him. If our

will, while remaining in itself and hidden without any change in itself, utters words by which it somehow or other reveals itself, how much more easily can almighty God appear, while his nature is hidden and remains immutably, in what ever form he wills, to whom he wills![8]

But then, speaking of humans' desire to see God, Augustine argued that, rightly understood, this desire was not to see such an aspect of God, but rather the divine nature itself. Moses' petition to see God "openly" (Exod. 33:11) was such a case. But, Augustine said, such vision could only be obtained after the cleansing of the heart, and when the mind was drawn away from all carnal senses, which is why the scriptures testified that "no one can see the face of God and live" (Exod. 33:20). Once the mind was turned away from any sensory knowledge, the person had a sort of out-of-body experience similar to death, which may have happened, as he said, in a state of advanced ecstasy, a state that had been known to certain saints prior to death when they were granted the perfection of revelation, like that revelation described in 1 John 3:2 ("when God is revealed we shall be like him, for we will see him as he is"). And, when humans rose to eternal life, their vision would be like that of the angels, "for we shall then be equal to them" and would be able to see things that were in this life invisible and inaccessible. Finally, taking a thoroughly antimaterialist line, Augustine made the claim that "the one who can see God invisibly can be joined to God incorporeally."[9]

In other places, Augustine offers simple admonitions that, despite the many anthropomorphic descriptions of God in the Bible, God does not have a physical body like ours. God has no lap nor arms, no bosom or hands. These are images that must be understood poetically or allegorically. In his third tractate on John's Gospel, he explains this and even goes on to say that the eyes that see God are not the eyes of flesh, but the eyes of the pure heart. And this is even true of the Son prior to the incarnation. Only those who cannot "grasp the invisible" are held by the visible and thus slip into idolatry.[10] Therefore, if visible representations are to have any validity, they must always remind us of their insufficiencies and draw us beyond themselves, in the end so that we might leave them behind entirely.

At the end of his great work *The City of God,* Augustine speaks about the kind of vision with which the saints will see God in the world to come, when the flesh will have become spiritual, and bodily sight will be transformed into spiritual sight. Citing Paul's claim that our present insight is only partial (as in a glass dimly—1 Cor. 13:9), he can also cite Paul's promise that someday it will be "face to face" as the holy angels already see God. Of course, this vision will be of a different order than the kind of "fleshly" or corporeal sight we now possess. God will be seen in the future time by eyes that are transformed and possess the ability to discern immaterial or spiritual truth and then

> perhaps God will be known to us and visible to us in the sense that God will be spiritually perceived by each one of us *in* each one of us, perceived in one another, perceived by each in themselves. God will be seen in the new heaven and the new earth, in the whole creation as it then will be; God will be seen in every body, by means of bodies, wherever the eyes of the spiritual body are directed with their penetrating gaze.[11]

Here, in a sense, Augustine adapts the Pauline notion that all creation reveals God and in all creation (including the human race) we may see God.

REPRESENTATIONS OF GOD IN VISUAL ART

Augustine's contemporary, Paulinus of Nola, embellished his basilica in the South of Italy with frescoes of biblical scenes and portraits of the saints. Although the building itself is long gone, Paulinus' written explanation and description of this art project have been preserved in a collection of his letters. Of particular interest is his description of the iconography of the Holy Trinity designed for the apse of the church. Possibly conscious of the written denouncements of attempts to picture the infinite and unknowable divine nature with any kind of human figures while still wanting to find a way to enlighten and inspire his congregation, Paulinus' image apparently used symbolic instead of figurative representations. According to a letter to his friend, he wrote verses that both described and praised the vault mosaics of his church:

The Trinity shines out in all its mystery. Christ is represented by a lamb, the Father's voice thunders forth from the sky, and the Holy Spirit flows down in the form of a dove. A wreath's gleaming circle surrounds the cross, and around this circle the apostles form a ring, represented by a chorus of doves. The holy unity of the Trinity merges in Christ, but the Trinity has its threefold symbolism. The Father's voice and the Spirit show forth God, the cross and the lamb proclaim the holy victim. The purple and the palm point to kingship and to triumph. Christ himself, the Rock, stands on the rock of the church, and from this rock four splashing fountains flow, the evangelists, the living streams of Christ.[12]

The three persons of the Trinity were thus portrayed as a lamb, dove, and something that would have symbolized a voice, which is rather hard to imagine. Perhaps a disembodied hand, a popular solution in contemporary Roman sculpture and painting, represented God (although still, in some sense, anthropomorphically), and protected Paulinus and his congregation from the danger posed by an actual "graven image" of God. In any case, the composition must not have been widely popular, since no copies of it are thought to exist.

Although we cannot know for certain, the likelihood that Paulinus' artisans used a disembodied hand to symbolize God (the First Person) is supported by examples from numerous fourth-century paintings and sculptures, particularly in scenes of Moses receiving the law and Abraham about to slay Isaac, possibly drawn from a Jewish prototype (since it also appears in the synagogue frescoes discovered at Dura Europos and pavement at Beth Alpha).[13] Both of these images represent God's intervention in human history in the time before the incarnation (ill. 18). Images of the burning bush also occur in Christian art and seem to be merely illustrations of the story. The hand motif continues into the fifth and sixth centuries in representations of Isaac's binding and Moses receiving the tablets of the law, to which are added scenes of Jesus' baptism, and any number of other compositions.[14] In all three cases, the hand (as in Paulinus's description) represents the voice of God—a visual image substituting for a spoken word (ill. 19). In time,

however, the anthropomorphic figure of God began to appear in scenes of Christ's baptism, replacing the hand as a motif. Together with the dove of the Holy Spirit and the figure of Jesus in the Jordan, the composition clearly represented the Holy Trinity (ill. 20).[15]

Arguably, a different kind of nonfigurative presentation of God (or the Trinity) is the image of the empty throne (*hetoimasia*) with a crown or cross set upon its thick cushion. One of the earliest examples of this comes from the mosaic program of Sta. Maria Maggiore, but stunning examples may be seen in Ravenna, in both the Arian and Orthodox baptisteries (ill. 21). The difficulty with interpreting this as an image of God or the Trinity is the frequent absence of any figure for the Holy Spirit and the difficulty in explaining the throne itself as a symbol for the Father, unless we read it back as the prototype of the medieval and renaissance "seat of wisdom" imagery. Thus, the image may be a reference to the realm of heaven, and the ascended and enthroned Son. Even though Paulinus' apse imagery was never reproduced exactly, the impulse to represent God or the Trinity symbolically or nonfiguratively (hand, dove, cross) seems to have been fairly common. Given these examples, the appearance of an anthropomorphic representation of God in the fourth century, much like those occurring in the later Middle Ages, seems incongruous and puzzling.

For example, in the collection of sarcophagi in the Pio Cristiano Museum of the Vatican, we see the representation of a bearded, older male wearing a tunic and *pallium* seated on a rock. He receives an offering from the two brothers; one has a basket of fruit, the other holds a lamb (ill. 22). The bearded figure makes a gesture toward Cain's offering of fruit—the same gesture made by the figures in the hospitality of Abraham mosaic described above (two fingers extended, the other three curled back to the palm). Behind his head are cut, in low relief, two other faces that might either be interpreted as onlookers (two angels?) or the other two persons of the Trinity. Interestingly, if God's gesture here is interpreted to be a sign of blessing, then the story in Genesis has been subverted in this image, almost certainly for some theological reason. More likely, the gesture is merely an indication of speech—God warning Cain against his anger. Later, as in the mosaics programs of S. Apollinare in Classe or S. Vitale, only the offering of

Abel is depicted, and God's hand once again appears in the place of an anthropomorphic figure.

This iconographic motif has parallels in several other fourth-century sculptural images, including images of the Trinity creating Adam and Eve (ill. 23). In each of these cases, the figure representing God is a bearded male, seated in a throne-like chair. In some of the images, the other members of the Trinity are represented as identical in facial type (although standing rather than seated), while in others the three faces vary somewhat, perhaps according to "age" or "rank." The implications for these differences for trinitarian theology are fascinating. One could easily argue that representing the three as identical is in line with Nicene pronouncements about the identity of natures, while representing the three as different suggests a subordinationist Trinity.

A more familiar but arguably allegorical representation of the Holy Trinity in early Christian art is the portrayal of Abraham's welcome of his three angelic visitors at the oak of Mamre (Gen. 18). Significantly, in this case male visitors are always shown with identical faces, a fact not implied in the narrative. Although the early fifteenth-century icon by Andrew Rublev is the most famous of these representations, there were earlier models, from frescoes and mosaics in the fourth through sixth centuries to a group of Bible illuminations in the twelfth century. A painting of this scene was said to have hung in the southern aisle of the church St. Sophia in Constantinople, over a table made from a tree believed to have been cut from the actual grove at Mamre.[16]

One of the earliest of these images appears among the mosaic program of the basilica of Sta. Maria Maggiore in Rome (ca. 435; ill. 24), while a later version appears in Ravenna's basilica of S. Vitale (ca. 540). Here the scene is in two parts (Abraham appears twice in the composition). On the left, we see Abraham holding out a platter bearing a calf to serve his three visitors. These three are dressed alike, and have nearly identical faces. On the far left we see Sarah looking on with an expression of bemusement, her finger tapping her chin, presumably laughing to herself after one of the visitors announced her impending postmenopausal pregnancy (Gen. 18:9–15). On the right, Abraham prepares to sacrifice this promised child, while the hand of God "calls" to

him to stop and notice the ram at his feet, given as an alternative offering (Gen. 22:9–13).

BYZANTINE EAST AND LATIN WEST

The representation of the hospitality of Abraham gradually became a recognized but symbolic means of portraying the Holy Trinity in art. Since different early Christian exegetes interpreted the story differently, some of them, like Augustine, asserting that the three were merely angels and not an apparition of the Trinity, we should be cautious about claiming that all such images represented the Trinity in the earlier period.[17] Whatever the intended signification of that iconography, however, representations of God the Father as an older bearded male disappear in the West until the Carolingian period and in the East altogether. One explanation for the distinction between East and West in this regard may be the carefully defined theology of images during and after the Byzantine iconoclastic controversy. In defense of the image, the iconophiles insisted that the doctrine of the incarnation required the representation of the Incarnate One, but in order to avoid the sin of idolatry they simultaneously forbade any portrayal of the Unbegotten One. John of Damascus forcefully made this distinction between images of God and Christ in his foundational writing, *On Holy Images:*

> For if we were to make an image of the invisible God, we would really sin; for it is impossible to depict one who is incorporeal and formless, invisible and uncircumscribable. And again: if we were to make images of human beings and regard them and venerate them as gods, we would be truly sacrilegious. But we do none of these things. For if we make an image of God who in his ineffable goodness became incarnate and was seen upon earth in the flesh, and lived among humans, and assumed the nature and destiny and form and color of flesh, we do not go astray. For we long to see his form; as the divine apostle says, "now we see puzzling reflections in a mirror."[18]

Here John clearly argues that it would be impossible to make an image of God the Father, for this One has no body or form to guide such rep-

resentation. For John, God is not only conditionally or provisionally invisible, but intrinsically and necessarily so.

Throughout his treatise, John directly addresses the problem of idolatry and the divine injunction against graven images (Exod. 20:4). In an earlier passage, he admits that God forbids the making of images because of idolatry and "that it is impossible to make an image of the immeasureable, uncircumscribed, invisible God." And he cites Deuteronomy 4:12, where Moses reminds the Israelites that "You heard the sound of words, but saw no form; there was only a voice." But, he says, these commandments were given to the Jews because they were particularly prone to idolatry. Christians, on the other hand, are able to avoid "superstitious error" and have received from God "the ability to discern what may be represented and what is uncircumscript."[19] John's claim of Christian spiritual superiority could have been used even to claim that Christians might depict the divine nature apart from the image of Christ, but he never does.

Therefore, according to John, avoiding visual representations of the First Person of the Trinity was the *Christian* way of repudiating the sin of idolatry. Christians did not make images of God because they were better than the pagans and, at the same time, they were required to make images of Christ because they were superior to Jews. Furthermore, canon law discouraged eastern Christians from using symbolic or allegorical images for Christ, such as a lamb, since to do so undercut the doctrine of the incarnation of the Second Person by denying Christ the form of a human being.[20] By extension, we can assume this also applied to the First Person, although the disembodied hand may still be seen in some icons of the baptism.[21]

The reappearance of an anthropomorphic God the Father image in the early western Middle Ages cannot be explained or understood by reference to contemporary theological writings. Although not exactly iconoclasts, most western writers from Gregory the Great onwards saw only a limited decorative and didactic role for images in churches, and spoke only of biblical narrative scenes and portraits of Christ, the Virgin, and the Saints, as if unaware of any representations of God the Father. It is, perhaps, this sense of having safely put "images in their proper place" that allowed them to flourish in popular piety as aids to

devotion, especially suited (according to many theologians of the time) for the unlettered members of society. The illustrated Bibles of the high Middle Ages serve as illustration of the point. However, around the turn of the twelfth century, Gilbert Crispin summarized what may have been an actual dialogue between a Jew and a Christian in which the Jew accused Christians of adoring images of their own God as crucified and further daring to depict "God sitting on a lofty throne blessing with an outstretched hand, and around him, as if it were a sign of great dignity, an eagle, a man, a bull-calf, and a lion."[22] Interestingly, the Christian respondent never referred directly to the images of God, but merely defended the four beasts as belonging to both Isaiah's and Ezekiel's theophanic visions.

In the thirteenth century, Bonaventure gave a three-part defense of the three uses of images in his *Commentary on the Sentences of Peter Lombard,* first as didactic—for the sake of simplicity of the unlearned (*propter simplicium ruditatem*), second as inspirational—on account of the sluggishness of the affections (*propter affectuum tarditatem*), and third as commemorative—for the purpose of aiding the memory (*propter memoriae labilitatem*).[23] So long as images served these constitutive functions, one could avoid idolatry. Although it is hard to imagine Bonaventure allowing images of God in his system, he rather clearly had representations of the saints and Christ in mind.

Thomas Aquinas similarly saw a value in the use of images, but identified different kinds of images and whether they deserve *latria* (worship), rather than enumerating the different functions of visual art. In his article addressing the question of whether Christ should be adored with the adoration of *latria*, he cites John of Damascus and concludes that no reverence should be shown to an object that bears an image, but it can be to the image itself as it shows forth its prototype. But, Thomas cautions (again citing John of Damascus), "no corporeal image could be raised to the true God Himself, since He is incorporeal."[24] Then Thomas makes an exception for the image of Christ "because in the New Testament God was made human, He can be adored in His corporeal image."[25] Even the minimalist defense of images as useful for devotion or education, therefore, made an exception for images of God the First Person, although it is not clear that Thomas really had

any in mind. The fact that the popular practice seems so disconnected from theological commentary raises some questions about the penetration of these arguments into the general culture. The West kept making images of Christ as a lamb and of God as a wise old man, while the iconographers of the East, with their more developed theology of images, resisted both.

Since Thomas did not directly acknowledge the existence of particular images of the incorporeal God in his discussion, it is difficult to know whether he was conscious of their existence. His questions essentially addressed the images of Christ and the cross, portraits of Mary and the saints, and relics. He might have allowed that anthropomorphic images of God the Father were mere symbols, and not intended to be understood in any other sense. Still, one would think that the image's consistency and popularity should have raised some serious objections by theologians. Much later, however, Martin Luther referred to images of God, along with angels, human beings, and animals in illustrated German Bibles, and vehemently declared the only prohibited images were those of God that might actually be worshiped.[26] John Calvin also wrote with apparent awareness (but in his case absolute disapproval) of such representations. By contrast to Luther, Calvin sounded much like the early apologists, denouncing all religious images, including figurative representations of God. Recognizing that their defenders (Greeks and "Papists") would argue that such pictures were merely didactic, and wanting to sound reasonable and even open-minded, Calvin took pains to make his own position clear:

> I am not gripped by the superstition of thinking absolutely no image permissible. But because sculpture and painting are gifts of God, I seek a pure and legitimate use of each. Let those things which the Lord has conferred upon us for his glory and our good be not only polluted by perverse misuse but also turned to our destruction. We believe it wrong that God should be represented by a visible appearance, because he himself has forbidden it [Ex. 20:4] and it cannot be done without some defacing of his glory. And lest they think us alone in this opinion, those who concern themselves will find that all

well-balanced writers have always disapproved of it. If it is not right to represent God by a physical likeness, much less will we be allowed to worship it as God or God in it. Therefore it remains that only those things are to be sculptured or painted which the eyes are capable of seeing; let not God's majesty, which is far above the perception of the eyes, be debased through unseemly representations.[27]

Based on this conclusive denouncement, what should western Christians do with these popular representations of God as an old man with a white beard? They are, after all, a part of a cultural legacy for Protestants and Catholics alike. Contemporary theologians object to them, but not all these objections follow the lines of Augustine, John of Damascus, or Calvin. Instead of attacking the image in general, certain criticism aims at the image in particular. Some would argue that the consistent representation of God as human, male, Caucasian, or even elderly raises more problems than does the impulse to represent God at all. Furthermore, these exclusively male images raise as many political or social problems as they do theological ones. Perhaps a modern solution to the problem of circumscribing the uncircumscribable or visually portraying the invisible would be to offer a variety of figures (perhaps more imaginative, inclusive, and experimental than lambs, doves, or Trinity triangles), each acknowledged to be mere allegories and imperfect symbols, thus clearly defending against the danger of identifying a single image with the nature of the divine. A constantly changing canon of visual and abstract images could dislodge the unfortunately ingrained and drastically limited "default" mental images that come to mind whenever someone speaks the name of God.

But as Augustine would remind us, God alone will decide whether or not to be perceived by humans (or angels, or animals, or other life forms), and if so in whatever manner God chooses and to whom God chooses. If so, that divine choice *might* be to be represented as an old man with a white beard, after all. Moreover, Christians teach that, in the incarnation, God *chose* to take on a bodily existence and appearance. They do not see this as limiting God's nature or divinity—in fact, to the contrary: the incarnation manifests God's works of mercy and

love, which in a true sense *does* reveal God's nature. Furthermore, the potential for idolatry through words (using the terminology of "Father," for example) is just as real as the potential for idolatry through pictures. Words are no less fallible or limited than pictures, and concepts that remain purely intellectual (if there are any such things) are as likely to be wrong as concepts that take visual form. How can the ear or even the mind be a more reliable medium for divine revelation than the eye, or than the sense perception on which it depends to inspire its insight or cognition? Moses, we recall, did actually *see* the burning bush—he did not just "think it up."

⌇

NOTES

1. Hymn text Walter Smith, 1867, this version in *The New Century Hymnal* (Cleveland: Pilgrim Press, 1995), 1. Note: Much of this article summarizes a much longer discussion in my forthcoming book, *Face to Face: The Portrait of the Divine in Early Christianity* (Minneapolis: Augsburg Fortress, 2004).

2. See Augustine, *Epistle*, 92, 120, and 147.

3. Justin Martyr, *I Apology* 9 (emphasis mine).

4. Ibid., 55.3–8.

5. Tertullian, *Apology* 17.1–18.

6. Origen, *On First Principles* 1.2.8.

7. Ibid., 1.2.11–12.

8. *Letter* 147.20, trans. R. Teske, *Augustine, Letters* II/2 (Hyde Park, N.Y.: New City Press, 2003), 344. In other places, Augustine argues that such appearances were only of angels, such as the three visitors to Abraham. See *On the Trinity* 2.4.20–22. Here Augustine insists that the Son would not have taken a human form prior to the incarnation.

9. Ibid., chap. 37. The paragraph contains a summary of previous chapters. Augustine also credits Ambrose for some of this teaching. He refers indirectly to the anthropomorphite controversy in chap. 49.

10. Augustine, *Tractate 3 on Gos. John* 17–19.3. Compare *On Faith and the Creed* 7.14.

11. Augustine, *The City of God*, 22.29, trans. H. Bettenson (New York: Penguin, 1972), 1087.

12. Paulinus, *Epistle* 32.10. Compare the description of the imagery in the basilica at Fundi, later in the letter 32.17: a lamb (for Christ), that is being "haloed" by a dove (Holy Spirit), and crowned by the "Father from a reddish cloud."

13. Less frequently, the burning bush appears in scenes with Moses, and the tabernacle may symbolize God's presence in the community. Compare this to the

iconography of the Synagogue at Dura Europos. See H. Kessler, *Spiritual Seeing: Picturing God's Invisibility in Medieval Art* (Philadelphia: University of Pennsylvania, 2000), 4–5.

14. See Kessler discussion cited above. The hand also appears on pilgrimage vials from Monza and in other compositions as noted by A. Grabar, *Christian Iconography: A Study of its Origins* (Princeton, N.J.: Princeton University Press, 1968), 114.

15. Some authors have commented on the trinitarian aspects of the scene of Jesus' baptism in the dome of the Arian baptistery in Ravenna, where the imposing figure of the river god seems to suggest the presence of the Father.

16. See H. Belting, *Image and Presence*, trans. E. Jephcott (Chicago: University of Chicago Press, 1994), 195.

17. See different interpretations of Abraham's hospitality in the earlier period, e.g., Justin Martyr, *Dialogue with Trypho*, 56, 127, 263; Irenaeus, *Proof of Apostolic Preaching*, 44–45; Tertullian, *On the Flesh of Christ*, 3.

18. John of Damascus, *On the Divine Images* 2.5, trans. A. Louth (Crestwood, N.Y.: St. Vladimir's Seminary Press, 2003), 61–62.

19. Ibid., 2.7.

20. Council in Trullo or Quinisext Council (692), canon 82: "In order therefore that 'that which is perfect' may be delineated to the eyes of all, at least in colored expression, we decree that the figure in human form of the Lamb who taketh away the sin of the world, Christ our God, be henceforth exhibited in images, instead of the ancient lamb, so that all may understand by means of it the depths of the humiliation of the Word of God, and that we may recall to our memory his conversation in the flesh, his passion and salutary death, and his redemption which was wrought for the whole world."

21. Not as far as I can tell in images of annunciation, nativity, ascension, or dormition of the Virgin, however.

22. This text may be found in C. Davis-Weyer, *Early Medieval Art 300–1150* (Toronto: University of Toronto Press, 1986), 165–67.

23. Bonaventure, *Sentences,* book 3, dist. 9, art 1, q. 2, conclusion. See the available translation of C. Garside, *Zwingli and the Arts* (New Haven, Conn.: Yale University Press, 1966), 91.

24. Thomas, *Summa* IIIa, q. 25, art. 3.

25. Ibid.

26. Luther, *Against the Heavenly Prophets (On the Destruction of Images),* see Luther, *Works* 40, 79–83, 86–88, 89.

27. Calvin, *Institutes* 1.11.12.

8

The *Place* of Art

DEBORAH HAYNES

Imagine that you are approaching an intersection where several roads converge. You stop and consider which road to take, for they lead in different directions. The title of this essay is like that. What, we might ask, is the place of art in contemporary culture? Or, what is the place of art in relation to theology and the study of religion? Or, what does place itself, as literal physical site, have to do with art? Such questions have engaged me for many years. But unlike an intersection, where one cannot move in opposite or parallel directions simultaneously, language and ideas are more fluid. Using both personal narrative and theological ideas, I will examine some of the interconnections implied by these questions.

Clearly, the direction of my thinking has been shaped by the fact that I was not initially trained as a theologian, but as an artist. I came to the study of religion and theology from studio practice. Therefore,

my questions are directed not at how art can serve theology, but at the relevance of theological and ethical reflection for the visual arts. Today, I do not work in a theological seminary or a department of religious studies, but in a secular university in a department of art and art history. My location shapes what I do in innumerable ways and I think it is important to acknowledge this.

The first part of this essay creates a framework for what follows in two ways. First, by describing three of my gallery installations, I set a context for my concern with broad religious and moral issues. Second, in discussing four attempts to set forth a theology of art where the role of art is to serve theology, I set a context for the longer second part of the essay. In this second part, I offer three propositions and consider what a theology of the arts might look like when considered from the artist's perspective. Using the work of artists Kim Abeles, Mel Chin, and Agnes Denes, I try to show that even without an explicit focus on theological questions, these artists deal with ultimate concerns. The last section of the essay focuses on *[THIS] Place*, a project that expresses my theological and ethical commitments and is deeply informed by years of studying religion, as well as art history and theory.

A FRAMEWORK

As a young student and then as a practicing artist, I was impelled for many years by the need to express "the sacred" through clay work, drawings, environmental installations, and performances. Admittedly, the "sacred" is a vague category, but I use the term in this sense: to be sacred, a thing, person, or activity must be highly valued by us and it must hold power over us. For me, the earth is sacred; human relationships are sacred; the mysterious context of our lives is sacred. My installations of the late 1970s and early 1980s reflect these values.

In my 1979 *Gaea* installation, for example, I expressed concern about the extinction of species, depletion of natural resources, pollution of the environment, and overpopulation. In preparing to install the piece, I drove across the state of Oregon, collecting stones, earth, sand, and sticks from various sites. Then I spent several days arranging these materials in a nine-by-twelve-foot room in a gallery to form a figure on the floor.

After I had completed the installation itself, I posted a word-tree image on the wall:

The earth is precious,
a sacrosanct body on which we live.
She is a goddess, and this work is named after
the Greek goddess, Gaea, who is the sure foundation
of all that is, the first being born of chaos and from whom
all else evolved. Here *Gaea* is composed of naturally occurring
materials, collected from my regional environment, and replaceable
in that environment. The *prima materia* is transformed by arranging
rather than by unalterable firing. Increasingly I choose to work in ways
that sidestep our habitual cycles of production and consumption, ways
that resist the commodity market, that neither pollute nor use non-
renewable resources, that loosen the boundaries and constrictions
of Mind, and that express an attitude of reverence for the
earth and coexistence with all sentient beings. Still,
my grasping mind asks, "But what *is* art?"
My spirit gives an elusive answer:
"This body is a vision.
I am the earth as the sea is my blood.
I am clay,
sand,
stone,
stick,
string,
cinder,
and seed."

In two *Temenos* installations during 1980 and 1981, I worked in much larger galleries than I had earlier. I sought in both of these installations to create spaces for contemplation, using mostly found materials as I had in *Gaea*—sand, stones, sticks, clay, and cloth. The Greek word temenos means sacred precinct, a share of land apportioned to the

god or goddess and a center of worship. Many cultures have defined sacred space using enclosures, temples, and gardens. In these gallery installations, I wanted to evoke the presence of a temple where the world might be resanctified. "As I witness the literal destruction of life on the planet," the gallery materials proclaimed, "a sense of urgency arises. I seek to reestablish a sense of connection with the body/earth, and to rediscover the holy in all spaces and living beings." In retrospect, I view these installations as courageous, but partial. There are, of course, limitations to all such gallery work. While it might provoke reflection, it does not actually create change in a place. I will come back to this idea later in this essay.

My art grew out of strong religious and moral values, and in the early 1980s I felt an urgent need to formulate a theoretical basis for this practice. I thus began to develop a theory of creativity based on a theology of the arts. I was drawn to study world religions and theology in an attempt to articulate that theoretical basis. There were guiding questions I pursued: Are there moral imperatives to which art of necessity should attend? What is the relationship of human creativity to divine creativity? How might theology serve the artist in the creative process? And which theologies might be most helpful? How can the insights of art historical and theological study be appropriated and used as vehicles for change?

In the years since I undertook graduate study in religion and art history, I cannot say that I have ever satisfactorily answered these questions. As a writer, however, I have consistently returned to one theme: the reaffirmation of the critical and revelatory potential of art within our commodity-driven culture that largely repudiates concern with religious and moral values in the arts. From one perspective, all of my work in the subsequent years has been an attempt to expand upon this.[1] Certainly I am not alone in this quest, and it will be helpful to acknowledge some of the theological work that forms part of the stage on which I create a different set and enact another play.

When it was first published in 1987, Wilson Yates's *The Arts in Theological Education* offered a vocabulary for understanding the subtleties and nuances of the relationship of religion and the arts, especially in relation to Christian theology and the arts. As Yates wrote, a theol-

ogy of the arts delineates the role of the arts in revealing the religious meaning of culture and faith. It also sets forth the limits of what the arts can and cannot do for theological understanding.[2] At the foundation, a theology of the arts is based on the idea that images are an especially efficacious means for expressing human understanding of the divine.

Jeremy Begbie's *Voicing Creation's Praise* and George Pattison's *Art, Modernity, and Faith* both attempt to provide the basis for a Christian theology of art by examining historical antecedents. In setting forth his Christian theology of art, Begbie proposes a cognitive understanding of art—that art is capable of providing genuine knowledge of reality beyond human self-consciousness. Building on the critiques of Kant developed by Hans Georg Gadamer and Michael Polanyi, he argues persuasively for art that expresses our embeddedness in creation, instead of abstract aesthetic experience, and for art as a form of action rather than disinterested judgment.[3]

While many current theologies of art remain focused in Christian faith, the last chapter of Pattison's *Art, Modernity, and Faith* discusses how a contemporary theology of art might be in fruitful dialogue with other traditions, such as Zen Buddhism, where there has been an integrated relationship of the arts and religious practice for centuries. I agree with Pattison's assertion that a theology of art, although it does not require artists to become overtly religious in their work, does require a certain seriousness of intent—a "serious humour, a serious tenderness, a serious play and a serious joy as well as a serious doubt and a serious despair."[4] It is important to remember that modern and contemporary artists often work independent of particular religious traditions, and this raises a different set of questions regarding art and religion, as well as the meaning of a theology of art.

From Paul Tillich and theologians working in the neo-Calvinist tradition of South African Abraham Kuyper, to Jacques Maritain, Etienne Gilson, and John Ruskin, Begbie and Pattison offer readable summaries of previous theologies of art. This work of recuperation provides useful background and history for all efforts to articulate the relationship of theology and the arts.

In *Religious Aesthetics* and *Beauty and Holiness*, Frank Burch Brown and James Alfred Martin, respectively, engage a series of significant ques-

tions concerning the relationship of religion and aesthetics, and they indicate directions for future scholarship and study.[5] What *is* art and what *is* religion in our postmodern era of cultural pluralism and diversity? Analogously, what is aesthetics, especially from the standpoint of theology? How might a dialogue between these two reenergize each of the partners of the dialogue? Brown studies a number of aesthetic categories such as taste, norms, and standards. Martin focuses on classical and contemporary formulations of the concepts of beauty and holiness. Drawing from the Hebrew Bible, Plato and Kant to Gadamer, Derrida, and Bakhtin, these writers have created a useful intellectual genealogy and compendium of information about key religious and aesthetic categories.

Certainly there are many other significant resources linking religion and art, theology and aesthetics from the last two decades. Here the work of Margaret R. Miles, John Dillenberger, Jane Daggett Dillenberger, Thomas Martland, and Samuel Laeuchli, among others, stand out. But I mention Begbie, Pattison, Brown, and Martin primarily to clarify the point that theologies of the arts are usually, and understandably, articulated by theologians who are looking at how the arts might further theological agendas. This is why the language used emphasizes how the arts express theological doctrines and thus may enhance liturgy and worship.

But what happens when we invert the usual questions? We know that the arts can serve theology, but how can theology be of service to the arts? In trying to answer this question, it is worth remembering, as Wilson Yates has suggested, that there are at least three crucial points of commonality between theology and the arts.[6] Any answer to the question of how theology can be of service to the arts presupposes these shared aspects.

First, both art and theology are products of creative imagination. In relation to the visual arts, this is a truism, although we may well wonder about this in the age of cultural appropriation. I recently saw an exhibition of a young New York artist whose paintings were direct copies of Lucas Fontana, Ellsworth Kelly, and other modernists. I had thought that the 1980s and 1990s were the decades of appropriated, stolen, and copied images, but evidently such work continues unabated. Nevertheless, for most artists, the creative imagination is the source of the work of art.

In relation to theology, I suspect that this claim may be contested. Some theologians assert that theology is divine revelation, but constructive theologians such as Gordon Kaufman have another view. Kaufman's theological corpus is based on the presupposition that theology is an imaginative and constructive activity, an open and evolving discourse, rather than a set of revealed and tradition-bound doctrines.[7] Imaginative theological construction is a form of creative authorship that helps us to articulate our place within the cosmos. As an artist, trained to consider my own creative work as imaginative and constructive, and knowing that my creative acts also help me to find a place in the world, such an interpretation of theology remains compelling. In this regard, theological ideas can serve as a model for and inform the creation of art, just as the arts can serve as a model for theological construction.

Second, art and theology share common artistic elements, such as the use of imagination and intuition, mythic language and evocative symbols, metaphor, image, and narrative, and awareness of the dramatic moment. In analyzing art as metaphorical communication, Jeremy Begbie points out that art may be performed or viewed repeatedly, but its interpretation is never fully disclosed through discourse.[8] I would add that, like all theological insight, the work of art is not reducible to literal statement. As a function of such shared aesthetic elements, theology can serve art as a document and source for understanding the nature of both historical and contemporary art.

Third, both art and theology present images and patterns of meaning regarding the ultimate nature and meaning of existence. This was one of Georg Hegel's main insights, though he saw philosophy as the highest manifestation of Spirit. This is also one of the reasons why, trained as an artist and after working as an artist for some years, I wanted to study theology. When I encountered the idea in Hans Blumenberg's *The Legitimacy of the Modern Age* that the self-conception of the artist and theoretical interpretations of the creative process were borrowed from theology, I knew that my own theological study made sense.[9] Theology can serve the arts as a resource for helping to identify and understand the central questions of human existence. It can help the artist to understand the character of contemporary culture, and especially its spiritual longings. Of course, there is no singular contemporary culture, but here I am

thinking of the ways in which liberation, feminist, and ecological theologies, for example, speak to our present cultural condition. In my view, these common factors provide a compelling foundation from which to examine other questions.

A THEOLOGY OF THE ARTS FROM THE ARTIST'S PERSPECTIVE

With this background in mind, what might a theology of the arts look like from the artist's perspective? How might theological doctrines and liturgical practices inform and enhance artistic practice? While I cannot answer these questions comprehensively, I seek to address them by offering three propositions and discussing a number of works of art.

Proposition 1: Theology can provide the arts with insight about vocation and, specifically, about the vocation of the artist. I begin here, because this is where I began, at least in one aspect of my scholarly work.[10] Over many years of study and writing about the artist's vocation, I concluded that there is a great need today for artists who will cultivate visionary imagination, as well as prophetic and critical faculties. Theology, and the world's religious traditions in general, can provide much needed insight about what visual imagination and prophetic criticism look like.

I believe that the artist has a personal calling to interpret the dilemmas we face, thereby giving voice to hopes and fears, experiences and dreams. In doing this, the artist's work is oriented to this world, to the present as it moves inexorably toward the future. And, it is active: it urges engagement and commitment to the world in order to bring about the political, social, and cultural transformation necessary for the embodiment of values such as peace, love, and justice. Certainly, such statements are highly rhetorical, but they indicate the central values that guide my understanding of the vocation of the artist.

Proposition 2: Theological doctrines related to prophecy, revelation, and sacrament can serve as a resource for the arts. From this foundation of considering the role and function of the artist, it is possible to address a second set of general questions related to the prophetic, revelatory, and sacramental potential of the arts. Art is efficacious. It has power to move us in profound ways, as well as to provoke fury and rage. The history of iconoclasm provides ample evidence of this power.

Images reveal insights about our historical moment, they criticize what is going on in the present, and they point the way toward the future. From Goya and Daumier to contemporary environmental artists, this prophetic potential of art has often been expressed. Here I offer four examples of such contemporary work, moving from sculpture to projects where artists shape an entire environment. Each of these works of contemporary art reveals present broken relationships, patterns of human destructiveness, and loss and disconnection—or, in theological terms, sin and evil.

Artist Kim Abeles carefully tracks changes in the sky and pollution levels in Los Angeles in her *Smog Collectors*. Abeles made her first images using smog and particulate matter in 1987, but she did not develop a series of smog collectors until the 1990s. A *Smog Collector* is made by cutting a stencil—Abeles has used images of body organs, industrial sites, and presidential portraits—and exposing it for up to sixty days to particulate matter in the polluted Los Angeles environment. At one point, the artist placed the stencils on the roof of her studio, but they have also been placed at other sites as well. For instance, a sculptural series of smog collectors was commissioned by the California Bureau of Automotive Repair in 1991–92; these were set up throughout Los Angeles. When the stencils were removed, the images created by the smog were then exposed. Of course, much more is exposed with such works. As Abeles eloquently put it: *"The Smog Collectors* materialize the reality of the air we breathe. . . . Since the worst in our air can't be seen, *Smog Collectors* are both literal and metaphoric depictions of the current conditions of our life source. They are reminders of our industrial decisions: the road we took that seemed so modern."[11]

Mel Chin's project *Revival Field* was a powerful example of another kind of ecoproject. In 1990, at the Pig's Eye landfill in St. Paul, Minnesota, Chin and scientist Rufus L. Chaney began a project to reclaim ravaged land. Their goal was to detoxify a sixty-square-foot area in the landfill by doing green remediation, using plants known as hyperaccumulators to extract heavy metals such as zinc and cadmium from the soil as they grow. After it was originally planted, this "garden" was cared for by St. Paul's Maintenance Department; and in fall of 1991, the plants were harvested, dried, ashed, and analyzed under controlled conditions

by Dr. Chaney. As of October 2002, the site had been closed and the project considered finished.

Chin and his collaborators hope that eventually land restoration projects such as *Revival Field* will help with the cost of healing toxic landfills. For the tenth anniversary of this first project, Chin initiated a similar collaboration with the Institute of Plant Nutrition at the University of Hohenheim in Stuttgart, Germany.

In 1982, Agnes Denes began work on a site near Battery Park in lower Manhattan, close to the former World Trade Center. She called the project *Wheatfield, Battery City Park: A Confrontation.* There, she cleared debris from four acres that had been used as a landfill, spread an inch of topsoil, and planted two acres of wheat. For four months she cared for the field until it was fully grown. In August she harvested a thousand pounds of grain and fed it to horses from the New York City Police Department.

Then, between 1992 and 1996, Denes undertook a much larger project called *Tree Mountain—A Living Time Capsule.* In Ylorski, Finland, Denes built a hill on top of gravel pits, approximately 420 x 270 x 28 meters. She shaped the hill as an ellipse, and then invited ten thousand people from all over the world to plant trees there. Each tree bears the name of the person who planted it and is designed to bear the names of that person's ancestors for four hundred years. Her intention is both to transform a blighted landscape into an abundant forest, and to engage a diverse community in a massive collaborative project. Works such as *Wheatfield* and *Tree Mountain* are examples of what Denes calls "philosophy in the land." These monumental ecoprojects are conceptualized and designed at the intersection of philosophy, mathematics, science, and community.

As far as I know, none of these three artists is actively engaged in studying or thinking about theology as a resource for their work. I believe, however, that theological ideas can help us to interpret their work responsibly. The work itself speaks about the fragility and contingency of human (and all) life in our mysterious planetary context. Each of these examples highlights human relationships to the sacred context of life.

Proposition 3: *Theology itself, as the discipline that aims to articulate religious doctrines about God, the divine, and the sacred, can aid the arts.* Here one looks straight into the core of theology. What God

is, how we conceptualize the divine and the sacred, is one of the first explicit tasks of theology. The question of how the arts can visualize such ideas is open to the interpretation of individual artists. Art can be didactic, like some theology, or it can narrate its truths in a less overt way.

As an example of how this proposition might be given artistic form, I turn now to a description of a creative project titled *[THIS] Place,* which I began in 2000 (ill. 25). The unusual bracketing and italics in the title are meant to emphasize that I live and work in *this* place, and that the project is itself about place. Over time I will both work on and write about it. *[THIS] Place* is challenging, though difficult to theorize. In its broadest conception, my aim is to define the *topos* or place of art.

I could say that in general my art expresses my theology, or more precisely that *[THIS] Place* reflects a pantheistic spirituality. But I fear that for many people in religion and theology, such language will seem hopelessly vague. Nevertheless, I have recently been inspired by Owen Thomas, who argued in several articles that spirituality is a term in need of redefinition.[12] Spirituality is as much concerned with the outer life of the body, community, our institutions, and so forth, as with the inner life. Thomas suggests that the term is actually more inclusive than "religion," insofar as all people have some kind of spirituality, while some claim they do not have a religion. What follows, then, may perhaps best be described as an account of my art as spiritual or contemplative practice.

On one level, *[THIS] Place* is simply where I live: a one-acre polygon in Jamestown, Colorado, with a view of Mt. Porphory and bordered on its longest side by the James Creek. The house is located on the south side of the James Canyon, near three other structures—an underground sanctuary, small office, and studio. It was known as Ivydell long before we moved here in 1999, because of a small sign that hung on the porch. There are several discrete areas. The upper terrace, behind the house, is home to a variety of native plants that are adapted to the dry Colorado mountain climate. Water from springs behind the studio is captured in three cisterns to the east, along the upper bench. There I cultivate wild volunteers: nettles, raspberries, mullein, feverfew, and mugwort. On the river bench I grow edible and medicinal herbs: garlic and greens, bee balm and purple coneflower, sage and horseradish, motherwort and Saint John's Wort, lemon balm and chocolate

mint, skullcap and rehmannia, astragulus and valerian. Along the river walk, I planted rhubarb a few years ago. It is slow growing, but finds its place among bluebells and false campanula and water parsnip. Willow trees abound. During the past two years, I have planted seven fruit trees. As Russell Page commented, "To plant trees is to give body and life to one's dreams for a better world."[13]

Daily I circumambulate the site and rake its paths, entering into relationship with this *temenos*, this sacred place. The circumambulation path consists of nearly three hundred red sandstone tiles from a local quarry. Mindful walking along this path has become part of my daily meditative practice. Sitting on various perches, I watch the light play across trees with their branches stretching one hundred feet into the sky. And the sky! Cerulean, azure, pristine. In cities from San Francisco to Boston, from Vladivostok to Lucknow, this blue appears faded, the air varying shades of brown. I track changes in the landscape and sky, in the creek and animal life. This year I have been smitten, once again, by butterflies. The snakes that I sometimes see on summer days were evasive this year. I always felt blessed to catch sight of one.

The activities within the overall structure of *[THIS] Place* include the mundane affairs of daily life—sweeping, mowing, scraping old paint, and repainting the sides of a building. There is gardening and its attendant elements: digging, hoeing, planting, watering, tending, weeding, mulching, pruning, harvesting, gathering seeds. But my activity also includes what we more easily call creative work—reading and writing, drawing and marble carving. I write scholarly essays and read learned tomes on the fate of the concept of place by Yi-Fu Tuan, Edward Casey, and others.[14] I draw. I have been working for several years on a series of drawings called *Marking Time*. In August 2003, I finished a five-by-twelve-foot drawing from this series that took nearly ten months to complete. The subject of the drawing was my contemplative walking practice at *[THIS] Place* over nine months.

And then there is the marble. I work outside between the studio and the medicinal garden, in the stone yard, usually under a tarp to protect myself from the sun and rain. Marble is a beautiful stone. In hardness, it is halfway between alabaster and granite. This means that marble may be carved by hand, and that it yields easily to pneumatic

chisels. I use both. Just now, I am working on a large stone, weighing about 250 pounds. Moving stone is its own challenge. Without a forklift or Bobcat, I get help from neighbors, or use ancient techniques perfected by the Egyptians, rolling the stone on small metal cylinders, or using logs and levers to raise and lower it.

On the surface, my stone work bears some resemblance to other artists' work, such as Ian Hamilton and Sue Finlay's fourteen-acre garden in Scotland, titled Stonypath, or to Jenny Holzer's stone benches with sandblasted "Truisms" carved into their surfaces. There are, however, significant differences between my work and theirs, not the least of which is my own direct engagement with the stone. I am also less concerned about the art world, and more concerned with how to live a life worth living and how to establish a relationship with a place. Out of my ultimate concern, I have decided to give my creative energy to *[THIS] Place.*

Several years ago I began to write Greek and Latin words in stone: *temenos, vocatio, amor fati.* Sacred precinct, calling, love of fate. In historical sites from the Samothracian sanctuary to Sardis, stone inscriptions provide us with knowledge about the ancient past. Now I carve words in marble and place them around *[THIS] Place.* "Ivydell," reads the large triangular stone at the driveway gate. This was the text of a small sign that hung above the door on a cabin that occupied this site early in the twentieth century. *Temenos* rests at the base of the steps leading into the medicinal garden (ill. 26, 27). At the top of the steps, a five-foot-long marble bench declares "The vocation of the artist is the *reclamation* of the future." A threshold stone, *The Sisters,* marks a group of nine crack willow trees (ill. 28). In 2002 a gifted stonemason named Ezekiel Lopez helped create an outdoor sanctuary among the trees. I am currently working on a stone for a platform inside this patio with the words of the Buddhist *metta bhavana* meditation. *[THIS] Place* is a large standing stone that now rests on a beautiful sandstone-covered base on a special pin, so that its two discrete faces can be turned. Lying in the stream, an old marble chunk reads *Water* (ill. 29). In the year since placing it there, the marble, which is composed of calcium carbonate, has eroded, leaving a delicate surface texture that would be hard to replicate with tools. *Dona Nobis Otium Sanctum*

provides a seat beside the creek. With such words, phrases, and sentences, I feel as though I name the world.

Part of my fascination with this activity is the way the process of carving words in stone clarifies and focuses the mind. It is a spiritual practice in its own right. As in prayer, meditation, and mindful sitting, stillness and concentration are cultivated. One-pointed attention, the opposite of continuously interrupted attention and multitasking, is absolutely essential. Quite literally, the mind must stay focused on the tip of the chisel. Steadiness of mind and hand and evenness of quiet breath are necessary in order not to gouge or damage the stone. I do not mean to glorify or misrepresent this process, for carving marble is also full of other moments, moments of frustration, adversity, and the boredom of repetition.

Nevertheless, carving an "S" is a dance of slow sensuous curves, as the chisel glides through stone and the body moves to accommodate the letter's twists and turns. A "B" is half a dance or a set of intricate steps where right angles meet roundness. A "T" is a long straight meditation, its two lines creating a special crossing point. In plant geometry, the crossing point is that unique layer in a plant, sometimes only one cell wide, where energy moves up toward the sun, then down into the earth, where the life force changes direction. It is a metaphor for the way inner self and outer reality separate and connect in turns. M. C. Richards described the movement as resembling a figure eight or Moebus strip, "where what is enclosed and digging down turns into what is open and lifting up. . . . The two realms are an organic breathing continuum."[15] My "T" reverberates with her images.

So, on one level, this place is where I live, where I read and write, draw and work in marble. On another level, however, *[THIS] Place is* a creative project about contemplative practice in a particular place, and about belonging and community. I am exploring the vagaries of living at a particular time and place, this *chronos* and *topos*, cultivating both my powers of perception and engaging the land, its history, and its present state. The Southern Arapaho tribes spent summers in this canyon before the Sand Creek Massacre in 1864. That history is detailed in Margaret Coel's book, *Chief Left Hand, Southern Arapaho,* which recounts a sad and all-too-familiar tale of deception, broken promises, and murder.[16] Later in the nineteenth century, the area was a

major center for mining gold, silver, and other metals such as fluorite. The legacies of that activity currently include reclamation of wetlands and cleanup of toxic mines. The Honeywell Corporation is currently working on the restoration of one of the largest mine sites. The fact that [THIS] Place has also had its own history is pertinent to how I think about and interact with it. I have begun research on the history and use of the area with a colleague who is an environmental engineer.

In recent years, a few writers have eloquently spoken about establishing this connection to place. In *Opening Our Moral Eye,* for example, M. C. Richards wrote passionately about "the renewal of art through agriculture."[17] Claiming that art is a form of spiritual perception, she urged artists to develop their imaginations. Yet, how do we enhance our powers of imagination? Imagination is nurtured through carefully observing the cycles of life and death around us, looking at how all things live and how they die. Color gives us direct experience of time, especially the changes of color associated with different times of day and year. Watching clouds, light and shadow, and stars, both farmer and artist learn to read the sky. Tending plants and observing the world, we learn meditative attention. We develop both outer sight and inner vision.

Related to Richards's ideas, Wes Jackson suggests that artists should become "homecomers," persons who choose "not necessarily to go home but to go someplace and dig in and begin the long search and experiment to become native."[18] Given the fragmentation of our lives and the loss of connection to the physical world, such artists can model what genuine reconnection might be. Michael Pollan, building on the work of J. B. Jackson, Wendell Berry, and others, suggests that we should look to the garden for a new ethos, a new set of values for living in the twenty-first century.[19]

Barbara Gates's *Already Home: A Topography of Spirit and Place* offers a vivid example of this new ethos. In the narrative, the author explores the geological and cultural history of her Ocean View neighborhood in Berkeley, California, including its five-thousand-year-old history as the site of Ohlone Indian shellmounds. My interest in and commitment to place (and to a particular place) is not unique to me. In fact, that is one of the major points that surfaces throughout *Already*

Home. "The whole universe—past, present, and future—is right here in this room," Gates says near the end of the book.[20] Not only are we connected with our historical ancestors on the spot we currently inhabit, but my own aspirations to know *[THIS] Place* are connected to Barbara Gates's fascination with her neighborhood thirteen hundred miles away.

I am engaged in the process that such writers describe. I live in a place that I want to study and to know. I seek knowledge of what grows and lives here and of how the elements change over the course of days, months, and years—knowledge that comes from observing and listening to the world. This is *gnosis,* a deep spiritual knowing. If we can more thoroughly understand our relationship to where we are, to the chronotope we inhabit, then we may be able to live ourselves into a new relationship to the future. As many of us spend our lives increasingly online in a dromocentric, or speed-centered culture, some must nurture connections to the earth and remember the phenomenological world. One way to do this is by entering into relationship with a place. If time is motion, then place is a pause in time's movement. It takes time to get to know a place. As Yi-Fu Tuan put it, "[Place] is made up of experiences, mostly fleeting and undramatic, repeated day after day and over the span of years. It is a unique blend of sights, sounds, and smells, a unique harmony of natural and artificial rhythms such as times of sunrise and sunset, of work and play. The feel of a place is registered in one's muscles and bones."[21]

In my view, place is an ontological category: it helps us to define ourselves and our existence. Place tells us who and what we are in relation to *where* we are.[22] For me, this is not only a philosophical point, but a religious, theological, and spiritual insight as well. Religions connect us to the world, in particular times, cultures, and places. Theologies offer us orientation toward the divine, the world, and the human. In the end, I admit that my art expresses my theological perspective in ways that I find difficult to articulate fully in verbal language.

As a young adult I was inspired by the contemplative architecture and gardens of India and Japan—from the Stupa at Sanchi to the Zen gardens at Ryoanji. My commitment to creating aesthetic experience rather than art products was further strengthened not only by creating installations and performances during the 1970s and 1980s, but also by

years of writing art reviews and witnessing the art world close-at-hand. *[THIS] Place* reflects both this intellectual and artistic history.

As an artist, I believe that a theology of art must address the theological and ethical dimensions of creativity. Some artists claim that their art evolves out of "pure" unmediated experience, or that it expresses no particular relationship with others, with history, nature, or the cultural worlds. I think this is nonsense. Creative activity never occurs in a vacuum, but is always connected to one's past experience, social location, and to various strands of life in the present. Considered from a broad perspective, the products of artistic creativity may be considered as religious and moral acts precisely because of their consequences in the world. From this point of view, the creative process is also intrinsically religious and moral insofar as it involves actions for which we are responsible and accountable within a given community.

I began this essay by asking a complex question, what is the place of art? I believe that the place of art is in daily life, in the actual *places* we inhabit. We create ourselves as we create art; we nourish and renew ourselves as we affirm our particularity in a place. It is crucial to remember that such creation, renewal, and affirmation happen in and through the mundane details of everyday life. In *[THIS] Place,* I give form to this conviction.

But I also asked at the outset about the place of art in relation to religion and theology. For the theologian, art can express theological truths and moral values. It can give visible form to what often remains invisible, and this is part of its unique power in all religious traditions. However, for the artist who approaches the intersection where theological ideas, religious history, and contemporary manifestations of spirituality meet, a rich and creative journey awaits.

~

NOTES

1. In a new book titled *Art Lessons: Meditations on the Creative Life* (Boulder, Colo.: Westview Press, 2003), I articulated my ideas about theology of the arts. In a chapter "Toward a Theology of Art," I outlined several interrelated questions that are at the core of this enterprise. But even that description seems quite limited. This present essay might therefore be read as an expansion of, or perhaps more accurately as an inversion of, the issues discussed in *Art Lessons.*

2. Wilson Yates, *The Arts in Theological Education* (Atlanta: Scholars Press, 1987), 144.

3. Jeremy Begbie, *Voicing Creation's Praise: Towards a Theology of the Arts* (Edinburgh: T & T Clark, 1991) and George Pattison, *Art, Modernity, and Faith: Towards a Theology of Art* (New York: St. Martin's, 1991).

4. Pattison, *Art, Modernity, and Faith*, 154.

5. Frank Burch Brown, *Religious Aesthetics: A Theological Study of Making and Meaning* (Princeton, N.J.: Princeton University Press, 1989), and James Alfred Martin Jr., *Beauty and Holiness: The Dialogue between Aesthetics and Religion* (Princeton, N.J.: Princeton University Press, 1990).

6. Yates, *The Arts in Theological Education*, 101–4. I am reframing Yates' formulation slightly in what follows.

7. This point of view is articulated throughout his work, but most comprehensively in Gordon D. Kaufman, *In Face of Mystery: A Constructive Theology* (Cambridge, Mass.: Harvard University Press, 1993).

8. Begbie, *Voicing Creation's Praise*, 233–55.

9. Hans Blumenberg, *The Legitimacy of the Modern Age,* trans. Robert M. Wallace (Cambridge, Mass.: MIT Press, 1983).

10. My second book explored this theme in considerable depth. See Deborah J. Haynes, *The Vocation of the Artist* (New York: Cambridge University Press, 1995).

11. Kim Abeles, *Encyclopedia Persona A–Z* (Los Angeles: Fellows of Contemporary Art, 1993), 86.

12. Owen Thomas, "Some Problems in Contemporary Christian Spirituality," *Anglican Theological Review* LXXXII 2: 267–81.

13. Russell Page, from *The Education of the Gardener,* quoted in Michael Pollan, *Second Nature: A Gardener's Education* (New York: Delta, 1991).

14. Yi-Fu Tuan, *Space and Place: The Perspective of Experience* (Minneapolis: University of Minnesota Press, 1977); Edward S. Casey, *Getting Back into Place: Toward a Renewed Understanding of the Place-World* (Bloomington: Indiana University Press, 1993); Edward S. Casey, *The Fate of Place: A Philosophical History* (Berkeley: University of California Press, 1997); Edward S. Casey, *Representing Place: Landscape Painting and Maps* (Minneapolis: University of Minnesota Press, 2002); Mary Anne Warren, *Moral Status: Obligations to Persons and Other Living Things* (Oxford: Clarendon Press, 1997); and Michael Zimmerman, *The Concept of Moral Obligation* (New York: Cambridge University Press, 1996).

15. M. C. Richards, *The Crossing Point: Selected Talks and Writings* (Middletown, Conn.: Wesleyan University Press, 1973), ix.

16. Margaret Coel, *Chief Left Hand, Southern Arapaho* (Norman: University of Oklahoma Press, 1981).

17. M. C. Richards, *Opening Our Moral Eye: Essays, Talks, and Poems Embracing Creativity and Community,* ed. Deborah J. Haynes (Hudson, N.Y.: Lindisfarne Press, 1996), 134–39.

18. Wes Jackson, *Becoming Native to This Place* (Washington, D.C.: Counterpoint, 1996), 97.

19. Pollan, in *Second Nature*.

20. Barbara Gates, *Already Home: A Topography of Spirit and Place* (Boston: Shambhala Publications, 2003), 222.

21. Tuan, *Space and Place*, 183–84.

22. Casey, *Getting Back into Place*, xv.

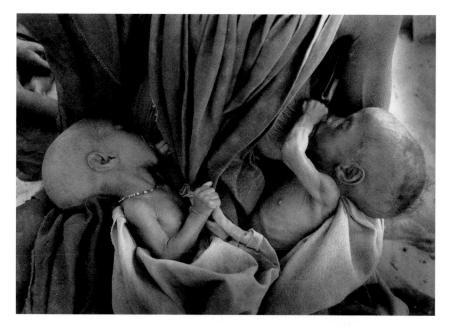

Ill. 1

Sebastião Salgado
Drought and Famine
Mali, 1985
© Sebastião Salgado (Amazonas/Contact Press Images)

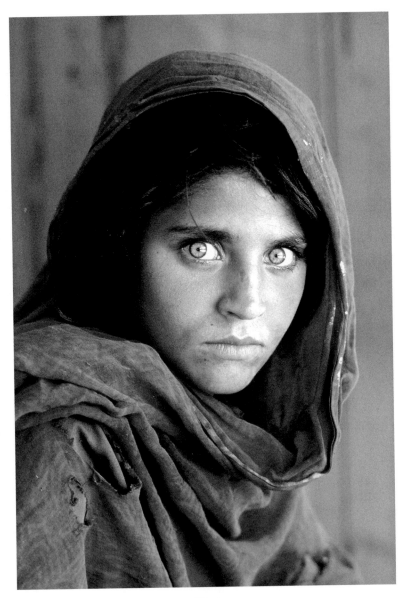

Ill. 2

Steve McCurry
Haunted eyes tell of a young Afghan refugee's fears
Baluchistan, Pakistan, 1985
© Steve McCurry (Magnum Photos)

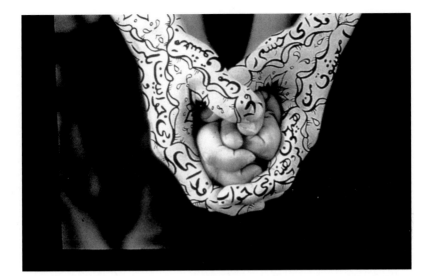

Ill. 3

Shirin Neshat
Faith, 1995
RC print and ink, 11 x 14 inches (27.9 x 35.6 cm)
© 1995 Shirin Neshat
Photo taken by Kyong Park
Courtesy Barbara Gladstone

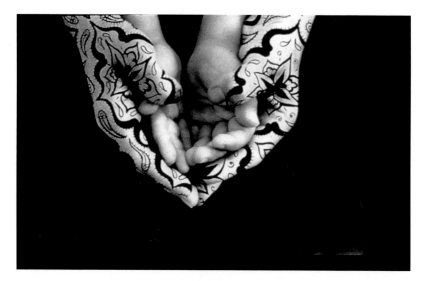

Ill. 4

Shirin Neshat
Bonding, 1995
11 x 14 inches (27.9 x 35.6 cm)
© 1995 Shirin Neshat
Photo taken by Kyong Park
Courtesy Barbara Gladstone

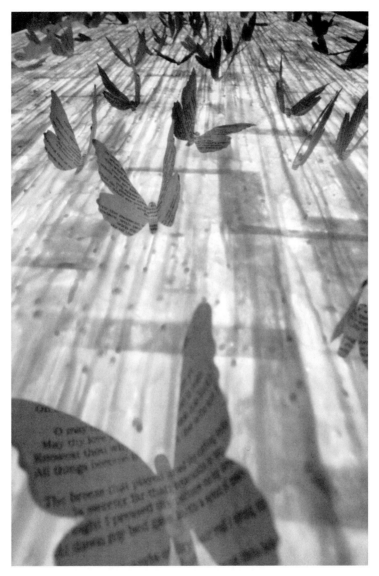

Ill. 5.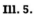

Seyed Alavi
Ode to Rumi; Drawn to Light
Rice paper, beeswax, paper butterflies, Sufi poetry
30' W x 35' H
© 2000 Seyed Alavi; used with permission

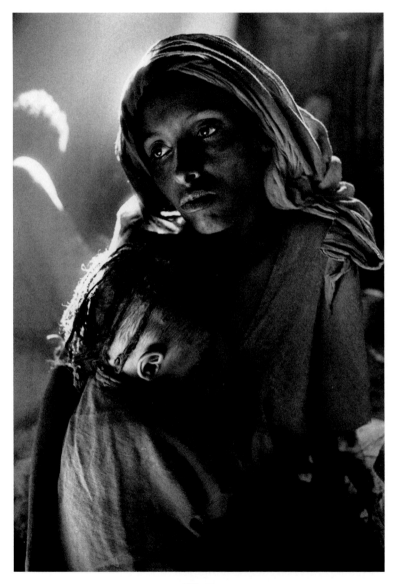

Ill. 6
Sebastião Salgado
Korem Camp
Ethiopia, 1984
© Sebastião Salgado (Amazonas/Contact Press Images)

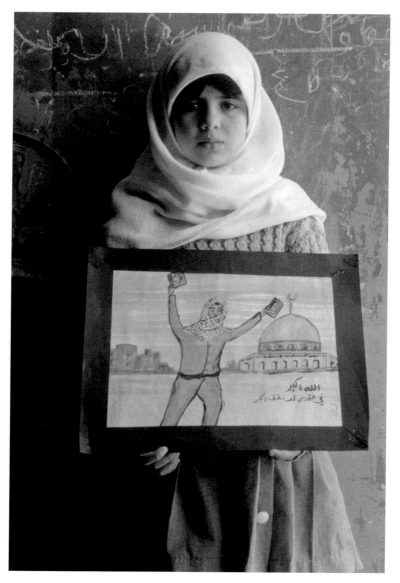

Ill. 7

Joanna Pinneo
Paper Dreams: Palestinian Girl
Jordan, 1991
© Joanna Pinneo; used with permission

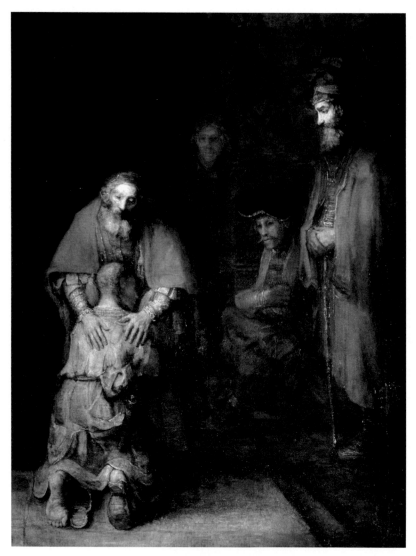

Ill. 8

Rembrandt van Rijn
The Return of the Prodigal Son
1668–1669
oil on canvas, 265 x 205 cm.
Hermitage, St. Petersburg, Russia
Photo Credit: Scala / Art Resource, NY

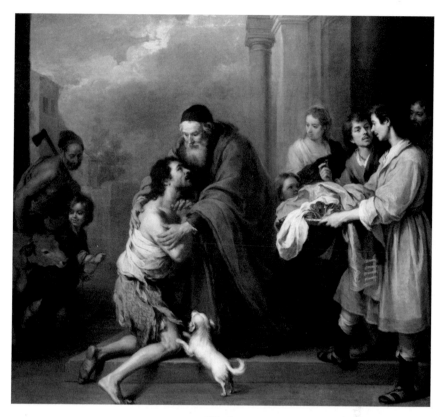

Ill. 9

Bartolomé Esteban Murillo
The Return of the Prodigal Son
1667/1670
oil on canvas, 236.3 x 261.0 cm.
National Gallery of Art
Washington, D.C.
Gift of the Avalon Foundation

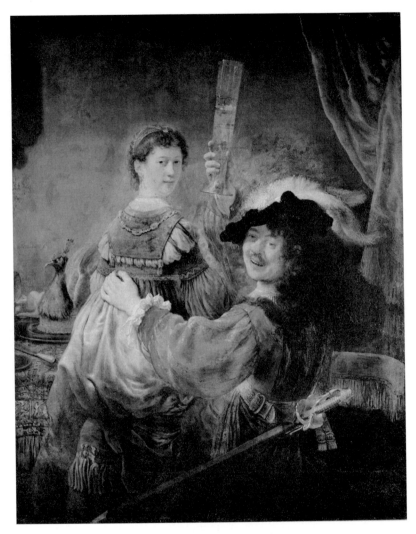

Ill. 10
Rembrandt van Rijn
The Prodigal Son Squanders His Inheritance; also called
Rembrandt (Self-Portrait) and Saskia in the Parable of the Prodigal Son
1635–1639
oil on canvas, 131 x 161 cm.
Gemaeldegalerie, Staatliche Kunstsammlungen
Photo credit: Erich Lessing / Art Resource, NY

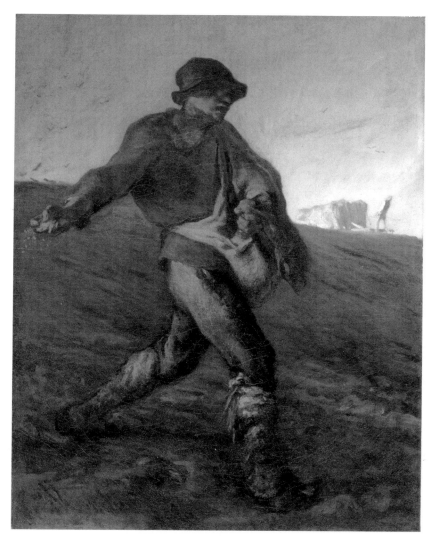

Ill. 11

Jean-Francois Millet
The Sower
1850, oil on canvas
101.6 x 82.6 cm (40 x 32.5 in.)
Museum of Fine Arts, Boston
Photograph: © 2004 Museum of Fine Arts, Boston

Ill. 12

Sir John Everett Millais
The Sower
Published 1864
Relief print on paper, 140 x 108 mm.
Tate Gallery, London, Great Britain
Photo credit: Tate Gallery, London / Art Resource, NY

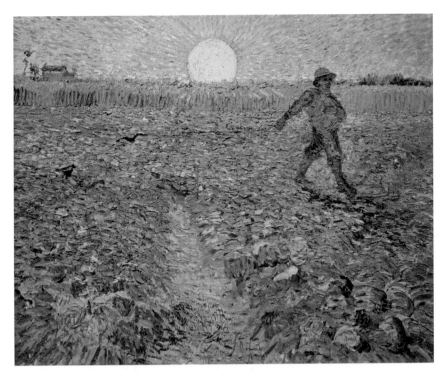

Ill. 13

Vincent van Gogh
The Sower
1888
Rijksmuseum Kroeller-Mueller, Otterlo
Photo credit: Erich Lessing / Art Resource, NY

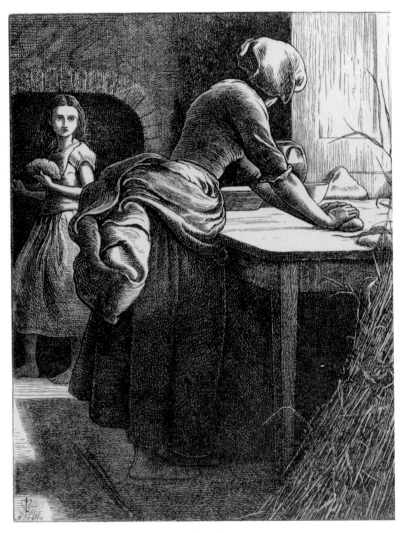

Ill. 14

Sir John Everett Millais
The Leaven
Published 1864
Relief print on paper, 140 x 108 mm.
Tate Gallery, London, Great Britain
Photo credit: Tate Gallery, London / Art Resource, NY

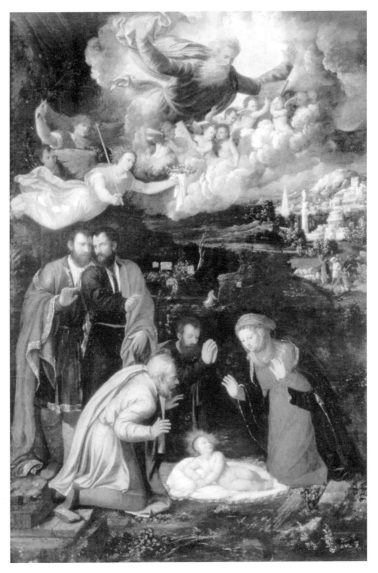

Ill. 15

Battista Dossi
Nativity with God the Father
Galleria e Museu Estense
Modena, Italy
Photo: The Bridgeman Art Library, London

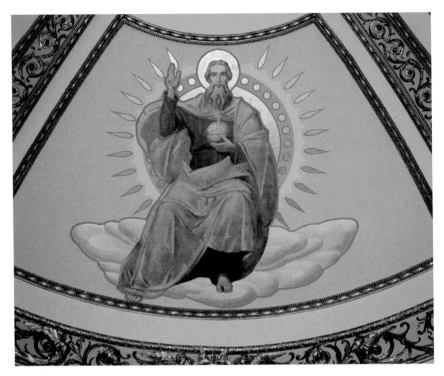

Ill. 16

God
Apse of Cathedral of the Incarnation
Nashville, Tennessee
Photo: Robin M. Jensen

Ill. 17

Trinity
Apse of St. Peter's Catholic Church
New Iberia, Louisiana
Photo: Robin M. Jensen

Ill. 18

Moses Receiving the Law from the Hand of God
"Two Brothers" sarcophagus
4th century
Museo Pio Cristiano, Vatican
Photo: Robin M. Jensen

Ill. 19

Sacrifice of Abel and Melchizedek
Presbyterium, S. Vitale, Ravenna, early to mid-6th century
Photo: Robin M. Jensen

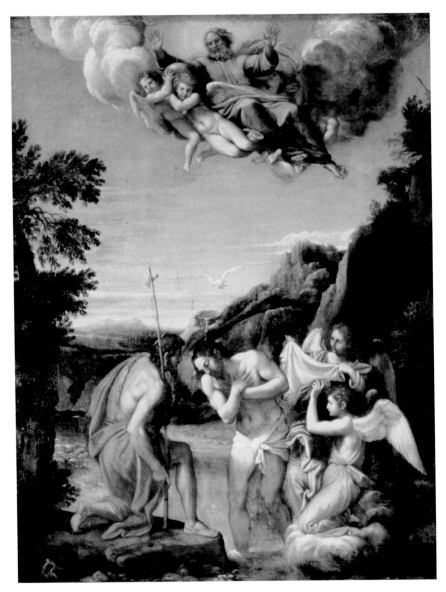

Ill. 20

Francesco Albani, *Baptism of Christ*
Photo: The Bridgeman Art Library, London

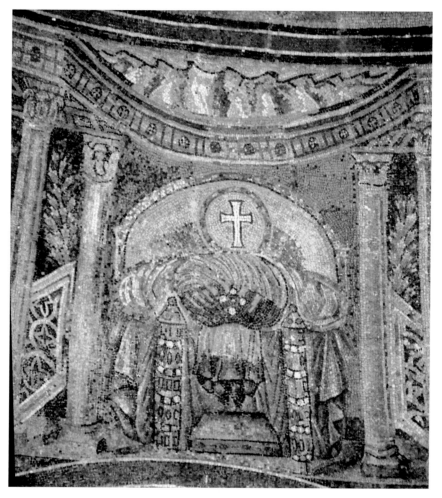

Ill. 21

Empty Throne with Cross
Orthodox (Neonian) Baptistery
Ravenna
mid-5th century
Photo: Robin M. Jensen

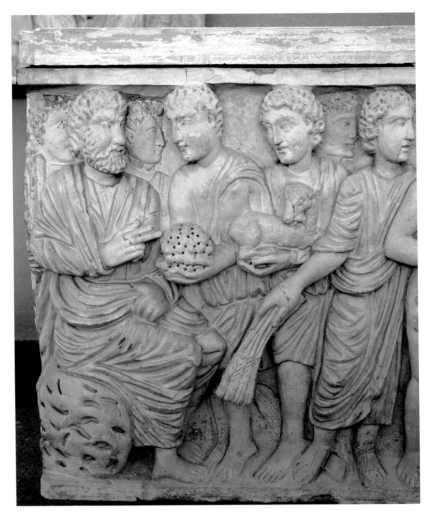

Ill. 22

Cain and Abel Presenting their Sacrifices to God
Sarcophagus
4th century
Museo Pio Cristiano, Vatican
Photo: Robin M. Jensen

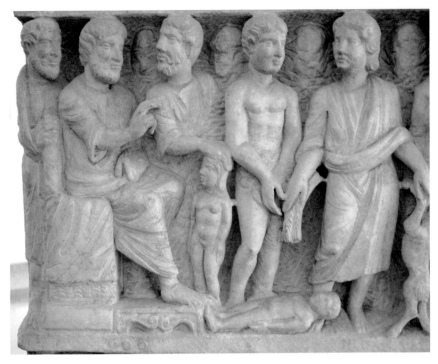

Ill. 23

Trinity Creating Adam and Eve
Sarcophagus
4th century
Museo Pio Cristiano, Vatican
Photo: Robin M. Jensen

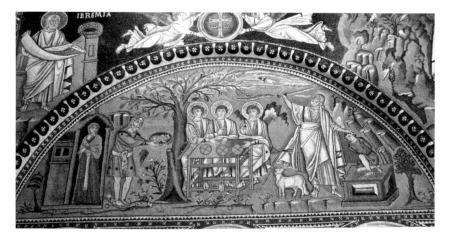

Ill. 24

Abraham and His Three Visitors with the Sacrifice of Isaac
S. Vitale, Ravenna, early to mid-6th century
Photo: Robin M. Jensen

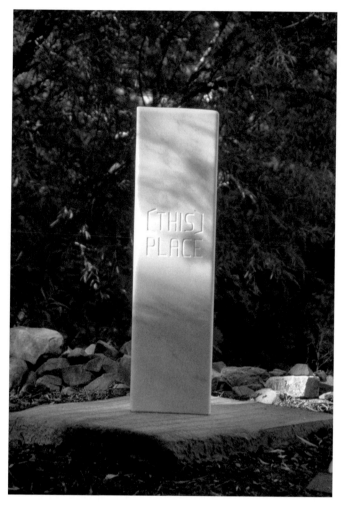

Ill. 25

Deborah Haynes, *[THIS] Place*, title stone, 2003
Marble, Jamestown, Colorado

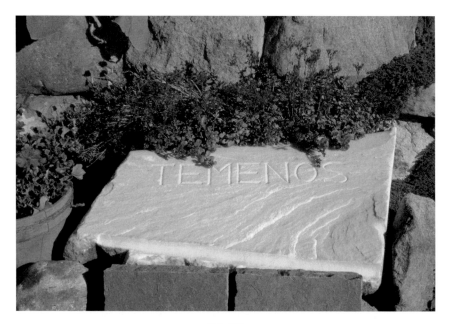

Ill. 26

Deborah Haynes
TEMENOS; from *[THIS] Place*
2001
Marble
Jamestown, Colorado

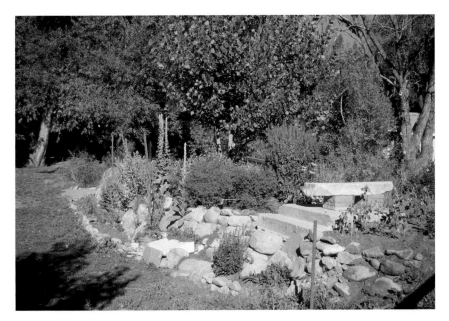

Ill. 27

Deborah Haynes
medicinal garden view; from *[THIS] Place*
2000–present
Jamestown, Colorado

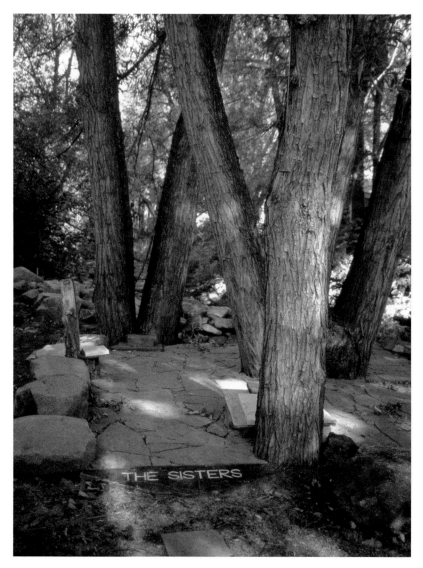

Ill. 28

Deborah Haynes
THE SISTERS; from [THIS] Place
2001
Marble
Jamestown, Colorado

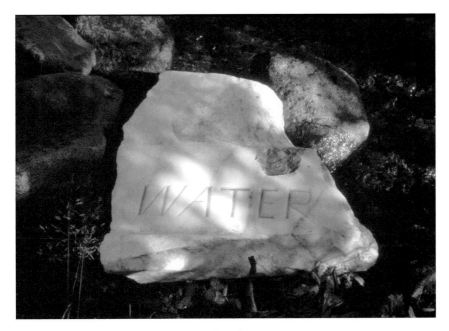

Ill. 29

Deborah Haynes
WATER; from *[THIS] Place*
2003
Marble
Jamestown, Colorado

Ill. 30

James Quentin Young
Cross
Classroom Gallery
United Theological Seminary of the Twin Cities
New Brighton, Minnesota

Ill. 31

Asmat Art (Irian Java, Indonesia)
Spencer Gallery Library
United Theological Seminary of the Twin Cities
New Brighton, Minnesota
Courtesy of the American Museum of Asmat Art

Ill. 32

Day of the Dead Altar
Community Art Project
with Nancy Chinn, artist-in-residence
United Theological Seminary of the Twin Cities
New Brighton, Minnesota

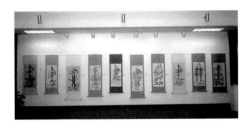
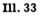

Ill. 33

Islamic Calligraphy
works by Haji Deen MiGuang Jiang from China,
Mouneer Sha'rani from Syria, and Fayeq S. Oweis from the United States
Spencer Library Gallery
United Theological Seminary of the Twin Cities
New Brighton, Minnesota

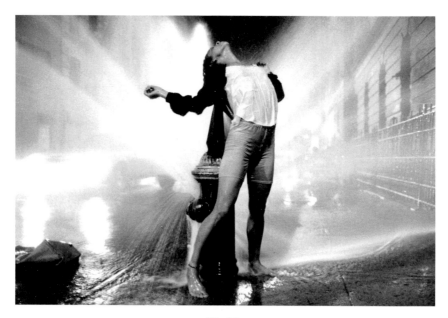

Ill. 34.

Scott Thode
Venus Rising

PART III **The Arts and the Practice of Ministry**

9

Liturgical Aesthetics

The Travail of Christian Worship

DON E. SALIERS

> Look at the liturgy: among the forms of Christian art, it is the
> transcendent and dominant one; the Spirit of God . . . formed
> it, in order to have pleasure in it. . . . The beauty of the liturgy
> belongs among the glorious gifts of God which are granted us
> when we seek the kingdom of God. In any other instances, the
> liturgy becomes a spectacle and a sin.[1]

In a culture dominated by entertainment, hyped-up immediacy of feel-
ing, manipulated desire, and forgetfulness of being, can we still talk
about Christian liturgy this way?[2] What is this "beauty" in liturgical life
of which van der Leeuw speaks so readily? Such questions are a path-
way into theological aesthetics, and in particular to this essay in "litur-

gical aesthetics." Here I intend to *think about* the aesthetic dimensions of public worship, as well as to suggest how we may *think with* those dimensions about larger issues of faith and art.

The history of Christian faith and theology is also a history of the eye, the ear, of bodily gesture and movement, the mind imagining, and the senses conjoining. Wherever human beings hear and encounter the divine, the consequences are poetic, visionary, metaphoric, parabolic, and ordered sound—voices, instruments, and dance. Central to Christian faith and life are the practices of worship. The poetry of hymns and psalms and spiritual songs arises in the earliest worshiping assemblies. The common elements of earth, air, fire, and water, and the fruits of earth and human work—oil, wheat become bread, and grapes become wine, ordered sound and visual form—all take on symbolic and communicative power when used in Christian worship.

I propose that theological aesthetics keeps returning to primary practices that constitute worship of God. Despite all temptations to the contrary, Christianity steadfastly remains a religion of the body: Christ incarnate, the Word's body crucified, risen, proclaimed, and enacted in rituals of the common meal in his name. From the beginning, Christian communities forge and transform human ideas of the common good, much less the beautiful, in and through central ritual activities. Such rituals, with few exceptions, are permeated with human arts, requiring receptivity of human senses and intellect. Suspicion of the arts in worship arises when the power of the sensual is deemed to lead to idolatry, or when it leads only to self-absorption.[3] This is why the church must continually reflect on the means by which the divine/human transaction called "liturgy" takes place. If the music of heaven became the music of earth, and the Word of God was heard and made visible, then the aesthetics and the poetics of worship are crucial to the continual work of theology. As David Power has observed, "In the realm of the holy, the poetic must win out, [for it is the poetic that] must integrate the tragic and the comic of life with a vision of the future."[4]

Current debates and collisions of sensibility concerning worship in North American contexts now bring these considerations into the arena of pastoral practice and everyday life for many Christian traditions— hence the need for liturgical theology to provide a framework for re-

thinking the aesthetic dimensions of worship and the "poetics" of liturgical participation. While questions of holiness and beauty have always accompanied discourse about God, especially in periods heavily influenced by Platonic and neoplatonic sources, our present situation in church and culture renders such questions fragmented and problematic. The very terms "aesthetics," "beauty," and "holiness" are now themselves contested notions.

This essay aims to set an agenda for liturgical aesthetics. Six "tensive" theses will be advanced and explored, with a particular eye toward what may be called the *kenotic aesthetic of Christian liturgy.* While strong differences among Christian worshiping traditions are to be acknowledged, this agenda may provide a broadly ecumenical framework for addressing a range of current theological and liturgical issues well beyond the scope of a single essay.

BEAUTY AND HOLINESS: A Primary Religious Ambivalence

Hans Urs von Balthasar has remarked, "In a world without beauty . . . in a world which is perhaps not wholly without beauty, but which can no longer see it or reckon with it: in such a world the good also loses its attractiveness, the self-evidence of why it must be carried out."[5] In working out a theological aesthetics on the basis of divine revelatory initiative, von Balthasar seeks to show the inner connection between the beautiful and the good, between the aesthetic and the ethical. Receptivity toward what is beautiful is crucial to the ability to envision and do what is good. Works of art can be said to die, in his view, under a dull and uncomprehending human gaze, so "even the radiance of holiness can . . . become blunted when it encounters nothing but hollow indifference."[6] This suggests why we might focus on active receptivity toward the beautiful and the good in Christian worship. Without the aesthetic embodied in communal practices, the vision of goodness grounded in the holiness of God may lose its point.

Christian theology has shown a long and studied ambivalence toward human aesthetic capacities, especially toward relationships between art and religious faith. On the one hand, beauty has been included among the transcendentals ingredient in classical theology, often linked with reasoning to and about God by analogy. On the other hand,

prophetic strands in Judaism and Christianity have regarded the human imagination with suspicion, generating historical periods of strident iconoclasm. Idolatry and the distractions of sensuality are two main polemical targets of such religious critique. Yet God's glory, and the goodness and beauty of the created order of heaven and earth, is intrinsic to praise and thanksgiving in Christian public worship. Doxology is central to naming God, just as lament over the broken and the unlovely features of human life and the world is needed for prophetic and truthful worship. Doing justice and mercy in the face of human distortion and death is the impulse when lament and doxology meet in worship.

We must name and face ambivalences here. This is not simply because of the Platonic and neoplatonic cautions against substituting beauty and pleasure for the pursuit of true virtue and faith in God. Ambivalence is built into the message of Christianity. The symbol of the cross and the claim that God in Christ assumed sin and death creates a necessary tension internal to Christian revelation itself. Thus, any consideration of how Christian liturgy should employ aesthetic means cannot concentrate naively on beauty by itself. Many theologians in the long history of theology have claimed that the wonders of created beauty can and ought to lead human beings toward God, the Source of all goodness and beauty. But running alongside this theme sounded in the creation psalms and the great eucharistic prayers of the church, East and West, is the theme of human sin and the distortions of a fallen creation. Whatever eros toward beauty we assume, and whatever human artistic powers may be, the self-giving of God in the life, passion, death, and resurrection of Christ stands against all tendencies toward idolatry and human self-absorption.

If liturgical aesthetics is to illuminate relations between the beauty and goodness of God mediated by liturgical events, it must do so by naming original ambivalences as well. This may prove especially important to the current situation originating in so-called "culture wars" among and with Christian churches today. The inability to make mature theological assessments of various artistic media today is due, in part, to uncritical assumptions about the concepts before us: beauty, goodness and holiness. Debates about what is appropriate in worship, too, often devolve into unreflective appeals to "taste" and cultural preferences.[7]

Among the tasks of liturgical theology is the explication of the "primary theology" of a given worshiping assembly. Such primary theology is itself shaped by and expressed by aesthetic means. Here "aesthetic" refers both to the forms of perception, and to the qualities of particular words, symbols, gestures, visual and aural forms. In other words, the aesthetic requires attention to what gains attention, and to what is received as beautiful, and so forth. This is at once a theoretical and a practical discipline.

WHAT CHRISTIAN LITURGY REQUIRES

For several years in the 1960s and early 1970s, my family and I lived in a city neighborhood. The neighborhood children taught our four daughters, then quite young, a set of ritual songs. They would gather to form a circle and, calling out to one another across twirling jump ropes, would begin to sing and move. One at a time, and occasionally in pairs, the children would dance into the circle, hop a few steps, then dance away, all the time singing amid the whirling ropes: "Miss Mary Mack, Mack, Mack, all dressed in black, black, black, with silver buttons, buttons, buttons, all down her back, back, back. . . ." This ritual game gave pleasure and conferred identity to participants and observers alike.

That dancing, singing image of the children still sheds light on matters of aesthetics and poetics in Christian worship. They learned the rhythms and the words and the rules in and through the participation. The circling song and movements were improvisational, sometimes strikingly so, but the rules were clearly shared by all. The song had to have the right accent in order that the dance could take place. The delight, the physical energy, and the seriousness of the children were evident, yet marked by surprises. One could say that all were conjoined in the ruled freedom of the play. The combination of seriousness, rules, and play is reminiscent of Romano Guardini's famous definition of liturgy as "holy play."[8] The children's ritual play suggests that the aesthetics of religious ritual cannot be divorced from the poetics of liturgy, the actual participation of human beings in the "making" of the event experienced in the liturgical assembly. To this we shall return.

Christian assemblies for the worship of God require ordered sound, sight, space, movement, gesture, symbolic acts, and sacred texts. The meaning and point of language used to address God and the as-

sembly depends radically on the nonlinguistic forms and practices for its formative and expressive power. Paradoxically, all such culturally embedded phenomena must also transcend the given specific culture of the assembly, if God is properly addressed. This is why, despite widely varying Christian traditions of worship, I propose that liturgical action itself is best understood as an eschatological art.[9]

Events of Christian worship, while not all "liturgical" in the narrow sense of adhering to a set of prescribed prayers and ritual actions, are communal actions in which the participants are engaged in shared practices aimed at the glorification of God and the building up of the community in faith and love. Liturgies are thus not "works of art" to be admired, but communal acts aimed at communion with the divine. Thus, the divine/human dialogue in Word and in sacrament, faithfully celebrated, is simultaneously aesthetic and theological. But this is precisely why Christian liturgy requires a series of tensions and juxtapositions, verbal and nonverbal.[10] Theological reflection born of liturgical participation on God's glory and on relationships between beauty and holiness must always confront the "anti-aesthetic" entailed in the passion and death of Christ. The highest pitch of this tension may be found in the liturgy of Holy Week, where the brokenness and pain of Christ's passion and death is juxtaposed yet interpenetrates the glory of the resurrection. The Mel Gibson film *The Passion of the Christ,* whatever its virtues, tends to create an intense aesthetic of violence with minimal attention to the anti-aesthetic of the larger context.

In this sense, we affirm that artistic and aesthetic dimensions of human life are intrinsic to liturgical practices, hence to theological understanding. In the context of liturgical participation, the poetics and aesthetic dimensions of worship are internally connected to concepts of holiness, goodness, and beauty, divine and human. But this, as we have observed, plunges us into a set of permanent tensions. We cannot assume that the "beauty of holiness" is self-evident, let alone easily grasped. The ambivalence displayed in Augustine's *Confessions* is therefore not his alone.

> When I love you, what do I love? Not the body's beauty, nor time's rhythm, nor light's brightness . . . nor song's sweet melodies, nor the fragrance of flowers, lotions and spices, nor

manna and honey, nor the feel of flesh embracing flesh—none of these are what I love when I love my God. And yet, it's something like light, sound, smell, food, and touch that I love when I love my God—the light, voice, food, fragrance, and embrace of my inner self, where a light shines for my soul. . . . That's what I love when I love my God![11]

No one can fail to see how deeply intertwined sensible joy and delight in creaturely things are in Augustine's reflections on worshipful love of God. He was possessed of a sense for what is beautiful, rooted here in a neoplatonic conception of reason as *eros*, but also steeped in the language of doxology born in the psalms and Christian Scriptures. Whether intended or not, he cites the sensible stuff of liturgical rites of his day in uttering what love of God is "like." The seeming denial of the bodily, the temporal, and the sensual aspects of religious worship is immediately reforged into the descriptive and ascriptive language of the address of worship.

Augustine's remark suggests what we may call *proto-analogies of beauty*. They arise from participation in liturgical actions. While rooted in human experiences, the analogies are generated in prayer, song, and common ritual. They provide what Barth refers to as "analogies of faith." Rather than providing a basis for reasoning from experience to God, these experiential analogies are dependent upon the intentionality of liturgy as a divine/human transaction. The divine/human exchange is, for Christian theology, dependent upon the divine self-giving. The beauty of God's holy self-giving is a "kenotic" beauty precisely because of the passion and the cross. This is constitutive of any account of a Christian liturgical aesthetics.

A striking passage in Karl Barth's *Church Dogmatics* speaks of the attraction to the divine beauty. "If we can and must say that God is beautiful, to say this is to say how [God] enlightens and convinces and persuades us." God possesses "this power of attraction which wins and conquers, in the fact that [God] is . . . divinely beautiful, . . . as the unattainable primal beauty, yet really beautiful." God is the "One who gives pleasure, creates desire and renews with enjoyment."[12]

This lies at the heart of any Christian aesthetics, and especially of liturgical aesthetics. Recalling Augustine and other classical theologians' recognition of the role of delight and attraction toward God, Barth also

wishes to counter any false "aestheticism" that would make human beauty itself the cause of our knowing and worshiping God. For Barth, as for von Balthasar, God's beauty is subordinated to the glory of God, for God cannot remain the deity and be subject to something metaphysical shared with the created order. For Augustine, the issue is ambivalent human subjectivity; for Barth, the issue is God's sovereignty and the difference between Creator and the creatures. Von Balthasar saw and appreciated this in Barth and thus, in his own theological work, incorporates a revelatory role for both the attraction (beauty) of God's glory, and for the evoked desire at the heart of prayer and worship.

The claim that God is both ground and object of the deepest creaturely desire is, I contend, a necessary basis for the following proposals concerning liturgical aesthetics. If we can speak of Christian liturgy as both "source and summit" of the Christian life, then we must investigate how any particular liturgical assembly forms and gives expression to the appropriate dispositions and participation in glory and the holiness of God. For the Christian faith, both the glory and the holiness require a profoundly kenotic element in experience and in theological thinking.

SIX THESES TOWARD A CHRISTIAN LITURGICAL AESTHETIC

We are now in a position to consider six theses that bear upon the larger aim of this essay. I intend these as interrelated. While each may be, and must be, examined on its own, their bearing upon a constructive theory of liturgical aesthetics can only be shown in their relation to one another when studying specific liturgical communities. A brief exposition of each will lead to a concluding proposal concerning "active receptivity" appropriate to a kenotic aesthetic of Christian liturgy. Each thesis contains a number of assumptions and implications that cannot be fully pursued here. My contention is that, in working through these points, the general outline of an adequate theological framework will emerge.

The following theses constitute the foundation for a theory of liturgical aesthetics:

1. Christian liturgy is always culturally embodied and embedded.

2. Christian public worship is an art, but not a work of art; it is, in the words of Aidan Kavanagh, a "performative artful symbolic action."[13]

3. The Christian assembly originates in the liturgy of Jesus Christ, thus requiring the paradoxical character of the "glory of the cross," and the poetic fusion of word and act.

4. Every worshiping assembly requires three interrelated levels of participation: the phenomenal/aesthetic, the ecclesial, and the mystical.

5. Christian liturgy is faithful, authentic, and relevant to the extent it displays a series of permanent tensions.

6. Christian liturgy is an eschatological art requiring active receptivity to the form and content of revelation.

Culturally Embodied and Embedded

To observe that Christian liturgy is culturally embodied and embedded is commonplace, yet the implications of this claim have not always been drawn out adequately. When human beings assemble for worship, there is usually speaking, singing, listening, observing, gesturing, movement, and particular ritual actions with particular objects. James F. White once defined worship as "speaking and touching in God's name."[14] This minimalist definition begins with the human actions in order to highlight the human stuff internal to the theological character of worship. Whatever is said and sung about the divine, human means of communication are involved. Moreover, such means are products of specific human cultures in particular times and places.

A more classical definition of Christian liturgy speaks of the glorification of God and the sanctification of all that is human and creaturely. Even here, we note a co-inherent claim. In the very act of praise and thanksgiving, humanity is subject to being made holy. The ascription of holiness to the divine implies the "being made holy" of those who worship. Despite the tendency to associate such a definition with the sense of the "timeless" and the eternal, the very process of sanctification implies temporality and particularity. Sanctification is not otherworldly, but social, bodily, historical life.

Thus we cannot analyze or interpret liturgical life without attending to the fact that language, music, movement, and symbols used in worship are, themselves, culture-permeated. Each may be spoken of as an "art"—rhetoric, musical performance, gesture, iconography, archi-

tecture, and particular objects now given ritual significance—having origins in the social/cultural life of a particular people. Sermons, hymns, prayers, the visual and kinetic dimensions of architectural environments, are "aesthetic" spheres of human being and understanding.

The history of Christian worship is also a history of the variable cultural aesthetics (sensibilities) and art forms involved. When, for example, the church moved from persecution to establishment in fourth-century Rome, royal court ceremonial became part of certain Roman pontifical rites. When Christianity was presented to American slaves of African descent, the art and the aesthetics of song and rituals such as the "ring-shout" emerged as part of slave patterning of common worship. When Martin Luther composed new texts for the congregation to sing, he reshaped antecedent chant melodies into free metrical hymn tunes. The resulting fusion of text and tune introduced a new aesthetic. At the same time, John Calvin allowed only metrical psalm texts to be sung—but, surprisingly, to newly minted tunes derived from French court dances! Ulrich Zwingli found music so emotionally powerful that he silenced instruments and singing, lest worshipers be distracted from the pure Word and grace of God.

Not only are the elements of liturgy just cited "from" particular human arts within particular cultures or subcultures, liturgy is always practiced in the wider domain of social/cultural engagements. There is no "pure" participation in the sense that persons and the means of participation in worship are culture-transcendent. Christian assemblies have always "borrowed" materials and artistic means in the worship of God. This does not mean, of course, that there are no culture-transcending forces at work in faithful liturgical celebration. The fifth and sixth theses reintroduce culture-critique as necessary in forms of worship.

Performative Artful Symbolic Action

The second thesis claims that Christian liturgy is an art, but not, in the first instance, a "work of art." In his discussion of what constitutes a "work of art," Nicholas Wolterstorff observes a number of diverse conceptions. A basic definition is that "a work of (fine) art is just that of a product of one of the (fine) arts."[15] But if we want a concept that combines the idea of the aesthetic dimension of human life along with

some notion of human intention, we come to define a work of art as *"an entity made or presented in order to serve as object of aesthetic contemplation."*[16] While there are certainly contemplative dimensions in Christian liturgy (more in some traditions than in others), the point is that the worshipers contemplate "God" and the divine life, not the liturgy. Or, more precisely, it is by means of the liturgy that worshipers contemplate God in certain traditions. Here we need to distinguish "aesthetic" and "religious" contemplation, though the latter characteristically used aesthetic means—at least within so-called kataphatic traditions of devotion and piety. Apophatic traditions aim at the removal of all images and aesthetic means—though often paradoxically with the aid of images in the process of practicing their negation.

In further consideration of how and why liturgy may or may not become an "object" of aesthetic interest and contemplation, the work of Kierkegaard, Edwards, Barth, and von Balthasar becomes relevant. The question is not either liturgy or aesthetics, either liturgy or the arts, but rather is about the complex relations between the aesthetic and religious forms of participation within particular liturgical traditions.

To confront the problematic status of "beauty" and aesthetic sensibility in liturgical participation, it is necessary in our present situation to begin with what George Steiner has called our "fragile schooling in humanity."[17] Could one of the distinctive roles of faithful Christian liturgy be to strengthen and deepen this schooling in humanity? What else can the assembly bring and offer to God? Whatever social vision of the good, whatever culture-permeated practices of speaking, singing, beholding, enacting in concert are employed, these are the defining means of participation. We shall refer to this as the "phenomenal/aesthetic" level of participation in thesis five. Theological claims about the divine/human transaction in worship must attend to the incarnate human means. All too often, theological claims are contravened and subverted by the forms of celebration and the diminished perception of Word and sacrament in actual assemblies. How the phenomenal/aesthetic level is related to the "ecclesial" and "mystical" levels of participation is a key question raised by thesis five.

We cannot speak now so confidently of God in ecclesial life as in earlier times. This is because of the permeability of what is culturally

(and theologically) "inside" and "outside" the church. The culture of hype and the banality of evil and of purported human cultural values we desire create a dissonance. Only by moving through the ways in which liturgical elements are subject to both a hermeneutics of cultural appropriation (and appreciation) and a hermeneutics of cultural suspicion can we arrive at the conditions for understanding the relationship of the three primary levels of liturgical participation. Nostalgia for some "pure" liturgy and for some unambiguous "age of faith" may even mislead us concerning the soteriological dimensions of liturgical aesthetics. What can be made clear, however, is my conviction that authentic liturgical participation "in Spirit and in truth" provides a way of living in the face of the harsh ambiguities and the human ambivalence toward the holiness of God's incarnate life in Jesus Christ, suffering, dead, and rising.

Originating in the "Liturgy" of Jesus Christ

Thus, thesis three is central to assessments of particular patterns of worship. The Christian assembly originates in narratives and signs gathered about the life, teaching, deeds, suffering, death, and resurrection of Jesus Christ. I refer to this pattern as his "liturgy." Since what he said and did must be enacted together in light of his dying and being raised, the continuing enactment of the saving mystery claimed by Christian faith requires a fusion of verbal and nonverbal modes of life. There are narratives surrounding and leading to and from what God uttered, in both testaments of Scripture. It is helpful to think of the "liturgy" of Jesus as an incarnate, enacted parable of God. But the language of the liturgy—in reading, proclamation, prayer, and song—is itself performative, not simply informative.

Texts in Christian liturgy, both written and spoken, are radically dependent for their meaning and point on that which is not language at all. The rhetorical arts in preaching cannot be sustained unless a community also learns to receive and give, to feed and be fed, to wash and be washed, to judge and be judged, to love and be loved, to reconcile and be reconciled, to forgive and be forgiven, and to refer all things to God. In order for what Jesus said and did to be transacted in the present saying and doing of the liturgical action, the pattern of his life is to

be received under the signs of his suffering, dying, and rising. Here we also anticipate the eschatological nature of Christian liturgy. The very act of assembling is based on the divine promises to bring to fulfillment that which was spoken by the prophets and which was said and done in Jesus Christ. This leads directly to one of the central proposals of this project: we encounter the most intense unity of his word and deed imaged in the stories and strong symbols of dying and rising in the liturgy of Holy Week, especially in the triduum and the Easter vigil. Here, the paradoxical tensions lie in wait, so to speak, for the human assembly. These intensities, I shall argue, are present in various modalities in each Christian assembly. This is not simply a description; it is also a normative claim against the resistances of human cultures.

Permanent Tensions

This already takes us into the point of the fifth thesis, returning to the fourth below. The authenticity and relevance of Christian liturgy to any specific cultural context is dependent upon how well (and under adequate aesthetic forms) the permanent tensions of the Christian gospel are shown. We shall note that this "showing" or manifestation in liturgical action requires appropriate "saying" as well. In faithful and authentic Christian liturgy, we confront a series of tensions: between the "already and the not-yet" of the kingdom of God; between material form and spiritual substance; between the mediation of the divine in human modalities and the mystery of the divine and the tensions of possible idolatries and deceptions. Because human beings bring existential struggles to liturgical participation, the tension between the "holy" and the "unholy" is always present in some form in every worshiping assembly.

The analysis of distinctive tensions within the proclamation of the Gospel and central mystery celebrated at the heart of all Christian rites will shed light on the idea of "kenotic aesthetic." Only by viewing Christian liturgy as an eschatological art, with a distinctive "kenotic" element in its employment of cultural aesthetics, can we begin to reply to the problematic status of worship in contemporary American culture.

Thesis five is an integrating point for the previous four. Borrowing from a classical notion of levels of liturgical participation, I propose that three principal levels are required to illuminate liturgy. The first, or

phenomenal, level involves all the "arts" and the attendant "aesthetics" of participation. Here, differences across traditions of practice and liturgical aesthesis—patterns of perception and styles of participation—are evident. Thus, the phenomenological task is to render a persuasive account of how singing, praying, listening, gesturing, movement, and ritual engagement entail the use and the modification (even the transformation) of specific "cultural aesthetics." This requires a thick description of any particular community at worship.

Three Levels of Participation—the Aesthetic and More

But if we are to speak of Christian liturgy, then the level of active/contemplative participation must be related to awareness of ecclesial solidarity. All the "active participation" of which *Sacrosanctum Concilium* so boldly speaks (and which contemporary Protestant worship admonishes!) may or may not involve participation as the church—the catholicity of the community gathered about Jesus Christ "in all times and places." Here, one of the distinctive marks of Christian liturgical participation is solidarity with the living and the dead in Christ, and a notion of conjoining "earthly worship" with the "worship of heaven."

Arguing from the centrality of the mystery of the incarnate Christ, suffering, dead, buried, resurrected, and ascended, the third level of participation engages in the mystery of the divine life itself in its revealed and revealing form. Here, we must be careful to distinguish "mystery" from "mystification." The sense of the co-presence and even co-inherence of divinity and humanity is part of this mystery. Without specific occasions focused on the transfiguration of the human by virtue of the paschal mystery, we cannot fully discern the way in which the aesthetic and the ecclesial levels are consummated in the "participation in the life of God." Lacking this, Christian public worship cannot fully achieve its own self-critique, nor can it hope to address the resistances of contemporary American culture. I propose that, lacking a sense of the interrelated character of these levels of liturgical participation, Christian liturgy cannot "show" its capacity for "culture-transcendence." This is necessary to determine whether or not we can speak of the paradox of employed, culturally specific "aesthetics" in order to offer a theological critique of the reigning cultural aesthetic.

Specific examples from so-called "traditional" and "contemporary" worship forms and patterns show how it is possible to develop a sense for the phenomenal/aesthetic level, without receptivity to the ecclesial, or how both of these may be present, but not related, to the eschatological dimensions of the mystery of the divine glory. But this turn sheds light on a theological retrieval of the relations between beauty and holiness.

While my investigation begins with the most obvious sense of participation in and through aesthetic (artistic) means, it also seeks to uncover the linkages between all three levels of participation. We can honor the *Constitution on the Sacred Liturgy* in calling for "full, conscious, and active participation" of the faithful. At the same time, this can be deceiving if we think that is sufficient, or that it can simply be brought about by pragmatic or instrumentalist techniques. Rather, the question of aesthetic criteria guiding "full, active, and conscious" must be embedded in theological claims attendant upon being the Body of Christ at worship. This, as I have already suggested, requires a palpable sense of catholicity. But even more crucial is the reality of belonging to the community marked by the dying and rising Christ. These, too, imply and require aesthetic embodiment. These we find supremely in the pattern and content of the Easter triduum. While always enacted in particular times and cultural settings, the dynamics of the central mystery of Christian faith holds the key to issues of "culture transcendence."

Here the paradox of the kenotic Christ suggests what Joseph Gelineau called the "paschal human in Christ" as a norm of judgment on all cultural aesthetic powers. This norm is simultaneously a hermeneutics of appreciation, and a hermeneutics of suspicion. The capacities to reflect the glory of God in and through music, the visual, the kinetic, and the ritually symbolic belong to each specific culture; yet the presumptive and ambivalent character of those same cultures stand under judgment.

Each particular culture has a range of aesthetic means and a range of aesthetic sensibilities. Some, like so-called "traditional cultures," may certainly have a more uniform set of means and sensibility. By contrast, the characteristic attributed to "postmodern" cultures is one of fragmented strands, and a splintering into "subcultures" with little in

common. My argument is not dependent upon opposing traditional or "classical" to contemporary or "postmodern" cultures. The key point is that each culture, however circumscribed, must bring its own aesthetic means and sensibility to Christian liturgy in order to understand what must be "broken" and judged by the central symbols of the Christian faith.

If Christian faith and thought continually orient and reorient around the saving mystery of the life, teaching, death, and resurrection of Jesus Christ, than the continuing enactment of that mystery in word and ritual action (the living utterance, the meal, and the water bath) both requires and continually judges the aesthetics brought to liturgy. The arts brought to the liturgical assembly are necessary and must be assessed not on purely aesthetic grounds, as with "works of art." Rather, they are subject to the inner paradox Christian liturgy celebrates: the kenotic aesthetic found in Christ. This sensibility and perceptive capability is encountered and formed in human communities who stand under the "glory of the cross." This, itself, is a peculiar disposition, not simply given in the natural inclinations of the human spirit. It is received. Like the virtue of humility, it is a strong receptivity, a vulnerability to that which is other than our own self-ideals.

The tensive character of faithful liturgical aesthetics is experienced in a way of perceiving, and a way of being, in the world. The world is beheld "as" a created order. The world is seen "as" the arena of God's concern and activity. The words of scripture are heard "as" an address to us. This "seeing as" and "hearing as" is part of the imaginative reorientation to life and to the whole cosmos that vital and authentic liturgy provides. This is often precisely because the surrounding culture resists it. Such a vision and a way of life are, therefore, not products of human artistry, much less "experiences" of the aesthetic kind. Rather, only by deploying the central symbols and stories of the Christian gospel with aesthetic power in light of the kenotic life of God in Christ are such a vision and way of life possible.

"Work and culture are the place where human beings and the world meet in the glory of God."[18] But Jean Corbon speaks of how this is obscured and resisted by human beings who lack a sense of divine glory. "If the universe is to be recognized and experienced," he claims,

"as filled with [God's] glory, human beings must first become once again the dwelling places of this glory and be clothed in it."[19] This, I will argue, is only possible because of the self-emptying of all pretense to divinity. This is the means of grace at the heart of the passion narrative of Christ, and of the passion of God to save God's people and, indeed, all creation.

The aesthetics of Christian liturgy cannot therefore be confined to considerations of beauty and sensibility, though it requires these. The coming to see and to live in the world "as" God's good creation, fallen and redeemed by divine grace in actual time and history, is also a coming to envision the good, and to be drawn to do it. This is not to be an "aesthetic experience" in the liturgy (though this may, from time to time, occur), but a being formed in the affections and dispositions to live out in the "liturgy of life," the paradoxical beauty beheld in the paschal human freely offered.

Communion with God is part of the ground and the *telos* of authentic and faithful liturgy. But the beauty of this is held captive in the forces of every culture. This is, in part, what is meant by sin. The eschatological vision offered at the heart of Christian worship is found in what God glories in. As Irenaeus claimed, "The glory of God is living human beings, and the life of human beings is the vision of God . . . for the glory of human beings is God, but the receptacle of the Energy of God and of his entire Wisdom and his entire Power is human beings."[20]

This brings us to the threshold of the eschatological character of every Christian assembly. Participation in the divine life requires a making visible, audible, and palpable the vision of the good for all creation. The "glory" of God is, thus, not simply in creation, or in human artistry, but is found most powerfully in the face of the dying and risen Christ, and is promised in the vision of God's *shalom* for all creation, for "heaven and earth." Christian liturgy that obscures, or fails to bring a maturation into the mystery of God's glory and promises for the world, falls prey to cultural and to "aesthetic" captivities of every kind.

Chief among the cultural captivities is the tyranny of the "immediate" of "hype," and especially of the banality of violence, present in North American electronic entertainment culture. Only by sustained practices of holding the human before an alternative image of the

human before God can these captivities be addressed. If my synoptic exposition and analysis of the intrinsic aesthetic dimensions of Christian liturgy is at all near the mark, then a sketch of a liturgical critique of culture is possible. Barth and von Balthasar can join van der Leeuw at this point: "the doctrine of the image of God includes the entire theological aesthetics or aesthetical theology. In the form of the crucified, humiliated and problematic, yet eternally worthy of worship, lies a judgment, but at the same time also a justification, for all human attempts at creating form."[21] More significantly, the restored and eschatologically oriented *imago dei* is offered at the heart of Christian liturgical life over time, in every cultural context.

For all this, a fundamental problem remains. Human beings live simultaneously in several "cultural worlds." These are not consistent or even congruent with one another. "Postmodernity" is a phrase used to name this reality. Whether the kenotic aesthetic of Christian liturgy, and its attendant "paschal human" iconography for culture, can reach into these other social/cultural inhabitations is not something a specific "liturgical theology" or particular aesthetic approach to liturgical celebrations can guarantee. The cultural-transcendent aspects of liturgical life cannot be manipulated by human artistic means. But what is possible is continual attentiveness to the qualities in liturgical participation that set conditions for the Holy Spirit yet to transfigure and transform our cultural captivities. Such attentiveness is itself a profoundly aesthetic matter. The "ritual logic of Christian public prayer and sacrament is primarily embodied and sensory, imagistic and experiential, rather than cognitive or intellectual."[22]

In our present North American entertainment culture, Christian liturgy must cultivate those symbolic means that can evoke, sustain, and empower a vision of God and of the cosmos in which beauty and goodness coinhere in life—not simply in thought, or in individual personal experience. The assessment of ritual practices—with, in, and through their diverse aesthetic forms—requires continual testing for adequacy to self-giving glory of the divine life poured out into the whole creation, in light of the passion and cross. This we recognize as holy—awesomely and sublimely beyond our rational grasp, hinted at and evoked by symbolic, metaphorical, and parabolic participation. For

human beings and human societies, the tensive holding together of what is not holy with the holy is practiced in the liturgy.[23] There, we may say—but without presumption—it is effected and brought to life.

Embracing the Tensions: Active Receptivity

The active receptivity toward beauty and holiness must itself learn the permanent tensions in the worship of God. Whatever the beauty of God is, for the Christian worshiping assembly, it must include the brokenness and the nonbeauty of the crucifixion. This is the extreme point of tension. Thus, we encounter the two primary causes for theological suspicion of the discourse of beauty: idolatry and distraction.

Because Christian worship, in nearly all its manifestations, employs a range of artistic means, the church must always be in the midst of sorting out the immediately attractive from the culturally durable. A proper ambivalence toward the aesthetics of worship is, thus, a virtue. Faithfulness and relevance of Christian liturgy in our present cultural context is dependent upon how well these permanent tensions of Christian faith are offered, experienced, and reflected upon. We are confronted with a series of tensions *intrinsic* to the act of worship itself: between the "already" and the "not yet" of the kingdom of God; between the material forms and the spiritual substance of the various arts we employ; between the "hearing" and the "coming-to-see"; between liturgical participation and living faithful lives toward the good in the midst of moral and ethical struggles; between true and false prophesy; between holiness and all the idolatries of which we are capable. The aesthetics of Christian liturgy serve also as an act of resistance against societal forces and structures that lead to human self-deception and dullness to whatever is true, lovely, and of good report.

Active receptivity toward the kenosis of incarnate deity is both the means and the goal of faithful liturgical life. It remains, of course, to compare and contrast in detail the poetics of worship in distinct traditions. Here, we must be content to have sketched on the larger canvas. We cannot adequately *think about* or *think with* Christian liturgy until the theses proposed here are part of our theopoetic repertoire.

≈

NOTES

1. Gerardus van der Leeuw, *Sacred and Profane Beauty: The Holy in Art,* trans. David E. Green (New York: Holt, Reinhart and Winston, 1963), 110.

2. This is a slighty revised version of an essay published in Christopher I. Wilkins, ed., *The Papers of the Henry Luce II Fellows in Theology,* V (Pittsburgh: Series in Theological Scholarship and Research, 2002).

3. Albert Rouet observes that "if the Church has been and remains suspicious of the body, this is because the body offers the prime temptation toward self-absorption and becomes the principal means for captivating others. [This] real danger shows, however, that the occasion for the risk is equally an occasion for transfiguration" in Albert Rouet, *Liturgy and the Arts,* trans. Paul Philibert, O.P. (Collegeville: Liturgical Press, 1997), 148–49.

4. David N. Power, *Unsearchable Riches: The Symbolic Nature of Liturgy* (New York: Pueblo, 1984), 74.

5. Hans Urs von Balthasar, *The Glory of the Lord, A Theological Aesthetics,* trans., Erasmo Leiva-Merikakis, I (San Francisco: Ignatius Press, 1982), 19.

6. Ibid., 23.

7. This does not mean that considerations of "taste" are irrelevant. Frank Burch Brown has written convincingly about relations between taste and religious imagination in worship and spirituality. See his *Good Taste, Bad Taste, and Christian Taste: Aesthetics in Religious Life* (New York: Oxford University Press, 2000), especially 3–25.

8. Romano Guardini, *The Spirit of the Liturgy* (New York: Crossroad, 1998).

9. I will return to this in the sixth thesis explored in the next section of the essay. For an earlier extensive exposition of the idea of "eschatological art," see Don E. Saliers, *Worship as Theology: Foretaste of Glory Divine* (Nashville: Abingdon Press, 1994).

10. I am indebted to the work of Gordon W. Lathrop for the methodological significance of "juxtaposition." He presents a persuasive account of how the generative tensions (the old and the new, type and anti-type, word and symbol) within scripture carry over into Christian worship. See Gordon W. Lathrop, *Holy Things:* A Liturgical Theology (Minneapolis: Fortress Press, 1995).

11. Augustine, *Confessions,* X.6.8.

12. Karl Barth, *Church Dogmatics,* trans. G. W. Bromiley, II/1 (Edinburgh: T. & T. Clark, 1961), 650.

13. Aidan Kavanagh, "The Politics of Symbol and Art," *Symbol and Art in Worship,* ed. Luis Maldonado and David Power, Concillium: Religion in the Eighties, no. 132 (Edinburgh: T. & T. Clark; New York: Seabury Press, 1980), 38.

14. James F. White, *Introduction to Christian Worship,* 2nd ed. (Nashville: Abingdon Press, 1997), chap. 1.

15. Nicholas Wolterstorff, *Art in Action: Toward a Christian Aesthetic* (Grand Rapids: Wm. B. Eerdmanns, 1980), 17.

16. Ibid., 18 (italics are his).

17. George Steiner, *Real Presences* (Chicago: University of Chicago Press, 1989), 193.

18. Jean Corbon, *The Wellspring of Worship,* trans. Matthew J. O'Connell (New York, Mahwah, N.J.: Paulist Press, 1988), 158. These comments are in the context of his discussion of the Orthodox conception of "divinization" of the human person. "If our gaze is to liberate the beauty hidden in all things, it must first be bathed with light in him whose gaze sends beauty streaming out." Ibid., 162.

19. Ibid., 158.

20. Irenaeus, *Against the Heresies,* IV, 20, 7; III, 20, 2.

21. van der Leeuw, *Sacred and Profane Beauty,* 327.

22. Nathan D. Mitchell, *Liturgy and the Social Sciences* (Collegeville, Minn.: Liturgical Press, 1999), 6.

23. This theme is carried out persuasively in Gordon W. Lathrop's work. See *Holy Things: A Liturgical Theology* and *Holy People: A Liturgical Ecclesiology* (Minneapolis: Fortress Press, 1995, 1999).

Engaging Eucharistic Images in Film

Ecclesiological and Liturgical Meanings

JANN CATHER WEAVER

FILM AS GRAND VISUAL NARRATIVES

The omnipresence of film in Western civilization serves as a shaper of culture. Film tells grand[1] visual narratives,[2] ascribing religious meaning and order to people's lives. In the case of Hollywood, films are rarely countercultural or "parabolic"; they present "mythic," grand visual narratives.[3] In this essay, we shall focus on the explicit recognition of film as a visual, inimitable theological text: in particular, we will explore eucharistic images in film and the subsequent widening of ecclesiological, liturgical meanings.[4] Engaging

film through theological and visual methodologies is the vital responsibility of theologians, ethicists, sociologists, artists, pastors, and priests. Film, as a unique art form (or text) of theology, thickens our theological understandings. Filmic images are compelling and consequential to religious imagination and spirituality, that is, to the very qualitative shaping of human existence and experience.

Hollywood epics depicting biblical narratives are notoriously nonsensical, though the filmic quest for Jesus carries on in Hollywood.[5] While biblical narratives, as read in the Jewish (*Tanakh*) and Christian Bibles, are transformative and theologically ageless, translating these biblical narratives into "literal" visual representations on film is reductionistic and culturally provisional. Deductively, the same result may be inevitable with literal filmic narratives of any world religion. "Literal" translations of religious narratives into film rely upon people's craving for established "mythic" grand narratives.

"Mythic" grand narratives, as developed by Claude Lévi-Strauss and developed further by Elli Köngäs Marand and Pierre Maranda, reconcile "irreducible opposites" and can establish a certain worldview. Within a method of understanding parable as a narrative form used by Jesus of the Christian scriptures, John Dominic Crossan places mythic narratives as binary opposites of parables.[6] Parables show us the seams and edges of myth. "Myths are the agents of stability, fictions the agents of change."[7] Parables are fictions, not myths; they are meant to change, not reassure us. Parable is always a somewhat unnerving experience. Parables subvert the world.[8]

Yet, we cannot have parables without myths. Jesus "parabled" myths through his narratives. Crossan furthers the understanding of myth and parable through this adage: "You have built a lovely home, myth assures us; but, whispers parable, you are right above an earthquake fault."[9]

This essay examines representations of eucharistic images in two films that traverse a splice of the film industry: an international (British) film, *Priest,*[10] and an independent African American film, *Daughters of the Dust.*[11] Each film represents peculiar, distinguishing liturgical eucharistic scenes, calling us to engage the mythic structures of liturgical and ecclesiological practices, eucharistic meanings, and rhythmic/textual legacies in

the depths of the eucharist. Oddly, we will seek the visual representation of the invisible sacramental realities through filmic outward signs.

EUCHARIST, FILM, AND MAKING MEANINGS

Life without meaning defies definition. Life *is* meaning. Moreover, meaning without life is a disembodied and insensible abstraction. Some theologies claim creation and humanity are divinely endowed with meaning; other theologies assert meaning is created and made by structured systems; and still other theologies believe humanity is made to make meaning out of the stuff and substance of life.

The eucharist, being a liturgical act of embodiment (eating and drinking) as well as enactment of eschatological "realities," involves and invokes a structural making of meanings. Frank Burch Brown, in *Religious Aesthetics,* discusses the relationship of meanings' structural markers and the nature of the eucharist:

> And everyone will agree that meaning of every kind pertains to relations. Something has meaning only in relation to something else and for someone. A meaning that is intended or *"given"* must somehow be embodied or encoded in a perceptible form if it is to be *received* or "taken"; and it will be "taken," *received,* or realized by some person or group only when the *elements* of the embodiment or code are understood, along with the way the embodied form or code is being used. Such understanding usually depends on at least minimal cognizance of the social and historical context of the maker/sender, and inevitably is influenced as well by the situation and pre-understandings of the respondent/receiver.[12]

The eucharist and meaning share these particular markers: they involve relationship; they are "given" and embodied "in a perceptible form"; they are to be received or "taken" by some person; the embodied elements are understood, along with the way the elements are used; and they are bound by "social and historical context," influenced by "situation and pre-understandings" of the recipient. Eucharist happens in relationship to Christ and community. The elements of the "body and blood of Christ" are "given" in the "perceptible form" of bread and wine, and "taken"/received within an

understood liturgical form. This liturgical form has a "social and historical context" within the church that influences the eucharistic "pre-understandings" of the communicant: memory, eschatology, Real Presence, and the body of Christ as global and local.

Eucharist, as a sacrament, is a visual, embodied sign/enactment of invisible graces and realities. As we see above, eucharist shares the markers of meaning. Eucharist is one form of making meaning in people's lives through its liturgical performance and substance. The sacramental relationship between eucharist and the making of meanings brings us back to the discussion of film and its role of making meanings. Though one cannot claim that film is necessarily sacramental, we might venture to claim that film makes meanings—meanings, which, at times, may be sacramental in nature, even eucharistic in nature: a visual embodiment of the visible invisibilities of sacraments.

EUCHARIST AND MEANINGS IN *PRIEST*[13]

Father Greg Pilkington begins his first ministry in a Liverpool Catholic parish. The head priest, Fr. Matthew Thomas, intimately lives with the parsonage's "housekeeper," Maria Kerrigan. Many critics and protesters of this film focus on Father Greg as a gay priest. For example, "the police catch him in a car, breaking his priestly vow of celibacy with a male lover. His homosexuality makes headlines, and he becomes a target of relentless public scrutiny, cruelty, and alienation."[14]

With such reviews, the major conflict in the film is often overlooked or never seen. This is not a film focusing solely on the gay realities of a priest. Nor is the major conflict in this film about breaking the vow of celibacy. (If this were the case, then the film would have directed its plot also toward Fr. Thomas.) The film's focus is on the consequences of not breaking the seal of the confessional and the objectification of bodies, including the eucharistic body of Christ.

The father of a family in his parish is committing incest against his fourteen-year-old daughter, Lisa Unsworth. (Her last name is not coincidental.) Lisa's father, objectifying the body, torments Lisa and Fr. Greg by confessing his actions in the confessional. Fr. Greg cannot tell anyone of the sexual abuse due to the seal of the confessional. He cannot even tell Lisa's mother, who is unaware of the crime.

Fr. Greg confronts the father on the street, outside of the confessional, and tells him that his sexual abuse with Lisa has to stop. Lisa's father refuses and tells Fr. Greg to stay out of his business. Eventually, the mother walks in on her husband with Lisa. The mother throws her husband out of the house and confronts Fr. Greg with the reality that he knew about the abuse and did not protect her daughter. Seething with anger and pain, Lisa's mother screeches at Fr. Greg, "I hope you burn in hell!"[15] The seal of the confessional aided and abetted the incestuous objectification of Lisa's body.

Through "analogy of action,"[16] the plot deepens during a scene where Fr. Greg and Fr. Thomas perform the eucharist liturgy and distribute the elements to the congregation. Fr. Greg's lover, Graham, unexpectedly attends the Sunday eucharist liturgy. Fr. Greg stumbles when he sees Graham in the congregation. The audio text of the film wavers in and out with eerie sounds, representing Fr. Greg's shock and predicament. When Graham comes to receive the host, Fr. Greg refuses to serve ("give") him. Graham exits the sanctuary in shame and disgust. As Graham leaves the sanctuary, in the background of the scene we see Lisa's father, Mr. Unsworth, returning to his pew after receiving the eucharistic elements from Fr. Thomas.

According to the above discussion on making meanings, Fr. Greg ruptures the structure that makes meaning for Graham by denying him the opportunity to receive the body of Christ in the form of the host. Fr. Greg, seeing Graham as an objectified "gay body," "unworthy" to receive, refuses to give Graham the body of Christ. When face to face with Graham during the eucharist liturgy, Fr. Greg may suddenly recognize his own gay body—as in a mirror—as also "unworthy" to "receive"—or even "give" Christ's body.[17] This realization is parabolic, one that Fr. Greg cannot reconcile in the context of the liturgy.

Later, Graham accuses Fr. Greg of treating him like a leper.[18] This is an ironic accusation since Jesus lived and healed within communities of lepers. The present, risen body of Christ in the eucharist, though, is denied to "unworthy, leprous" gay bodies. These objectified bodies are prohibited from making meanings through the order of the eucharist liturgy.

For Fr. Greg, bodily loving Graham, to "give" and "receive" within a relational structure, creates meaning for them outside the "situation

and pre-understanding" of the confines of church practice and doctrine. Within a liturgy of church order, however, a different "social and historical context" for their relationship reshapes the "situation and pre-understanding," binding Greg to a divergent structure of making meaning. "Unworthiness" to "receive" and "give" becomes the doctrinal marker for meaning in the liturgy, rather than Jesus' unequivocal giving in his ministry. Jesus is known to even dip his bread in the same cup as Judas, a parabolic action in a meal upon which the eucharist claims to be based. In a theology of "unworthiness," "receiving" and "giving" the elements of the eucharist become solely mythic, barely tainted by the parabolic, life-giving practices of Jesus of Nazareth.

In the film, Fr. Greg giving his body in love to Graham and receiving love from Graham analogously intermingles with the body and blood of Christ. (Fr. Greg admits later that the body of Christ on the crucifix is "utterly desirable.") Sexual expression is as profound an embodiment of meaning (albeit different) as is "receiving" and "giving" the eucharist. If the church prohibits participating in one or the other of these embodied actions, a void is created, filled with meaninglessness, rejection, and shame. This "analogy of action" makes the eucharist—as an embodiment of Christ (transubstantiation or transfiguration[19]) in the bread and cup—as intense and vital to humans making meaning as is sexual expression, especially if bound by a shared mythic and parabolic "social and historical context" of a particular Christian community.[20]

Priest, however, neglects to address directly the "worthiness" of Lisa's father (Mr. *Unsworth*) to receive the body of Christ. His acts of sexual abuse remain hidden in the confessional. He receives the host regardless of his practice of sexual abuse—an obscene act of objectifying, dominating power which destroys meaning and which clearly lies outside the "social and historical context" of the Christian community. Even after the disclosure of his incestuous abuse of his daughter, the film fails to draw a third "analogy of action" involving Mr. Unsworth's approach to the table. This silence is bewildering. Viewers may be left to believe that gay bodies are objectively "unworthy" to receive the host, while a sexual predator is deemed "worthy." This failure on the part of the film falsely moves the focus of the film back to

lesbian/gay/bisexual/transgender (LGBT) sexuality, leaving sexual abuse outside the film's larger *mise en scène*.

CULTURAL REMNANTS AND EUCHARISTIC TEXTUAL RESONANCE IN *DAUGHTERS OF THE DUST*

The 1991 independent film by Julie Dash, *Daughters of the Dust,* visually narrates a ritualized threshold (liminal) event in the life of a Gullah African American family. Gullah people live on the Sea Islands off the southeastern coast of the United States, immersed in Gullah language[21] and cultural remnants of their (Ibo) ancestors who lived in Africa, surviving both the Middle Passage and centuries of slavery. The prologue of the film provides the historical context of this filmic event.

At the turn of the century, Sea Island Gullahs, descendants of African captives, remained isolated from the mainland of South Carolina and Georgia. As a result of their isolation, the Gullah created and maintained a distinct, imaginative, and original African American culture. Gullah communities recalled, remembered, and recollected much of what their ancestors brought with them from Africa.[22]

In *Daughters of the Dust,* the *fin-de-siècle* generation of the nineteenth-century Peazant family of the Sea Island Gullahs prepares to "cross over"[23] to the mainland and move north for a dreamed-of and better life. The extended members of the Peazant family gather for a day—the last day before they are to "cross over"—for a last meal[24] of cultural foods and the essential gumbo.

Two women of the family who have already "crossed over" to the mainland return for this last meal. One woman, Viola, is a convert to a fundamentalist Christianity. For Viola, the mainland means Jesus and culture with a capital "C."[25] The other woman, Yellow Mary, whose name refers to the light color of her skin, returns from familial exile. The elder women of the family shame and shun Yellow Mary for being "ruin't"; for Yellow Mary, who had been raped[26] on the mainland by her employer, turned to prostitution to survive—thus her "ruin't" state.

Central to the Peazant family is the grandmother and matriarch, Nana, born in slavery and now the guardian of the cultural remnants of African ritual and worldview.[27] Nana Peazant unconditionally welcomes Viola and her Bible, as well as Yellow Mary in her "ruin't" state. Yellow

Mary wears a charm around her neck of St. Christopher, who is invoked against sudden death and impenitence at death, commonly known as the saint for travelers. Nana questions the meaning of the Bible and the St. Christopher charm, finding their meanings dissimilar to African beliefs and ways.[28] Yet, she recognizes these materials from the mainland cultures as becoming meaningful "rooting" symbols for her family when they "cross over" to the mainland and settle in the North.

Nana Peazant insists, however, to the dismissal of her family members, that her family remember and remain connected to their African ancestors who have gone before them—gone before them in Africa, in the Middle Passage, and on the Sea Island. While visiting her husband's grave, she tells her great-grandson, Eli, what he must do when his family crosses over the threshold to the mainland:

> Those in this grave, like those who're across the sea, they're with us. They're all the same. The ancestors and the womb are one. Call on your ancestors, Eli. Let them guide you. You need their strength. Eli, I need you to make the family strong . . .
>
> Eli . . . We carry these memories inside of us. Do you believe that hundreds and hundreds of Africans brought here on this other side would forget everything they once knew? We don't know where the recollections come from. Sometimes we dream them. But we carry these memories inside of us . . .
>
> Eli, I'm trying to teach you how to touch your own spirit. . . . I'm trying to give you something to take north with you, along with all your great big dreams . . .
>
> Call on the old Africans, Eli. They'll come to you when you least expect them. . . . Let those old souls come into your heart, Eli. Let them touch you with the hands of time. Let them feed your head with wisdom that ain't from this day and time. Because when you leave this island, Eli Peazant, you ain't going to no land of milk and honey.[29]

Nana possesses a tin canister, filled with "scraps of memories"[30] from her life and her ancestors. In this canister lie West African cultural remnants: material fragments, scraps of fabric, and locks of hair. These cultural remnants serve as vestiges of her ancestral life, so she may re-

member the past into the present and conjure forward the future. Revealed through these cultural, material remnants are the realized spirits of the ancestors who protect, revive, and guide the Peazant family. Some members of Nana's family mock her canister and conjure bags of cultural remnants. "Where we're heading, Nana, there'll be no need for an old woman's magic."[31]

These cultural remnants are magic in its most powerful understanding: "a system, among humanity's more primal cognitive systems, for mapping and managing the world in the form of signs."[32] To grasp this, we must suspend our rational worldview that practices the dissolution of magic—the dissolution of magic as irrational, supernatural phenomena within the realm of the occult. Contemporary scholars regard magic as a primordial and enduring system of communication, a form of language. Magic is ritual speech and action, which performs what it expresses.[33] As religion historian Lawrence Sullivan claims, "Magic reminds us that the world consists of signs, that every obvious reality is only a sign pointing to some more hidden one."[34]

We may liken this to the scientific understanding of matter, pointing to its inner structure of organized relationships of root elements, molecules, atoms, particles, and quarks.[35] What distinguishes magic from science, however, is magic's "heightened, intensive reliance on ritual performance and mimetic (imitative) efficacy."[36] Thus in the African American magical tradition of conjure, practitioners effect transformations of reality by performing imitative operations upon natural . . . substances.[37]

Nana lives in this African tradition of conjure, able to conjure magic's power for transformation of reality. Following the family's last meal, Nana sews a small leather pouch, known as a charm or conjure bag, recognized in her culture as a "Hand."[38] Viola's Christianity calls on Nana to trust in Jesus, rather than charms made of dried roots and remnants from her canister. Nana's "Hand" and its power clearly frighten Viola (who wishes to forsake African traditions and steal away to Jesus).[39]

Removing from her canister of "scrapes of memories," Nana holds a lock of hair.

"When I was child, my mother cut this from her hair before she was sold away from me."[40] Nana kisses her mother's hair, tucking the

lock into the "Hand." Nana takes another lock of hair, kisses it, and places it in the "Hand." Nana continues,

> Now, I'm adding my own hair. There must be a bond, a con-
> nection, between those that go up north and those that re-
> main, between us who are here and those who are across the
> sea. A connection! We are as two people, in one body. The last
> of the old, and the first of the new. We will always live this
> double life, you know, because we're from the sea. We came
> here in chains, and we must survive. We must survive.[41]

When Nana completely sews the "Hand," she leads her family in a religious ritual, "A Root Revival of Love."[42] This ritual regenerates and revives the connection of the family with the ancestors. Nana holds forth the "Hand" and says, "We've taken old Gods and given them new names."[43] Nana places her conjured "Hand" on Viola's Bible along with Yellow Mary's St. Christopher's charm. She binds them together with red thread, invoking the ancestors' power of regeneration to lead the family as they "cross over" to the mainland.

Nana offers her family the power of transformation in this new, syncretized "Hand"—her conjure bag of African cultural remnants, the Bible, and the St. Christopher's charm—physically bound together, con-necting her family with African and Christian ancestors and their power to revive and regenerate in present and future time. The new "Hand" is the activated element for the radically transformative power in this performance ritual. "This 'Hand,' it's from me, from them, from us—same soul as you are. Come children, kiss this hand full of me."[44]

The screenplay notes this as the magical event where Nana "calls upon the womb of time to help shatter the temporal restrictions of her own existence to become a being who is beyond death, beyond aging, beyond time."[45] Conjured by magic, Nana's syncretized "Hand" of cul-tural elements becomes efficacious. She leads the family in a conjura-tional performance, a liturgy of regeneration and revival with the an-cestors to transform reality. Julie Dash calls this "communion" "immersing themselves in their traditions and culture."[46] This ritual syncretizes the remnants of the ancestral cultures of Africa, the Middle Passage, and slavery with "mainland" Christian artifacts. Nana refuses

to abandon the rituals and powers of her African roots. Rather, she builds upon their power, invoking new gods with new elements: "Take my 'Hand.' I'm the one that gives you strength."[47]

The family comes forward, some kneel, to kiss the syncretized, conjured "Hand." Nana's litany continues: "Take me wherever you go. I'm your strength. / Take me wherever you go. I'm your strength. / . . . wherever you go."[48] Through participating in the ritual, members of the Peazant family recognize the bound cultural remnants as new elements bearing threshold, liminal power for radical change. Nana ushers them through the liminal portal, "crossing over" to a changed world and a new reality.

The character most skeptical of "old woman's magic" yells at her daughters as they approach to kiss the "Hand." "Hoodoo. Hoodoo! Hoodoo mess! Ain't no roots and herbs going to change nothing. Don't go and spoil everything! Old Used-To-Do-It-This-Way don't help none today!"[49] The woman turns her back and walks away from her family. Nana calls after her, "Come, come child. I love you 'cause you're mine!"[50] All who have ears can hear the liturgical resonance between Nana's "Root Revival of Love" and eucharistic litanies. Binding together a living connection, both litanies resonate in rhythm, cadence, and textual nuance in a conjurational performance of accumulative sacramentality:

> This "Hand," it's from me, from them, from us—same soul as you are.
> Come children, kiss this hand full of me.[51]

> . . . in every time and beyond time, we come to this table to know the risen Christ in the breaking of the bread.[52]

> Take my "Hand." I'm the one that gives you strength.[53]
> Take and eat: This is my body which is given for you . . .
> This is my blood which will be shed for you.[54]

> Take me wherever you go. I'm your strength.
> Take and eat, this is the Body of Christ, broken for you.[55]

Take me wherever you go. I'm your strength.
Take and drink, this is the cup of the new covenant, poured
out for you[56] . . . wherever you go.[57]

Do this in remembrance of me.[58]

In company with all believers in every time and beyond time,
we come to this table to know the risen Christ in the breaking
of the bread.[59]

Nana's Root Revival ritual and eucharistic litanies are more alike
than dissimilar.[60] Both rituals are conjurational performances to make
meaning; both are rituals of embodied, relational connection (kissing
vis-à-vis eating and drinking) and remembering (*anamnesis*); and both
involve conjuring (invoking the Holy Spirit, the *epiclesis*). Each ritual
has cadenced and patterned behavior; each uses efficacious, performa-
tive, and mimetic[61] language and elements. Regarding language, "Take
my 'Hand' "[62] is mimetic of "Take and eat: This is my body which is
given for you. . . . This is my blood which will be shed for you."[63]
Regarding elements, the "Hand" bound with the Bible and charm ac-
cumulates sacramentality as perceptible and efficacious as the trans-
formed elements of bread and wine. Both rituals transform ordinary
material into powerful elements by conjured "magic" (*epiclesis*). The
"Hand" is the power of the ancestors and cultural remnants, bound to-
gether, to "cross over" into a new reality; the elements of the bread and
wine, through the power of incantation (*epiclesis*), become (with varied
understandings) the renewed reality of the body and blood of Christ.

As Nana claims, "We've taken old Gods [*sic*] and given them new
names."[64] Rituals of meaning rely on the syncretized blending of rem-
nants/elements of culture and materials of faith to accumulate sacra-
mentality. Liturgical theologians acknowledge the eucharist as a syn-
cretistic appropriation of a Jewish religious meal (with the synoptic
writers claiming this meal to be a Passover meal).[65] Jesus, in a conjura-
tional performance, changes ordinary material of a meal into the ele-
ments of his broken body and poured out blood. The eucharist in the
early church did not abandon the ritually patterned Jewish religious
meal. Rather, the early church blended their new experience of Jesus as

the Risen One with Jewish meal patterns. The ensuing eucharistic meal is a new, conjurational performance, unleashing the power of the meal to reveal Christ's risen realities. Ritually partaking of the elements in celebrating the eucharist is an embodied, liminal event.

The filmic text of *Daughters of the Dust* gives us new eyes with which to see eucharistic meals. The human pattern of conjurational performance for threshold "crossing over" into new realities surpasses the Christian eucharist. What Christians have come to know as the eucharist is but one ritual where meaning is located in sharing elements of transformed nature. *Daughters of the Dust* offers us a vision of seeing God's transformative nature beyond the confines of the eucharist. While Christians participate in eucharist, diverse religions, cultures, and peoples of the world have equally powerful conjurational rituals. Imagine, through all these rituals, that the peoples of the world might recognize each other on the liminal mainland, the Ultimate Meaning of life and death.

TO "PARABLE" BEGINNINGS

By engaging the eucharistic images in two films, we see the "parabled" beginnings of how some films can visually tell grand narratives, mythic and parabolic, thicken the ecclesiological and liturgical meanings of the eucharist, and regenerate stale ritual. That the church may have left this task to filmmakers may be a reflection on the church. If the church, however, pays attention to the ways meaning is made in films, it may garner these filmic images of the grand eucharistic narratives to act as parables to the established eucharistic myth and liturgy; films may "parable" beginnings to relight the church's ecclesiological and liturgical stasis.

The church may engage the unnerving nature of these films to "parable" eucharistic liturgical traditions into revitalized structural markers to see the unexpected meanings in the eucharist. May the "Hollywood myths" of the church begin to be "parabled" to "give" and "receive" the elements of conjured dust and legacies' remnants, prayed-over baked grain and fermented grapes, to make meanings for all bodies of creation. And may the markers of meaning be known to regenerate the "parabled" beginnings of the eucharist.

NOTES

1. "Grand," as in formative and foundational.

2. I am uneasy in having to claim that movies of the order of *Wayne's World, Ace Ventura,* and *Batman* shape people's lives, as unsightly as they are. They present value systems, reinforce worldviews through entertainment, and carry commonly shared meaning. My main focus at this time, however, is on films that theologically and aesthetically inquire into the complex nature of human realities—that is, films as visual, grand narratives of the human condition that expand—and revise—dominant theological meanings.

3. See below for the discussion of mythic and parabolic narratives. John Dominic Crossan, *The Dark Interval: Towards a Theology of Story* (Sonoma, Calif.: Polebridge Press, 1988).

4. See Margaret Miles, *Image as Insight: Visual Understanding in Western Christianity and Secular Culture* (Boston: Beacon Press, 1985); Robert K. Johnston, *Reel Spirituality: Theology of Film in Dialogue* (Grand Rapids: Baker Academic, 2000); Joel W. Martin and Conrad E. Ostwalt Jr., eds., *Screening the Sacred: Religion, Myth, and Ideology in Popular American Film* (Boulder, Colo.: Westview Press, 1995); and John R. May and Michael Bird, eds., *Religion in Film* (Knoxville, Tenn.: University of Tennessee Press, 1982).

5. Most recently in Mel Gibson's film, *The Passion of the Christ,* dir. Mel Gibson, 126 minutes, A New Market Films Release, Icon Distribution, Inc., 2003/2004.

6. Crossan, *The Dark Interval,* 35, 40, 42.

7. Frank Kermode, *The Sense of an Ending* (New York: Oxford University Press, 1967), 39.

8. Crossan, *The Dark Interval,* 38–39.

9. Ibid., 38–39, 40, 42.

10. *Priest,* dir. Antonia Bird, 98 minutes, Miramax production of a BBC production, 1995. DVD.

11. *Daughters of the Dust,* writ. and dir. Julie Dash, 113 minutes, Kino Video, 1991. DVD.

12. Frank Burch Brown, *Religious Aesthetics: A Theological Study of Making and Meaning,* Studies in Literature and Religion (Princeton, N.J.: Princeton University Press, 1989), 101 (emphasis mine).

13. *Priest,* DVD.

14. www.ifilm.com (Synopsis).

15. *Priest,* DVD.

16. "Analogy of action" is an ancient dramatic device used to deepen the text of the film, often in religious ways. Greek dramatists knew this device, a double plot, yet the modern Western culture inherited it through Elizabethan theater. Shakespeare's artistry lies not only in his ability to define the English language, but also in his way to adapt two or three stories (double and triple plot), weaving them together to create an artistic whole. Rather than using a single plot line, as preferred by Aristotle, invoking analogy of action in film juxtaposes the inter-

dependence of several stories so each elucidates the central action, "first by . . . similarity but finally by . . . difference" (May and Bird, *Religion in Film*, 44–45). "Plot is only the surface level of action; on a deeper level is the underlying movement of spirit" (Ibid., 46). Through analogy of action, the surface level of the action, the plot, "not only expands horizontally by analogy but also thickens vertically (again by analogy) as it moves through deeper levels" (Ibid., 47).

17. I do not know the doctrine of the Roman Catholic Church to presume this is an accurate depiction of church doctrine and practice. My analysis relies on the filmic text and does not rely on any known Roman Catholic doctrine about the right to receive the eucharist if one is lesbian/gay/bisexual/transgender (LGBT).

18. The former parish priest, Fr. Ellerton, whom Fr. Greg replaces at the parish, exclaims to Fr. Greg, "So you couldn't *give* him communion! I never denied anyone communion. They had more right to *receive* it than I had to *give* it" (emphasis mine). *Priest*, DVD.

19. Transfiguration is an "updating in terms of modern philosophy" of transubstantiation. An acceptable view in the Roman Catholic Church, advanced by theologians Piet Schoonenberg and Edward Schillebeeckx, uses the concept of meaning rather than value to understand what occurs to the bread and wine during the eucharist liturgy. John Macquarrie claims that transfiguration means an object is "constituted in its very being by its significance within a world . . . viewed only from a human perspective." Macquarrie continues his point: "Briefly, things are constituted ontologically in their thinghood not by substance but by having a place in a world, a significance; a world, in turn, is not a mere aggregate of physical objects, but a personally *structured totality of meanings*" (emphasis mine). John Macquarrie, *A Guide to the Sacraments* (New York: Continuum Publishing, 1999), 133.

20. See James Nelson, *Between Two Gardens: Reflections of Sexuality and Religious Experience* (New York: Pilgrim Press, 1983).

21. The Gullah language is a dialect of West African language(s) blended with English. See Lorenzo Dow Turner, *Africanisms in the Gullah Dialect*, intro. Katherine Wyly Mille (Columbia: University of South Carolina Press, 1949, 2002).

22. *Daughters of the Dust*, DVD.

23. This film understands the phrase to "cross over" to denote their passage to the mainland. The phrase nuances a death and crossing into an unknown but believed-to-be-vital new life. Theorists call this a liminal event, the entering and crossing over a threshold into a changed life. Biblically, this is the cross and empty tomb, the eschatological already-but-not-yet of God's final answer to death. Theologically, this phrase is a point for debate for developing a theology of death, dying, and resurrection.

24. Some theologically minded commentators eisogete this as a "Last Supper" with all its implications. This theological and biblical nuance is *not* in the filmic text.

25. I thank Shirley Koepsell of United Theological Seminary of the Twin Cities for this nuance.

26. Julie Dash, *Daughters of the Dust: The Making of an African American Woman's Film* (New York: New Press, 1992), 123, 155. Yellow Mary: "At the

same time, the raping of colored women is as common as the fish in the sea." Yellow Mary is talking with Eula, Eli's wife, who was recently raped by a stranger on the island. Later, Eula asks the family if she is also "ruin't." That is, if they treat Yellow Mary with scorn, why do they treat her (Eula) with sympathy?

27. Nana remains on the island when the rest of her family travels north to the promised land of work and "wish books." A scene in the film has members of the family pointing out items they want in the northern "wish book" of Sears and Roebuck.

28. Dash notes that the West African Yoruba God of "Bacoso," founder of destiny, has been replaced by the St. Christopher charm. Nana: "What's that you wear around your neck?" Yellow Mary: "St. Christopher's charm for travelers on a journey." Nana: "What kind of belief that is? He protect you?" (Dash, *Daughters of the Dust*, 116–17.)

29. Ibid., 93–94, 96–97.

30. A description by E. Franklin Frazier, "where we hold and store things, our specially concocted 'hair grease,' our secrets, our private things." (Ibid., 43, 148.)

31. Ibid.

32. Theophus H. Smith, *Conjuring Culture: Biblical Formations of Black America* (New York: Oxford University Press, 1994), 4.

33. Ibid.

34. Lawrence Sullivan, ed., *Hidden Truths: Magic, Alchemy, and the Occult* (New York: Macmillan, 1987/1989), x–xi; quoted in Smith, *Conjuring Culture*, 4–5. Smith also cites David Pocock, observing that "what we call 'magic' . . . is only one of, and of the same order as, many symbolic actions which overcome the discrepancies of thought." See Pocock in Marcell Mauss, *A General Theory of Magic* (Boston: Routledge and Kegan Paul, 1972), 2, 4, as noted in Smith, *Conjuring Culture*, 12, 13 n. 4.

35. Sullivan, in Smith, *Conjuring Culture*, 5.

36. Smith, 13, n. 4.

37. "Thus in African American magical tradition of conjure, practitioners effect transformations of reality by performing imitative operations upon natural and artificial substances. Those substances include herbs and nail clippings, potions and clothing, grave dirt, and so forth. Mimetic operations also attend the use of biblical themes and figures in black America's conjuration tradition . . ." Ibid.

38. Dash, *Daughters of the Dust*, 150. The "Hand" contains the *elements* of meaning. Contemplating the use of the word "Hand" for the conjure bag nuances what human hands do to make meaning: hands are held (*given/received*) to communicate details of relationships; as one's face, hands reveal the age/length of their labor. Moreover, Dash colors the hands of the Gullah people in *Daughters* to represent the "hands of the old folks who had worked the indigo processing plant" on the island. Actually, though, the indigo stain would not remain on the workers' hands. Dash's use of "indigo hands" is a semiotic sign of slavery, used "to create a new kind of icon around slavery rather than the traditional showing of the whip marks or the chains." The "Hand" for Dash conjures the past centuries of slavery, not only the cultural remnants of Africa. Ibid., 31, 104.

39. Ibid., 152.
40. Ibid., 150.
41. Ibid., 151; *Daughters of the Dust*, DVD.
42. Dash, *Daughters of the Dust*, 158.
43. Ibid., 159.
44. *Daughters of the Dust*, DVD.
45. Dash, *Daughters of the Dust*, 160.
46. Ibid., 160.
47. Ibid.
48. Ibid.
49. Ibid., 161.
50. Ibid.
51. *Daughters of the Dust*, DVD.
52. *Book of Worship: United Church of Christ*, Notebook Edition (New York: United Church of Christ, 1986), 68.
53. Dash, *Daughters of the Dust*, 160.
54. Third-century "Anaphora of Hippolytus" in Enrico Mazza, *The Celebration of the Eucharist: The Origin of the Rite and the Development of Its Interpretation*, trans. Matthew J. O'Connell (Collegeville, Minn.: Liturgical Press, 1999), 312; and Joyce Ann Zimmerman, *Liturgy as Language of Faith: A Liturgical Methodology in the Mode of Paul Ricoeur's Textual Hermeneutics* (New York: University Press of America, 1988), 132.
55. *Book of Worship*, 51.
56. Ibid., 52.
57. Dash, *Daughters of the Dust*, 160.
58. *Book of Worship*, 47.
59. Ibid., 68.
60. This is not to eisogete Nana's Root Revival as eucharistic; rather, we discover a fundamental commonality in two rituals of remembering and regeneration.
61. Smith, *Conjuring Culture*, 24; 13, n. 4.
62. Dash, *Daughters of the Dust*, 160.
63. "Anaphora of Hippolytus," 312; and Zimmerman, *Liturgy as Language of Faith*, 132.
64. Dash, *Daughters of the Dust*, 159.
65. Gregory Dom Dix, *The Shape of Liturgy* (Glasgow: University Press, 1945. Reprint 1954); Leonel L. Mitchell, *The Meaning of Ritual* (Harrisburg, Pa.: Morehouse Publishing, 1977), 72–75; William R. Crockett, *Eucharist: Symbol of Transformation* (New York: Pueblo Publishing, 1989), 39ff; Mazza, *The Celebration of the Eucharist*, 9–17, 24–26.

Three Models for Arts Programs in Seminaries and Churches

Exhibitions, Residencies, and Collaborations

CINDI BETH JOHNSON

Since the 1970s, a number of theological schools have developed programs in religion and the arts that have supported course work and degree offerings, and served as outreach to other seminaries, churches, and the wider community.[1] This essay will focus on three paracurricular initiatives that one such program, the Religion and Arts Program of United Theological Seminary of the Twin Cities, has developed.[2] The initiatives are an exhibition program, an artist-in-residence program, and a collaborative program with arts institutions. They are not unique to United, for several schools, including Pacific School of Religion, Wesley Theological Seminary, Christian Theological Seminary, Andover Newton Theological School, and Fuller Seminary have all done similar work. For the purpose of this essay, how-

ever, we will focus on the initiatives at United as case studies of what is possible. In analyzing these programs, we will consider how they might be used in churches as well as in seminaries, and how they can be developed within a limited budget.

ESTABLISHING AN EXHIBITION PROGRAM

The development of a regular exhibition program at United Seminary was a significant step for the seminary in its incorporation of the arts into its academic life. The program began in the 1993–94 academic year with the development of a suitable space for installing exhibitions. The seminary has since added three more gallery areas in already existing spaces. The creation of these exhibit spaces was done with a minimum of expense and time and could be easily reproduced in another seminary or in a church setting.

The first exhibit space was created in the classroom wing (ill. 30). The goal was to create a designated space for ongoing exhibitions of religious art. Exhibitions that were chosen explored religious themes such as creation, suffering, and transformation. Exhibits featured historical works and contemporary art of individual artists as well as groups. Our first year gave the seminary an opportunity to develop a system for curating, scheduling, preparing, installing, and promoting exhibits. The gallery featured a variety of exhibits allowing students, staff, faculty, and members of the wider community opportunities to interact with the art.

Our main gallery space is in the hallway of our classroom wing. The space was outfitted with canister lights and hanging bars without otherwise making significant changes to the space. It was done with minimal expense. Issues of security were addressed, and the hallway was converted to an attractive exhibition space. Artworks are now accentuated by museum-quality lighting down the spine of the hallway. The gallery area has window bays that are ideal for displaying sculpture without risk of damage from direct sunlight. Expansive wall spaces are ideal for hanging works of art.

We developed three other exhibit spaces to show exhibits that rotate on a regular basis. The Spencer Library Gallery offers one large wall roughly twenty-five-feet long that provides space to display visual works and sculptures. It provides a special degree of security since the

library staff is on duty when the library is unlocked. The second gallery, the McMillan Gallery, has been developed in the lower level of the McMillan building, which houses the faculty and administrative offices. This gallery provides art for members of the community and for visitors who come to the seminary to conduct business or for meetings. An area for more intimate shows has been developed in the Small Dining Room. Exhibits installed there are usually long term. This space has natural light and a wall roughly twenty feet long has been equipped with hanging bars, affording a space in which there is more privacy for viewers, away from the flow of student traffic. Seminary walls that have not been used for exhibition space are filled with works including both original art and poster art that are from the seminary's permanent collection. These works also rotate on a regular basis.

A new exhibit space opened with a first show in September of 2004. This new exhibit area, located in the Bigelow Chapel, is in the processional aisle of the chapel. The innovative building design consists of large curvilinear laminated wood panels, glass wall openings and skylights.[3] The gallery wall is connected to the sanctuary space and exhibits will be seen from all vantage points in the chapel.

The first exhibit in 1993 featured the collection of Liz Downing Heller, a retired Presbyterian minister who has long worked in the area of the church and religious art. Pieces from her collection include art by Sadao Watanabe, Warren Mackenzie, and Nalini Jayasuriya as well as art commissioned by Heller for her ordination. The exhibit demonstrated how a significant collection can be built over time, the type of works one collector selected for purchase, and the artistic and theological rationale used by the owner in determining the works she selected.

Following the Heller exhibit, we installed two national shows. The first was CIVA's (Christians in the Visual Arts) traveling *Misere* series by Georges Rouault and the second was a series *A Jesus for Our Time* by Jerome Witkin. The Witkin exhibit was brought to campus by a student, Kimberly Vrudny, as a part of her practicum in Theology, Worship and the Arts, an M.A. program offered by the Seminary.[4] For security reasons both shows were installed in the library. There were guided lecture tours developed for these exhibits that offered artistic, historical, and theological insights on the works.

One of the largest shows of the year was an exhibit of Asmat art that was installed in the Classroom Gallery and in the Spencer Library (ill. 31). On loan from the American Museum of Asmat Art, a local museum, the exhibit included works of spears, figure carvings, war shields, bowls, drums, an ancestor pole, and a soulship. The Asmat works came from the Asmat people who dwell in Irian Java, Indonesia. The museum, rooted in the Crosier Order's mission work, is of major anthropological significance. The exhibit allowed us to relate to a Roman Catholic order, a tribal people's art, and to the religious power of art from a distant and removed tribe.

In the spring of 1994, we exhibited Nicaraguan art that came to the seminary from students who had returned from a United Seminary global studies trip. The art, bold in color and line, came from Nicaraguan village artists and reflected the power of art to communicate the vitality of a people struggling in a politically oppressive situation. In the case of this show and the Asmat show, the exhibits not only allowed us to view unique works but also invited us into a different cultural experience. The power of art to help the viewer transcend cultural differences is another important aspect of our exhibition program.

The final show of that first year was an exhibit of works by a group of artists who were all members of the Episcopal Cathedral Church of St. Mark in Minneapolis. One of the artists approached the seminary, asking for a venue where they could create the show. The exhibit included sculpture, calligraphy, collage, and painting. The works themselves were remarkable, but the power of the exhibit was made evident in hearing the artists reflect during gallery talks on how their art was an expression of their faith.

With each of these exhibits, we held an opening reception that, when possible, included gallery talks by the artist(s), the curator, or the collector. Receptions took place during lunch to accommodate the schedule of our students. When possible, a chapel service was designed around the exhibit and held on the same day as the gallery talk to model the connection between worship and the visual arts. The public was invited to all of the exhibits through mailings, press releases, and personal invitations. The students, staff, faculty, and members of the wider community responded with great enthusiasm.

At the end of the first year, we had learned many things: that professors will incorporate an exhibit into a previously planned course spontaneously, that people will drive some distance to see a show, and that groups will ask for a guided group tour. Most importantly, we learned that we could do it quite easily and on a reasonable budget. Students and faculty were given the opportunity to live, study, and teach in and around these exhibits, and they found themselves inspired by the imaginative energy radiating from the works. When the end of the academic year arrived, testimony to the emptiness of the previously art-filled walls was given throughout the institution in comments that spoke of a significant absence.

The conversion of the hallway into a gallery space, even with the new sources of light and hanging bars, was quite inexpensive. We found the key was to be creative, both in terms of available space and of exhibit potential. In our case a sterile white hallway was transformed into a place that held Asmat handbags, a Classical Realist Black Madonna and stoles commissioned for an ordination. The library court came alive in a new way with the powerful colors of Jerome Witkin, the stark black and white images of Rouault's *Miserere* series, and a spirit-laden Asmat soulship.

It is increasingly common, too, for congregations to develop gallery spaces and exhibitions. St. Peter's Lutheran Church in Manhattan, New York, describes their exhibition program as part of their ministry. They state on their web site that the church helps

> to fulfill St. Peter's art ministry by offering our Living Room, Narthex and Stairwell galleries to emerging and established artists who by their lives and work explore greater dimensions of spirituality. It is our belief that this activity will provoke dialog among people of New York City regarding the nature and scope of art's spiritual qualities.[5]

A seminary or church group that would like to consider developing an exhibition space and a gallery program should consider the following issues. The first issue is the choice of an appropriate space. Selection of space will depend on factors like wall coverings, the ability to mount hanging strips, security, and the possibility of installing ap-

propriate lights. If possible, it is ideal to invite an artist or someone from a museum to walk through the space, helping the community to consider its options. Issues of security and accessibility tend to conflict at times. In the end, the issue of security is usually decided by the nature of the neighborhood in which the seminary or church is located. When you can, opt for putting art in a place where there is maximum exposure. That brings art into the heart of the community.

Exhibitions can be created by seeking artists within the congregation and community, contacting art teachers at area schools, or networking with local museums. It is important to have a budget. Your budget will influence the type of exhibits you can show, but many exhibits can be done for a modest cost, especially if shipping costs are not involved. There are also numerous traveling shows through organizations like CIVA that have minimal costs. Local museums also provide exhibits as a part of their outreach. The advantage is museum-quality work that often comes with professional assistance in hanging the show. Networking with other arts groups will also provide helpful contacts. In a seminary, it is ideal to strive to install some exhibits that parallel a course being taught, a conference, theme, or some other school event. This allows for another direct way to connect with the curriculum. Upcoming classes can be surveyed for ideas, and conversations with faculty will aid in choosing appropriate exhibits. In addition to finding the sources for exhibits, seminaries and churches will need to consider issues related to insurance and will need to acquire equipment and a crew for the installation.

Perhaps the most important caution is to start slowly and strive for quality rather than quantity. Many religious galleries try to do a new exhibit each month, which is quite ambitious. I would suggest starting with the goal of installing four exhibits in one year, each exhibit remaining on view for at least two months. That allows an adequate amount of time for the entire community to view and relate to the exhibit; and it allows a period necessary for doing events, such as gallery talks, tours, and receptions. In our setting, we try to display a range of artistic styles by artists from different cultural traditions. What is most ideal is to include a variety of themes over a year-long period, such as a cross-cultural show, a group show, an individual show, and a show re-

lated to a liturgical season. In several cases, we have also had shows done by a student for a class project, independent study, practicum, or as a senior-year retrospective. The work of installing an exhibit is not to be underestimated, for it requires equipment, people, and endurance. Once the exhibit is installed, make sure the community knows about it. Publicize the exhibit in newsletters, with invitations, and with press releases. Set a reception date timed to allow the majority of community members to attend. While students are busy, I find that many of them are excited to help with this kind of a project. In addition to providing a chance for them to express their creativity, it also offers an opportunity to work on a project that is very tangible with very clear beginning and ending points.

I believe that an exhibition program is the most accessible way to begin to integrate art into a seminary community. Even with a minimum of effort, the community can be influenced by the art simply by passing through the exhibition area on a regular basis. In United Seminary's case, students routinely experience exhibits just by going to class. During the first year, we frequently acknowledged that we were learning while we were doing. As we evaluated the year we knew that some things would need to change, but we also felt we had accomplished our goal—to develop a space for ongoing exhibitions of religious art.

The exhibition program is the oldest of our major programs and has proved quite successful. Indeed, between exhibits, people express their sense of loss as they face empty walls. If we were to suggest one program model to initiate, the exhibition program serves well as an entry point. While an artist-in-residence might not reach a large number of students, or while a museum event will have selective attendance, a well-placed exhibition area in a seminary or church will have an impact on most all members of the community. Now, ten years after our first efforts, it would be hard to imagine life at the seminary without an exhibition program, as it has become an essential part of our ethos and community life.

ESTABLISHING AN ARTIST-IN-RESIDENCE PROGRAM

An artist-in-residence program is another effective means of integrating the arts into the academic life of the seminary. While residencies can

consist of many formats, three different versions of such a program will be discussed. The first is an example that includes a poet-in-residence for a long residency, the second involves an artist-in-residence for a short, one-week residency, with events that are created around a particular theme, and the final example involves an artist-in-residence from another cultural perspective.

Artist-in-residence programs have been in existence at seminaries for many years. Bringing works of art into a seminary setting is an important step; but with the actual presence of a person engaged in doing art, the encounter with the art becomes more involved and offers potential for a more profound experience. In effect, by inviting an artist-in-residence into a theological setting, the dialogue expands as the community has an opportunity to interact with the art and the artist, and to observe the artistic process firsthand.

The vital component of a residency, the observing of an artist's work and his or her artistic process, can be accomplished in a variety of ways. One method is for the artist to demonstrate his or her medium. The poet might perform a reading and lead a discussion, or the musician might give a concert or a recital. A second method allows for the artist to invite participants to observe the process and the creation of art. A potter can throw pots while a class observes and a painter can stretch a canvas, apply gesso, and apply oils in a place where students can watch and interact. A third method invites the artist to reflect on the artistic process and its theological import in lectures or discussion. With a visual artist, an exhibit can be mounted and a gallery talk or discussion can take place.

What is most important is that the community is able to observe the artist at work, actually creating art. Even with art forms that are more solitary—writing a poem or composing a score—there are still ways to invite the community into that experience. A composer or writer might elicit words, phrases, or melodies from the community and then incorporate them into the final product, to be read publicly at a specified time. A dancer might invite students to create movements that would then be choreographed into a final piece that reflects a theme or issue that is significant to the community. A visual artist could be given a space in which to paint, sculpt, weave, or draw. The experience of

watching an artist create art in a seminary community will, by its very nature, elicit theological reflection, discussion, and insight.

In order for an artist-in-residence program to be successful, it is important to be intentional about how the artist will be integrated into the community. An essential component of any artist's residency is being visible in the community and establishing a connection to the curriculum and the faculty. Doug Adams, professor of Christianity and the Arts at Pacific School of Religion, explains his process. "I introduce the artist to the community through arranging appearances in classes as well as through chapels, informal gatherings, and art exhibitions."[6] Adams goes on to say,

> Integrating the artist into the mainline curriculum is important; artists do not influence students if they are involved primarily in extracurricular continuing education, outreach, and development. Let us include artists-in-residence in summer courses and continuing education events, but let us concentrate on illuminating the core curriculum and the full-time students and faculty.[7]

Any seminary will offer numerous classes that an artist might visit, but Adams is specific about which ones would be his preference. He suggests that it is ideal to have the arts included in courses that are part of the required curriculum, such as church history, theology, ethics, Old Testament and New Testament.[8] Indeed, in these introductory and often required courses, an artist will receive maximum visibility.

Most residency programs include a number of expectations for the artist-in-residence. Artists are usually expected to interact with the community: to participate in worship, to work with students, and to visit classes. In some residencies, working with and mentoring students who are practicing artists are expected.

While there are specific expectations of an artist, there are also benefits for the artist. A residency normally provides an artist a place to exhibit his or her work. Some settings will invite an artist to donate a work of art at the end of his or her residency; others might purchase a work to add to the seminary's permanent collection. This can be important because artists often seek greater visibility for their art and do

not always have access to public spaces for exhibitions. This can be especially true if the artist works with overtly religious themes, a subject from which many galleries shy away. A residency might also provide studio space. In this case an artist might appreciate the opportunity to work in a studio space located in a theological setting. Remuneration takes the form of an honorarium. Some schools will give an artist the opportunity to audit a class in exchange for his or her residency.

A "long-term" artist-in-residence program may last for a month, one semester, or possibly as long as one academic year. The advantages of a long-term residency are several. In these cases, the artist is able to have more time to be known "in" and "by" the community. This is helpful for accommodating the complex schedules of resident and commuter students. A long-term residency allows programming to be more evenly paced over a greater period of time. Even though the time of the residency is longer, the rhythm of academic life dictates that students may be on campus only one day or during one time period in any given week, so the timing of offerings needs to be varied.

Alternatively, a short-term residency can also be a helpful model. This type of a model can be important when dealing with practical considerations such as travel costs, or when the artist's schedule prohibits an extended residency. Some artists will prefer a short-term commitment. In this case, in order to maximize the residency, the artist is integrated into numerous and varied events in a relatively short period of time. In a short-term residency, one can schedule events at varying times of the day and week to expand the community's access to the program. Student participation will usually depend on personal motivation and interest. Some students will give a maximum amount of time for a short period of time. Other students will find that multiple options in a one-week period will be too overwhelming.

Whenever possible, we try to involve the artists in worship. This gives the community an example of how the arts can become an integral and vital part of worship. If the artist is a poet, he or she might do a reading. A visual artist might include a work during the worship service. Alternatively, an artwork can be the focus of a chapel meditation or homily.

Pam Wynn was the first long-term artist-in-residence at United Seminary. A published and gifted poet, she was in residence for one

month. Wynn lived near the seminary, eliminating residency costs and permitting the goals of the program, not the budget, to determine the parameters of her engagement. We scheduled events at varying times of the day to give the community multiple opportunities to encounter this poet. During her residency, she offered a series of lunch-hour "artist talks," led a creative writing workshop, and met with students on an individual basis to mentor them in their own writing. Certain events were planned to stand as individual events, but they were also designed as part of a whole program of themes and offerings. Wynn had contact with more than a hundred people during her residency. She invited the community to take a break from the structured schedule, to suspend the normal academic routine, and to engage issues using other forms of creativity. She would share her poetry as well as lead worship, inviting others to write poetry for theological and personal expression. During her residency, we learned that there were many "poets" among the students. By her presence and mentoring, Wynn encouraged the development of their artistry.

There were many benefits that came from her residency. One benefit for her was the opportunity to be a member of a community where study and reflection of God was intentional. Wynn's interests and the community's interests complemented each other, and numerous ideas were exchanged in lively discussions. Her contributions were several. She led chapel services, served as a guest lecturer in courses, helped students write poetry, presented readings, and invited students to discover how poetry could be used in worship. Since the completion of her residency, Wynn has continued to play a vital role in our community. In the fall of 2002, Wynn elected to enter the seminary's M.A. program in Theology and the Arts.

In contrast to long-term residencies, United Seminary has also experienced short-term residencies based on particular themes. Nancy Chinn, a liturgical artist and educator, lived among us for one week to explore "The Other Side of the Mask, Reclaiming Halloween." The residency was planned and shaped collaboratively with the artist, and was scheduled to coincide with three celebrations: Day of the Dead, Halloween, and All Saints' Day. By combining these three events into one overall emphasis, Chinn incorporated rituals and traditions be-

longing to each of these traditions to help participants discover similarities and differences. Events during the residency included lunch-hour presentations, a late-afternoon event, an early-evening lecture to accommodate varying schedules, as well as an experiential arts workshop and a community art project. The events varied not only in time but also in style and content. Some were presentations delivered by Chinn, some invited community participation, while others revolved around worship. Participants in the week's events came from both within and outside of the community. To our delight, community involvement and attendance was significant.

Perhaps the most significant focus of Chinn's residency was a "community art project" set up in a portion of the seminary's cafeteria (ill. 32). The community art project was designed to provide an overarching venture that spanned the course of the residency, encompassing the participation of individuals throughout the week and in a final closing community ritual. The cafeteria setting was chosen deliberately because it is a gathering place along a major thoroughfare at the school. The hope was to make the project visible and accessible to the entire community. This allowed people simply to observe if they wished, to stop by briefly as time permitted, or to return for extended periods of time.

The community art project was structured so that persons of different artistic skill levels and with differing amounts of time would be able to participate. The emphasis was to engage in theological reflection while doing art rather than to become obsessed with producing master works of art. Chinn invited the community to create individual pieces that would later become part of a larger group installation. Shoeboxes and materials were provided so that individuals could decorate the boxes with images that told stories of loss, or that honored a person of significance to them. Materials used—crayons, paper, paint, and tissue—were inexpensive and accessible. Perhaps one of the greatest gifts for our upper midwestern community was to learn about the traditions of Day of the Dead, which is celebrated more frequently in Central and South America. Under Chinn's instruction, we learned about the traditions and values of another culture, finding that there were many similarities and themes that we hold in common.

On the last day of the residency, the community art project was cel-
ebrated with a closing ritual. The individual projects were combined to
form an altar. Candles were lit, flowers were placed and, as is custom-
ary for the Day of the Dead, food and beverages were positioned on the
altar. Chinn led us in a time of thanks and remembrance, helping us ex-
perience and embrace our community's understandings, new and old, of
the Day of the Dead and its significance and connection to All Saints'
Day. For that one week, the communion of saints was experienced in
community through art. Loss is a universal theme, and we learned
about the importance of not only remembering loss but remembering it
in community.

A final artist-in-residence model points to the importance of invit-
ing artists from other cultures to expand awareness and understanding.
In this case, the structure of the residency included an exhibit, a work-
shop, a lecture, public events, and guided tours. This residency, held in
the spring of 2003, was coordinated by Fawzia Reda, a Muslim artist
and lecturer on Islamic art, calligraphy, and architecture. For her resi-
dency, Reda curated a calligraphy exhibit featuring the work of Haji
Deen MiGuang Jiang from China, Mouneer Sha'rani from Syria, and
Fayeq S. Oweis from the United States (ill. 33). By coincidence, the ex-
hibit and residency overlapped the start of the United States' invasion
of Iraq. The works, containing sayings from the Qur'an as well as
Arabic poetry and proverbs, along with the Gospel of Matthew, pro-
vided a stark contrast to the images of war viewed on the daily news.

Reda also organized an Islamic calligraphy workshop led by Fayeq
S. Oweis, one of the artists from the exhibit. Junior-high-school stu-
dents from a nearby mosque were invited to join our seminary students
in attending the workshop. Workshop participants created calligraphy
and learned about the Islamic art form and its traditions. An article in
the *St. Paul Pioneer Press* highlighted the poignant timing as these two
worlds found a unique and holy connection through the arts. "The tim-
ing ensured that more than pretty Arabic writing was on the minds of
the Muslim students who prayed in the Seminary's library and the fu-
ture pastors who offered tours to giggly school girls in flowing caftans
and headscarves."[9] For a few weeks the exhibit walls, graced with im-
ages of elegant Arabic script, helped these communities to appreciate

cultural differences and to build bridges of understanding, awareness, and hope for peace.

These are only three examples of what a residency might look like. The shape and length of a residency can and should vary according to the needs of the artist and the institution. As one might note, creativity is the only limit and events can lead to unexpected experiences. By having artists in their midst, students can glimpse a kind of creativity that will enhance the skills they learn in seminary. When artists are present, students begin to see modeled before their eyes the many ways in which the arts empower spiritual development. While this does not happen without some intentionality, the doors of possibility are opened when artists become part of theological education.

ESTABLISHING A COMMUNITY COLLABORATION

The final model of how to integrate arts into the life of a seminary community involves an educational collaboration between a seminary and an arts institution.

United Seminary has held three "Theology and the Arts Day" programs at local museums.[10] Each program incorporated museum staff, docents, and teachers or leaders from the seminary community. Two of the three days were held at the Minneapolis Institute of Arts (MIA) and one was held at the Minnesota Museum of American Art (MMAA). The Minneapolis Institute of Arts is one of the leading fine arts museums in the nation. The Minnesota Museum of American Art in the Twin Cities is solely dedicated to American Art. The goal of each of the days was to provide a public forum for dialogue on art and religion for students, staff, faculty, and members of the wider community. Participants from United Seminary, the Minnesota Consortium of Theological Schools, and members of the arts and religion community were invited to attend.

The first "Theology and the Arts Day," held at the MIA, was not widely advertised, yet the interest and participation was strong. It drew more than 125 attendees. The format for the day included plenary sessions with keynote addresses and small group gallery tours. The overarching program for the day drew on Wilson Yates' study of the intersections between art and religion. Five of those intersections became guiding rubrics for the conversation:

- The role of art in religious ritual
- The power of art to raise religious questions about the meaning and purpose of life—to pull us onto religious turf
- The invitation to encounter and appropriate the spirituality of the religious traditions from which we come
- The ability of art to speak to us prophetically and to engage our own prophetic consciousness
- The power of art to become sacramental in its power; that it may become the means through which divine truth and grace is mediated.[11]

For all the "Days," keynote speakers were drawn from either the museum staff or the seminary community. Topics for the addresses explored the intersections between art and religion with reference to works within the museum's collection. We found that including major works from the museum's collection elevated the treatment of this dialogue and was a major factor in the program's success. The events also included featured exhibits when possible, including *Half Past Autumn: The Art of Gordon Parks* and, on another occasion, *Francis Bacon: A Retrospective*.

Paired teams of museum docents with seminary representatives led the small groups in museum gallery tours. The docents and seminary representatives were asked to be conversation partners and facilitators of the group time. During registration, participants were given the opportunity to select a gallery tour according to their personal interests based on cultural periods of art history such as:

- Art of the Americas
- African Art
- Asian Art
- Landmarks in Print Collecting
- Medieval Renaissance Art
- Western Nineteenth- and Twentieth-Century Art

In later years, the offerings reflected religious themes rather than art periods and included:

- Alienation and Enlightenment
- Art in Religious Ritual

- Creation
- Images of Sacred Figures
- Love and Grace
- The Mystical Experience
- Prophetic Judgment
- Sacred Story
- The Word as Image

We found that working with religious themes instead of periods of art made the connections between art and religion even more meaningful.

Each section of the day was carefully planned by representatives of the museum and personnel from the seminary in order to consider the overall structure and theme for the day. The museum staff offered helpful insights and ideas for constructing the program especially in regard to maximizing our use of the museum space and creating gallery tours. The willingness of the museum to be a full partner with the seminary contributed greatly to the success of the project.

According to a survey, the predominant reason given for attendance at the "Theology and the Arts Day" was an interest in the theme of religion and art. From the beginning, it was obvious that the subject matter tapped into something powerful because the program produced such an enthusiastic response. Persons who attended identified themselves as interested in the topic for personal or professional reasons. They identified themselves as artists, students, pastors, and theologians. Many of them listed the museum itself as a significant draw.

Our hope was not only to provide participants with information about the intersections of art and religion and practical experience in the galleries, but also to provide models for interacting with art that they could take back to their own setting. We tried to demonstrate specific ways of relating to a work of art, how to approach a work, how to ask questions of the work, and how to have a dialogue about the work from a religious perspective. In addition to the experiences of the day, we also gave participants a packet of information about art and religious resources in the community and beyond. The packet included an extensive bibliography and a clear message that part of the mission of

United Seminary is to serve as an ongoing resource for them in their work in the area of religion and the arts.

While we sponsored this event through the seminary, the format could be easily adapted and sponsored by a congregation or a group of congregations. The key ingredient includes a willing collaboration between a religious organization and an arts institution. As museums realize the wellspring of interest that a dialogue between theology and the arts engenders, they are likely to become eager partners. The tremendous public interest in art and spirituality suggests a depth of possibility when it comes to collaborating with an arts institution.

～

Consideration of how the arts are used in theological education is extremely important because of the significant link between the training of church leaders and what ultimately happens in local congregations. My assumption is that the arts help us experience and express the presence of the Divine. And as we experience that presence, the arts help us to convey that presence to others. The exhibition program brings art into the halls of higher education, inviting theological reflection. The artist-in-residence program brings artists into the seminary and allows students the opportunity to observe the artistic process unfold and to explore its implications for theological understanding. The museum program invites students and the community to move beyond the seminary setting into an arts institution to imagine the role of the arts beyond the museum's walls. The success of these projects suggests that such endeavors can and should be developed. The potential impact of such endeavors is significant for the future health and vitality of theological education and the church.

～

NOTES

1. Wilson Yates, *The Arts in Theological Education* (Atlanta: Scholars Press, 1987), 43.

2. The term paracurricular refers to those learning experiences and opportunities that exist alongside of the curriculum. An example might be a spiritual for-

mation group or an arts program that is part of the seminary learning experience but is not part of the explicit curriculum.

3. http://www.unitedseminary-mn.org.

4. The M.A. in Theology, Worship and the Arts, a degree granted by United Seminary, has been renamed. It is now an M.A. in Theology and the Arts.

5. http://www.saintpeters.org/art/index.html.

6. Doug Adams, "Affirming Artist-in-Residence Programs as Messy," *ARTS: The Arts in Religious and Theological Studies* 4/3 (1992): 26.

7. Ibid.

8. Ibid.

9. Hannah Allam, "The Art of Islam," *St. Paul Pioneer Press* (April 10, 2003).

10. The format for the day was based, in part, on a program first developed at the National Gallery of Art in London in 1992 by Tom Devonshire Jones, director of Art and Christianity Enquiry (ACE). His program, entitled "The Theology and Art Study Day," included plenary sessions on topics such as "Theology, Art, and Meaning," "The Reformation," and individual artists Veronesi, Carravaggio, and Paula Rego. For a discussion of the program, see John S. Nuveen, "Notes on a Theology and Art Study Day at the National Gallery in London," *ARTS: The Arts in Religious and Theological Studies* 4/3 (Summer 1992): 3.

11. Wilson Yates, "The Intersections of Art and Religion: Reflections on Works from The Minneapolis Institute of Arts," *ARTS: The Arts in Religious and Theological Studies* 10/1 (1998): 21–25.

～ **12** ～

Revealings

Exploring the Practice of Prayer and Photographic Images

SIDNEY D. FOWLER

Attentiveness is all;
I sometimes think of prayer as a certain quality of attention . . .[1]
—KATHLEEN NORRIS

When you think about it, we almost never pay absolute attention.
The minute we do something happens. We see whatever we're
looking at with such attention, and something else is given—a sort of revelation.[2]
—MAY SARTON

It seems that in Latin "photograph"
would be said "imago lucis opera expressa," which is to say:
image revealed, "extracted," "mounted," "expressed"...
by action of light.[3]
—ROLAND BARTHES

At the prayer and photography workshop I was leading, instead of using the stock photograph that I gave her, the woman took a photo of her estranged daughter out of her purse and held it in her hand. She carefully looked at the image. Together, all in the room took a deep breath and silently asked God to be with them during the time of prayer. Breathing deeply, the woman looked at the photo and then, closing her eyes, drew it to her heart. Rhythmically, she repeated the movement: breathing in, looking at the photo, praying, closing eyes, drawing the photo to her heart, breathing in, repeating the process. At the end of our time, we held our images to our hearts and were silent. After some time passed, we talked about what happened. The woman said, "I have tried and tried to pray about my daughter. I don't even know what to pray for. Things are a mess. Just drawing her to my heart and to God seemed honest, and seemed like the prayer I wanted to pray."

I never met Venus Williams and I am not talking about the tennis player. The Venus Williams about whom I am speaking was the focus of Scott Thode's photograph *Venus Rising* (ill. 34). In time, however, she became the focus of thoughts and prayers. From the moment I saw her, saw the photo, she projected herself into my life. "O God, I see light, see blasting water, see New York at night, see a brave woman stretching, arching toward the heavens." She seemed to call out to me for a response—at least, to begin with, a prayer. I suggested that the photo of Venus Williams be included among images for exploring Epiphany in a church school curriculum prototype. While seeking permission to use the image from Scott Thode, I discovered that Venus was HIV positive, a former IV-drug user, and homeless. She died from AIDS in August of 1997. Thode demanded that any use of her picture must have integrity. We included a caption with the image that described her life.[4] In testing the prototype that included the photo, a few congregations welcomed her photo; others found it inappropriate to use. It was not used in the final actual resource. Photographic images seem to have an amazing ability, if we pay attention, to sometimes offend, sometimes comfort, sometimes transform us. Venus led me in prayer.

This article seeks to discover how such use of photographic images might enhance the practice of prayer for persons with visual abilities. My interest in this exploration comes from the following:

1. The requests for assistance from persons and communities who desire to deepen their practice of prayer and, although currently uncomfortable with the arts, are open to connecting with the arts to aid in that deepening

2. A desire to connect the arts with a basic Christian practice, the practice of prayer, in an accessible way

3. A commitment to focus on the spiritual formation possibility of the arts over the use of the arts for illustration or instruction alone

4. The deepening of my own practice of prayer that came from the gifts of particular photographic images, engaged in community over time

In this essay, I suggest understandings and connections that I use to form exercises that explore prayer by using photographic images. I focus particularly on an understanding of prayer as loving attention. I identify why I choose photographic images as an accessible and focused way to enhance prayer. I conclude by describing three exercises that were practiced with groups and insights gained from that practice.

PRAYER AS PAYING LOVING ATTENTION

A common understanding of prayer that I encounter as a pastor and spiritual director is that of conversation between the one who prays and God. At best, it seems persons understand that prayer is a two-way conversation. The words of the one who prays, however, most often seem to dominate the conversation. Public prayer reinforces such an understanding by leading congregations into sometimes powerful, sometimes shallow, liturgies of words or by inviting a well-worded worship leader or pastor to pray. This presses in on many, leading them to neglect prayer altogether. Some feel their words are not perfect—not worthy before God. As was true for the woman mentioned at the beginning of this essay, the words do not come or they belittle the yearnings of the heart. Words, solely from personal vocabulary, speak only to a portion of the mystery and revelation of God. The danger is that the use of only cognitively crafted words may crowd out the coming before God. Both God's and the world's imaginative revealing may be missed.

Another understanding of prayer subtly shifts the emphasis in prayer from conversation to relationship—the basis of any conversation. Words remain part of prayer, but are not the soil in which it flourishes. In relationship, prayer also involves silence, breathing, emotions, imagination, dreams, and all our senses. It is a relationship of loving and holy attention, one to the other. The very paying attention is prayer.

Prayer in this understanding does not usually begin with a quick greeting, but rather with deep breath. It begins with the physical acknowledgment of sharing breath with the one who gives breath. From the start, we pay attention to the most basic character of our relationship to God—our life is from and in God.

In *The Practice of Prayer*, Margaret Guenther speaks about prayer most often as a conversation. But when she speaks of true prayer, she says, "True prayer, whatever outward form it might take, is first and foremost a condition of loving attentiveness to God in which we find ourselves open and receptive to who we are in our deepest selves."[5] Simone Weil, the French mystic and philosopher, pressed such an understanding as well. "The key is the realisation that prayer consists of attention. It is the orientation of all the attention of which the soul is capable towards God. The quality of the attention counts for much in the quality of prayer."[6]

"Paying attention" frees the practice of prayer from only discrete times of conversation and opens the one who prays to be present to God—to long for, to listen for, to look for—in all of life. Sallie McFague calls for such in our relationship to all of God's creation, human and nonhuman. "By paying such attention to some fragment, some piece of matter in the world, we are in fact praying."[7] This understanding of prayer reflects a "kataphatic" spirituality that affirms and seeks God, who is imminent and incarnate—revealed in life.[8] Prayer that emphasizes relating and paying attention may open up those who pray and open up God's revealing in the entire world.

To pay loving attention at prayer is a spiritual discipline or practice. One who pays attention, and loves the other, takes time with the other and looks closely. Looking requires, however, laying aside our interests, desires, and preconceptions. Only when laying aside such bias may one authentically encounter God or the other. Weil called for this

discipline in both relationships to God and to others. "When prayer is intense and pure enough for such a contact to be established, the whole attention turns toward God."[9] Later she stated, "The soul empties itself of all its own contents in order to receive into itself the person it is looking at, just as he or she is, in all his or her truth. Only whoever is capable of attention can do this."[10] The one who seeks to pay attention to God's revealing in prayer and the world must also seek an open and honest heart.

With the shift to loving attention, prayer also becomes a multiple-sensory experience. Along with the traditional call to speaking and listening, seeing and imaging play a role. Within the relationship, one gazes into the other—discovering details, emotion, and a deeper knowing of the other. In contemplative traditions that draw upon the visual, there is an external presence, the other, that the eyes of those who pray are compelled to include in their praying.[11] Through the visual grounded in God, images in the world around us, including the visual arts, may become a field and a face from which we encounter God's revealing.

REVEALINGS
Praying and Paying Loving Attention with Photographic Images

Photographic images may provide an accessible and focused means for prayer that pays loving attention. Although at certain times and places the church has looked to the icon, architecture, stained glass, paintings, sculpture, fabrics, and relics as means for devotion, photography may have a distinctive approach at this time. This is particularly true for those whose experience with visual images is media produced—as is the case with those images from magazines, newspapers, posters, advertisements, electronic media, and frames frozen from film, television, and online sources.

While painting and sculpture are often seen as art for the art lover, photographic images are so common they may not be considered by many as "art." It seems most adults declare, "I am no artist nor possess any real art." Most adults, however, are confident clicking a throwaway camera or digital camera and proudly displaying the family photos. Photographic images perhaps frame the real—real place, real peo-

ple, real time—in ways that media formed by hand, clay, stone, fabric, glass, and paint do not.[12] To persons uncomfortable with connecting the arts and faith, photographic images—produced, viewed, and displayed by ordinary folk—may be a first step in opening them to the possibilities for all the visual arts.

Another reason that I choose photographic images is their ability to focus, frame, or hold both place and time. A photographic image may serve as an offering inviting our attention. One may pray, "God, we lift before you this place, these people, this moment." The framing allows us to focus our attention, so our contemplation may go deeper. We see only what has been framed. Although one may imagine what is not in the picture, we are not lost in endless scanning or continuous time. David Finn suggests the surprising gift of such limiting:

> One of the mysteries of the camera is that it enables one to see more in less—*more* aesthetic impact in the confined area of the viewfinder; *less* than what can be seen by the naked eye with its wide range of vision. . . . Training the eye to concentrate attention in a square or rectangle area transforms the vast world we see around us into discrete pictures.[13]

In a similar way, photographic images hold time, freeze time, and portray a particular moment viewed in a fraction of a second. The increased use of digital cameras and their series of frozen moments, the electronic index, demonstrate this photographic ability. In a minuscule period of time, a photographer records a moment, which we may now hold before God in prayer. Brought into that moment, we may seek guidance, connection, confession, and hope. Coming out of the photographed moment, the one who prays may discern God's yearning to redeem and hallow this time.

Finally, I choose photographic images because I find practicing prayer with photos assists one who prays in paying attention to places, people, and moments beyond any single photographed moment. Dorothea Lange observed, "The camera is an instrument that teaches people how to see without a camera."[14] John Berger has asserted that a photograph achieves a distinct expressiveness by recording a particular event, but when studied in leisure "allows us to see the interconnected-

ness and related coexistence of events."[15] Following the loving attention to a photographic image, the one who prays may focus, frame, observe, and respond in faith outside any discreet moment of prayer by paying attention in the world. Practicing prayer with photographic images can assist in enriching the practice of the person whom Michael Frost identifies as the prayerful Christian:

> A prayerful Christian person is one who has come to attention, who has prepared to be shaken out of the closet of apathy and laziness, who refuses to drift through life without thought or reflection. A prayerful person has eyes wide open, has spiritual antennae up, and is looking for signals of God's incarnational creativity all around.[16]

With such prayerful attention to the world, persons may "pray without ceasing" (1 Thess. 5:17).

CONCERNS IN PRAYING WITH PHOTOGRAPHIC IMAGES

In forming exercises for groups and individuals, I attempt to be sensitive to the integrity of both prayer and images. My intent was not to create clever teaching activities, but to invite those who pray into an authentic engagement with God. I am also aware of dangers of "using" photos in prayer. McFague in her work draws attention to the "arrogant eye" and "the eye of the camera: scopophilia." The understanding of the arrogant eye, drawn from the feminist theory of Marilyn Frye, sees everything only in relationship to the self as either for or against self.[17] It is a controlling eye. Scopophilia, based on Sigmund Freud's work, is another distortion by "subjecting other people to a curious, controlling gaze, seeing them as object."[18] The film *One Hour Photo* portrays one who pays attention in a way that reflects the arrogant eye. A photo developer, played by Robin Williams, obsesses and finally becomes violent with a family that he "pays attention" to after years of developing their film. At a haunting moment, he acknowledges that the first use of the term "snapshot" was a hunting term. That understanding echoes the insight of Susan Sontag, who reminds us of terms common to those who use guns and cameras—load, aim, and shoot.[19] One effort I make to preserve the integrity of prayer and image is to invite

those who practice these prayers to consider how they "enter" and "move from" discrete moments of prayer. One must intend to seek God and view with the loving eye—seeking the integrity of what is viewed.

Another concern while prayerfully engaging a photographic image is that rather than praying an image into God's care, we allow the image to pull us away from God. The monastic practice of "custody of the eyes" first described in the Rule of Saint Augustine, followed in the Dominican Order, and later included in the Catechism of Trent, charges persons to be careful of what one sees—for it may lead one into "evils which have their origin in the indulgence of the eyes" and away from God.[20] Often persons were instructed to look down lest one would be led into temptation. In another understanding of the "custody of the eyes," one was charged to guard what one sees, for one is responsible to care for whatever one sees.[21] In praying with images, one needs to become sensitive to the "pull" of the image. To pray with an image may lead one to set aside the image and pray about what it stirs up inside the one who prays. The image indeed may lead to confession, repentance, transformation, or action. The use of photographs in prayer does make possible a kataphatic spirituality that anticipates God's revealing in the stuff of life.[22] Care must be taken in discerning God's presence and listening for God's call revealed through the stuff-of-life imaged in photographs. Those who pray are challenged to bring boldly all they see into prayer and into the transforming and just presence of God.

PREPARING FOR AND FOLLOWING PRAYER WITH PHOTOGRAPHIC IMAGES

In each of the three prayer exercises I share here, I attempt to be sensitive to both the possibilities and concerns by paying attention to how one enters and concludes prayer. I consider the following:

Upon Entering

Reflect on the following questions: How will you prepare yourself for prayer? How will you state your intention to be open to God and God's revealing? How will you lay aside interests that may make you distort or unable to see God's revealing?

Possibilities may include beginning in silence and with deep breaths; stating your openness; creating an environment for prayer with a ritual

such as lighting a candle; naming fears and temptations that emerge for you from the images, and gathering images and information about images with gratitude, as if they were holy offerings. Rather than only a conversation or conversation about God or making a list of personal desires, set a context of loving relationship with God and the world.

Following Prayer

Reflect on the following questions: How will you move from a time of discrete prayer, a time of paying attention to a photographic image, to engagement in the world? How will you move from solitude and a virtual experience with a photographic image, even though placed in a context of holy relationship, to an encounter with God's world?

Make a move from the discrete moment to living out prayer—continuing to pay attention.

THREE SUGGESTED PRACTICES OF PRAYER USING PHOTOGRAPHIC IMAGES

These exercises were adapted from traditional forms of prayer such as centering and breath prayer, Lectio Divina, body prayer, and spontaneous prayer. For most of the exercises, any form of photography could be used, such as snapshots, portraits, landscapes, advertising stills, scientific and research photos, "art" photographs, or popular photographs that are well-known to the general public. My hope is that persons will repeat these exercises over a period of time. As with any form of prayer, this practice enables one to go deeper over time and enriches prayer even when there seems to be no immediate or dramatic revealing.

Prayer Exercise 1: "O God, I See . . ."

To prepare for prayer, an individual selects a photographic image on which to focus. For the first few times, to make the exercise as accessible as possible, persons may choose a familiar snapshot from home or an image that they find particularly compelling.

Following a time of prayerful preparation, the individual prays by saying silently or aloud, "O God, I see" and noting observations. For example, "O God, I see an x-ray. O God, I see light and dark. O God, I see someone's heart. O God, I see someone's lungs. I think the person is healthy. O God, I see someone vulnerable, perhaps scared. O God, I

see deep inside someone." Persons continue to express to God what they see until there is a lull or a sense of completion. At that time, persons express to God any longings, feelings, thoughts, thanks, and/or intercessions they carry, or they may remain quiet.

This form of prayer stresses our paying attention and receiving the gifts and wisdom that comes from simply seeing in the presence of God.

Prayer Exercise 2: Visio Divina

Select an image from which to pray. Following a time of prayerful preparation, persons view an image looking for a detail or aspect of the image that especially disturbs, inspires, teaches, or challenges. (Perhaps one may cover the image with a blank sheet of paper and reveal the image by slowly pulling back the sheet of the paper.) Then the one who prays closes one's eyes and brings the chosen aspect before God. On a second viewing, the one who prays considers, "From this image, O God, what do you desire for me or your people?" or "O God, to what are you calling me or us?" Again, eyes close during a time of reflection. The prayer may end in silence, in words of gratitude, or with the Prayer of Our Savior. The prayer may also end by simply viewing the image in silence and resting in God's presence.

This form of prayer is adapted from a version of Lectio Divina — a holy reading of scripture in which the one who prays ruminates on the Word of God. It places value on photographic images of the world as another source for God's revealing.

Prayer Exercise 3: Held in the Heart

To prepare for prayer, the one who prays selects an image that can be held in one's hand or hands while one prays.

Following a time of prayerful preparation, the person breathes deeply and gazes at the picture in hand. The person looks closely at the image—and after a few moments, closes eyes and draws the image to the person's heart/chest and continues to breathe deeply. The person may offer words to God or simply rest in silence with the image. The person may repeat the process, almost rhythmically, several times. Sometimes one concludes by describing to God what one has held at one's heart, speaking the Prayer of our Savior, or breathing a deep

breath and pressing the image to the heart.

This form of prayer attempts to blend breath prayer and body prayer that involves a simple rite. In some ways it is also a visual "centering" prayer. Rather than using a holy word as a touchstone while approaching God in silence, a photographic image is used. This exercise, different than the two above, does not require any words.

INSIGHTS FROM PRACTICE WITH GROUPS

These exercises were practiced in a number of adult group settings: two two-session Sunday school classes, two workshops on prayer and photography, an Advent prayer group, and two one-session workshops, one "Meeting God: Deepening Spirituality through Worship," and the other "Praying through the Waters: Prayer and the Catechumenate." In the groups, few participants had experience working with the visual arts. Most were interested in the topic because of the focus on prayer. In most sessions, one or two stated an interest in the topic because they enjoyed taking photographs.

The sessions usually followed the same pattern: an orientation to prayer as paying attention, a time of group-building where persons identified and explained a compelling photograph from among many,[23] then each of the exercises was explained, practiced, and discussed. Between sessions, participants were encouraged to practice the exercises. In the follow-up session, exercises were practiced again and explored further. After each exercise, participants reflected on questions from among the following:[24]

- Describe what these experiences were like for you. What happened in your mind and heart and body?
- Do you think of these experiences as prayer or not? Why or why not? How was this experience similar or different from your past experiences in prayer?
- Describe any feelings about and insights into using photography while praying. Are there any advantages to praying with photographs or any concerns?
- In what ways did God seem to be present or not present in your experience?

- Identify what you think is significant—enlightening, disturbing, or compelling—to you about your practice of praying with photographs. Identify what you might want someone else, as a dear friend, to know about this experience.

In discussing the exercises, participants seemed to make observations in three areas: about God, whom they met while praying; about seeing in the presence of God; and about how their prayer and workshops on prayer may be impacted in the future. Many comments were shared in common in all the groups. A few of the comments, however, were raised by a single participant, but resonated with the broader group.

About God

When asked how they experienced God in the exercises, one pastor said God opened his eyes to see and imagine things in the photograph. "It wasn't like when I talk to God in prayer. God was leading me to see and just being with me as I looked and was quiet." Another participant reflected such an understanding of God's leading in selecting an image for the opening session activity. In her observation, God drew her to the image "White Lace" (a color photograph of a white gown drying on a clothesline in a rural setting against a vivid blue sky). The image seemed to select her more than she selected the image. A Christian educator in a workshop in New Hampshire described her experience after the "O God, I see . . ." exercise in this way: "It was different. Saying 'O God' before I said what I saw, it made what I did into 'loving attention.' God was there when I looked at the picture. It was different. I'm going to start praying that way with pictures on the front page of our newspaper." For these participants, God led them to see and was present in revealing that to which they gave loving attention. God as the ultimate referent of seeing mattered. God was not so much one who answered spoken petitions, but rather said, "Notice this; look closely; I am with you."

About Seeing

After viewing photographs in prayer, participants discussed the difference it made in all their viewing. In a second session of a workshop, a pastor talked about how the Visio Divina exercise kept coming to him throughout the week. "I was driving to work and all of a sudden I re-

ally saw the trees along the road. They were magnificent—all standing in a row together, strong, full, and green. I said 'Thank you, God.' I don't think I usually do that in such a spontaneous way." His response recalls the earlier insight of Lange about how photography helps people see without a camera. Others mentioned how the slow revealing of photographic images and the use of small frames in uncovering images enriched the way they saw all that was around them—other photos, other visual images, the world itself. When asked how the exercise was prayer for the participants, a participant in the second session of a Sunday school class described how the exercises actually did not seem like prayer in any discrete, "Dear God-to-Amen," sort of way. Rather for him, prayer became more of a "lingering sensitivity to the world around me." Prayer became reverent attentiveness to the world, a way of seeing, in the presence of God.

Following the exercises, participants often discussed what slowing down and prayerful seeing was like for them. In the Advent workshop, a member described his response to two very different photos, one of a baseball game and the other of Lange's "Migrant Mother." It was "immediate" and opened up "a flood-gate of emotions, memories, and imagination." He talked about how often in prayer he had to think through what he was going to say to God. While viewing images, however, he seemed quickly confronted with what to bring before God.

Following both the "O God, I see . . ." and Visio Divina exercises, other participants commented about shifts in their seeing. At first they observed a particular aspect of the photo. The more they looked, however, they saw that aspect in a totally different way. Their initial perception changed. For others, they were soon drawn to another aspect of the photograph altogether. After another man's prayer with "Migrant Mother," he said, "I know it's crazy, but all I saw for the longest time was the mother and her sadness. Then, all of a sudden, there was this baby. I started wondering where life was going to take the baby. I prayed about that." These shifts in attention especially occurred after exploring an image with another who had prayed with the same image, or after hearing the story or history of a particular image.

⌖

About How the Exercises Shape Future Praying and Leading Groups in Praying

The exercise "Held in the Heart" seemed to draw the most responses from those in workshops—although not many were verbal responses. It was not intended in the initial design, but there was a gradual move from the more verbal-oriented prayers of "O God, I see . . ." and Visio Divina to the less verbal, to the simple wordless movement prayer of "Held in the Heart." Following discrete times of practicing the exercises, persons seemed to desire to remain in the silence. Indeed, it was an awkward shift to talking about the prayers. The use of images seemed to move participants in these groups into a desire for silence in a new way. One workshop participant remarked, "I never slow down and just breathe. To be with God and hold the picture close, I didn't want you to interrupt us." My experience of teaching centering prayer, a prayer that rests in silence and openness to God, has often been difficult. Persons not used to silence seem often to grow anxious. The particular practice of "Held in the Heart," however, seemed to facilitate silence. Persons, once introduced to it, desired more. Perhaps this was because they were not asked to articulate anything about the picture or identify a particular meaning. They slowed down—able only to look and pray more deeply.

"Held in the Heart" also combined prayer, a simple act of looking, and a simple move of an image that was away from one's body to one's body. An educator in New Hampshire described this as a powerful experience for her. "When I look at the family album or newspaper pictures or art, it's usually out there at least an arm's length away. When I brought the picture to my heart, the chasm was bridged. It got to me. We were part of each other. It was intimate." When she said this, many persons nodded and agreed. She seemed to state what happened for many in the room. Prayerful attention combined with even simple physical acts may lead one to embody prayer, a silent prayer of intercession, at a deep level.

In evaluating the workshops, participants and I observed a particular difficulty with moving from praying with an image to reflecting about praying. Although many would state they felt like they prayed, reflections centered on interpretations of and questions about the photographic images. Questions such as "Where was God in the experi-

ence?" most often shifted to "What did you see in the picture or get out of it?" This may reflect discomfort with talking about prayer more than discussing the meaning of an image. I do not, however, necessarily view this as avoidance of the "God" questions. Perhaps it reflects a hunger of adults to interpret and see together in community. It also extends prayer into the life of a community as they discuss an image. Such a communal seeing reinforces prayer as paying attention. Through the richness of their interpretive community, they brought a broader seeing of an image before God, broader than any single one could offer.

A few participants spoke about how much "fun" the prayer exercises were. At the same time, they recognized how disturbing and tragic many of the images were. This strange tension between pleasure and sadness pointed back to earlier cautions about using photographic images. I was reminded of scopophilia and the arrogant eye or engagement in a photographic/virtual experience with another rather than a real engagement. Following the first session of the Advent workshop, a man explained his enjoyment of praying with the exercises: "all my senses were engaged. . . . I felt something." In this instance, "fun" seemed to describe a fresh way of seeing and bringing the world before God, rather than using words warily. Still, in future prayers and workshops, participants must be careful how they draw upon images. Will this way of prayer seek to control God and the world around them or to disconnect them? The hope is that this way of prayer will, instead, open and connect them to the world and God.

Over time I added a variation to the "O God, I see . . ." exercise. Through small viewers made from transparency slide frames, participants looked at parts of images. They viewed images through frames. Increasingly, persons talked about their own desire to see and pray through a lens or frame. Several times following a first session, participants brought their own snapshots and photographs to the next session. Carefully each person described what it was like taking the picture and what it meant to them. No longer only willing to view through the lens of another, alive with seeing the world around them, they wanted to pray through their lenses, their own framing.

This increasing interest by others and me to create photographs led us to ask questions of those who do it often. In what ways do photog-

raphers pray? For photographers who say they pray, does their craft shape and influence their prayers, and do their prayers influence their photographs in any way? Such interviews and prayers need to be included in future workshops. Such interviews will be helpful in designing other exercises for praying, for paying loving attention.

Through photography, we may practice a way of prayer that helps us see the world and reveals God's call. Held in prayer and viewed expectantly, a photograph may reveal the forgotten infant, the estranged daughter, a hydrant's healing spray on a woman with HIV, one earth from the moon's view—surprising revelations. In that viewing, in the presence of God, we may pay loving attention both to the world and to the revealed God. We may see more. We may love more.

∼

NOTES

1. Kathleen Norris, *Amazing Grace: A Vocabulary of Faith* (New York: Riverhead Books, Penguin Putnam, 1998), 350.

2. May Sarton, quoted in Sallie McFague, *Super, Natural Christian: How We Should Love Nature* (Minneapolis: Fortress Press, 1997), 29.

3. Roland Barthes, *Camera Lucida: Reflections on Photography* (New York: Hill and Wang, 1981), 81.

4. *Behold: Arts for the Church Year,* prototype (Kelowna, B.C., Canada: Seasons of the Spirit Publishers, 2000), 4.

5. Margaret Guenther, *The Practice of Prayer* (Cambridge: Cowley Publications, 1998), 44.

6. Simone Weil, *Waiting for God* (New York: G.P. Putnam's Sons, 1951), 57. Other writers have emphasized "paying attention" in their understanding of prayer and spirituality. See Howard Thurman, *Meditations of the Heart* (Boston: Beacon Press, 1953/1981), 209; Kathleen Norris, *Amazing Grace: A Vocabulary of Faith* (New York: Riverhead Books, Penguin Putnam Inc., 1998); McFague, *Super, Natural Christian,* 26–44; John Wijngaards, *Experiencing Jesus* (Notre Dame: Ave Maria Press, 1981); Thomas Keating, "The Practice of Attention/ Intention" at www.geocities.com/Heartland/Meadows/7709/attend.html; and Michael Frost, *Seeing God in the Ordinary: A Theology of Everyday* (Peabody, Mass.: Hendrickson Publishers, 2000), 35–59.

7. McFague, *Super, Natural Christian,* 29.

8. Harvey D. Egan, "Christian Apophatic and Kataphatic Mysticisms," *Theological Studies* (Fall 1978): 399–425.

9. Weil, *Waiting for God,* 57.

10. Ibid., 64.

11. See William A. Dryness, *Visual Faith: Art, Theology, and Worship in Dialogue* (Grand Rapids: Baker Academic, 2001), 33–38. Dryness connects the traditions of the mediated image. He comments on the distinct role of the visual icon in the East and the images and relics in the West. Of the icon, he stated, "The icon, therefore was much more than aesthetic image to grace the church and stimulate holy thoughts. It was something that expressed held theological convictions, and it was meant to move the viewer to love and serve God. . . . As John of Damascus insisted in his defense of icons, the use of images was stipulated from the beginning as a part of holy devotion. . . ."

12. See Barthes, *Camera Lucida*, 5–6. Here Barthes insists on the realness of a photograph that lingers over time. "The Photography always leads the corpus I need back to the body I see; it is the absolute particular. . ." He states that the "referent adheres." Even when the photograph is treated, staged, or distorted, elements are drawn from the real photographed in real time. This feature may be an important contribution of photography to assist in prayer—seeking God's revealing in the real.

13. David Finn, *How to Look at Photographs* (New York: Harry N. Abrams, 1994), 32.

14. Jan Phillips, *God Is at Eye Level: Photography as a Healing Art* (Wheaton: Quest Books, 2000), 103.

15. John Berger and Jean Mohr, *Another Way of Telling* (New York: Vintage International, 1995), 120.

16. Frost, *Seeing God*, 34.

17. McFague, *Super, Natural Christian*, 83.

18. Ibid., 84.

19. Susan Sontag, *On Photography* (New York: Doubleday/Anchor Books, 1990), 4. Throughout the essays in this volume, Sontag presents concerns about the practice of and use of photography. Many of her concerns point to the ability of photographers and those who view photos to detach from the subject of a photo. The photographer distances self from the subject. Horror may be faced only as art. Photography may control and improperly categorize a subject. She points to how photography may be used in both narcissistic and depersonalizing ways. In all these ways, photography may be used to lead one to pay less loving attention than more, the more that prayer and this article intend.

20. See the Catechism of Trent at www.cin.org/user/james/ebooks/master/rent/tcomm06, and The Rule of St. Augustine at www.op.org/domcentral/trad/rule.

21. Rose Mary Doughtery, "She Who Sees Is Responsible," *Shalem News On Line* 19.2 (Summer 1995) at www. Shalem.org/sn/19.2rmd.

22. Egan, "Christian Apophatic." This presentation of kataphatic mysticism, along with *On Divine Images* by John of Damascus, theologically asserts the incarnation of Christ as the basis for looking to the material world, including artistic expressions, as possible revelations of God. See John of Damascus, *On the Divine Images: Three Apologies against Those Who Attack the Divine Images*, trans. David Anderson (Crestwood, N.Y.: St. Vladimir's Seminary Press, 2000).

23. Photographs utilized in the workshops included: William Anders' *Earthrise*, Dennis Brack's *The Dancers*, Manuel Alvarez Bravo's *Public Thirst/Sed pública* and *Crowned with Palms/Coronada de palmas*, Debbie Fleming Caffery's image of boy, mirror, and baby powder and image of Mexican girl with candles, Dorothea Lange's *Migrant Mother*, Leonard McCombe's *Mexican woman and her daughter making tortillas, Man Stopping Tank, Beijing, June 1989*, Mark D. Phillips' image of Toronto Blue Jays and New York Yankees game, W. Eugene Smith's *Tomoko in Her Bath*, Scott Thodes' *Venus Rising*, William Tierman's *White Lace*, and David Hagen's image of a homeless woman in *Face to Face: Portraits of Homeless People in Cleveland* (Cleveland: Northeast Ohio Coalition for the Homeless, 2003), 5.

24. For a description of aesthetic and qualitative research in educational settings, see Sidney D. Fowler, "Imaging the Word: A Descriptive Account of Curriculum Development Utilizing Artistic Images" (Diss., Teachers College, Columbia University, 2000). See also Elliot Eisner, *The Enlightened Eye: Qualitative Inquiry and the Enhancement of Educational Practice* (New York: Macmillan, 1991), and Elizabeth Vallance, "Aesthetic Inquiry: Art Criticism," *Forms of Curriculum Inquiry*, ed. Edmund C. Short (Albany: State University of New York Press, 1991).